Jan Białostocki

The Art of the Renaissance in Eastern Europe
Hungary · Bohemia · Poland

THE WRIGHTSMAN LECTURES

Cornell University Press

FRONTISPIECE: Bartolommeo Berrecci and Santi Gucci:
Double tomb of Sigismund I and Sigismund II August, 1529–31 and 1574–5.
Cracow, Wawel Cathedral, Sigismund Chapel

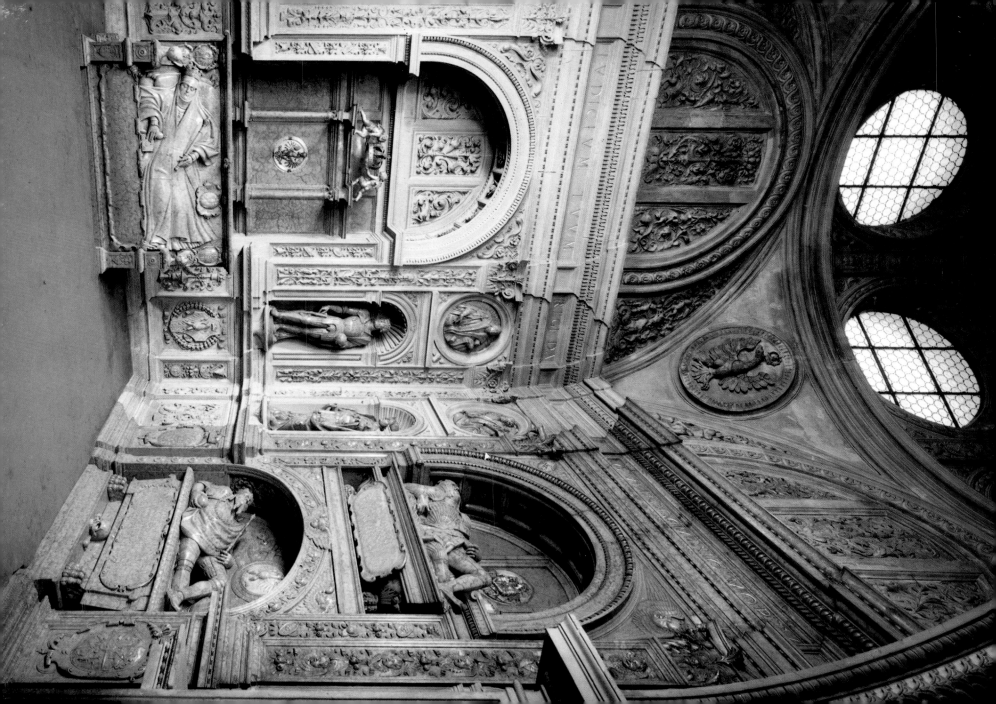

Jan Białostocki

The Art of the Renaissance in Eastern Europe

Hungary · Bohemia · Poland

THE WRIGHTSMAN LECTURES delivered under the auspices of the New York University Institute of Fine Arts

Cornell University Press Ithaca, New York

This is the eighth volume of the *Wrightsman Lectures*, which are delivered annually under the auspices of the New York University Institute of Fine Arts

First published 1976 by Cornell University Press

International Standard Book Number 0–8014–1008–8
Library of Congress Catalog Card Number 75–3429

Printed in Great Britain by Ebenezer Baylis & Son Limited,
The Trinity Press, Worcester and London

Contents

List of Illustrations vii

Photographic Acknowledgements xviii

Some Important Dates xx

Preface xxiii

Chapter 1
Humanism and Early Patronage 1

Chapter 2
The Castle 13

Chapter 3
The Chapel 28

Chapter 4
The Tomb 45

Chapter 5
The Town 59

Chapter 6
Classicism, Mannerism and Vernacular 73

Notes 89

Illustrations 105

Bibliography 281

Index 307

List of Illustrations

Plates

Frontispiece
Bartolommeo Berrecci and Santi Gucci: Double tomb of Sigismund I and Sigismund II August, 1529–31 and 1574–5. Cracow, Wawel Cathedral, Sigismund Chapel

PLATE I
Gerardo and Monte del Fora: Frontispiece with St Jerome and Matthias Corvinus and Beatrix in adoration in *S. Didimi Alexandrini De Spiritu Sancto et Cyrilli Alexandrini opera . . .*, 1487. New York, Pierpont Morgan Library, MS 496, fol. 2

PLATE II
Master of the Behem-Codex: Tannery. Miniature in the *Behem-Codex*, 1505. Cracow, Jagellonian Library, MS 16, fol. 276r.

PLATE III
Bartolommeo Berrecci: Sigismund Chapel, view of the drum and the dome

PLATE IV
Master 'M.S.': Crucifixion. Esztergom, Kereszteny Museum

Text Illustrations

Fig. I
Map of eastern Europe about 1500

Fig. II
Plan of the ground floor of the royal castle on the Wawel Hill, Cracow

Fig. III
View of the royal castle on the Wawel Hill, Cracow, from above

Fig. IV
Bakócz chapel in its original location. Plan drawn by J. B. Packh before the removal in 1823

Fig. V
Location of the Bakócz chapel at the Esztergom cathedral. After Balogh

Fig. VI
Plan of the excavated foundations of the Jan Łaski chapel in the cathedral at Gniezno

Fig. VII
Bartolommeo Berrecci: Sigismund Chapel, 1517–33, in the Wawel cathedral, Cracow. Vertical section

Fig. VIII
Bartolommeo Berrecci: Sigismund Chapel in the Wawel cathedral, Cracow. Plan

Fig. IX
Composition of the wall of the Sigismund Chapel. Diagram after L. Kalinowski

Fig. X
Map of the locations of centrally planned chapels in Poland. After J. Z. Łoziński

Fig. XI
Diagram of the sunken roof house with a parapet of the Polish type

Figs XII–XIII
Wawrzyniec Lorek: Manor, 1565–71, at Pabianice. Parapet of the Polish type and gable parapets of the Bohemian type

Fig. XIV
Map of eastern Europe after the Battle of Mohács, 1526, and the occupation of Buda, 1543, by the Turks

Fig. XV
Bonifaz Wohlmut: Organ loft. Prague, St Vitus's Cathedral. Plan of the vaulting of the ground and second floors, following O. Pollak

Fig. XVI
Plan of the castle of Florian Griespach, 1540–56/8, Kačeřov

Fig. XVII
Plan of the castle of Florian Griespach, 1553–72? and 1613–14, Nelahozeves

Fig. XVIII
Archduke Ferdinand of Tirol: Design for the Hvězda castle. Vienna, Nationalbibliothek.

Fig. XIX
Bonifaz Wohlmut: Plan of the fortifications surrounding the Hvězda castle, 1556–8

Black and White Illustrations

Chapter 1

1 Marco Frisin and Pietro Antonio Solari: Faceted palace, 1487–91 (remodelled later, window frames 1682), Moscow, Kremlin

2 Alevis Novyi (Alvise Lamberti da Montagnana?): Iron Gate, 1503, Bakhchisaray, Demir Khapu Palace

3 Alevis Novyi (Alvise Lamberti da Montagnana?): Cathedral of St Michael the Archangel, after 1504. Moscow, Kremlin

4 Royal workshop in Buda: Second frontispiece in Antonio Averlino Filarete, *De architectura libri* XXV, 1489. Venice, Biblioteca Marciana, Cod. lat. 2796, fol. 5r.

5 Attavante degli Attavanti: Frontispiece of a Missal with God the Father, a Roman nereid sarcophagus and a portrait of Matthias Corvinus, 1485. Brussels, Bibliothèque Royale, Ms 9008, fol. 8v.

6 Gian Cristoforo Romano: Beatrix of Aragon. Relief. Budapest, Castle Museum

7 Gian Cristoforo Romano: Matthias Corvinus. Relief. Budapest, Castle Museum

8 Lombard or Florentine artist: Substructure of the Crucifixion group: sphinxes, dolphins and astrological representations (Crucifixion by a Paris workshop, before 1404). Esztergom, Cathedral (treasury)

9 Bolognese goldsmith, after a design by Francesco Francia: 'Apostolic Cross,' Esztergom, Cathedral (treasury)

10 Pollaiuolo workshop: Throne drapery of Matthias Corvinus (The Galgóc drapery). Budapest, National Museum

11 Italian artist (Master Albertus Florentinus?): Allegories of Virtues. Frescoes, about 1494–5. Esztergom, Castle

12 Ivan Dukhnović (Giovanni Dalmata): 'Diósgyör Madonna.' Miskolc, Diósgyör Castle, Museum

13 Tabernacle of George Szathmáry. Pécs, Cathedral

14 Tabernacle of Andrew Nagyrévy, about 1504–5. Pest, Parish Church of the Inner City

15 Madonna of Andreas Báthory, 1526. Budapest, National Museum

16 Franciscus Florentinus: Tomb of Jan Olbracht, 1502–5 (the effigy of the king probably by Jörg Huber), Cracow, Wawel Cathedral

17 Antonio della Porta and Pace Gaggini: Tomb of Raoul de Lannoy, begun 1507–8, assembled before 1524. Folleville, near Amiens

18 Benedetto da Rovezzano: Tomb of Gonfaloniere Soderini, c. 1509. Florence, S. Maria del Carmine

19 Detail of the balustrade with a candelabrum from the Nyék hunting lodge. Budapest, Castle Museum

20 Frieze with cornucopias, from the façade of the chapel of Cardinal Bakócz, 1507–8. Esztergom, Cathedral (crypt)

21 Castle of Jakub Dębiński, 1470–80, slightly remodelled in the seventeenth and nineteenth centuries. Dębno, east of Cracow

22 Collegium Maius of the Jagellonian University, 1492–7 and 1518–40. Cracow

23 Tomb of Barbara Tarnowska from Rożnów, about 1520. Tarnów, Cathedral

24 Southern portal of Tarnów Cathedral, after 1505

25 Albrecht Dürer: Marriage of the Virgin. Woodcut from the *Life of the Virgin*, about 1504–5

Chapter 2

26 Buda Castle. Detail of a woodcut from Schedel's *Chronicle, c.* 1470

27 Pieter Coecke van Aelst: Detail of View of Constantinople, showing statues of the pagan deities in bronze brought from Buda and melted in 1536. Woodcut from *Moeurs et fachons des Turcs* after Marlier

28 Italian, second half of the fifteenth century: Candelabrum from the Buda castle. Istanbul, Hagia Sophia

29–30 Capitals from the Buda castle. Budapest, National Museum and Castle Museum

31–2 Frieze with dolphins and candelabrum ornament with fruits from the Buda castle. Budapest, Castle Museum

33 Capital from the Buda castle. Budapest, Castle Museum

34 Leon Battista Alberti: Capital from San Sepolcro, Cappella Ruccellai, 1467. Florence, San Pancrazio

35 Ceramic pavement from the Buda castle. Reconstructed in the Budapest Castle Museum

36 General view of the ruins of Matthias Corvinus's castle at Visegrád

37 Effigy of Matthias Corvinus. Stove tile. Budapest, Castle Museum

38 Master of the Marble Madonnas: Typanum of the royal chapel in Matthias Corvinus's castle, 1480–5. Visegrád, Museum of King Matthias

39 Courtyard with Hercules fountain, after reconstruction. Visegrád, Matthias Corvinus's castle

40 Hercules and the Lernaean Hydra, group from the Hercules fountain in Matthias Corvinus's castle, Visegrád. Visegrád, Museum

41 Panel from the Hercules fountain with Corvinus's coat of arms, 1484–5. Visegrád, Castle

42 Benedikt Ried: Vladislav Hall, 1493–1502. Interior view. Prague, Hradshin Castle

43–4 Benedikt Ried: Vladislav Hall, 1493–1502. View from the north and view from the south. Prague, Hradshin Castle

45 Benedikt Ried: Capital of the Vladislav Hall. Prague, Hradshin Castle

46 Benedikt Ried: Portal between the Vladislav Hall and the old Parliament room, about 1500. Prague, Hradshin Castle

47 Benedikt Ried: Triple window inside the Vladislav Hall, east wall (portal added in 1598 by Giovanni Gargioli). Prague, Hradshin Castle

48 Benedikt Ried: Exterior portal of Riders' Staircase, after 1500. Prague, Hradshin Castle

49 Benedikt Ried: Interior portal of Riders' Staircase. Prague, Hradshin Castle

50 Benedikt Ried: 'Ludvík-wing', about 1500–10. Prague, Hradshin Castle

51 Benedikt Ried: Interior portal of the Bohemian chancellery, 1509. Prague, Hradshin Castle

51a Style of Benedikt Ried: Southern portal of the St George's Church, about 1520. Prague, Hradshin

52 Franciscus Florentinus: West wing of the Wawel castle, 'Queen Elizabeth's House', 1502–7. Cracow

53 Franciscus Florentinus's workshop: Tendril ornament from a window frame. Cracow, Wawel State Art Collections (Lapidarium)

54 Detail of architectural decoration with tendril ornament from the hunting lodge at Nyék. Budapest, Castle Museum

55 Franciscus Florentinus: Oriel in the west wing of the Wawel castle. Cracow

56 Royal castle on the Wawel Hill. North and east wing, 1507–36. Cracow

57 Royal castle on the Wawel Hill. East and south wing, 1507–36. Cracow

58 Royal castle on the Wawel Hill. General view from the north. Cracow

59 Maerten van Heemskerck: View of the Vatican with the wing of the Cortile di San Damaso. Drawing, 1533. Vienna, Albertina

60 'Wawel-type' portal, earlier group, 1507–16. Cracow, Wawel Castle

61 'Wawel-type' portal, later group, 1523–9. Cracow, Wawel Castle

62 'Wawel-type' portal, 1520–35, in Piotrków castle. Nineteenth-century woodcut

63 Portal of the 'Wawel-type' combined with the window. Cracow, Wawel Castle

64 Columns of the upper floor arcade, capitals and coffered ceiling. Cracow, Wawel Castle

65 Master Benedikt: Castle at Piotrków, 1511–19. Early nineteenth-century drawing. Warsaw, University Library (Print Room)

66 'Wawel-type' portal, 1530s. (Wall paintings late sixteenth century.) Pardubice, Castle

67 'Wawel-type' portal, about 1540. Jaroměř, Church

68 Balustrade of the choir, 1510–20, Cracow, Church of Our Lady, St Lazarus's Chapel

69 Dionizy Stuba: Medallions with Roman emperors and empresses, Third floor arcade, wall paintings outside, 1536, Cracow, Wawel Castle

70 Hans Dürer: *Tabula Cebetis*. Wall paintings in the Deputies' Room, 1532 (heavily restored), Cracow, Wawel Castle

71 Hans Dürer and Master Antoni from Wrocław: Tournaments. Wall paintings, c. 1535 (restored). Cracow, Wawel Castle

72 Sebastian Tauerbach and assistants: Ceiling with coffers and heads, 1535f. Cracow, Wawel Castle (Deputies' Room)

73 Hypothetical reconstruction of the original composition of the ceiling with heads in the Deputies' Room, Wawel Castle, by Dr A. Misiąg Bocheńska

74 Coffered ceiling with heads, about 1465. Naples, Castelnuovo (Triumphal Arch of Alfonso I)

75 Coffered ceiling with heads. Split, Baptistery (formerly Temple of Jupiter)

76–8 Sebastian Tauerbach and assistants: Three of the heads from the ceiling of the Deputies' Room, 1535f. Cracow, Wawel Castle

79 Sebastian Tauerbach and assistants: One of the heads from the ceiling of the Deputies' Room, 1535f. Cracow, Wawel Castle

80–1 Portals between the rooms of the ground floor, 1536, of the castle at Brzeg (Brieg)

82 Castle gate, 1533 at Legnica (Liegnitz)

83 Medallions with the heads of the Roman emperors. Brzeg (Brieg), Castle

84 Castle gatehouse, 1551–3, sculptural decoration by A. Walther, K. Khune and J. Wester. Brzeg (Brieg), Castle

85 Gallery of the rulers of the Piast dynasty. Brzeg, Castle gatehouse

86 Castle façade, 1546–7. Chojnów (Haynau)

87 Allegorical figure of Water. Detail of the decoration on the gatehouse (Fig. 84) of the Brzeg castle, based on Rosso's *Thetis* print

Chapter 3

88 General view of the wall paintings, about 1496, Kutná Hora, Cathedral (Smíšek chapel)

89 Three men fulfilling liturgical functions (?). Lower register of the wall paintings. Kutná Hora, Cathedral (Smíšek chapel)

90 Niche with chandeliers, candles and books. Wall painting. Kutná Hora, Cathedral (Smíšek chapel)

91 View towards the altar wall of the Bakócz chapel, begun 1506, Esztergom, Cathedral

92 Stall wall of the Bakócz chapel before transformation. Drawing by J. B. Packh, 1823. Budapest, Museum of Fine Arts

93 Walled up façade of the Bakócz chapel towards the interior of the cathedral. Drawing by J. B. Packh, 1823. Budapest, Museum of fine Arts

94 Ruins of the old Esztergom cathedral with the Bakócz chapel. Drawing by J. A. Krey, 1756. Vienna, War Archive

95 Andrea Ferrucci: Altar of the Bakócz chapel, 1519, with nineteenth-century restorations and additions

96 Arches and capitals with a part of the inscription frieze. Esztergom, Bakócz chapel

97 Interior of the Bakócz chapel: the wall with the two doors and a window. Esztergom

98 Giuliano da Sangallo: Cappella Barbadori in the sacristy of Santo Spirito, 1489–97. Florence

99 Chapel of János Lázói, 1512. Small west portal. Alba Julia (Gyulafehérvár)

100 Chapel of János Lázói, 1512. View of the façade. Alba Julia (Gyulafehérvár)

101 Bartolommeo Berecci: Sigismund Chapel, 1517–33. Cracow, Wawel Cathedral

102 Bartolommeo Berecci: Sigismund Chapel. Interior towards the altar. Cracow, Wawel Cathedral

103 Bartolommeo Berecci: Sigismund Chapel. Interior towards the royal throne. Cracow, Wawel Cathedral

104 Bartolommeo Berecci: Sigismund Chapel. Interior towards the tomb wall. Cracow, Wawel Cathedral

105 Bartolommeo Berrecci: Sigismund Chapel. Corner of the royal throne wall and the tomb wall. Cracow, Wawel Cathedral

106 Bartolommeo Berrecci: Sigismund Chapel. The drum and the dome. Cracow, Wawel Cathedral

107 Bartolommeo Berrecci or his workshop: King Solomon relief. Cracow, Wawel Cathedral, Sigismund Chapel

108 Bartolommeo Berrecci or his workshop: King David relief. Cracow, Wawel Cathedral, Sigismund Chapel

109 Bartolommeo Berrecci and his workshop: Tympanum above the entrance wall (with Adam and Eve). Cracow, Wawel Cathedral, Sigismund Chapel

110 Bartolommeo Berrecci and his workshop: Allegorical figure of Plenty (?). Left field in the tympanum above the tomb wall. Cracow, Wawel Cathedral, Sigismund Chapel

111 Bartolommeo Berrecci and his workshop: Tympanum above the altar wall. Cracow, Wawel Cathedral, Sigismund Chapel

112 Bartolommeo Berrecci and his workshop: Triton and nereid. Field to the right in the tympanum above the throne wall. Cracow, Wawel Cathedral, Sigismund Chapel

113 Window frame with dolphins. Cracow, Wawel Cathedral, Sigismund Chapel

114 Bartolommeo Berrecci and his workshop: Triton and nereid. Right field in the tympanum above the tomb wall. Cracow, Wawel Cathedral, Sigismund Chapel

115 Roman sarcophagus with tritons and nereids, beginning of third century A.D. Rome, National Museum

116 Roman sarcophagus with tritons and nereids, first to second century A.D. Boston, Museum of Fine Arts

117 Raphael: *Galatea* (detail: Triton and nereid). Rome, Villa Farnesina

118 Bartolommeo Berrecci: Venus Anadyomene (?). Tympanum above the altar wall. Cracow, Wawel Cathedral, Sigismund Chapel

119 Venus Anadyomene, side of a Roman sarcophagus, beginning of the third century A.D. Rome, Borghese Gallery

120 Bartolommeo Berrecci: Signature in the lantern of the Sigismund Chapel. Cracow, Wawel Cathedral

121 Bartolommeo Berrecci: Chapel of Bishop Piotr Tomicki, about 1530. Cracow, Wawel Cathedral

122 Samuel Świątkowicz: St Mary's Chapel, 1603–11. Włocławek, Cathedral

123 Vasa Chapel, 1664–76. Vault. Cracow, Wawel Cathedral

124 Vasa Chapel and Sigismund Chapel, from the south. Cracow, Wawel Cathedral

Chapter 4

125 Joannes Fiorentinus: Epitaph, *c.* 1510, from the Dominican Friars Church, Buda

126 Joannes Fiorentinus: Epitaph of Bernardo Monelli, 1496. Budapest, Castle Museum

127 Joannes Fiorentinus: Epitaph of Jan Łaski, 1516. Gniezno, Cathedral

128 Joannes Fiorentinus: Epitaph of Andrzej Łaski. Gniezno, Cathedral

129 Joannes Fiorentinus: Baptismal font from Menyő, 1515. Bucharest, Historical Museum (formerly in the Museum in Oradea-Nagyvárad)

130 Coat of arms of Nicolaus Báthory, Bishop of Vác, 1483. Balassagyarmat, Páloc Museum

131 Pannonian tomb stele from the castle garden in Buda. Budapest, Historical Museum

132 Pannonian tomb stele of Herennius Pudens. Budapest, Castle Museum

133 Veit Stoss: Epitaph of Filippo Buonaccorsi, called Callimachus (executed in the Vischer workshop, Nuremberg), 1500–10 (see Fig. 137). Cracow, Church of the Dominican Friars

134 Surgeon in his study, from a Roman sarcophagus, *c.* 300–330 A.D. New York, Metropolitan Museum of Art

135 Circle of Altichiero: Petrarch in his study. Illumination. Darmstadt, Library

136 Epitaph of the organist Conrad Paumann (died 1473). Munich, Church of Our Lady

137 Veit Stoss: Epitaph of Filippo Buonaccorsi (see Fig. 133). Original form as shown in the drawing by J. N. Danielski, 1829

138 Master 'M.F.': Tomb of Stanislaus Sauer, 1533, remodelled after 1535. Wrocław, Church of the Holy Cross

139 Master 'M.F.': Epitaph slab of Heinrich Rybisch, 1534. Wrocław, St Elizabeth's Church

140 Andreas Walther I: Tomb of Heinrich Rybisch, 1539, incorporating the slab of 1534 (Fig. 139). Wrocław, St Elizabeth's Church

141 Andreas Walther I: Effigy of Heinrich Rybisch (detail of Fig. 140)

142 Tomb of Jan V Turzo, Bishop of Wrocław, 1537. Figure by an unknown artist, architecture by Andreas Walther I. Wrocław, Cathedral (after H. Lutsch)

143 Tomb of Balthasar of Promnitz, after 1562. Nysa (Neisse), St Jacob's Church

144 Tomb of Jan V Turzo, Bishop of Wrocław, 1537. The surviving figure. Wrocław, Cathedral

145 Bartolommeo Berrecci, Giovanni Cini and assistants: Canopy above the Gothic tomb of King Władysław Jagiełło, 1519–24. Cracow, Wawel Cathedral

146 Ceiling of the canopy of the Władysław Jagiełło tomb (detail of Fig. 145)

147 Detail of the capitals of the canopy shown in Fig. 145

148 The Triumph of Caesar. Detail of the ceiling of the canopy shown in Fig. 146

149 Bartolommeo Berrecci (?): Tomb of Jan Konarski (1521). Cracow, Wawel Cathedral

150 Bernardino Zanobi de Giannottis and Giovanni Cini: Effigy from the tomb of the chancellor Krzysztof Szydłowiecki (died 1532). Opatów, Collegiate Church

151 Bernardino Zanobi de Giannottis and Giovanni Cini: Tomb of the Dukes of Masovia, Stanisław and Janusz (died 1524 and 1526). Restored after being badly damaged in 1944. Warsaw, Cathedral

152 Jan Oslev: Tomb of Duke Jan Podiebrad and his wife Krystyna Szydłowiecka, 1557. Oleśnica (Oels), Castle Church

153 Tomb of Jacob of Salza, Bishop of Nysa, 1539. Nysa (Neisse), St Jacob's Church

154 Alexander Colijn: Tomb of the Habsburg rulers, 1564–73 and 1590. Prague, St Vitus's Cathedral

155 Tomb of Sofia Pathóscy, 1583, from Cetatea de Baltă, Bucharest, Historical Museum (formerly in the museum in Cluj-Kolozsvár)

156 Vischer workshop: Tomb of Cardinal Fryderyk Jagiellon, commissioned in 1510. Cracow, Wawel Cathedral

157 Hans Süss von Kulmbach: The Adoration of the Magi, before 1511

158 Vischer workshop: St Stanisław presenting Fryderyk Jagiellon to the Virgin and Child. Relief from the tomb of Cardinal Fryderyk Jagiellon. Cracow, Wawel Cathedral

159 Jan Biały (?): Stalls and portals, 1581–3. Elements of the former tomb of St Hyacinthus. Cracow, Church of St Giles

160 Jan Biały (?): Tomb of St Hyacinthus, 1581–3. Reconstruction of the original form in the chapel of the Dominican Friars Church (after K. Sinko and S. Świszczowski)

161–2 Vischer workshop (with assistance of Peter Flötner ?): Bronze plaques of Seweryn Boner and Zofia Bethman Boner, 1535–8. Cracow, Church of Our Lady

163 Peter Vischer the Elder's workshop: Bronze plaque of Piotr Kmita, after 1505. Cracow, Wawel Cathedral

164 Hieronim Canavesi: Tomb of Kasper Wielogłowski (died 1564). Czchów, Parish Church

165 Followers of Santi Gucci: Walerian and Anna Montelupi. Detail from the Montelupi Tomb (Fig. 168). Cracow, Church of Our Lady

166 Santi Gucci or his workshop: Paweł Myszkowski. One of the relief effigies of the Myszkowski family in the dome of its chapel, 1602–14. Cracow, Dominican Friars Church

167 Hieronim Canavesi: Tomb of the Orlik couple. Watercolour by J. K. Wojnarowski, 1847. Cracow, Jagiellonian Library

168 Followers of Santi Gucci: Tomb of the Montelupi family, early seventeenth century. Cracow, Church of Our Lady

169 Santi Gucci and his workshop: Tomb of the Kryski family, 1572–6. Drobin, Parish Church

170 Bartolommeo Ammanati: Tomb of Marco Mantoa Benavides, 1546. Padua, Eremitani Church

171 Tomb of Chancellor Krzysztof Szydłowiecki (died 1532). Opatów, Collegiate Church

172–3 Mourners. Two details from the bronze relief at the bottom of Fig. 171

174 Bartolommeo Berrecci: Tomb of Sigismund I, 1529–31. Cracow, Wawel Cathedral, Sigismund Chapel

175 Andrea Sansovino (?): Tomb of Cardinal Pietro Manzi dei Vincenzi, after 1504. Rome, S. Maria in Aracoeli

176 Nanni di Bartolo (called Rosso): Sleeping soldier from the Brenzoni monument, 1427–39. Verona, S. Fermo Maggiore

177 Andrea Sansovino: Tomb of Ascanio Sforza, commissioned 1507. Rome, S. Maria del Popolo

178 Jacopo Sansovino: Cardinal of Santangelo. Statue from the double tomb designed by Andrea Sansovino, about 1520. Rome, S. Marcello al Corso

179 Sandro Botticelli: Mars and Venus. London, National Gallery

180 Head of Sigismund I. Detail of Fig. 174

181 Bartolommeo Berrecci (or Gian Maria Padovano): Tomb of Bishop Piotr Tomicki in his chapel, about 1535. Cracow, Wawel Cathedral (see also Fig. 121)

182 Bartolommeo Berrecci (or Gian Maria Padovano): Upper part of the figure of Bishop Piotr Tomicki. Detail of Fig. 181

183 Sculptor from the circle of Andrea Bregno: Tomb of Cardinal Antonio Jacopo Venerio (died 1479). Rome, S. Clemente

184 Tomb of Sir Roger de Kerdeston, 1337. St Mary's Church, Reepham, Norfolk

185 Tomb of Piotr Boratyński, 1558. Cracow, Wawel Cathedral

186 Jonah under his bower of gourds. Detail from the back of a lipsanoteca. Brescia, Museo Civico

187 Bartolommeo Berrecci (or Gian Maria Padovano): Tomb of Barbara Tarnowska (born Tenczyńska), after 1536. Tarnów, Cathedral

188 Jan Michałowicz of Urzędów: Tomb of Bishop Andrzej Zebrzydowski, 1562–3, Cracow, Wawel Cathedral

189 Jan Michałowicz of Urzędów: Tomb of Urszula Leżeńska. Brzeziny, Parish Church

190–1 Jan Michałowicz of Urzędów: Details of the Tomb of Bishop Andrzej Zebrzydowski (Fig. 188): Upper part of the architectural decoration with the putto on a panther; Head of Andrzej Zebrzydowski. Cracow, Wawel Cathedral

192 Jan Michałowicz of Urzędów: The Padniewski (later Potocki) Chapel, 1572–5. Exterior view. Cracow, Wawel Cathedral

193 Padniewski Chapel (later Potocki Chapel) with the tomb, before the Neo-Classical remodelling, 1832–40. Drawing by F. Lanci. Warsaw, Muzeum Narodowe

194 Jan Michałowicz of Urzędów: Tomb of Bishop Filip Padniewski, about 1575. Cracow, Wawel Cathedral

195 Bartolommeo Berrecci (?): Tomb of the three Jan Tarnowskis. Tarnów, Cathedral

196 Tomb of Jan and Janusz Kościelecki, 1559. Kościelec, near Inowrocław, north-central Poland

197 Hieronim Canavesi: Tomb of the Górka family, 1578. Poznań, Cathedral

198–9 Gian Maria Mosca il Padovano: Tomb of Jan and Jan Krzysztof Tarnowski, 1560–70. Reconstruction of the original design of 1560 and the present form. Tarnów, Cathedral

200 Tomb of Sigismund I, 1529–31. Reconstruction of the original form. Cracow, Cathedral

201 Santi Gucci: Tomb of Sigismund II August, 1574–5. Cracow, Wawel Cathedral, Sigismund Chapel

202 Double tomb of Sigismund I and Sigismund II August. After the remodelling in 1571–5. Cracow, Wawel Cathedral, Sigismund Chapel

203 Santi Gucci: Tomb of King Stefan Batory, 1595. Cracow, Wawel Cathedral

204 Santi Gucci: Tomb of Anna Jagellonica, 1574–5. Cracow, Wawel Cathedral

205 Santi Gucci: King Stefan Batory. Detail of Fig. 203

Chapter 5

206 Master of the Behem Codex: Foundry. Miniature in the Behem Codex, 1505. Cracow, Jagellonian Library, MS 16, fol. 28r. Original size, 17.5 × 14 cm

207 Master of the Behem Codex: Shooting yard. Miniature in the Behem Codex, 1505. Cracow, Jagellonian Library, MS 16, fol. 295r. Reproduced in original size

208 Stanisław Samostrzelnik: Sigismund I adoring Christ. Miniature, Sigismund I Book of Hours. London, British Museum

209 Master 'M.S.': Christ falling under the Cross. Esztergom, Ecclesiastical Museum

210 Hans Süss von Kulmbach: The Assumption of St. Catherine, 1515. Cracow, Church of Our Lady

211 Georg Pencz: Painted wings of the silver altar, 1531–8. Cracow, Wawel Cathedral, Sigismund Chapel

212 Pankraz Labenwolf and Melchior Baier (design by Peter Flötner): Reliefs of the silver altar, 1531–8, seen open. Cracow, Wawel Cathedral, Sigismund Chapel

213 Altar from Zator Castle, about 1521. Detail. Cracow, Wawel State Art Collections

214 Altar from the Wawel cathedral, 1545–6. Bodzentyn, Parish Church

215 Altar of St George, 1515–27. Svatý Jur (Pozsonyszentgyörgy), near Bratislava

216 Market square with town hall and St Giles's Church in Bardejov (Bártfa)

217 Master Alexius: Detail of the ornaments of the entrance loggia at the town hall, 1501–9 at Bardejov (Bártfa)

218 Master Alexius: Entrance loggia to the town hall at Bardejov (Bártfa), 1501–9

219 Master Alexius: Coffered ceiling of the big hall, 1508. Bardejov (Bártfa), Town Hall

220 Master Alexius: Doorway of the council chamber, 1507. Inlay panels by Johannes Mensator. Bardejov (Bártfa), Town Hall

221 Stall from St Giles's Church at Bardejov (Bártfa), 1515–20. Budapest, National Museum

222 Gregory of Késmárk: Perspective inlay on a stall, 1516. Levoča (Lőcse), St Jacob's Church

223 F.(?) Marone: Stall from Nyírbátor, 1511. Budapest, National Museum (view in the church before the restoration)

224 F.(?) Marone: Candelabrum panel, detail of a stall from Nyírbátor, 1511. Budapest, National Museum

225 F.(?) Marone: Illusionistic panel with signature, detail of a stall from Nyírbátor, 1511. Budapest, National Museum

226 Golden Crown House, 1521–8. Silesian type of parapet. Wrocław (photographed before demolition in 1904)

227 Market square with parapet houses of various dates in Pardubice

228 Green Gatehouse, 1538, in Pardubice

229 Benedikt Ried: Castle of Ząbkowice (Frankenštejn), 1522–32

230 Parish church with parapet, 1529. Paczków (Patschkau)

231 Cresting of the castle wing at Jindřichův Hradec

232 House with gable parapet in Slavonice

233 Týn school, after 1562. Prague, Old Market Square

234 Gables of the Trinity Church, 1484. Gdańsk

235 Lobkovic-Švarcenberk Palace, 1545–63. Prague, Hradšín

236 Master Pavel: Town Hall, 1537–9. Litoměřice

237 Palace of the Lords of Rožmberk, north façade, 1545–52 and 1557–63. Prague, Hradšín (drawing of 1738)

238 Wawrzyniec Lorek: Manor, 1565–71. Bohemian gable and Polish parapet. Pabianice

239 Market square with cloth hall. Reconstruction drawing. Cracow

240 Cloth Hall, 1556–60, Cracow. Model reconstruction of the original form

241 Cloth Hall. Short side from the south, probably by Gian Maria Mosca il Padovano. Some alterations of 1875–9. Cracow

242 Cloth Hall. Long side seen from the east, with Neo-Gothic and Neo-Renaissance additions by T. Pryliński, 1875-9. Cracow

243 Santi Gucci (?): Masks from the cresting of the Cloth Hall, Cracow

244 Gian Maria Mosca il Padovano (?): Town hall, mid sixteenth century. Tarnów

245 Dr Anczowski's 'Black House', 1575-7 and 1675-9. Lwów

246 Synagogue with parapet of the Polish type. Luboml

247 Parapet of the Polish type, about 1570, Grodno Castle, Zagórze Śląskie (Kynau)

248 Town hall, 1617, and a house, after 1560, in Veselí nad Lužnicou

249 Giovanni de Statio (Hans Vlach): Town hall, 1554-9. Plzeň

250 Town hall, about 1580, in Český Krumlov

251 Parapet of the town hall (later the dean's house), about 1600, in Sušice

252 Castle of the Turzo family, 1564, at Betlanovce (Bethlenfalva)

253 Castle, 1625, at Fričovce (Frics)

254 Parapet of the castle (early seventeenth-century) at Niedzica (Nedec)

255 Church tower, parapet early seventeenth century, at Frydman (Frigyesvágás)

256-7 Parapets of houses on the market square in Prešov (Eperjes)

258 Villa Porto Colleoni, 1490-1500. Thiene, near Vicenza

259 Scuola di San Marco, 1485-95. Venice

260 Merlon cresting, 1520-3. Halle an der Saale, Cathedral

261 Passauer Hof, mid sixteenth century. Stein on the Danube, Lower Austria

262 Dario Varotari: Palazzo Emo Capodilista, after 1575. Montecchia

263 Lorenz Gunter (?): Oriel on the town hall, 1548. Wrocław

264 Renaissance arcades of the town hall, 1615. Roof structures, nineteenth century. Levoča (Lőcse)

265 Giovanni Battista Quadro: Town hall, 1550-60, at Poznań

266 Cracow gatehouse, 1574-8, rebuilt 1782 and nineteenth century. Lublin

267 Giovanni Battista Quadro: Portals of the Serlio type. Poznań, Town Hall

268 Giovanni Battista Quadro: Great Hall. Poznań, Town Hall

269 Giovanni Battista Quadro: Façade of the Poznań, Town Hall

270 Regular plan of the town Györ. After Speckle's *Treatise on Fortifications*, 1589

271 Plan of the town Nové Zámky (Érsekújvár), 1562, designed by Ottavio Baldigara. Plan by G. Ssicha, after 1663

272 Pietro di Giacomo Cattaneo: Ideal plan of a town, 1554

273 Plan of Zamość as actually realized, 1587-1605

274 Development of the plan of Zamość. Hypothetical reconstruction by T. Zarębska

275 Bernardo Morando: Collegiate Church, 1587-after 1600. Zamość

276 General view of the main square of Zamość with town hall, 1591-1600, 1639-51 and later

Chapter 6

277 Villa built for Jost Ludwik Decius, first half of the sixteenth century; remodelled 1616-21. Cracow, Wola Justowska

278 Villa built for Jost Ludwik Decius. Plan. Cracow, Wola Justowska

279 Paolo della Stella and Bonifaz Wohlmut: Villa Belvedere (Letohrádek), 1538-63. Prague, Hradshin Hill

280 Paolo della Stella and Bonifaz Wohlmut: Villa Belvedere (Letohrádek), 1538-63. Front view. Prague, Hradshin Hill

281 Garden with the fountain in front of the Villa Belvedere, Prague

282 Paolo della Stella: Hercules and Cerberus. Relief of the Villa Belvedere. Prague

283 Bonifaz Wohlmut: Royal Ball Court, 1567-9. Prague, Hradshin Hill

284 Bonifaz Wohlmut: Royal Ball Court. Portal with sgraffiti. Prague, Hradshin Hill

285 Bonifaz Wohlmut: Organ loft, 1556-61. Prague, St Vitus's Cathedral

286 Bonifaz Wohlmut: Parliament Hall and the lodge of the Secretary of State, 1551–63. Prague, Hradšin Castle

287 Pietro Ferrabosco (?): Schweizertor, 1552–3. Vienna, Burg

288 West portal of the castle at Kačeřov

289 General view of the castle of Florian Griespach, 1540–56/8. Kačeřov

290 Entrance to the west wing of the castle of Florian Griespach, 1553–72 and 1613–14. Nelahozeves

291 Courtyard with arcades in the castle of Florian Griespach. Nelahozeves

292 Castle, 1549–60 (later transformed), at Kostelec nad Černými Lesy

293 Courtyard of the castle, 1560–7, at Opočno

294 Leonardo Garda de Biseno (?): Courtyard of the castle, 1557–62, at Moravský Krumlov

295 Courtyard of the castle, 1573–8, at Náměšť nad Oslavou

296 Courtyard of the castle, about 1580, at Jindřichův Hradec

297 Giovanni Battista and Ulrico Aostalli (Avostalis): Courtyard of the castle at Litomyšl, 1568–73. View towards the front wing

298 Pietro Ferrabosco (design) and Pietro Gabri (construction): Castle at Bučovice, 1567–82. View from the garden

299 Pietro Ferrabosco (design) and Pietro Gabri (construction): Castle at Bučovice, 1567–82. Courtyard

300 Courtyard of the castle of the Szafraniec family, about 1580, at Pieskowa Skała, near Cracow

301 Staircase and portal of the castle, 1573–8, at Náměšť nad Oslavou

302 Fireplace in the castle of the Rákóczy family at Sárospatak, 1542

303 Hans Tirol, Juan Maria del Pambio and Giovanni Lucchese: Hvězda Castle, 1555–6. Outskirts of Prague

304 Hvězda Castle. Interior (see Fig. 303). Before restoration

305 Santi Gucci: Castle, 1585–95; remodelled 1841–6. Książ Wielki

306 Santi Gucci: Castle. Main building and side pavilion. Książ Wielki

307 Santi Gucci: Myszkowski Chapel, 1602–14. Cracow, Dominican Friars Church

308 Santi Gucci: Myszkowski Chapel, 1602–14. Cracow, Dominican Friars Church

309 Tenczyński Chapel, 1613–16. Staszów

310 Paolo Dominici: Valachian Church, 1591–1629. Tower by Pietro di Barbona, 1572–82 and remodelled in the seventeenth century. Lwów

311 Hans Kramer and Willem van den Blocke: High Gate, 1586–8, at Gdańsk

312 Abraham van den Blocke: Golden Gate (Long Street Gate), 1612–14, at Gdańsk

313 Anthonis van Opbergen: Arsenal, 1602–5. South-east front. Gdańsk

314 Anthonis van Opbergen: Arsenal, 1602–5. North-west front. Gdańsk

315 Anthonis van Opbergen: Arsenal, 1602–5. Detail. Gdańsk

316 Cornelis Floris: Duke Albrecht of Prussia's tomb, 1568–74. Kaliningrad (Königsberg)

317 Willem van den Blocke (attributed to): Kos family tomb, 1600. Oliwa, Cathedral

318 Abraham van den Blocke: Bahr family tomb, 1614–20. Gdańsk, Church of Our Lady

319 Silesian artist: Nunhart epitaph, about 1560. Wrocław, Muzeum Narodowe

320 Jan Vredeman de Vries: Allegory of lawful and unlawful behaviour. Decorative painting in the town hall, 1593–4. Gdańsk

321 Circle of Pietro Tacca: Fountain with monsters, 1637, in the courtyard of the castle at Bučovice

322 Matthias Wallbaum (silverwork) and Anton Mozart (miniatures): Shrine, 1598, Augsburg. New York, Metropolitan Museum of Art

323 German intarsia, the so-called 'Wrangelschrank', late sixteenth century. Münster, Landesmuseum

324 Castle, after 1547, at Horšovský Týn

325 Giovanni Battista and Ulrico Aostalli (Avostalis): Main portal and illusionistic rustication, 1568–73, in Litomyšl Castle

326 Giovanni Battista and Ulrico Aostalli (Avostalis): Loggia of the façade wing, 1568–73, of Litomyšl Castle

327 Giovanni Battista and Ulrico Aostalli (Avostalis): Castle, 1568–73, at Litomyšl

328 G. P. Martinola and G. Bendel: Decoration of the rotunda of the castle, 1594–7, at Jindřichův Hradec

329 Giovanni Maria Faconi and Antonio Cometta: Rotunda at the castle, 1591–3. View from outside. Jindřichův Hradec

330 Jacopo Balin: Parish church, 1586–9 and 1610–13. Kazimierz Dolny

331 Giambattista of Venice: Collegiate Church, 1560. Pułtusk

332 Vault decoration, painted stucco, 1603–7. Lublin, St Bernard Friars Church

333 Albin Fontana: Vault decoration, painted stucco, 1599–1632. Kalisz, Franciscan Friars Church

334 Jan Jaroszewicz and Jan Wolff: Vault decoration, painted stucco, about 1625. Uchanie, Parish Church

335 Santi Gucci: Stalls in the Lady Chapel, 1594–5. Cracow, Wawel Cathedral

336 Castle (last remodelling of the parts shown here, 1591–1606) at Baranów

337 Courtyard of the castle, 1591–1606, at Baranów

338 Castle, last remodelling 1598–1633, at Krasiczyn

339 Parapet of the south wing of the castle at Krasiczyn (extensively restored early twentieth century)

340 Workshop of Santi Gucci: Tomb of the Branicki family, 1596. Niepołomice near Cracow, Parish Church

341 Portal with dragon heads, arcade of the castle at Baranów

342 Tomb of Zofia and Mikołaj Mniszech. Radzyń. After a nineteenth-century drawing. Warsaw, University Library

343 Tomb of Arnulf and Stanisław Uchański, about 1600. Uchanie, Parish Church

344–5 Workshop of Samuel Świątkowicz: Chapel of the Firlej family, 1593–1601. Doorway between the nave and the chapel, and modern drawing of the interior with the tomb of the Firlej family. Bejsce

346 Workshop of Samuel Świątkowicz: Chapel of the Firlej family, 1593–1601. Detail of the decoration. Bejsce

347 Chełmno town hall parapet, 1567–70

348 Chełmno town hall, 1567–70

349 Houses of the Przybyła (St Nicholas and St Christopher Houses, 1615). Kazimierz Dolny

350 St Christopher relief. Kazimierz Dolny, Przybyła House

351 The Celejowski House, about 1635. Kazimierz Dolny

Photographic Acknowledgements

Stefan Arczyński, Wrocław, 81–7, 138–41, 144, 152, 230, 247, 263
Jan Białostocki, Warsaw, 50, 99, 248, 298
Jacek Borowik, Warsaw, 25, 151, 160, 270
Tadeusz Chrzanowski, Cracow, 22, 80, 153, 164, 168, 229, 266, 310, 347–8
Juliusz Chrościcki, Warsaw, 41
Courtesy of Dr G. Entz, Budapest, 8, 9, 11, 13, 14, 20, 36, 39, 40, 54, 91, 95–6, 97, 223, 302
Zbigniew Kamykowski, Warsaw, 169, 187, 197, 268
Stanisław Kolowca, Cracow, 147
Marian Kornecki, Cracow, 143

Courtesy of Dr J. Kotalík, Prague, 43, 45, 49, 218, 219, 237, 252
Lech Krzyżanowski, Warsaw, 318
Courtesy of Professor V. Lasarev, Moscow, 1, 2, 3
From book by H. Lutsch, 142
Stanisław Michta, Cracow, 70
Prokop Paul, Prague, 88, 90, 301
Juliusz Ross, Cracow, 217
Marek Rostworowski, Cracow, 206–7
Szczęsny Skibiński, Poznań, 267
Courtesy of Dr T. Zarębska, Warsaw, 274
Courtesy of Dr M. Zlat, Wrocław, 226

Museums, Institutions, Photographers affiliated to Institutions and Photographic Agencies

Deutsche Bildstelle Berlin, DDR, 316
Bildstelle der Martin-Luther-Universität, Halle-Wittenberg (Birnbaum), 260
Museum of Fine Arts, Boston, 116
Bibliothèque Royale, Brussels, 5
Institutul de Istoria Artei, Bucharest, 100, 129, 155
Budapest Museum of Fine Arts, 6, 7, 10, 12, 15, 29, 30, 38, 93
Szenczi, 209
Budapest National Gallery (Endre Kovacs), 92
Budapest Historical Museum, 19, 26, 31–3, 35, 37, 125, 126
Hungarian National Museum, Budapest (J. Karath), 130, 221, 224–5, 271
M.T.A. Régészeti Intézet; Sugar, Budapest, 132
Historical Museum, Aquincum (Budapest), 131
Jagellonian Library, Cracow, 167
State Art Collections, Wawel, Cracow
S. Kolowca, 71, 76–9
R. Kozłowski, 102, 104–5, 108, 117–18, 120
E. Rachwał, 53, 72, 107, 109–13, 124, 180, 201, 210, 212–13
E. Schuster, 16, 52, 56, 103, 106, 145, 158, 174, 181, 194, 203–5, 300
Łoziński, 202
A. Wierzba, 55, 58, 60, 61, 63, 64, 69, 73, 101, 146, 148, 156, 163, 185, 189, 190, 192, 211, 335
Alinari, Florence, 18, 34, 74, 98, 115, 119, 175–8, 183, 186, 258–9
Office of the Documentation of Monuments, Gdańsk,

German Archaeological Institute, Istanbul, 28
British Museum Library, London, 208
National Gallery, London, 208
National Monuments Record, London, 179
Bayerisches National Museum, Munich, 136
Landesmuseum für Kunst und Kulturgeschichte, Münster, 323
Metropolitan Museum, New York, 134, 322
Caisse Nationale des Monuments Historiques, Paris, 17
State Restoration Studios (PKZ), Poznań (R. Kani-kowski), 269
Narodní Galerie, Prague (M. Sonkova), 67
Státní Ústav, Prague, 46, 48, 236, 249, 250, 251, 280–2, 289, 293–4, 296–7, 329
Vl. Fyman, 42, 47, 51, 235, 279, 285–6, 290, 291, 327
O. Hilmerová, 66, 231, 326, 328
V. Hyklík, 51a, 154, 256–7, 288, 324–5
V. Obereigner, 233
V. Pospíšilová, 227–8, 232, 292, 295
Č. Šíla, 89, 216, 220, 222, 253, 264, 283–4, 299, 303–4, 321
Orbis, Prague (J. Hyklík)
Academia Nazionale dei Lincei, Rome, 114
Biblioteca Nazionale, Venice, 4
O. Böhm, Venice, 170
Bundesdenkmalamt, Vienna, 261, 287
Oesterreichische Bibliothek, Vienna, 59
Meyer, Vienna, 94
Muzeum Narodowe, Warsaw, 27, 193, 240, 319
Art Institute, Polish Academy of Sciences, Warsaw,

57, 62, 68, 127–8, 157, 164, 166, 196, 234, 238, 241, 246, 255, 265, 305, 332, 340–1, 346
Demetrykiewicz, 23
E. Kozłowska-Tomczyk, 65, 188, 191, 200, 276, 336, 342
J. Langda, 24, 121–3, 133, 137, 161–2, 165, 278, 308, 311–12, 334, 338
S. Kolowca, 159
W. Wolny, 150, 171–3, 214, 309, 333, 343–5, 351
J. Gumula, 244, 307
A. Bochnak, 182, 245, 277
T. Przypkowski, 254

Poddębski, 306, 337
W. Mądroszkiewicz, 314
Kłos, 330
S. Deptuszewski, 315, 339
Cybulski, 243
J. Szandomirski, 195, 199, 275, 349, 350
M. Kopydłowski, 317
S. Pronaszko, 331
Ruch, Warsaw (M. Raczkowski), 242
State Restoration Studios (PKZ), Warsaw (K. Kowalska), 320

Some Important Dates in the History of Eastern Europe 1444–1620

1444 Władysław Jagellon, king of Poland and Hungary, defeated and killed by the Turks at Varna

1447 Kazimierz IV Jagellon becomes king of Poland (died 1492)

1453 Constantinople taken by the Turks

1454 The Prussian federation acknowledges Polish sovereignty

1457 Malbork (Marienburg), the capital of the Teutonic Knights, taken by Polish forces

1458 Matthias Corvinus becomes king of Hungary (died 1490)

1459 Serbia occupied by the Turks

1466 (Second) Peace of Toruń. The Grand Master of the Teutonic Knights acknowledges Polish sovereignty

1471 Vladislav II Jagellon becomes king of Bohemia (died 1516)

1490 Matthias Corvinus dies in Vienna, which he had conquered in 1485. Vladislav II succeeds him as king of Hungary

1492 Jan Olbracht Jagellon becomes king of Poland (died 1501)

1501 Alexander Jagellon becomes king of Poland (died 1506)

1506 Sigismund I Jagellon (the Old) becomes king of Poland (died 1548)

1514 Rising of the peasants in Hungary under György Dózsa

1515 Vladislav II, at a meeting in Vienna, concedes the succession in Bohemia and Hungary to the Habsburgs after the extinction of his male descendants

1516 Vladislav II dies. His son Louis II succeeds to the thrones of both Bohemia and Hungary

1518 Sigismund I of Poland marries Bona Sforza

1521 Belgrade taken by the Turks

1525 Albrecht, the last Grand Master of the Teutonic Knights, secularizes the order, becoming Duke of Prussia with a seat in Königsberg under Polish sovereignty. He introduces the Reformation in Prussia

1526 Louis II of Hungary defeated and killed at Mohács. Ferdinand I Habsburg becomes king of Hungary and Bohemia. Large territories of Hungary occupied by the Turks

1527 Vienna besieged by the Turks, who are repulsed

1541 Turks advance in Hungary, Budapest taken

1543 Esztergom taken by the Turks

1548 Sigismund I of Poland dies. His son Sigismund II August succeeds as king of Poland and Grand Duke of Lithuania.

1559 Secularization of the Teutonic Knights Order in Livonia

1561 The former Grand Master Gotard Kettler becomes Duke of Kurland under Polish sovereignty

1569 New Union treaty between Poland and Lithuania. Large areas formerly Lithuanian incorporated into Poland

1572 Sigismund II August dies. Henri de Valois elected Polish king

1574 Henri de Valois leaves Poland and becomes Henri III of France

1575 Rudolf Habsburg becomes king of Bohemia

1576 Stefan Batory, prince of Transylvania, becomes king of Poland (died 1586). Rudolf II becomes emperor, resides in Prague

1579 Victorious campaigns of Batory against Russia, continuing in 1580 and 1581
1586 Batory dies, Sigismund III Vasa elected Polish king in 1587 (died 1632)
1596 The Turks defeat imperial army at Keresztes
1608 Rudolf II cedes Moravia, Austria and Hungary to his brother Matthias
1611 Rudolf II cedes Bohemia, Silesia and Lusatia to his brother Matthias
1612 Rudolf II dies, Matthias Habsburg becomes emperor
1618 Prague 'defenestration', a rising against the Habsburgs starts the Thirty Years War
1620 Czech nobility defeated by the Habsburg forces on Bilá Hora on the outskirts of Prague. End of Czech independence.

Preface

THE SIX CHAPTERS of the present book correspond precisely to the six Wrightsman Lectures given in autumn 1972 in the Metropolitan Museum of Art in New York. Only slight changes have been made in the text as presented then. The book should therefore be considered as a record of the spoken word and the illustrations are as indispensable a part of it as the slides were of the lectures. Such an origin affects the 'poetics' of the book: each lecture must have its dramatic progress and in some way must be self-sufficient. This fact has obviously affected the division of the material and has favoured the functional approach here adopted. The book is not a handbook nor is it a real synthesis of the art of the Renaissance in eastern Europe. I hope however that it will constitute at least a preliminary survey. Since there is practically no book in existence covering the field, I decided, when honoured with the invitation to give the Wrightsman Lectures for 1972, that this was a suitable opportunity to bring an important chapter of the history of art in my part of Europe to the closer attention of the New York audience, and – thanks to the publication of the lectures – to the attention of a world-wide public.

I have to confess that, although originating from eastern Europe, I could not master the complicated problems of the art history in the whole area to an equal degree and I have to apologize that the art of my own country, Poland, may well have received a more detailed and more competent presentation than that of Hungary and Czechoslovakia. However, I hope that this has not affected my judgements of value. The accessibility of Slavonic languages made it easier for me to deal with the art of Bohemia, Moravia and Slovakia than with that of Hungary. The excellent bibliography published by M. Boskovits (1965) was of considerable help.

But to master so wide a field, to obtain the necessary information, to collect photographs for illustrations, would not have been possible without the personal help of many friends and colleagues. Dr Jerzy Z. Łoziński was as always ready to serve with his tremendous knowledge of monuments, as chief of the Polish service of inventorization of monuments in the Art Institute of the Polish Academy of Sciences and Letters. He has read the whole text of the book and formulated his criticism. To him I am much indebted for his great help in obtaining photographs of several Polish monuments. Dr Stanisław Mossakowski also read the text and was helpful with his remarks and photographs. My assistants at the University of Warsaw, Dr Juliusz Chrościcki and Magister Marek Komorowski, have devoted much attention and time to the preparation of slides and photographs. I am also indebted to them for their help in a photographic campaign in spring 1972 in Czechoslovakia. In Poland I want to thank Dr Tadeusz Chrzanowski, Cracow; Professor Tadeusz Dobrzeniecki, Warsaw; Dr Andrzej Fischinger, Cracow; Dr Teresa Jakimowicz, Poznań; Dr hab. Janusz Kębłowski, Wrocław; Dr hab. Jerzy Kowalczyk, Warsaw; Dr Juliusz Ross, Cracow; Dr Jan Samek, Cracow; Dr Teresa Zarębska, Warsaw, and Dr hab. Mieczysław Zlat, Wrocław.

From Hungary I was helped in many ways. Professor Lajos Vayer furnished me with a book fundamental to my subject and difficult to find. In Budapest I also want to thank Dr Klára Garas, Dr Terész Gerszi, Dr Marianne Haraszti Takács, Dr György Rozsa and especially Dr Géza Entz, who collected most of the photographs of Hungarian monuments. Professor Géza Alföldi, Bochum, was kind enough to check the Hungarian spelling in the bibliography.

In Prague Professor Jiří Kotalík was as helpful as always; he made the photographic

campaign possible and provided a great number of the photographs of Bohemian and Moravian monuments. I am also very much indebted to Dr Jarmila Vacková-Šipová. For help in obtaining photographs from Moscow I am grateful to Professor Michael Liebman. Professor Victor N. Lasarev was kind enough to let me have the use of his very precious photographic material. In Rumania I benefited from the help of Professor Razvan Theodorescu, Bucharest, and Professor Viorica Marica, Cluj. For photographs from the German Democratic Republic I want to thank Professor Hans Joachim Mrusek and Dr Irene Roch, Halle.

In New York Mrs Andrea Norris devoted hours of attentive work to brushing up my English, while Miss Elisabeth Horton prepared a perfect typescript during my membership of the Princeton Institute for Advanced Study. This stay in Princeton made it possible to bring the editorial work on the book to an end in ideal conditions. I am grateful for that to Dr Carl Kaysen, former director of the Institute for Advanced Study, and to the late Millard Meiss. To the Phaidon Press I am grateful for their editorial care.

My last, but how important, thanks go to Mr and Mrs Charles Wrightsman, who made these lectures and their publication possible, and to Professor Craig Hugh Smyth (then director of the Institute of Fine Arts, New York University, now at I Tatti, Florence), under whose chairmanship they were given.

J.B.

The Art of the Renaissance
in Eastern Europe

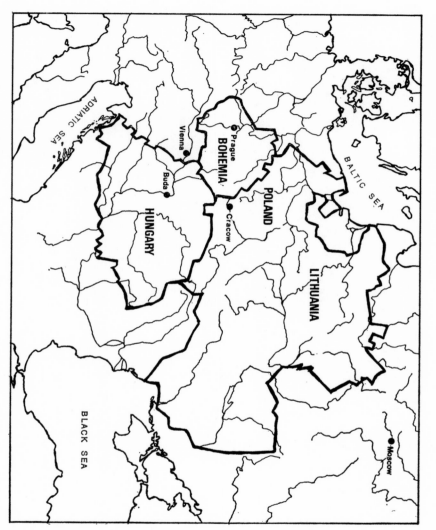

Fig. 1 Map of eastern Europe about 1500

1 Humanism and Early Patronage

The style of the Renaissance in eastern Europe

It is not within the scope of this book to publish unknown works of art or to solve the detailed art-historical problems of eastern Europe. The book is rather an endeavour to draw a coherent image of the main trends and achievements of the east European Renaissance considered as a whole. It cannot be said that the art of the Renaissance in Poland, Hungary and Bohemia has been neglected by scholars. On the contrary: a tremendous amount of difficult work has been done by Czech, Hungarian and Polish art historians in order to connect the – often ambiguous – documentary evidence with preserved monuments. Hungarian scholars have meticulously tried to reconstruct from scarce remains and written records the shapes, dimensions and character of splendid buildings, courtyards, gardens and fountains destroyed during the Turkish rule and the wars of liberation in Hungary. But no one has ever tried to look at the east European scene as a whole, as one artistic province. The only attempt of such a kind was that of a Swedish historian, August Hahr,[1] but his studies were only concerned with architecture and his main interest was concentrated in the later sixteenth and early seventeenth centuries. On the whole students have remained bound to the analytical method and have rarely tried, even within the borders of a single country, to arrive at a synthetic view.

I intend to make such an endeavour in this book. But since this is the first attempt, or one of the first, to arrange the art-historical facts in this geographical area conceived as a unit, it runs the risk of overstressing some features and understressing others. To proceed from facts to a general view, guidelines and a principle of selection are needed. I have chosen functional concepts as such guidelines for the present book. What architects and artists were expected to do was to create and to adorn the temporary residence (the castle); the permanent residence (the tomb and the chapel); and to create the social residence (the town). Art was giving shape to individual as well as to social existence, to its temporary as well as to its timeless surroundings. These are the aspects which will help us to consider the Renaissance in eastern Europe.

The word 'Renaissance' has, of course, several meanings. The three most important are the following: (1) a historical period, (2) a movement in intellectual history, which found expression in the specific outlook we call humanism, (3) a system of forms, qualities, artistic functions and themes which dominated art and architecture, decoration and design, and which we call the Renaissance style. Although these three different, but interconnected meanings share one name, they do not always coincide in their chronological and geographical demarcations. The limits of the period in history called Renaissance are variously defined in different countries. Humanism – even in Italy, its place of origin – precedes by a few generations the crystallization of artistic phenomena that we classify as Renaissance style.

In the present study our attention will go first of all to the Renaissance understood as a 'style' rather than a period of history or a humanistic outlook. The art of the Renaissance was born in Italy; and it took more than a hundred years before it spread all over the Continent. When the first buildings in the new style arose in France, Spain or Germany, the architecture surrounding them remained Gothic, and it took several more decades before the new merged with the old into an acceptable formula – new enough to satisfy the need for fashionable modernity, yet old enough not to be felt as something foreign. What is called the French Renaissance – Anet, Fontainebleau, Chambord, the works of

Colombe, Goujon, Pilon – and what is called German Renaissance – the Fugger Chapel at Augsburg, the Hartenfels Castle in Torgau, the sculpture of the Vischer workshop – all these standard examples of Renaissance art in western, central and northern Europe are extremely complex stylistic structures in which Gothic feeling of form transpires clearly through an imported system of Classical shapes.

It may sound paradoxical that in the east, in Hungary, Slovakia or Poland, we can meet the Renaissance – at least in the early stages of its development – in a more original, pure form, and can already find its impact there at a time when the expressive and decorative Late Gothic style was reaching its climax in France, Germany, Spain and England. In eastern Europe, too, we may follow the countless repetitions and modifications of Italian patterns and types, which spread so widely as to become a kind of artistic lingua franca, known to everybody, although pronounced with local variations. Thus the problem of the transplantation of the Renaissance into eastern Europe belongs among the basic questions of the history of modern art and allows us a glimpse into the mechanism of stylistic confrontations.

Thirty years ago Otto Benesch chose as the subject of his Lowell Institute Lectures 'The Art of the Renaissance in Northern Europe'. In the valuable book which was published as a result of those lectures and republished in 1965,[2] only one work of art is reproduced which does not belong to painting or the graphic arts – a sculpture by Pilon. Benesch concentrated on the two-dimensional arts in his lectures, because the Renaissance, as he understood it, had there found its best expression. And he understood it first of all as a new attitude towards nature, man, the universe and religion. His concept of the Renaissance was basically an ideological one, and his book should perhaps have been called 'The Art of *Humanism* in Northern Europe'.

The approach in this book will be somewhat different owing to the situation in eastern Europe. In contrast to Benesch, the material that I propose to bring to the reader's attention is principally architecture, sculpture and architectural decoration, and much less painting, let alone drawing. As Benesch spoke of Germany, the Netherlands and France, he could bring into his picture well-known personalities of intellectual as well as artistic eminence: Erasmus, Montaigne and Kepler, Dürer, Grünewald and Bruegel. When I introduce to you Hungarian humanists like János Vitéz and Janus Pannonius, or Polish writers and poets like Grzegorz of Sanok and Jan Kochanowski, when I present the works of sculptors like Joannes Fiorentinus, Santi Gucci and Jan Michałowicz, I cannot expect a similar immediate response.

For various historical and geographical reasons the culture of eastern Europe has achieved a more limited international recognition. Language barriers have prevented Slavic and Hungarian writers from being really widely known, while the masters of Latin prose and poetry from eastern Europe, once read by the international intellectual public,[3] have long been forgotten. The marvels of Hungarian art were annihilated after the battle of Mohács in 1526, when Hungary's power was broken and the country invaded by the Turks, and later at the time of 'reconquista'. The fate of Polish monuments of the Renaissance as well as of those in today's Czechoslovakia has been much better, but here, too, subsequent history has in many cases changed, transformed or damaged the works of the past.

This situation, however, encouraged rather than dissuaded me from taking up the subject, which has not been covered in any previous book and to which but a few sentences

are devoted in the current handbooks in western languages, such as the *Pelican History of Art*. One may say that the history of art in this area has still to be integrated into the general picture.

Russia

In order to present a little known province of Renaissance art in a few chapters I have had to introduce limitations, and they are quite important. The concept of 'eastern Europe' is of course a very vague one. Its scope depends on whether we consider it as opposed to western or to central Europe. Every division being more or less subjective, I decided to take into account only three countries – connected, however, by several strong links (see map): the Czech kingdom, comprising Moravia, Bohemia and Silesia; Hungary, including Slovakia and Transylvania; and the Polish–Lithuanian kingdom – all of them in their boundaries of the later fifteenth and sixteenth centuries. Other eastern regions will remain outside my direct and detailed survey.

The art of the rich merchant towns of the Dalmatian coast belongs more immediately to Italian development. These towns depended politically on Venice and, even when independent (like Dubrovnik, which nominally recognized the sovereignty of Hungarian kings), they were completely within the orbit of Italian civilization. On the other hand, Russia presents a special case, which I shall now briefly discuss.[4] The rulers of that country, mostly for military reasons, invited north Italian architects to Moscow in the second half of the fifteenth century, and Renaissance motifs therefore appear there at a very early date.

Aristotele Fieravanti, a famous Bolognese engineer, who worked for a short time in the Kremlin Budapest in 1467, arrived in Moscow in 1474. He built a Dormition church in the Kremlin (1475–9) and though he had to follow Russian architectural tradition (Ivan III sent him to Vladimir to study the local churches), he gave this traditional structure Italian proportions. Pietro Antonio Solari, who left Milan for Russia in 1490, erected several towers of the Kremlin wall, all of which were rebuilt in the seventeenth century or later. Together with Marco Friasin he was also responsible for what is perhaps the most Italianate building on the Kremlin hill – and in Russia as a whole: the so-called 'Faceted Palace' (Fig. 1), with its façade rusticated like those of Ferrarese or Bolognese buildings, and its main floor consisting of one spacious rectangular hall with a vaulting supported by a single pier in the centre (1487–91).[5] Solari continued the building, which had been started by Marco Friasin, and gave it its famous façade. The palace has been remodelled several times inside as well as out. Its present rectangular windows date from 1682. Originally it had double windows similar to those of the Spedale Maggiore in Milan.

The third wave of Italians in Russia was represented by a Venetian architect known there as Alevis Novyi and identified, by some scholars, with Alvise Lamberti da Montagnana.[6] He was brought to the east by Ivan III, but because of the war between Lithuania and Russia the journey was made through the Crimea, where the Tartar Khan Mengli Ghirey took the opportunity to make use of the architect. Alvise built for him the so-called Iron Gate at the Bakhchisaray palace, Demir Khapu (1503), merging Italian design with an oriental profusion of ornament (Fig. 2).[7] Having arrived in Moscow in 1504, Alvise built the cathedral of St Michael the Archangel, with beautiful great shells decorating the lunettes (Fig. 3),[8] and several other churches, since destroyed or completely changed.

This activity of Italians in Russia was in a sense an accident, since the way was not prepared

by humanistic interests. They were brought in because of their fame as military builders and the Renaissance artistic language they used was not exactly what was sought. And it is understandable that they did not produce works of a clearly Renaissance character, nor had they great significance for later developments in Russia. Their activity remained an episode.

Jagellonian Empire

For these reasons we can limit our considerations to the three countries which at the close of the fifteenth century were united under the reign of the Jagellonian dynasty. After the death of Matthias Corvinus in 1490, Vladislav, son of the Polish-Lithuanian king, Kazimierz IV, having already been king of Bohemia since 1471, was elected king of Hungary, and thus a kind of political and cultural union of Poland, Bohemia and Hungary was accomplished. The mutual relations were, however, not always good, sometimes downright bad, and this situation was not to last long. Vladislav united under his rule two important kingdoms (one of them, Bohemia, a part of the Holy Roman Empire) situated between the countries of German tongue on the one side and the advancing Turks on the other. His father ruled the oversize, united Polish-Lithuanian state, whose area was approximately equal to that of the Empire. For some time members of the Jagellonian dynasty controlled European politics and cultural development from the Baltic to the Adriatic and from Silesia to Transylvania. It is the territory of this Jagellonian empire – short-lived as it was, and endangered all the time by the threatening Turks – to which the present study is confined. Just as Russia does not fit into the coherent image, the Balkan countries, conquered by the Turks, remained to a large degree outside the common European development.

While our geographical limits are restricted, the chronological boundaries of what may be legitimately included in our review are wide rather than narrow. The impact of Italy was felt not only strongly, but also early: Hungary's first contacts with the Italian renewal of art took place at the time of the Angevin kings (1308–82) and during the reign of Sigismund of Luxemburg (1404–37). The first Florentine Quattrocento architect, Manetto Ammanatini, was called to Hungary after 1409.[9] From the second half of the fifteenth century the Italian Renaissance was firmly implanted in Buda, Visegrád and Esztergom. It came later to Prague, Cracow and Silesia, but its influence continued, transformed in various ways into a courtly or vernacular Mannerism, when in western Europe the Early Baroque was already fully established.

But although eastern Europe, described as above, was so quick in accepting the Renaissance and rather tenacious in keeping to its forms, the adoption of Italian models did not always correspond to their character and spirit. The import of new styles into Hungary and Poland was at first a purely élite, royal undertaking. In court circles it went with an intense interest in humanistic studies, but for a long time new buildings and works of art must have remained for many people strange and in several respects misunderstood. Also innovations were for long limited to the decorative adornments of portals and window frames, to colonnades in castle courtyards, to some types of sepulchral sculpture, whereas little or no effort was spent on the basic problems of space composition, the new ways of rendering human anatomy and the new forms of beauty, or the humanistic attitude to nature and the world of antiquity.

As long as Italian artists were at work in eastern Europe, they produced a transplanted Italian Renaissance, sometimes of quite high artistic distinction. Once taken over by local builders and sculptors, their ideas and techniques were either repeated with little discrimination, or became transformed in a spirit sometimes foreign to the intentions of their original inventors. Some Italian ideas were picked up, like the niche tomb of Florentine origin, which became a standard type of sepulchral monument in Poland for more than a hundred years, or the arcaded courtyard, which appeared in so many castles in Moravia. While the highest artistic level was reached in works true to their Italian inspiration and executed by Italian artists – sculptures by Giovanni Dalmata in Hungary, the Sigismund Chapel in Cracow and the Belvedere Villa in Prague – the most interesting and most original artistic phenomena occur precisely when Italian ideas were reinterpreted in the specific spirit of each cultural area and according to its own artistic tradition and needs.

What were the specific presuppositions for this early and intensive transplantation of Italian Renaissance into eastern centres, and which factors later favoured their acceptance outside the narrow court milieu in which they first appeared? To answer these questions one has to take into account the history of humanism in eastern Europe and also the way Late Gothic art developed in these countries.

The Italian impact in eastern Europe during the fourteenth and fifteenth centuries
I said that in this book we understand the Renaissance first of all *as a style*, formulated in Italy. But just as it was preceded by humanism in Italy, so it was similarly prepared by humanistic interests in eastern Europe. In the fourteenth century Hungary was ruled by kings of the Angevin dynasty, who were intimately involved in Italian politics, pretending, as they did, to the throne of Naples. Louis I the Great went twice to Italy (1348 and 1381) with his army in order to claim the government of Naples, and it is thus only to be expected that Italians and Italian culture were familiar at the Hungarian court at that time. This situation did not change during the reign of Sigismund of Luxemburg, who in 1411 was also elected German emperor. At that time Buda became an imperial town, as Prague had been in the time of Charles IV. The imperial court and chancellery included several Italians of great eminence: church dignitaries, generals and humanists came from Italy, attracted by that developing centre of European politics and culture.

Branda Castiglione, later to become a cardinal, was bishop of Veszprém, and Giovanni da Buondelmonte bishop of Kalocsa. They commissioned Italian artists to work on the decoration of their episcopal residences. Andrea Scolari was bishop of the important diocese and intellectual centre of Nagyvárad (now Oradea in Rumania), and his brother Filippo Scolari, better known as Pippo Spano (portrayed by Castagno in his frescoes for the Villa Pandolfini Carducci, today in S. Apollonia, Florence), held an important position as a military commander; he developed a considerable architectural patronage, erecting important fortifications in the Italian fashion, and building or enlarging castles, churches and hospitals.[10] Manetto Ammanatini, a carpenter and architect from Brunelleschi's circle, was working for Filippo Scolari as an architect, while Masolino da Panicale remained in Hungary from 1424 to 1427 and decorated Scolari's residences and the buildings founded by him with frescoes.[11] After Scolari's death, both Ammanatini and Masolino were employed by the emperor; Masolino, who soon returned to Italy, also worked for bishop Branda Castiglione in Veszprém. Several humanists appeared at Sigismund of Luxemburg's

court, among them Ambrogio Traversari, Antonio Loschi, Francesco Filelfo and, above all, Pier Paolo Vergerio, whom the emperor brought to Hungary from the Council of Constance and who remained there until his death in 1444.[12] The emperor was in touch with other humanists too: when in Rome, he was guided by Ciriaco of Ancona, while Poggio Bracciolini composed poems to celebrate his coronation.[13] Vergerio undertook a reform of the royal chancellery and had a strong influence on several humanists in Hungary, many of them of Croatian descent like János Vitéz from Sredna in Croatia, who, as a tutor to Matthias Corvinus, played an important role during the early part of this king's reign.[14] Corvinus was a patron who was to add the elegance and splendour of the new art of the Renaissance to the humanistic culture already in vogue in Hungary.

Matthias Corvinus was seventeen years old when he was elected king of Hungary in 1458, after the twenty-one years of unrest which had followed the death of Sigismund. For four years during that agitated period Hungary and the Polish-Lithuanian state were united by the person of King Władysław, son of Jagiełło, the founder of the dynasty. Although Władysław died in 1444 at the battle of Varna, won by the Turks, the contacts already established were to prove lasting. An important Polish humanist and philosopher, Grzegorz of Sanok, who stayed with Władysław and who survived the Varna disaster, remained for many years in Hungary and became, along with Vitéz, tutor to the young Corvinus. In this way close contacts were established between Polish and Hungarian intellectual life. There was indeed one international humanistic Latin culture encompassing intellectual centres from Cracow through Slovakia (which in spite of its Slavic population belonged to the Hungarian state), Hungary, Croatia, Slavonia, as far as the Dalmatian coast. This was the direct way in which first Italian ideas and then Italian style penetrated into eastern Europe at a time when similar developments were uncommon elsewhere in Europe.[15]

The University of Cracow, founded in 1364 as the second university in central Europe after Prague (1348), and remodelled and reformed around 1400, was in the fifteenth century the most important centre of intellectual development, especially in the fields of law, mathematics and astronomy. In Hungary the university founded by Louis I at Pécs in 1367 did not survive for more than thirty-five years.[16] Another short-lived academic institution created within the Hungarian state was the Academia Istropolitana in today's Bratislava (until 1918 Pozsony), a town on Slovak territory. It was founded in 1467 by the humanist Vitéz and included eminent scholars such as the astronomers Regiomontanus from Königsberg and Marcin Bylica from Olkusz near Cracow, but by 1491 it had ceased to exist.[17] Cracow remained the main centre of education, not only for Poland but also for the whole area to the south of the Carpathian mountains. It contributed essentially to the building up of intellectual and personal links between Hungary and Poland.[18] Hungary in its turn had strong connections with Ferrarese humanism in Italy. The most outstanding Latin poet and humanist active in Hungary under Matthias Corvinus was a Croatian named Ivan Česmički (1434–72), famous under his Latin pen-name of Janus Pannonius. He had studied at Guarino Guarini's school in Ferrara and was friendly with Enea Silvio Piccolomini, who at the time of his work in the imperial chancellery at Vienna had become a

friend of Pannonius's uncle János Vitéz, chancellor and primate of Hungary.[19] Contacts and relations of prominent scholars, humanists and statesmen in Hungary indicate a strong interest in Italian cultural developments, of which they became exponents in eastern Europe.

Matthias Corvinus's patronage

Matthias Corvinus, who ruled from 1458 to 1490, was a remarkable personality: violent and autocratic, clever and talented, he knew how to secure the borders of his state not only against the Turks, but also against the Habsburgs. In 1485 he conquered Vienna and incorporated the city into his kingdom. He was to die there five years later. He incorporated not only Moravia but also Silesia into his empire: his triumphal effigy, crowned by angels, a work of Britius Gausske, adorns the gate tower of Ortenburg castle in Bautzen, sixty miles east of Dresden.

But surprisingly this clever diplomat and excellent military leader was above all an enthusiastic lover of illustrated books and an outstanding patron of art and architecture.[20] Of his famous library with about 1,000 volumes, a considerable number for the time, and one of the four biggest in Renaissance Europe, only about 160 manuscripts remain, scattered through several countries (see Plate 1);[21] of his splendid castles and gardens, fountains and villas, described with the highest praise for their beauty and splendour by the Italian chronicler Antonio Bonfini,[22] there survive only a few miserable stones with marvellous Renaissance ornaments. Little evidence remains of Corvinus's patronage, except for the illuminations of his beloved books. But it suffices to look at the splendid pages of the architectural treatises by Alberti and by Filarete (Fig. 4) which belonged to the king (today they are preserved in Olomouc, Modena and Venice) to understand that the man for whom the most recent theoretical writings had been copied must have expected them to be put into practice by his architects, decorators, sculptors and painters.[23] Long before his second marriage in 1476 to Beatrix of Aragon from Naples, Corvinus had had constant relations with Italy and with Italian artists.

From written records we know that he tried to get the best from Italy: he received, ordered or tried to order works of art from Mantegna and Verrocchio, from Benedetto da Maiano and Giovanni Dalmata, from Attavante and Caradosso. We do not know how much he succeeded in getting. But he certainly did succeed in several cases. Both Benedetto da Maiano and Giovanni Dalmata came to Buda, as did Caradosso, and from Attavante Corvinus obtained marvellous illuminated manuscripts (Fig. 5). In 1467 he asked the authorities of Bologna in a letter to be so kind as to send him 'magistrum Aristotelem Fioravantis, architectum et ingignerium communis Bononiae', whose help he needed to build fortifications against the Turks.[24] The famous engineer remained in Buda at least from January to June 1467. Some years later he appears, as we have already seen, at the Russian court in Moscow. If his works in Russia are known, nothing remains of what he did in Buda, although it is recorded that he constructed a bridge over the Danube. We also know that from 1480 on a Florentine architect, Chimenti Camicia, was working for Corvinus, transforming the Gothic castle of Buda into a Renaissance residence.[25] Similar works were going on in Visegrád and Esztergom.

Matthias Corvinus's marriage to Beatrix of Aragon in 1476 made the Italian flavour of the court culture still stronger. Portraits of the king and queen, executed probably by

Gian Cristoforo Romano, show them in profile *all' antica* in white alabaster on a splendid dark-green serpentine background (Budapest, Castle Museum, Figs. 6, 7).[26] Lorenzo the Magnificent presented Corvinus with two reliefs by Verrocchio representing Alexander and Darius, which alluded to the key position of the king between the east and the west and to his role as a defender of the west against the eastern danger. Corvinus was represented as a successful military leader in forms suggesting Mars and Alexander the Great, and as for this last hero, it is recorded by Antonio Bonfini in the biography of the king that he took him as the model for his own life, 'quem semper vitae habuit archetypum'.[27]

The high artistic quality of this court art based on humanistic interests is evident if we look at works which are well preserved, such as the splendid Gothic Calvary transformed on Corvinus's order.[28] Its upper Gothic part, representing the Flagellation of Christ surmounted by a Crucifixion, was set on an elaborate support in late Quattrocento Italian style (Fig. 8). Three crouching sphinx-figures sit around a core decorated with enamels and pearls below the round plate surmounted by acanthus leaves and dolphins. The curved triangular fields connecting with the upper Gothic part are decorated with 'rond-bosse' enamels representing symbolic astral figurations. This masterpiece had long been attributed to the Lombard goldsmith Cristoforo Foppa, called il Caradosso, who is reported to have worked in Hungary for Corvinus, but recently its connections with Florentine art have been stressed. Florentine also is the magnificent tapestry which served as a throne hanging for Corvinus: it must have been connected with one of the Pollaiuolo brothers or their workshop (Fig. 10).[29]

From Verrocchio's workshop, which had produced the Alexander and Darius reliefs, the Hungarian humanist-king ordered a decorative fountain, perhaps as a gift for the Medici, but of that fountain we have no trace. Charles Seymour connects with this commission a graceful putto in the Washington National Gallery of Art.[30] Benedetto da Maiano, of whose activity at Buda we have no tangible evidence, is reported by Vasari to have come to Hungary first of all as an inlay master.[31] It was probably he who introduced that art to the east, where it later became very popular, as we shall see below in the chapter devoted to art in towns.

We have to form our idea of the wealth and splendour of Renaissance art in Hungary from extremely scarce remains. We know that it was not limited to the royal court;[32] all the bishops were patrons: at Szekesfehervár, at Veszprém, at Pécs, but most of all at Esztergom, where, after the humanist János Vitéz, who owned a splendid manuscript of Livy,[33] the young Ippolito d'Este was one of the archbishops.[34] The queen dowager, Beatrix, who retired to Esztergom after Corvinus's death, commissioned for the cathedral an elegant, so-called Apostolic Cross, executed in Bologna after a design by Francesco Francia (Fig. 9),[35] and was perhaps instrumental in the creation of other decorative works there. The relatively well-preserved wall paintings, executed by an artist from Filippino Lippi's circle (Fig. 11), have been attributed by Jolán Balogh to a Master Albertus Florentinus, who is recorded at Esztergom about 1495. They represent allegories of virtues and certainly formed part of a more extensive decorative programme.[36]

In the last years of Corvinus's life a prominent representative of the Renaissance came to Buda: the Dalmatian sculptor Ivan Dukhnović from Trogir, in Italy called Giovanni Dalmata (about 1440–after 1509).[37] Several works of sculpture found in Hungary have been attributed to him, and on stylistic grounds at least one of them may be considered to

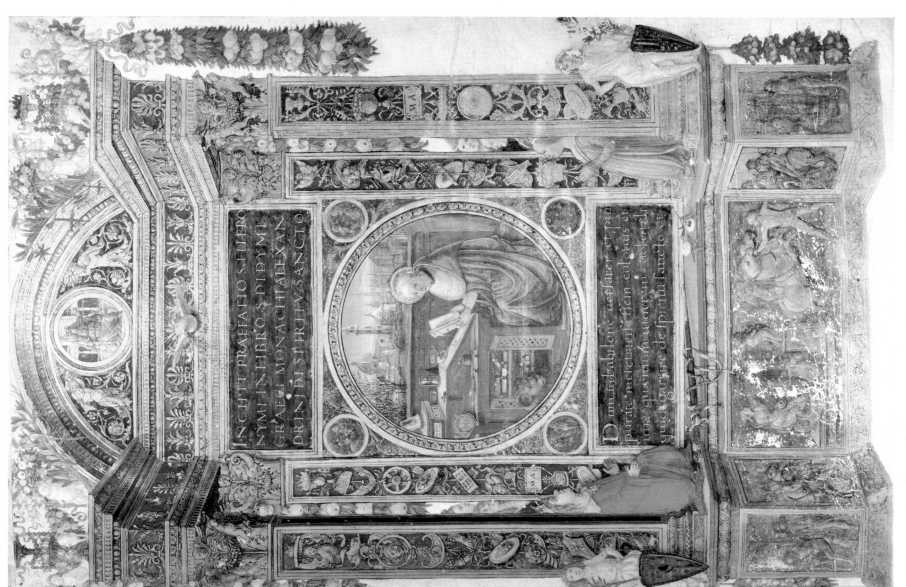

Plate I Gerardo and Monte del Fora: Frontispiece with St Jerome and Matthias Corvinus and Beatrix in adoration in S. *Didimi Alexandrini De Spiritu Sancto et Cyrilli Alexandrini opera . . .*, 1487. New York, Pierpont Morgan Library, MS 496, Fol. 2

be certainly from his hand: the large marble altar found at Diósgyör Castle, one of the most important works of Renaissance sculpture of the Quattrocento in Hungary (Fig. 12).[38] Unfortunately the relief is in a very poor state. It was found in two pieces, the larger one with the lower part of the Virgin and two accompanying figures of saints, which had long been in the Budapest Museum of Fine Arts, and a small, upper part, identified only recently (1959) and connected with the part already known.[39] Between the two pieces there is a gap, which deprives us of the most important elements of the group, the head of the Christ Child and the upper part of the Virgin's figure. Her head is completely ruined, no traces of the face remaining. Even in this deplorable state the relief, which is supposed to have been placed in the Corpus Christi church at Diósgyör, awakes our most vivid interest, because its quality is very high and the style of Ivan Dukhnović is unmistakable. Like the remains of Dalmata's tomb of Paul II in Rome, the Diósgyör relief shows broken folds in crystalline shapes, but it has at the same time a quiet grandeur of monumental design.[40] The loss of the other works that the Dalmatian master made in Hungary is all the more deplorable.

In the first years of the sixteenth century, important Renaissance works were also executed outside Buda. Especially popular must have been the marble tabernacles, of which one survives in the Pécs cathedral, presented by George Szathmáry (Fig. 13), and two in the parish church of the inner city at Pest (Fig. 14).[41] Somewhat later is the so-called Báthory Madonna, a very fine marble relief of 1526 (Fig. 15), whose unknown author was certainly one of the best sculptors working in Hungary.[42] In these works we finally meet fairly well-preserved masterpieces of the Italian Renaissance in Hungary and they help to give us an idea of the original appearance of the architecture and decoration of the Buda Castle.

The first Renaissance works of art in Poland

The Renaissance came to Hungary and to Poland not from northern Italy, as it did to most European countries, but from its very centre: the Pécs and Pest tabernacles show clearly the Florentine style. A few years before they were made, the Polish prince, Sigismund, son of King Kazimierz IV, went to Buda to spend some time at the court of his elder brother, Vladislav, king of Bohemia, who, as we have already learned, succeeded Matthias Corvinus as ruler of Hungary in 1490. Sigismund, being the fifth son of the Polish king and therefore unlikely ever to succeed to the throne, was educated by his tutor, Filippo Buonaccorsi, called Callimachus, an Italian humanist living in Cracow, not as a future sovereign but as a man of artistic and literary culture. An unexpected concatenation of circumstances – one brother became king of Bohemia and Hungary, another was a cardinal, and both remaining brothers, who ruled in Poland one after the other, died early – brought Sigismund to the Polish throne in 1506. This was an event of the utmost importance for Polish culture and for the spread of Italian art in the east.

As a prince Sigismund had spent three years in Buda in the atmosphere of a court full of Corvinian traditions, living in the castle of the great art patron and looking at the art treasures collected by him.[43] That stay must have been a profound experience for the young man, whose humanistic interests had been nourished by Callimachus and who was well prepared to meet in visual form those classical ideas he already knew from literature. Alarmed by the news of the death of his brother Jan Olbracht in 1501, he hurried home,

although not actually hoping to become his successor (his elder brother Alexander, Grand Duke of Lithuania, being the obvious candidate), and arrived in Cracow after Alexander's coronation.

It was natural for Sigismund to take care of artistic matters at the Polish court and it is due to his initiative that a tremendous artistic revolution took place in Cracow in the first years of the sixteenth century. He summoned Italian masters from Hungary and became a patron of the new art, which drew its inspiration from the Florentine Renaissance. Franciscus Florentinus and his workshop created the first works in the new style, beginning with the tomb of the deceased king (Fig. 16).[44] When Sigismund took over the initiative from the hands of his mother, the widowed Queen Elizabeth, the effigy of Jan Olbracht had already been executed. Its author was most probably Jörg Huber, a rather mediocre follower of the greatest Late Gothic sculptor ever to have worked in eastern Europe, Veit Stoss, who had left Cracow in 1496. Huber, who came from Passau, had collaborated with Veit Stoss on the tomb of Kazimierz IV, and must have been regarded by the queen as the artist best qualified to receive a new royal commission for a tomb. His rather awkward, short figure of the king must have struck Sigismund, after he had seen Hungarian monuments, as antiquated in style and inadequate in quality compared with the needs of royal magnificence. Sigismund charged Franciscus Florentinus to insert the Gothic figure in a rich new architectural structure, full of allusions to Roman triumphal glory. The monumental Classical framework encompasses the rather flat effigy with a new splendour.

The Olbracht tomb became a turning-point in stylistic history, and indicates clearly the direction of future developments. It is curious to compare this precocious work of 1502–5 with a somewhat similar tomb in northern France, later only by a few years, where the final solution turned out to be quite different. In 1507–8 Raoul de Lannoy, the French governor of Genoa, ordered a tomb for himself and his wife from the Genoese workshop of Antonio della Porta and Pace Gaggini, where the *tumba* decorated with mourning angels and two recumbent figures was actually carved.[45] The tomb, however, was not put into place before Lannoy died in 1513, and much later, before 1524, Lannoy's widow and son had it installed in Folleville, near Amiens, in a specially constructed chapel, where it was inserted into a rich canopy structure of Late Gothic design (Fig. 17). Its decoration unites Late Gothic and Renaissance motifs, these last already transformed by the local workshop. In France the new Italian element was absorbed, as it were, into the French tradition and the result was an ambiguous, mixed style in which old and new merged, with an obvious predominance of the traditional. In Cracow the Italian arch soars triumphantly over the subdued Gothic.

The artistic language of the Olbracht tomb's arch may easily be connected with Italian works in Hungary, although the surviving comparable material is slightly later. Similarities appear in the most important preserved building of the Hungarian Renaissance – to which we shall turn our attention in the third chapter – the chapel of Cardinal Bakócz at Esztergom, which was built in 1507–8, shortly after the erection of Olbracht's tomb.[46] The pattern of the frieze with cornucopias and rosettes which once adorned the façade of the chapel, and is preserved in fragments in the crypt of the present cathedral (Fig. 20), recurs in the main frieze of the Cracow structure.[47] The candelabra filling out its lesenes are quite similar to those at the Esztergom chapel sacristy as well as to those excavated from the ruins of Corvinus's hunting lodge at Nyék (Fig. 19).[48] The ornaments of the *tabula ansata*

of the inscription on the Olbracht *tumba* (Fig. 16) find a close analogy in one of the pedestals of the pilasters once on the Bakócz chapel façade.[49] These motifs must have belonged to the basic ornamental repertoire of Florentines working in Hungary, the country from which Franciscus Florentinus came to Cracow.

The rather heavy proportions of the structure, the deep niche of the arcade, and the use of double pilasters give the Olbracht tomb – in spite of its Quattrocento ornamental language – an almost High Renaissance character. Its closest analogy in Florence is Benedetto da Rovezzano's tomb of Gonfaloniere Soderini in S. Maria del Carmine, executed as late as about 1509 (Fig. 18).[50] It seems that the Olbracht tomb, finished in 1505, was in some respects quite up to date in relation to Italian development at the time of its creation.

This, then, was a new beginning. The same workshop started to rebuild the royal castle on the Wawel Hill, inaugurating a building process that was to last for more than a quarter of a century.[51]

As in Hungary, the Renaissance style came to Poland as a royal fancy; as in Hungary, its understanding and acceptance were prepared by the intellectual culture of humanism; and as in Hungary, it spread beyond the rulers and their immediate circle. It found eager partisans among the humanistically-minded dignitaries of church and state. I shall name only a few: Jan Łaski, the great chancellor of the Polish kingdom from 1503 and archbishop of Gniezno from 1510, who visited Italy in 1494 and 1500–1 and spent a long time in Rome between 1513 and 1515; the eminent Polish and Latin poet, Bishop Andrzej Krzycki, who undertook to transform in the Renaissance style the venerable Romanesque cathedral in Płock (1532–5); the great chancellor of the Polish kingdom, Krzysztof Szydłowiecki; and finally the excellent Jan Turzo, a humanist-bishop of Wrocław.[52]

Although coming to Hungary and to Poland as a result of the humanistic interests of the most prominent people, the art of the Renaissance found a wide response among large groups of the gentry, and it was accepted by local craftsmen who tried to adjust their traditional skills to new forms and models. In Hungary the Florentine Renaissance was already triumphant at the time when Sigismund came to Buda as a Polish prince; in Poland it was already flourishing in the first half of the next century, when many central European countries first began to yield to the fashionable decorative vogue brought to them by the masters of the Lombard lake district.

To be sure, in Corvinus's time, as in that of Sigismund, Gothic churches, town halls and houses continued to be erected, and still formed the basic artistic landscape. But the development of Late Gothic style in eastern Europe included features somewhat different from those typical in other countries and which were precisely those that made acceptance of the new style from the south easier. It was even possible for certain workshops to switch between the Gothic and the Renaissance vocabulary, and sometimes both kinds of motifs, Gothic and Italian, were fused together.

The architectural development of Late Gothic in Poland was different from the powerful and dynamic character it assumed in south Germany and Austria. 'The most general tendencies of Polish architecture in the fifteenth and sixteenth centuries,' writes Adam Miłobędzki, a specialist in Polish architectural history,[53] 'consisted in introducing regularity into plans, in stressing axes and symmetry in composition, in rejecting the Gothic skeleton structure and in stressing cubic masses, while in elevations discarding vertical articulations

in favour of horizontal ones. All this was not in conflict with the principles of Renaissance architecture.' (Figs. 21, 22).

It seems then that eastern Europe presented a particularly receptive soil for an early transplantation of the Renaissance: both the intellectual preparation of the patrons and the relative lack of dynamic Late Gothic architecture, at least in Poland and Hungary, favoured such a development.

The Late Gothic taste was, however, strong enough to transform new forms as soon as they were taken over by the local masters. Already at the time of the first appearance of Italian models such local transformations may occur. An interesting example is found in the cathedral, formerly the collegiate church, at Tarnów east of Cracow. In about 1520 Jan Tarnowski, a dignitary of the Polish kingdom, erected a tomb there for his mother Barbara from Rožnów, who had died in 1517.[54] We do not know the name of the artist; his work, however, is very symptomatic of the first endeavours to adapt the new style (Fig. 23). First, the Florentine type of tomb is reduced to a shallow composition, all in relief, and the Late Gothic character of form is apparent everywhere: the candelabra are transformed into something like Gothic foliage ornament, the angels, clothed in tunics, hold a violently bent ribbon and a wrinkled piece of parchment. Each element of the composition is a separate entity, they are assembled together, but are not fused into unity. To produce a recumbent effigy of the deceased must have been too difficult for the carver: he used the pattern of a mourning Virgin from Late Gothic Crucifixion groups and placed it horizontally on the sarcophagus, adorned with a grotesque mask. Here the Late Gothic character of form determines the style in spite of the fact that so many elements come from Italian models. Perhaps graphic sources also had their share in the Tarnów tomb,[55] as they certainly did in the southern portal (Fig. 24), executed shortly before, which is obviously based on Dürer's woodcut of the *Marriage of the Virgin*, done about 1504–5 (Fig. 25).[56]

Our history will therefore point out a gradual transformation of Italian models and norms: rationalism, tectonic character and a repertoire of forms conceived according to Renaissance norms yielded to imaginative shapes, to optical painterly effects and to a freedom of invention. The arrival of itinerant artisans from the Lombard lakes, the famous *comaschi*, was an important contribution to such an evolution, since they represented the Renaissance already transformed from its Tuscan ideal into a Lombard version, imbued with Gothic tradition.[57] In many European countries the *comaschi* were the first to bring the Renaissance style. In Poland and Hungary they were late-comers. The centre of Poland remained in Florentine hands and the tradition in Hungary was also Tuscan. This coexistence of two Italian trends of Renaissance art in eastern Europe introduced an extraordinary diversity of forms.

Such was the humanistic background and such were some of the results of the early patronage of art in eastern Europe in the late fifteenth and early sixteenth centuries. This rich and diversified panorama will be examined in the following chapters according to specific social and ideological functions which the new art had to fulfil in the cultural landscape of eastern Europe.

2 The Castle

Matthias Corvinus's castles

FOR CHRONICLERS AND travellers in the late fifteenth and early sixteenth centuries the castle built for Corvinus in Buda seemed to be a marvel. Even if we allow for the usual eulogistic exaggeration, we cannot doubt that the impression of splendour and beauty was overwhelming indeed. Corvinus began to construct a new addition to the old Gothic castle of his predecessors 'in the square space before the courtyard of emperor Sigismund'. Excavations have brought to light traces of this wing, which was situated on the river side (Fig. 26).[1] The chronicler Bonfini tells us that the king had commissioned bronze doors with representations of the works of Hercules, 'admirabiles et non minus a tergo, quam a fronte spectabiles' (wonderful, and no less impressive from the back than the front).[2] From a later writer, Caspar Ursini Velius in his *De Bello Pannonico*, we learn,[3] 'on the side of the river there are to be seen great buildings constructed for the king Matthias, with columns, stairs, and windows done in porphyry stone', and with the battles of the Lapiths wonderfully shown in bronze. These sources inform us that sculptures of Greek and Roman deities were to be seen in the first courtyard, statues of János Hunyadi, the father of the king, as well as of Corvinus himself and his brother László, in the second courtyard, and finally a marble fountain with a bronze figure of Pallas Athene in the third courtyard. Bronze candelabra stood in the staircase of the castle (Fig. 28). Records have it that all these bronze statues were taken to Constantinople by the Turks and were finally melted down in the seventeenth century. Only two candelabra, which were offered to the Hagia Sophia mosque, have been preserved to our day. In Peter Coecke van Aelst's woodcut a small representation of the mythological statues from Buda is shown; from 1526 to 1536, the year when they were sent to the foundry, they were standing between the Theodosius obelisk and the mosque (Fig. 27).[4]

From Vasari we learn about the master, the Florentine architect Chimenti Camicia: 'being in the king of Hungary's service he executed for him palaces, gardens, fountains, churches and several other important buildings, with ornaments, reliefs, decorated floors and other similar things which were supervised with great skill by Baccio Cellini' (an uncle of Benvenuto).[5] In spite of excavations that have brought to light several remains of very high quality, it is no longer possible to imagine the layout and outside shape of the Buda castle. It seems, however, that Corvinus's innovations were mostly in the new Renaissance style of decoration: window frames, pilasters, garden terraces and fountains. A lot of work was done in wood, Camicia having brought several carpenters from Italy. Wooden ceilings certainly introduced regular square coffering with a network of geometrical lines, which helped to stress rational space relationships and provided a place for star ornaments, rosettes and sculptured heads with astrological symbolism, later to be imitated, or independently used, in Cracow.[6] Some outstanding fragments of sculptural decoration have been excavated: friezes with dolphins and dragons, fruit garlands and heroic panoplies (Figs. 31, 32).

Details of the architectural ornamentation point to the early Tuscan Classicism, which developed under the impact of Alberti and which found its finest realization in the ducal palace at Urbino. László Gerevich finds many similarities between the remains of pilasters at Buda and those at Urbino.[7] Jolán Balogh on the other hand points out that capitals found at Buda (Figs. 29, 30, 33), as well as relief-panels and parapets, show stylistic connections with Florence itself; the capitals of Alberti's San Sepolcro in the Cappella Rucellai of

San Pancrazio (Fig. 34) and those of Michelozzo's Palazzo Medici are examples which are very close indeed.[8] Preserved parts of the decoration also include a most interesting ceramic pavement (Fig. 35) as well as stove tiles, some of them with effigies of Matthias Corvinus enthroned (Fig. 37). Towards the end of the king's reign, we recall, an outstanding sculptor came to Buda: Ivan Dukhnović, called Giovanni Dalmata in Italy, a representative of late Quattrocento style.[9] Corvinus liked Dukhnović a great deal and favoured him more than was usual, giving him a country house of considerable importance and – what was perhaps still more important – knighting him.[10] But as for Dalmata's artistic achievements in Buda, we are again left with hypotheses alone.

Some scholars have tried to connect his activity with works in another place that Corvinus liked and enlarged in the new style: the summer residence in Visegrád, some thirty miles up-river from Budapest. There, on the rather steep slope of the mountain, above the Danube, a strange, yet lovely mixture of Renaissance and Gothic forms arose (Fig. 36).[11] The chancellor of Hungary and bishop of Esztergom, Miklós Oláh, living in the second and third quarters of the sixteenth century, described Visegrád's charm in the following words:[12]

This area is square, raised above the large and magnificent wine-vaults for the king's use, well constructed and shaped, paved with uniform square stones; linden trees have been planted there, equidistant from each other, most fragrant in springtime and most pleasant to behold. In the middle of this court there is a fountain, made with wonderful skill in red marble, with carved images of the Muses. From its top the figure of Cupid, who sits on a marble winebag, sprays water, which – not less fast than cold, brought through canals from its source in the nearby mountains – with joyful sound splashes down from the pipes into the marble bowl and from there into the circular pool. Sometimes when King Matthias Corvinus (to whom all these facilities which I describe are due) celebrated a triumph, at his order – as I learned from old people – this fountain would spray wine – once white, once red – which was skilfully poured into the canals above at the foot of the mountain. In that place in spring and summer-time, when the trees were in blossom, the king used to sit in the sun to enjoy the fresh air, to have his meal and often also to receive envoys and give orders.

Of the big area covered by the residence only some parts brought to light by excavations are in such a state as to allow the imagination to reconstruct the original form. Hungarian restorers have even gone so far as to rebuild a part of the Gothic arcaded walk – perhaps built by the Franciscan friar Fra Giovanni – that once surrounded the square courtyard, in the middle of which stood a splendid Hercules fountain (Fig. 39).[13] The figures of Hercules and the Lernaean Hydra, preserved in the local museum (Fig. 40), have great dynamism but are extremely damaged. Of the octagonal structure of the basin three panels are happily preserved. Like most decorative works of Hungarian Renaissance architecture, they are carved in reddish Hungarian marble, which gives them a special character. The preserved panels present elegant, very simple compositions, their only ornaments being the various coats of arms of Corvinus, and fruit garlands and ribbons (Fig. 41). The figures of the Muses, mentioned in Oláh's description, must have belonged to another fountain and have been lost.

The Visegrád *cortile* must have been ready in 1483, since in that year the king, proud of

his villa, showed it to the ambassador of Pope Sixtus IV, who recorded Visegrád as a 'paradiso terrestre'.[14] Whether the attribution of the fountain to Giovanni Dalmata proposed by Meller and others can be maintained is a different problem. Some scholars (for instance, Jolán Balogh) consider another Italian master working in Hungary, the Master of the Marble Madonnas, to be responsible for the Visegrád fountain. There remains in Visegrád a beautiful tympanum of the portal of the royal chapel, with a Virgin and Child, which is attributed to this master (Fig. 38).[15]

Corvinus also built hunting lodges, one of them at Nyék in the neighbourhood of Buda, where extremely finely carved decorative elements have been brought to light by excavations (Figs. 19, 54).[16] In Nyék carvings were also found with markings by local Hungarian stonecutters, who must have already adopted the Italian style. The king was imitated by his chancellors, officials and bishops, and this growing wave of the Renaissance continued after his death under the new king Vladislav Jagellon. In the first quarter of the sixteenth century Hungary already abounded in Renaissance residences.[17] They have largely disappeared, but that extraordinary flourishing of the Hungarian Renaissance had already begun to leave important traces of its influence abroad in the last decade of the Quattrocento. This influence seems to be directly connected with the fact that the new king came to Buda from Prague and united in his hands the two kingdoms.

The castle in Prague under Vladislav II

In order to meet the wishes of the Hungarian nobles, Vladislav soon decided to set up his residence not in Prague but in Buda, a splendid capital with an *aula marmorea*, the construction of which was not yet complete, but which, compared with Charles IV's structures in Prague, must have looked like a different, new, and splendid world. Nevertheless he did not want to neglect his old kingdom. On the contrary, he wanted to show his new splendour and magnificence to the powerful Czech lords by erecting in Prague a most magnificent addition to the castle. He also wanted this new addition to be not only as splendid as were the buildings of Corvinus in Buda, but to include the new Italian forms as well – forms symbolic of the new style of ruling and perhaps by their Italian character stressing the Roman Catholic orthodoxy of the king against the Utraquist heresy current in Bohemia.

To realize these intentions Vladislav commissioned his architect, one of the most prominent masters of Late Gothic architecture, Benedict Ried, to come to Buda, to study the Italian structures erected in Hungary and to transplant their style to Prague. In this way in the early nineties of the fifteenth century Renaissance shapes reached the second east European royal residence, that of Prague.[18]

Ried was too talented and original a master to surrender to the new fashion unconditionally and to become a mere imitator of Italian ornaments. His work in Prague at the turn of the century constitutes one of the most interesting and ingenious achievements of that time, in which the most advanced elements and attitudes of Late Gothic were organically fused with the new ornamental vocabulary of the Italian Renaissance.

The first step in Ried's activity, in the years 1493–1502, was to transform the upper part of the old palace of Charles IV into the largest secular hall of the late Middle Ages (Fig. 42). It was designed to create a space for tournaments in which, it is recorded, more than a hundred riders sometimes participated. This raised, of course, tremendous problems from

a purely technical point of view. Although the first attempt at vaulting was not successful, Ried overcame all difficulties and created an interior which had no equal in the Europe of his time: a spacious, rectangular hall, crowned by a vault supported and organized by curved, elastically bent ribs, whose design impressed beholders with a feeling of mobility and dynamism.[19] With Late Gothic means Ried achieved, indoors, a balanced and harmonious composition of space, imbued with life expressed by the flowing rib design. At the same time, he gave a Renaissance imprint to the exterior. The flat walls of that immense hall, with buttresses drawn inside, are opened by double windows, framed on the northern side by fluted pilasters (Fig. 43) and on the south by half-columns (Fig. 44). The entablature of one window on the northern side bears the date 1493. For a long time this seemed impossible to accept, but the capitals of these columns and pilasters, when compared with Hungarian Renaissance architecture, show such great similarities that any doubts about their origin and possible dating may be forgotten.[20] It is true that, if we compare the capitals of the Albertian Holy Sepulchre (Fig. 34) with those of the Buda castle (Figs. 29, 30, 33), the difference is small – Tuscan professional stonecutters must have worked at Buda – but a comparison of the Buda capitals with those in Ried's Prague windows (Fig. 45) shows that Italian models have been transformed by the Czech stonecutters: they are simplified, they are less fluently modelled, sometimes they show a lack of understanding of the original forms – for instance, volutes of the capitals are transformed into ornamental rosettes.[21]

Renaissance ornamental vocabulary was also used by Ried inside the hall. Although the windows inside are not framed in Renaissance style, the portals show Italian forms. It is striking to see the way in which Benedict Ried used these new forms. First he reduced them to essentials, stripping them of all detail, keeping only the main elements of the Renaissance portal structure. But then he handled these elements in the same way that he had handled the Gothic ones. The large portal leading from the Vladislav Hall into the old Parliament room, erected about 1500 (Fig. 46), is a powerful structure crowned by a round pediment. Its heavy entablature, devoid of any detail, is supported by fluted pilasters bent around their vertical axes, so that the side of the pilaster at the base turns out to be its front at the capital. Deeper in the wall opening, another pair, this time of columns, support another, recessed, architrave. But the fluted shafts of columns make spirals, which gives them a dynamism similar to that which characterizes the outside pilasters, and also similar to that of the curvilinear vaulting-ribs above. This powerful energy arising from the centre of the portal is an excellent visual support for its oversize crowning tympanum and proves Ried's independent ability to handle the new forms freely according to his needs and to Late Gothic feeling.

Similar unorthodox treatment of Classical forms appears in the huge triple window of the east wall, disfigured in 1598 by the addition of a new portal by Giovanni Gargioli and by the new structure of the chapel (Fig. 47). The upper windows are separated by obliquely placed double pilasters, while the whole composition is framed in the lower part by spiral columns – a kind of connecting link between the Gothic and the Baroque.

To provide access for the riders taking part in tournaments, Ried built a 'riders' staircase', a marvel of Late Gothic vaulting virtuosity. The portal leading from outside to this staircase, built shortly after 1500 and considerably restored, represents perhaps the most Classical, restrained composition at the Hradčany castle (Fig. 48). But the other portal,

inside, is a *tour de force*, connecting in one work elements of both styles Ried was able to use (Fig. 49). The outside frame is made up of two fluted composite columns, partly incorporated into the wall but strongly plastic, which support the architrave. Inside this frame is inscribed an ogee arch, which includes another complicated Late Gothic arch. The Gothic motifs are here handled in a way which assimilates them to the Renaissance ones, which dominate. They lack the seemingly weightless fluidity of Late Gothic and adopt the material sturdiness typical of Ried's interpretation of Classical forms.

Immediately after the completion of the splendid Vladislav Hall the king gave orders to begin next on an addition to the Hradčany castle, which was later named after Vladislav's young son Ludvík (1506–26), an unhappy monarch who was to die in 1526 in the Battle of Mohács at the age of twenty. This 'Ludvík-wing' was begun in 1500 or 1501 and completed before 1510 (Fig. 50).[22] Its outside is like the so-called tower-castle type, narrow and tall, not at all Renaissance in shape, but its windows, framed in dignified, simple forms, and surmounted by cornices, give the building a calm, regular rhythm. The windows are cross-shaped and double on the eastern and western sides, whereas in the relatively narrow south wall triple windows are used. In the rooms of this wing Late Gothic vaults again occur, but the large room of the imperial chancellery has a horizontal beam-roof without any trace of Gothic forms.

The interior portal of the Bohemian chancellery, situated on the lower floor, with intricate net-vaulting, bears the date 1509 and represents one of the purest versions of Classicism to be met with among Ried's works (Fig. 51). It is similar to the contemporary architectural ornaments in Hungary, those in the Bakócz chapel at Esztergom.[23] Ried's Renaissance style reappears some ten years later in the harmonious southern portal of the old Romanesque church of St George in Prague (about 1520, Fig. 51a). Fluted Corinthian columns support a simple pediment. The wall recedes inside towards a second, smaller portal. Here the two columns support a semicircular tympanum with the relief of St George fighting the dragon. An obliquely placed wall above is composed of coffers with rosettes. It is not only a harmonious but also a highly imaginative work.

After the death of Corvinus in 1490, the Buda, Visegrád and Esztergom workshops had continued to work and they remained an important centre for Italianate art at least until the disaster of Mohács. They certainly lost the initial impact they had had under the great royal patron and, since Vladislav insisted on bringing the Prague residence up to the splendour of Buda, it is not impossible that some Italians went to Prague. This would explain the character of such works as the portal of the Bohemian chancellery. But in Prague the Italians had to work under the leadership of a northerner who was careful to fuse both styles into one whole or to use them at will according to the occasion. Ried was very highly appreciated by the king and received from him the greatest possible honour: like Giovanni Dalmata in Hungary, he was knighted. This probably took place in 1502 after the Vladislav Hall was finished and during Vladislav's visit to Prague.[24] While Dalmata was not the first Italian artist to be so highly honoured, for the history of the social position of artists in the east Ried's promotion to the nobility was a most important event. In Italy such things had already happened in the fifteenth century, but in the north and east this was a new departure, and one which almost symbolically marks the beginning of a new century, and of a new epoch in the history of art as well.

The Wawel castle in Cracow: architecture

The same year, 1502, was significant for the spread of the Renaissance to the third east European royal residence – Cracow. We remember that after the death of his elder brother, Jan Olbracht, in 1501, Sigismund Jagellon left the court at Buda, where he had been living for some years, and returned to Poland, his mind full of the impressions he had received in Hungary. Franciscus Italus, or Florentinus, who appears in Cracow records from that time on (15 February 1502) and who died in 1516, started to work on the Wawel Hill in Cracow, and the decoration of the late king's tomb was only his first, rather limited commission. His principal work was to be the erection of the new residence (Figs. II, III).[25] As in Vladislav's Prague and in Corvinus's Buda, the new buildings in Cracow were always made according to the medieval functionalist tradition. According to need, either separate units were erected and added to existing parts of the castle, or these existing buildings were transformed to receive a new shape or a new function or both. Just as Vladislav ordered the old castle of the Luxemburg kings to be transformed, so Sigismund erected his new buildings instead of, or transforming, the old structures. The construction of what is known as the Wawel castle of Polish kings in Cracow was done in sections, each addition being a separate unit, and only at some point during the progress of the work did the ingenious and fashionable idea of an arcaded courtyard help to put a unifying curtain around the rectangle of individually conceived units.[26]

The first work was done in the western wing (1502–7), which was the house built for the widowed queen, Elizabeth, after the Gothic structure of the castle had been ruined by fire in 1499 (Fig. 52). The Queen's House was conceived as a rectangular, separate house three floors high, each floor containing few rooms, one behind the other, in the tradition of Late Gothic castles. However, Franciscus Florentinus introduced some Renaissance elements in the window frames and doors. We know only a few of them: during later building and in the subsequent history of the castle and its restorations several early elements were lost. What is preserved is an oriel (Fig. 55) – not precisely a Renaissance form – which once projected from the outside wall of the Queen's House, and since the construction of the arcades has faced the arcaded gallery of the third floor. The oriel has a large triple window with framing pilasters decorated with panoplies and plant ornaments, a lintel with coats of arms and a quite elaborate cornice with modillions. The window next to the oriel has unfortunately been heavily restored, and its forms, although copied after damaged parts, cannot serve as evidence in stylistic considerations.

In any event the preserved original elements include striking similarities to Hungarian works. László Gerevich has studied these relationships and has compared the thin, subtle tendril ornament of the window-framing pilasters, known from an original but damaged part preserved in the Wawel collection (Fig. 53), to similar tendril patterns known in the panels which once decorated the front of the Bakócz chapel in Esztergom, in the scarce remains of the Nyék hunting lodge (Fig. 54) found during excavations, and in details of the Szathmáry tabernacle in the cathedral of Pécs (Fig. 13).[27] The panoplies, ribbons and garlands adorning the frieze and the pilasters of the oriel recur in the Jan Olbracht tomb in the nearby Wawel cathedral done by the same workshop (Fig. 16), as well as in several works of the Hungarian Renaissance, such as tomb reliefs by Joannes Fiorentinus (Figs. 125–8) or the marble panels that once enclosed the Visegrád fountain basin (Fig. 41).[28] It does not seem possible to attribute to definite artists the different style characteristics in the

earliest Wawel carvings; we know the names of a few Italian and Slovak stonecutters who came to Cracow, but we are not able to connect them with the various styles.[29] And they continued to come. The prince-patron Sigismund, after he initiated the works, went again to Buda in 1502 and in 1505. In 1502 he is reported to have bought architectural drawings from an Italian in Buda for half a gulden.[30] In 1507 and again in 1510 and 1511 new workmen were brought from Hungary to Cracow.[31]

In spite of the active art patronage of Hungarian lords, the lack of any large-scale commission from the royal court after Corvinus's death may also have contributed to this exodus of Florentine artists from Buda to Cracow.

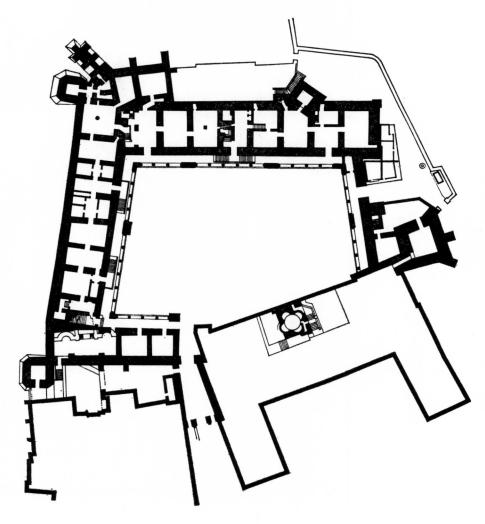

Fig. II Plan of the ground floor of the royal castle on the Wawel Hill, Cracow

After Sigismund became king in 1506, the construction of the castle was continued in the Polish capital and the next wing – the northern – was begun in 1507 (Fig. 56). Franciscus Florentinus directed the work until his death in 1516; it was continued from 1524 (or from 1521) to 1529 under Master Benedikt, an architect of German extraction who probably came from Slovakia, and from 1530 again by the excellent Florentine Bartolommeo

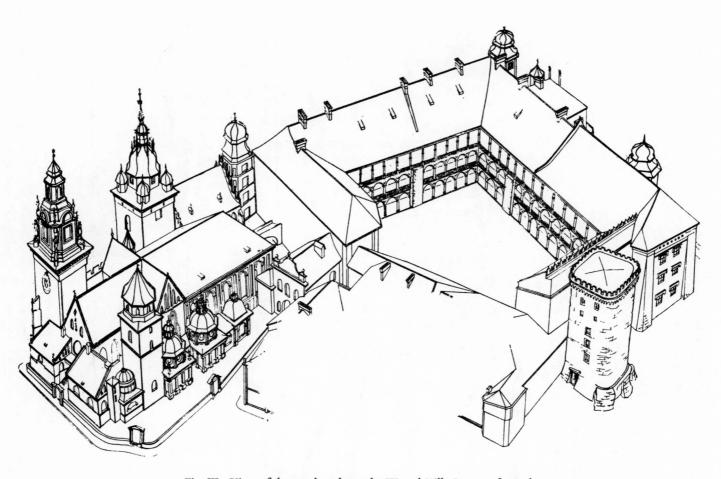

Fig. III View of the royal castle on the Wawel Hill, Cracow, from above

Berrecci until his death in 1537 (Fig. 57). By that time the castle was finished, with its purely decorative curtain wall closing the courtyard from the south.[32]

It has not been established at what precise moment the suite of buildings, growing more or less freely, was organized into a harmonious whole by the addition of three levels of colonnades in front of the castle walls. It must have been after 1507, when the west wing was finished; and in a written record describing the royal wedding of 1518 the arcades are already mentioned.[33] It is usually assumed that it was Franciscus Florentinus who devised the project, although it was only partly executed by him and continued by his followers. Capitals and other details of construction and decoration vary. To complicate the situation still more, in 1536 the castle, only recently completed, was partly burned and the east and south wings were seriously damaged. Berrecci began the restoration, which after his death was continued until the middle of the century by Nicolo Castiglione and Matteo the Italian.[34] Several parts were later rebuilt and a detailed reconstruction of the progress of the project is difficult. In any case the introduction of the arcaded courtyard was a decisive factor in transforming a sum of separate elements into an artistically organized whole. The interiors of the buildings were separated from each other, forming small apartments accessible by separate staircases. This individualistic treatment of each segment is visible in the way the windows are grouped. On the courtyard side the arcades give unity to the façades, whereas outside the irregular growth of the interior is clearly reflected in the irregular grouping of windows (Fig. 58).

The arcaded courtyard, while quite common in Italy, was rare in the north; it is found, however, in a few castles – such as that of the bishops of Warmia at Lidzbark (Heilsberg) – in cloisters and in college quadrangles. In Cracow there existed a recent example of such an arcaded quadrangle in the new building of the university, the Collegium Maius, built in 1492–7 by a workshop of Saxon origin (redone in 1518–40), but perhaps with some knowledge of Italian examples (Fig. 22).[35] As far as Renaissance castles are concerned, the arcaded courtyard at Wawel is the earliest surviving example outside Italy. It is known that the castle of Buda already had arcaded courtyards in the fourteenth century, as well as in parts built in the Renaissance. There were also colonnades at the front façade.[36] It is therefore quite possible that this motif, like so many other Renaissance innovations, came to Cracow from Hungary. But its character is very specific.

The size of the courtyard as well as the very considerable height of the upper floor and the structure of the roof were certainly factors which influenced the artist's solution. What he proposed was well rooted in Italian tradition but at the same time highly original. Neither a prototype nor a true imitation of the Wawel courtyard is known. The cloister of the Badia at Fiesole and the loggia of the Piccolomini Palace at Pienza have been mentioned as similar in the combination of arcades on the lower floors with columns or pilasters on the upper floor.[37] One could perhaps think of the quite recent Cortile di San Damaso (Fig. 59) built by Bramante in the Vatican,[38] were it not for the fact that its two lower floors are organized by pillars flanked by half-columns, from which the arches spring, and not by columns as in Cracow. Nevertheless that famous Vatican cortile has some similarity as far as the specific proportion of the slender upper floor in Cracow is concerned. The Wawel upper floor columns are so much oversize that it was felt necessary by their inventor to divide them in two by placing a ring in the middle. This very tall support is perceived not so much as one divided column but as two combined, each having its own

entasis: the lower one ends in the crown-like ring, the upper has an Ionic capital, on which a kind of jar is placed, and this constitutes the actual support of the roof-beams (Fig. 64). The roof protrudes strongly and the overhanging ceiling is coffered with rosettes.

The galleries of the courtyard are proportionally differentiated. Attempts have been made to find harmonic proportions in them, but a definite reading is difficult because of changes in the level of the ground floor, which must once have been considerably lower than it is now.[39] A strange motif in the courtyard is the massive buttresses situated at irregular intervals, whose height does not exceed the second gallery floor. Their purpose must be sought in the building process, since their function can hardly be aesthetic nor can it be claimed that they are needed to support the light upper gallery. Probably they were used as limiting elements of the building segments during construction. They introduce a disturbing element as do the small incongruencies of rhythm, irregularities in the spacing of columns and other details.[40]

These defects notwithstanding, the Wawel courtyard with its general regularity and spaciousness, its unexpected size and its steep, tall upper floor has a majestic character and seems perfect at first sight. It was perhaps less Classical in appearance when painted in strong colours, with dark-red column shafts, which corresponded to the light red of the floor made of ground brick. What must also have been quite 'un-Italian' in effect was a steep roof covered with patterned tiles in colours such as yellow and green. This was certainly a contribution of local taste, and more of it would have been found inside.[41]

The most striking thing in the interior decoration of the castle is the stone-carved portals, which were also originally painted in bright colours. They represent a special type and are so numerous that they are usually referred to as the Wawel-type portals. They are an exciting product of the coexistence of the Gothic tradition with Renaissance motifs, united in a quite organic way.[42] The main part of the portal, the jambs and the lintel, are built up of Late Gothic thin stone-shafts running into each other, penetrating and crossing. A Renaissance cornice was added to these structures in the first portals of this type, which must have been done between 1507 and 1516 (Fig. 60). They are adorned with some typical ornamental motifs such as egg and dart moulding and dentils.[43] Later, in the second stage of the development of this type in the twenties (1523–9), these portals grew in plastic volume and complexity (Fig. 61).[44] The Late Gothic motifs remain, but they receive more 'tactile' and not so much 'optical' treatment. The cornices become more and more rich, heavy and complicated. Sometimes Late Gothic 'Astwerk' – naturalistically represented dry branches – penetrates into them, but on the other hand Renaissance motifs appear on the jambs or the outside frames of some doors: small circles and rods with winding ribbons. In this way a unique mixture of two styles was achieved: in the small tympana delimited by Gothic arches we find fantastic images in which medieval imagination merges with Renaissance mythological associations. These tympana also seem to reflect quite different, transformations of Classical shells.[45] Sometimes they include radiating half-rosettes, like geometrical Romanesque, traditions.[45] Sometimes they include radiating half-rosettes, like geometrical transformations of Classical shells.[46] In one portal winged angels' heads are placed in the spandrels according to Italian usage.[47] Ornaments in cornices multiply and grow in size. Sometimes Latin phrases, such as *tendit in ardua virtus* and the like, appear in the upper panels of the lintels below the cornice.[48] In some cases bigger decorative structures in this style were created, as on the ground floor of the eastern wing on the courtyard side, where a square window with similar framing is located above the portal (Fig. 63).[49]

These portals make it obvious that an important share in the decoration of the Wawel castle must be credited to other than Italian masters. The name of the most prominent one is known. Master Benedikt, whom we have already mentioned as the supervisor of the castle construction in the years 1524–9, is described in a document as *almanus* and it is probable that he came from Slovakia, at that time a northern province of the Hungarian kingdom.[50] Traces of his work are found earlier in Piotrków – a town situated in central Poland some hundred miles to the north-west of Cracow – where he built a castle for the king from 1511–19.[51] In this work, now reduced to a disfigured torso, portals and windows of a type similar to those of Wawel were still preserved in the nineteenth century (Fig. 62). They originated in the following years, around 1520–35, and may already have been influenced by those in Cracow.[52] The castle built by Benedikt in Piotrków, whose more or less original shape is known from an early nineteenth-century drawing (Fig. 65) and an 1869 photograph, may have been an imitation of the 'Ludvík-wing', in Prague, built by Ried (Fig. 50).[53] The role of Master Benedikt in Poland seems to have been similar to that of Ried in Bohemia, in spite of his less outstanding talent, for he, too, occupied a transitional position between two styles and periods. Benedikt probably came into contact with Italian masters who worked in several centres in Slovakia, for instance in Bardejov, where quite correct Renaissance portals were built in the Gothic Town Hall in 1507–9 by Master Alexius (Figs. 218, 220).[54]

Portals of the Wawel type are also known outside the royal castles built by Benedikt, in some Cracow houses and convents.[55] They also appear in southern Poland in Tarnów,[56] and in Bohemia, for instance in the castle at Pardubice (Fig. 66), dating from the thirties of the sixteenth century (the wall painting is obviously later),[57] and in the mountain church at Jaroměř, of around 1540 (Fig. 67).[58] There are similar forms in Slovakia too. Perhaps the most unusual composition in this specific manner is a musical choir balustrade in a chapel of the Church of Our Lady in Cracow, where the Late Gothic tracery is topped by the Renaissance cornice in a quite imaginative way (Fig. 68).[59]

The fact that Master Benedikt most probably came from north Hungarian Slovakia (as did some of the stonecutters working at the Wawel castle), might suggest that this specific type of portal originated in Hungary, where the Late Gothic workshops first made contact with the Renaissance masters coming from Italy. But the evidence left among Hungarian, Czech and Slovak monuments is rather scanty and widely scattered, while in the castle at Cracow examples are not only extremely numerous but also clearly show an evolution. It seems, therefore, that it was the specific milieu of architects and sculptors in the *fabrica* of the Cracow castle, where Hungarians, Italians, Germans, Lithuanians and Poles worked side by side, that produced this most original type of portal: a Cracow contribution to the peaceful coexistence of north and south in the sixteenth century.

The Wawel castle in Cracow: decoration

The Wawel castle is the only one of the large royal residences built at that time in eastern Europe in which the interior decoration is at least partly preserved. Not only portals but also wall paintings inside and outside and splendid wooden ceilings, one of them most unusual, make the Cracow castle a complete princely residence, which was still further enriched later in the second half of the sixteenth century by a unique set of figural and ornamental tapestries commissioned in Flanders.[60]

The wall paintings of the Wawel castle belong to the Renaissance both iconographically and formally. On the outside they decorate the upper parts of the walls of the third floor, which in Cracow – in contrast to Italy – was the most important, serving for state affairs and other official business. In these wall paintings of 1536 there are medallions of late Roman emperors and empresses, surrounded by ornaments and set in an illusionistically conceived architecture with round windows (Fig. 69).[61] Everything is depicted *all'antica*, and decorations of similar character are also to be found inside. In King Sigismund's bedroom and anteroom the painted friezes include medallions, plant ornaments, hanging garlands, vases and flowers. These paintings were done before 1530. In King Sigismund's bedroom and anteroom the painted friezes include medallions, plant ornaments, hanging garlands, vases and flowers. These paintings were done before 1530. In 1532 another frieze was painted in the splendid room of the Deputies: it illustrates the allegorical *Tabula Cebetis*, a moralizing story of human life attributed to a Greek philosopher Kebes (Fig. 70). In two other rooms military parades and chivalrous tournaments were depicted about 1535 (Fig. 71). It is typical of the Cracow Renaissance that all these decorations were painted not by Italian but by German or local artists. In the field of painting commissions were always given to German centres. We know from documents that the *Tabula Cebetis* was painted by Hans Dürer, Albrecht's brother, who came to Cracow in 1527.[62] It is not unlikely that some of the other decorations with medallions and garlands are due to his obviously not very distinguished talent.

The parade of the army before the king was painted by an otherwise unknown Silesian master, Antoni from Wrocław, who came to Cracow after Hans Dürer's death in 1534. He also finished the tournament frescoes begun by Dürer.[63] The outside paintings, perhaps the most interesting, because of their marked Roman spirit, were executed in 1536 by Dionizy Stuba, a master whose origin and nationality are not known to us.[64] All these frescoes were white-washed by the Austrian authorities after the partitions of Poland, in the early nineteenth century, and were only cleaned in the first years of our century. Very much damaged, they were restored in the twenties and later.

The Room of the Deputies, where Hans Dürer depicted the allegory of human life, was once the most originally decorated interior. Its coffered ceiling had rosettes, coats of arms of Poland, Lithuania and the Sforza family – Bona Sforza having married the king in 1518 – and a very unusual series of 194 human heads carved in wood and looking down at the beholder (Fig. 72).[65] Like the whole castle, this room and its ceiling suffered very heavily under Austrian rule. By the early eighteenth century twenty-five heads were already missing; around 1800 the heads were dismantled and dispersed, mostly brought to the Laxenburg palace of the Habsburgs in the neighbourhood of Vienna. Between 1804 and 1807 the coffered ceiling was torn down by J. Markl, who adapted the castle to its new function – as barracks for the Austrian occupation army. The ceiling was reconstructed only in the 1920s, and the thirty heads which survived out of the original 194 were placed in the coffers. According to the documents published since that time, the original form of the ceiling was more complicated than the present reconstruction: eighty-eight coffers are supposed to have been deep, round and octagonal, and the other eighty-eight shallow, and cruciform. Mrs Bocheńska, who made a special study of the ceiling, presented a tentative reconstruction of its original form in which heads are situated in deep octagonal coffers while rosettes fill up the shallow fields (Fig. 73). But her solution may not be the last word on that question.

The Wawel heads have no known analogies in sixteenth-century art. Although reduced

to less than one-sixth of their original number, they present an admirable variety of characters, social, psychological and professional, and show a rare balance of realism and generalization: a gallery of Renaissance personages in allegorical roles (Figs. 76–9). They looked down from the splendid ceiling above the frescoes of the *Tabula Cebetis*. It is supposed that their symbolism was connected with the classical moral-allegorical current in northern humanism. But a precise iconographical analysis and reconstruction of the original programme does not seem possible, since the surviving heads make up too small a fraction of the original set.[66]

The work is attributed to the royal *laquearius* Sebastian Tauerbach, born in Lusatia (Lausitz), who came to Cracow from Silesia and signed the contract for the work on the last day of January 1535. But it is assumed that he must have had collaborators, one of them being identified as Hans Schnitzer, perhaps identical with Joannes Janda.[67] Tauerbach and his helpers, representatives of Germanic art of the early sixteenth century, united Late Gothic realism with a Renaissance sense of dignity and heroism, and brought to the execution of the heads a strong feeling for reality and individual characterization. But the idea itself must have come from the south. The only prototype pointed out so far is the coffered vault on the first floor of Alphonso I's triumphal arch in Castelnuovo at Naples, executed about 1465.[68] In the rather shallow coffers of that vault several angels' heads are represented, while in other coffers there are rosettes (Fig. 74). Since Bona Sforza, the Polish queen from 1518 onward, had spent some years of her youth at Naples, it was supposed that she could be credited with a share in the unusual idea of the Cracow heads. But Bona did not show any special interest in the arts and one could suggest other sources for that invention. Mrs Bocheńska has already pointed out that a Roman example of a coffered vault with heads is known: in the former Temple of Jupiter in Split, transformed in the Middle Ages into a baptistery (Fig. 75). It is not impossible that this particular vault was known to Laurana, the architect of the Naples arch, although one may suppose that similar Roman structures were known to Renaissance artists. There was such an ancient town gate in Perugia, with heads looking down from the vault.

Perhaps it is not necessary to consider the Naples vault a direct prototype for the Wawel heads, since we can infer from descriptions that closer models, namely coffered ceilings, and not vaults, with human heads existed in the castle of Corvinus at Buda (where collaborators of Laurana from Naples were perhaps employed).[69] This would be another case of the important role played by Hungary in the transmission of Renaissance motifs from Italy to Poland. After all, Croatia and a part of the Dalmatian coast belonged to the kingdom of Corvinus and it is not impossible that the Split vault was known to the masters at work in Buda.

Be that as it may, the manner in which this Classical idea was transformed on the Cracow ceiling points to the north European style. Tauerbach came from Silesia; the painter who painted the heads came from the Silesian town of Nysa (Neisse), and Antoni, author of the wall paintings in the castle, was from Wrocław. Silesia had been dependent on the Czech kingdom from the fourteenth century, but it maintained strong links with the Polish capital. King Sigismund, before he became the Polish monarch, was Duke of Głogów (Glogau) in Silesia. There were several family connections between Poland and that province of the Czech kingdom – one important family were the Turzo, with branches in Slovakia, Cracow and Wrocław.[70] At that time Silesia received Renaissance ideas from many sides, from Bohemia, Saxony, but also from Cracow.[71]

The castle in Brzeg, Silesia

The direct impact of the Wawel courtyard can be seen only in one building: the castle of the dukes of the Silesian branch of the old Polish Piast dynasty at Brzeg (Brieg), some thirty miles south-east of Wrocław.[72] Frederick II, Duke of Legnica (Liegnitz) and Brzeg, started the modernization of the damaged old Gothic castle in the early thirties of the sixteenth century, first perhaps using the workshop of Georg von Amberg, who came from Saxony. There are some portals preserved inside, executed in 1536, which show an extremely superficial and naïve use of Italian motifs (Figs. 80, 81); they already appear transformed as a result of a long and indirect route through central Germany. To the same workshop is due the quite monumental but also only very roughly Italianized castle gate at Legnica of 1533 (Fig. 82).[73]

Around 1544 Italians came to Brzeg, but they came neither from Buda nor from Cracow. They were not Florentines but Lombards, and belonged to the strong and from that time uninterrupted flow of stonecutters and builders from the Lugano and Como lake district which was to bring vital powers to east European art until the eighteenth century.[74]

The Renaissance style the Lombards brought to Silesia was certainly not so rough and uncultivated as the manner of the German workshops working there earlier in that century, but it was also far from the elegance and refinement of the architects who built the Buda and Cracow castles. Nevertheless the young Duke George II, who was the patron of the work after Frederick II died in 1547, must have had a very clear idea of how he wanted his castle to look. The close relations with the court in Cracow and a political bias in favour of Poland and against the Habsburg empire may also have played a role in the decision to transform the Brzeg castle into a replica of Wawel. It would probably be too much to say that it was a replica of the Cracow castle, and we are unfortunately left only with guesses as to the original shape of the courtyard, finished by 1560 and reduced to ashes by the cannons of Frederick II of Prussia in 1741. After that disaster only a few arcades of the ground floor could be reconstructed in plaster casts, but those remains and old descriptions leave no doubt that the courtyard was splendid: Brzeg was ranked among the most famous castles and brought great renown to the Italian architects of the Parr or Parrio family, Jacopo and Francesco Parr, who had directed the work.[75] As in the castle in Cracow, buildings enclosed the courtyard only on three sides, the fourth side being a decorative curtain wall, but the character of the arcades was different. As in Cracow, images of Roman emperors were used in the decoration of the courtyard, but they were – as in Lombardy or France – reliefs and not paintings (Fig. 83). Of the old splendour of the courtyard and the polychromed interiors nothing is left.[76] Nevertheless what is preserved of the Brzeg castle is remarkable.

The gatehouse (Fig. 84) with three floors and three bays, with an asymmetrical gateway and a narrow passage, organized according to a triumphal arch scheme, is covered with sculpture and reliefs in a way which recalls Lombard examples, the best known being the Certosa of Pavia.[77] Life-size standing figures of Duke George II and his wife Barbara of Brandenburg with their coats of arms dominate the dense pattern of vertical ornamented pilasters and entablatures which frame the windows. Between the second and the third floors a unique gallery of twenty-four rulers of the Piast dynasty is represented in half-length figures, expressing the pride of the duke looking back to the splendour of his ancestors (Fig. 85).

The idea of these princely portraits originated perhaps in such representations as the medallions of Frederick II and his wife at the Legnica castle gatehouse (Fig. 82) and of Frederick II and his duchess on the façade of the castle at Chojnów (1546–57), done probably by the same Parr workshop (Fig. 86).[78] For the idea of the gallery of ancestors in half-length, models may be found in the woodcuts of the World Chronicle of Hartman Schedel (1497) or in the triumphal arch of Maximilian I (1513), while the actual effigies were mostly inspired by the woodcuts illustrating the *Chronica Polonorum* by Maciej Miechowita, published in Cracow in 1519.[79] Designed probably by an Italian – most probably Francesco Parr – the sculptures were done by several local sculptors, among whom the only one identifiable is Andreas Walther I.[80] The luxuriant decoration of the pilasters is based on current motifs of plant and grotesque ornaments (in some cases it goes back to prints by Agostino Musi), but it also includes some figural representations, such as the allegorical figure of water (Fig. 87), based on a print after Rosso's *Thetis*, or the Lucretia, based on the engraving from the same series of mythological deities.[81] The French element in this decoration is stressed by one of its interpreters.[82]

If at the Wawel castle the Italian Renaissance appeared first of all in purely architectural forms of Tuscan origin, restrained and dignified, at Brzeg a dynamic, sculptural decoration came to the fore. But its plastic character was not stressed and, when seen from some distance, it appears almost flat, while the architectural shape – although its surface seems to vibrate – remains a cubic block.

The arcades of the Silesian castle are gone, and what remains shows only more strongly the different feeling of form brought to the east by the Lombard artists. The future belonged to them, and the Parr family was to make a splendid career from Mecklenburg, where Francesco Parr with the collaboration of his brother modernized the castle at Güstrow (1558–65; courtyard finished in 1566 by Hans Strol) and where J. B. Parr worked in Schwerin (1560–3), to Sweden, where the Parrs built castles at Uppsala, Stockholm and elsewhere.[83]

Brzeg became an important centre of north Italian art, and by 1560 it had one of the most numerous colonies of Italian artists in Europe. It was there that the two waves – the Tuscan coming from Hungary and Poland, the Lombard coming through Austria and Germany – clashed. The remains of the Brzeg castle are a kind of symbolic monument to the victory of the Lombards, who spoke a language much closer to the local traditions and whose art could easily be adopted by the east European craftsmen.

Old chapels decorated in Renaissance style

ITALIAN CHURCHES IN the late Middle Ages included rectangular chapels, founded and furnished either by guilds or by private families and individuals. Many such chapels were redecorated in the Early Renaissance. This was, of course, the simplest way to give a modern splendour to the old architectural form. Such undertakings are to be met with in eastern Europe too. For example, the Chapel of St Václav (Wenceslas) in Prague Cathedral was painted in 1506–9 by the excellent Master of the Litoměřice Altarpiece.[1] One of the most interesting early decorations was executed around 1496 in the Smíšek chapel of St Barbara's Church at Kutná Hora (Fig. 88). This chapel, one of those forming the Late Gothic ambulatory, received a coat of wall painting at that time, probably as an ex-voto of a senior civil servant, Michael Smíšek, who had been reprieved after receiving the death sentence.[2] The paintings include a most interesting illusionistic device in the lowest section, where niches with church implements are represented (Fig. 90).[3] In the same register three persons – probably members of the Smíšek family – appear to fulfil some, perhaps liturgical, functions, lighting candles and the like (Fig. 89). In the upper registers on the high walls there is a cycle comprising 'The Tiburtine Sibyl and the Emperor Augustus', 'The Queen of Sheba crossing the water', 'The Crucifixion' and 'The Justice of Trajan'. These paintings are a remarkable mixture of northern and Italian stylistic ingredients. In 1938 Jaroslav Pešina stressed similarities with the Dutch Master of the Tiburtine Sibyl,[4] whereas Jarmila Vacková, in a study published recently, pointed out that the fusion of northern realism with a synthetic vision of space in the Smíšek paintings is similar to the style known from Joos van Ghent's Urbino paintings, where the detailed and atmospheric way of Flemish painting was combined with Tuscan and Umbrian synthetic and luministic art.[5]

It has not been possible to identify the painter of the Smíšek chapel wall paintings, those 'fresques admirables et uniques qui seront toujours l'école des artistes' – as Emile-Antoine Bourdelle said of them in 1909[6] – but the attribution to a German painter from the Upper Rhine who executed the altar wings in the Lichtenthal convent in Baden-Baden, proposed by Stange, was rightly dismissed by Pešina.[7] The traces of the influence of Schongauer prints do not help to establish the origin of the author, since the prints were widely diffused and known in central as well as in eastern Europe. Italian features are most striking in the illusionistic effect of the lowest register.

Michael Smíšek was buried in 1511 under the pavement of his chapel, but neither in the shape of the chapel nor in the wall paintings was this sepulchral function of the structure made visible. The chapel remained a Gothic structure adjacent to the right aisle of the ambulatory, and only its painted decoration was unmistakably linked with the Renaissance. Developments in Italy however had led in the fifteenth century to the formation of a specific type of centralized chapel corresponding to the Renaissance concept of architecture.

Chapels as small, half-autonomous structures were not an innovation of the Renaissance; they became, however, that type of structure which allowed Renaissance architects to give shape to their ideals of perfectly centralized buildings.[8] These ideals were expressed in paintings, where the background architecture is so often shown as centralized, but in practice such buildings were rather rare and they were built on a smaller scale. Not all such small centralized structures were chapels; some were sacristies like that by Brunelleschi in S. Lorenzo, Florence, or small churches like the same architect's S. Maria degli Angeli, left unfinished, or like Giuliano da Sangallo's S. Maria delle Carceri in Prato, but most of

them were chapels. Brunelleschi's Pazzi chapel, Antonio Ciaccheri Manetti's and Antonio Rossellino's chapel of the Cardinal of Portugal in S. Miniato and its replica, the Piccolomini chapel in S. Anna dei Lombardi (in Monte Oliveto) in Naples, formed the Italian tradition of centralized chapels, whose function was mostly sepulchral. In the north of Italy such examples were the Portinari chapel in S. Eustorgio in Milan by Michelozzo or the Colleoni chapel in Bergamo by Amedeo. Michelangelo's Medici chapel in Florence was to become the most famous of them all. But it may be said without exaggeration that nowhere outside Italy did the centralized sepulchral chapel prove so popular as in eastern Europe, and particularly in Poland. There are in Poland about 200 such chapels still in existence (see pp. 43-4), several of them not built until the seventeenth century, but clearly continuing the type formulated in the Early or in the High Renaissance.[9]

The Bakócz chapel in Esztergom

Like the other Italian forms which came to eastern Europe in the period of the Renaissance, these chapels first appeared in Hungary. From there the type was brought to Poland, where it found an extraordinarily wide diffusion, while Bohemia was prevented by various factors connected with the Reformation, which disturbed religious customs and disrupted traditions, from playing any role in the reception of that specific chapel type. The most important example in Hungary was the chapel built in Esztergom for the most prominent Hungarian ecclesiastical and secular dignitary, Tamas Bakócz, cardinal and archbishop of Esztergom, and extraordinary chancellor of Hungary (Figs. 91-7). Its foundation stone dates the inauguration of the work to 1506.[10]

At the end of the seventeenth century, the Polish king Jan III Sobieski, after rescuing Vienna from the Turkish siege and defeating the Turks, liberated the castle and the old bishopric of Esztergom, which had been under Turkish occupation since 1543. On 28 October 1683, he reported in a letter to Pope Innocent XI that, to celebrate the victory, a solemn *Te Deum* was sung in the fortress chapel, 'of extraordinary quality and especially valuable for its antique ornaments'.[11]

Ever since its completion, the Bakócz chapel had been considered almost miraculously beautiful and it is really miraculous that it survived in such good condition after the Esztergom castle hill was taken by the Turks in 1543, recovered by the emperor's army in 1595, reconquered by the Turks in 1605, and finally liberated by Sobieski in 1683, but heavily shelled by Turkish artillery in 1685. This unique monument to the glory of the Renaissance in Hungary, although it was not destroyed, has not survived in its original form nor even in its original place. Its present location, encompassed as it is by the mass of the rather heavy Neo-Classical cathedral, is most unfavourable for an appreciation of its original, centralized form.

This splendid structure, mentioned by several travellers of the sixteenth, seventeenth and eighteenth centuries, became more and more damaged. After the destruction of the greater part of the old cathedral, only the cube of the Bakócz chapel was left standing among the new Turkish structures (Fig. 94). The old cupola must have been destroyed in the late seventeenth century. In 1759 projects for a new, Late Baroque cathedral were ordered and some of them, by Franz Anton Hillebrandt, were so conceived as to fit the precious relic of the past into the new Baroque plan.[12] But it was only in 1822 that the construction of the new cathedral, this time a Neo-Classical one, was begun. The chapel

was inventoried (Fig. IV), every stone being numbered, and it was taken apart, transported to a new place, some eighteen yards (seventeen metres) distant and twelve yards (eleven metres) below its original level location, and there skilfully rebuilt. The move was disadvantageous not only because the chapel was now encompassed by the huge mass of the Neo-Classical church, but also because it had to be situated not at the right, but at the left

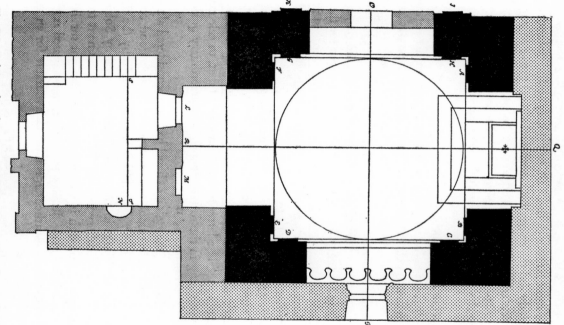

Fig. IV Bakócz chapel in its original location. Plan drawn by J. B. Packh before the removal in 1823. The left-hand side of the plan faces North

aisle of the cathedral (Fig. V). Since the altar had to remain on the east side, the large arch in the north wall which framed the entrance from the aisle had to be walled up,[13] and stalls brought there from the south niche (Fig. 92), which now had to serve as the entrance arch. The dome constructed by Lippert in 1875 to replace the old one, which had been

illuminated by a lantern, was without any light, and so introduced a rather gloomy canopy above the Renaissance space below. The big window that was opened in the new wall opposite the entrance gave very strong lighting from one side and completely changed the original distribution of light in the interior. And so the shape of this first east European centralized building of the Renaissance no longer looks as it did 400 years ago. Nevertheless it is even now not only a historical document, but also a great work of art.

Fig. V Location of the Bakócz chapel at the Esztergom cathedral (after Balogh). The left-hand side of the plan faces North

I have already mentioned that, when Cardinal Bakócz, who had visited Italy several times, started to build his chapel, it was planned to be adjacent to the right aisle of the old Romanesque and Gothic cathedral. A large arch framed by pilasters was opened in the outside wall of the cathedral (Fig. 93), and a frieze decorated with cornucopias and masks was placed above the cornice. Its remains are now in the crypt (Fig. 20). Marble stalls were placed in front of the entrance below the two round windows, which were located one above the other – one in the wall, another in the lunette above the cornice (Fig. 92). In the wall closing the barrel-vaulted recess to the right of the entrance there were two doors crowned with semicircular tympana, the left one false, the right one giving access to the

sacristy (Fig. 97). A small window above the doors served as a choir window. In the sacristy there was also a lavabo framed by finely carved lesenes supporting a round arch.

In the niche to the left of the entrance there stood an altar of white Carrara marble, put there in the last stage of the construction of the chapel, executed in 1519 by Andrea Ferrucci of Florence (Fig. 95), author of the well-known marble retables at Fiesole and in the Victoria and Albert Museum in London. At present it is mutilated – the two big statues of saints were added in the nineteenth century, when extensive restorations were also made to the reliefs of the Evangelists, the heads of which are new. The relief of the Annunciation, to which the chapel was dedicated, was also considerably restored. No trace has been found of the original statues of saints which stood in the three niches of the retable.

The impression made by the original dome, whose outside shape is known only from small images in old prints, must have been splendid. In the coffers there were ninety-six panels of bronze, each 3½ feet high (110·6 cm.), with reliefs covered with gold and silver. According to old descriptions they represented scenes from the Life of Christ and figures of saints. The framework of the coffering was made of reddish copper, so that the whole shell of the dome was a marvel: 'Everybody who enters the chapel remains amazed', the chronicler Evlia Tchélébi wrote in 1663.[14] 'It is like a bowl of copper with a golden net inside.' The colours of gilt copper and bronze reflecting the light flowing from the lantern above complemented the red Hungarian marble of the walls. The white retable of Ferrucci contrasted in colour, but not in style, with the character of the interior. Fluted pilasters supporting the entablature are placed in the corners, lower pilasters adjacent to them support the arches of the very short arms of the cross, which vary in length. The only decoration is the capitals of the big pilasters, some of them adorned with the coat of arms of Bakócz, the ornaments filling out the triangular spandrels between the arch and the cornice, and finally, the big round shields with the coats of arms placed in the pendentives (Fig. 96).

No Italian model for the Bakócz chapel has been found, nor is its author known. In spite of the ample source material skilfully gathered together in an excellent monograph by Dr Jolán Balogh, it is only by comparative stylistic analysis that one can establish the Italian milieu from which the architect must have originated. Dr Balogh points out that the closest predecessor to the composition of the Bakócz chapel is the sacristy of S. Spirito, Florence, built by Giuliano da Sangallo between 1489 and 1497. Especially close is the relatively small chapel of the sacristy, the so-called Cappella Barbadori (Fig. 98); here one finds the same type of wall decoration as appears at Esztergom: an arch supported by pilasters, framed by big fluted pilasters supporting the entablature.[15] But except for the type of supports and their relation everything is different. In Florence there is no dome, only a vault above the lunettes, and in spite of its elaborate architectural system the S. Spirito chapel strongly recalls Early Renaissance stylistic tendencies: its architectural members are made of *pietra serena*, contrasting with the whitewashed, neutral background of the walls. In Esztergom everything is made of red marble, which gives to the structure a royal dignity recalling the porphyry sarcophagi of the emperors. Pilasters, capitals, arches and entablature are sculpted from the same material – the chapel does not seem to be an aggregate of parts skilfully put together, but has the organic unity of a piece of sculpture carved from one block. Its forms are heavier than the Florentine ones – triangles filled up with decoration, coats of arms and coffers with rosettes, introduce more three-dimensional diversity, more play with light and shade in the upper parts of the structure.

But the forms themselves are clearly of Florentine origin. The pair of doors leading to the sacristy imitate the interior portal of S. Spirito of 1487, made by Salvi d'Andrea, and the capitals of the pilasters are very similar to those in Alberti's San Sepolcro in the Cappella Rucellai of S. Pancrazio (1467; Fig. 34), as well as to those in S. Maria Maddalena dei Pazzi, made by the studio of Giuliano da Sangallo (1480–92). Very similar capitals had occurred some twenty-five to thirty years earlier in the Buda castle (Figs. 29, 30, 33).

One can therefore regard the Bakócz chapel as the exceptionally original work of an important artist from the Late Quattrocento Florentine circle, who – certainly encouraged by a patron eager to create an outstandingly beautiful work – knew how to take advantage of costly local materials and of the vast financial means of the cardinal.

An inscription in the entablature states that Tamás Bakócz of Erdeüd, Cardinal of Esztergom, erected the chapel to the Mother of God, the Virgin Mary, in 1507. Although the chapel's form was Classical, its intentions and scope were Christian. The cardinal certainly wanted to parade his wealth and his taste, instructed by Italian experience, but his primary purpose was to erect a structure where he was to be buried. Indeed, his grave was in the crypt, but nothing in the chapel reflects this sepulchral character, except for the centralized shape characteristic for martyria and mausolea from time immemorial. Although dedicated to the Annunciation of the Virgin, the Esztergom chapel was not called by that name in later times, but became known as the Bakócz chapel, and what it has really immortalized is the name of the cardinal. And from our point of view it may be right to say that he erected it after all as his own monument. The name of the artist, however, has been lost – or rather the names, for there must have been several of them, although probably only one was responsible for the 'perfecta sacelli idea' – as it is formulated in a late source – the general design.[16]

The Lázói and Łaski chapels

The first Renaissance chapel built in eastern Europe after that in Esztergom was on a far lower artistic level. In 1512 the provost János Lázói erected a rectangular chapel, without a dome and rather uncomplicated in shape, at the cathedral of Gyulafehérvár, now Alba Julia, in Transylvania (Fig. 100).[17] Here the forms of the decoration came from Lombardy rather than Tuscany, and show interesting features of the reception of the Renaissance in the provinces. The façade is decorated with Renaissance motifs and inside an intricate Late Gothic net-vaulting is found. But the dedicatory inscription is similar to that in the Bakócz chapel and the form of the letters is equally beautiful. Also the small west portal is Florentine in style (Fig. 99).

The next step leads to Poland: here the first chapel was erected between 1518 and 1523 by a man who was a close acquaintance of Bakócz, the primate of Poland Jan Łaski. Two years after his return from Esztergom, where he spent some time in 1516 as representative of the king of Poland, Łaski submitted a project to the chapter of Gniezno, his archbishop's see, to erect a chapel at the cathedral, replacing three Gothic ones.[18] Soon, however, he changed his mind and decided to erect an independent mausoleum chapel in the cemetery of the cathedral.

The evolution of Łaski's views about the way he wanted to be buried is characteristic of the historical turning-point between the Middle Ages and the Renaissance. We are well informed about his ideas through the Notebook which he kept from 1495 on.[19] First he

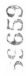

says that the executors of his will are free to decide where his tomb is to be placed. If he dies in a foreign country he wishes to be buried close to the place of death. Should he die in Poland, his body is to be buried either in his family church at Łask, or in one of the cathedrals with which he was connected through his ecclesiastical positions. In 1506, when he had been grand-chancellor of the crown for three years, he expressed the wish that his tomb be situated in front of the choir of the Gniezno cathedral, close to the tomb of his friend Jaszko, the dean, and he wanted his coat of arms to be placed there. A few years later, in 1511, after he had become archbishop of Gniezno, he ordered that he should be buried in the Gniezno cathedral close to the tomb of St Adalbert, the name-saint of the church. It is significant that it was in Esztergom, in 1516, after a stay in Rome from 1513 to 1515, that Łaski once again changed his will. This time he no longer wanted to be buried in the church – he wanted his grave to be placed in the cemetery, with a tombstone and a canopy supported by columns above it. Only two years later he proposed to have a chapel adjacent to the aisle of the cathedral, but finally the building was erected as a separate structure in the cemetery. Łaski said he wanted to be buried there because he did not feel worthy to be buried among the graves of his pious predecessors.

It is, however, difficult to take these words at their face value. It was certainly the rather secular wish to commemorate his person and name which determined him to erect a separate mausoleum. On his tomb slab, which he commissioned from the Esztergom studio of Joannes Fiorentinus,[20] the main motifs are the primate's big coat of arms, surrounded with a wreath of flowers, and a panel with an inscription recording his activities and positions (fig. 127). The only Christian element is a small cross at the top.

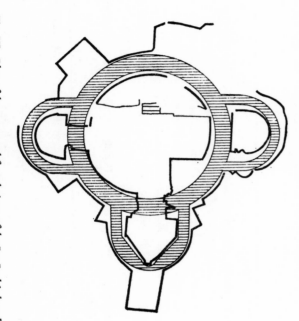

Fig. VI Plan of the excavated foundations of the Jan Łaski chapel in the cathedral at Gniezno

This is the only monument which remains of Łaski. His chapel was destroyed in 1778, and no drawing, no print, has preserved its shape.[21] When its foundations were excavated first in 1931 and then in 1947, they were taken by some scholars for Romanesque walls.

They are indeed similar to them and the chapel remains a riddle. Its plan – a circle with three semicircular apses – is not foreign to the general tendencies of Renaissance architecture, but it is impossible to name precise analogies (Fig. VI). It is a pity that we are not able to visualize the appearance of the structure, erected on a plan known to us, by the architect of the ambitious archbishop. However, at the time his chapel was being completed, another structure arose on the Wawel Hill in Cracow – one which was to remain the most important and the most beautiful of all east European chapels and which opens the long cycle of Polish centralized chapels of the Renaissance.[22]

The Sigismund Chapel in Cracow: architecture

In a letter of 1517 King Sigismund I of Poland, writing from Wilno to his executive Jan Boner, set down what was to be the first record in the history of his chapel:

The Italian was here with the model (*exemplum*) of the chapel which he will build for us and we liked it well, but we ordered him to change a few things in accordance with the views which we expressed. We have indicated to him also how much we want in the tomb to be made of marble, which you will learn better from him and from the papers. You should, therefore, arrange for as much marble to be brought from Hungary as will be needed, since he says that the marble there is more suitable for such a work than elsewhere and the transportation from there is more convenient. He told us also that he would need eight collaborators to carve the statues and once having them he would like to complete the chapel in three years and a half, which is certainly later than we would desire, but if we care so much about temporary buildings, why should we stint the means we use for those in which we have to dwell forever?[23]

The construction of Sigismund's chapel took much more time than the architect and the king expected. It was twelve years before the building was completed and a contract was signed to carve the statues that were to decorate its interior. On 8 June 1533, the chapel was at last consecrated.[24] Even then work on the furnishings had not yet been finished and it was only in 1538 that the silver altar, commissioned in Nuremberg, was put in place. The growth of the chapel is exceptionally well documented, almost all the account books for that time having been preserved.

The king's letter does not mention the name of the *Italus* who was charged with the work. The Cracow records of payment and other documents (such as the last will of the architect), prove however that he was Bartolommeo Berrecci, completely unknown in his native country as an artist.[25] It has been established that he came from Pontassieve, near Florence, and there are reasons to assume that he was in Rome early in his life, probably involved in some works done in the Sangallo circle, but we do not know whether he was called to Poland from Italy or from Hungary. The fact that he recommended the use of Hungarian marble supports the second possibility and it is assumed by some scholars that he may have been brought by the Primate Jan Łaski when he visited Esztergom in 1516.[26] At that time Sigismund's first queen, Barbara (of the Hungarian Zapolya family) had died and the king began to think about erecting a suitable building for her tomb. Some motifs in the rich decoration of the chapel are similar to those appearing in the Hungarian Renaissance, such as the candelabra with birds known from the remains of the Buda castle and the dolphins used in the Bakócz chapel.

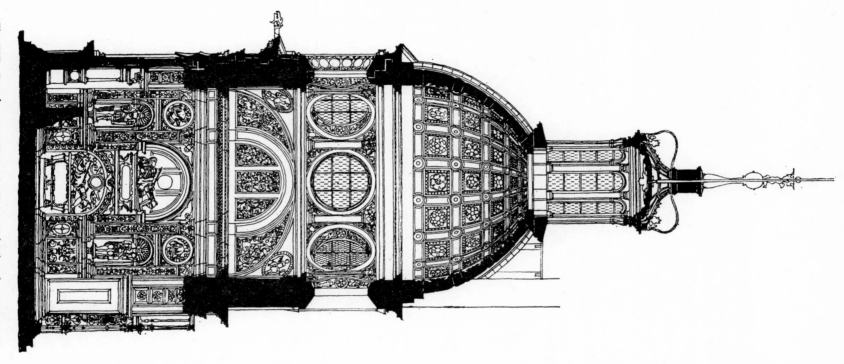

Fig. VII Bartolommeo Berrecci: Sigismund Chapel, 1517–33, in the Wawel cathedral, Cracow. Vertical section

If the Bakócz chapel represented the last stage of the development of Italian architecture towards the High Renaissance, in Berrecci's masterpiece the early stage of that style already manifests some tendencies towards an individualistic freedom in the use of Classical motifs, and it may be classified – according to Lech Kalinowski, who wrote the fundamental study of the chapel – as a 'not Classical' work of the Renaissance.[27]

The shape of the chapel, built on the site of the Gothic one on the southern side of the Cracow cathedral, was determined in some important respects by the size of the plot and the height of the cathedral aisle, later considerably raised during the eighteenth-century modification (Fig. VII). Limited as he was by these conditions and striving to allow the interior to be lit as strongly as possible by daylight, Berrecci conceived a masterly structure, amazing for an architect by whom we know no previous work. His was the first splendid Renaissance building erected in Poland from the ground and it remained unique in its stylistic purity and beauty.

The windowless cube of the body carries a rather high octagonal drum with big round windows and surmounted by a steep, half-elliptical dome covered with metallic sheets, which once were silvered (Fig. 101). Above this dome is a high, round lantern, on the top of which, upon a big crown, a putto – admired for its beauty by those who were able to behold it from a short distance – kneeling on a copper sphere holds a cross. The dome and the lantern are large in relation to the block of the chapel's body, and they suggest the direct tradition of Brunelleschi's dome of Florence cathedral. Kalinowski has found an analogous architectural composition among the drawings of Leonardo.[28]

The interior plan of the chapel is a square with shallow niches (Fig. VIII), and from

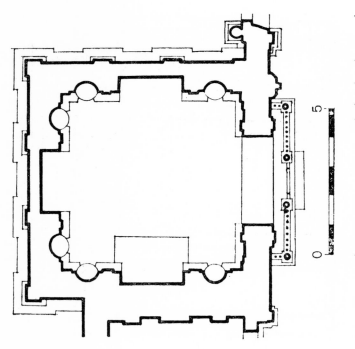

Fig. VIII Bartolommeo Berrecci: Sigismund Chapel in the Wawel cathedral, Cracow. The bottom of the plan faces North

the outside its shape is cubic. Against the south wall opposite the entrance arch is a royal throne (Fig. 103); against the east wall the altar (Fig. 102) and opposite that, the tomb (Fig. 104). When Sigismund II August, the son and successor of the founder of the chapel, approached old age, he ordered his own sarcophagus to be placed in the chapel, and thus in the 1570s the tomb structure was remodelled; both sarcophagi were now placed in the same niche – that of the father being raised to the second storey, that of the son inserted on the lower one (Frontispiece).

The lower zones of all four walls are composed according to a triumphal arch pattern (Fig. IX). This composition is crowned by a cornice, above which large lunettes form the transition to the drum of the dome. While the exterior pilasters of the triumphal arch pattern visually support the slightly lowered exterior arch of the lunette, the interior pilasters are continued above the cornice and form a semicircle delimiting a tympanum. The tympanum is divided by two vertical strips into three fields according to the Roman pattern of the so-called 'thermal window',[29] rather rare at this early date, later popularized by Palladio, but also occurring earlier, for instance in the inlay decoration on the outside of Florence Cathedral, on the façade of the chapel of the Cardinal of Portugal and in the lunettes of the Piccolomini chapel at Naples.[30]

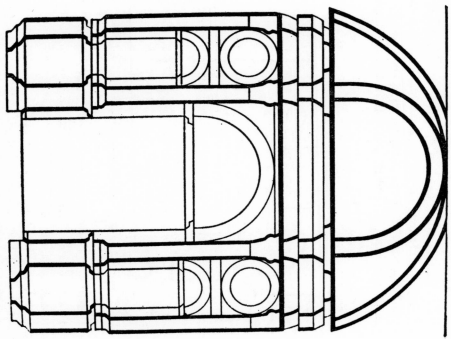

Fig. IX Composition of the wall of the Sigismund Chapel. Diagram after L. Kalinowski.

The lateral rectangles of the triumphal arch pattern are subdivided in Cracow by heavy cornices, which cut off one third in the upper part, where tondos of the Evangelists and Prophets are placed, while below, in the niches crowned by shell-apses, there are figures of saints. The large central arches delimit the shallow niches for the throne, the tomb and the altar. The entrance wall with a large arch has no statues.

Above the lunettes and the pendentives adorned with coats of arms a magnificent dome, with coffers decorated with rosettes, rises up, supported by the powerful drum, which is circular inside as opposed to its octagonal shape outside, and has eight big round windows (Plate III). Although only five of them now allow light inside – the aisle of the church having been raised – with the lantern they provide a strong illumination of the coffered dome and of the windowless cube of the chapel.

There are several departures from usual norms in the handling of Classical architectural motifs, the most important – pointed out by Kalinowski[31] – being the non-alignment of the secondary cornices in the triumphal arch pattern, where the horizontal divisions are put on three different levels (Fig. IX), and the non-alignment of the vertical divisions of the dome-coffering with the pilasters of the drum (Fig. 106). These unique solutions, whose unorthodox character could have been easily avoided, must have been adopted with full awareness of their aesthetic effect, which is one of a certain tension and uneasiness in the lower register and of an inherent dynamism in the upper one. Although rather flat and calm in its general lines, the architecture of the chapel conceals a disguised mobility, compelling the eye to wander restlessly from one level of the cornices to another and in the dome from one vertical axis to another. The optical effort of correcting these shifting vertical accents may even lead to a kind of visual mobilizing of the dome, which must be intentionally turned around its lantern to make the ribs fit the pilasters.[32]

The six statues of saints and the six reliefs of Evangelists and Prophets executed by Berrecci and his collaborators are – despite considerable differences of quality – by far the most important set of Renaissance statuary in Poland, where sculpture was mostly limited to tomb decoration. The marble panelling of the walls and pilasters includes rather restrained Classical grotesque ornament, whereas the zones above the main cornice are enlivened with dramatic and plastic reliefs. Five irregular fields contain an abundant sculptural decoration, which draws heavily on Classical models and combines ornamental plants and fantastic animals with figurative scenes representing nereids, tritons and other Classical figures.

The Sigismund Chapel in Cracow: iconography and symbolism

There is nothing uncommon in the representation of the Evangelists, and the appearance of Saints Peter and Paul on the altar wall, of Florian and Wacław, the patron saints of Poland, on the tomb wall, of Sigismund and John, the name-saints of the king and of his closest collaborator Jan Boner, on the throne wall, can be easily explained (Fig. 105). The two excellent reliefs of King Solomon and King David with his harp (Figs. 107, 108) are bearers of a more specific meaning. It is striking that Solomon has the features of King Sigismund, and David those of Jan Boner, or of his nephew and successor Seweryn Boner, although this second similarity is rather vague and supported more by tradition than by visual evidence.

Solomon has always been considered an exemplar of wisdom, and especially of royal

wisdom. He was also famous as the builder of the most perfect temple. Hence his inclusion and his transformation into a disguised portrait of the founder was doubly justified. But there exists even more specific evidence that the connection between Solomon and King Sigismund was in the mind of contemporaries.[33] On 1 September 1531, Erasmus of Rotterdam, who had received many gifts from Poland, and who was invited in vain by the king to come to Cracow, wrote to Seweryn Boner what may be considered at least partly a typical humanist *laudatio*, but at the same time may express a real appreciation:

I observe with joy that the happiness which Plato wished to the states was granted to your Poland, where the most outstanding men are lovers of philosophy. . . . Philosophy is for me that wisdom called by Solomon more valuable than all the jewels and he begged God for it before all other things. The qualities of this philosophy are such that thanks to it a man is able to order his personal life better and he will be useful to his native country at war and in peacetime. The splendid example of such a philosophy is possessed by the most glorious Polish Kingdom in the person of its pilot, King Sigismund.[34]

It may be doubted whether the king, pious as he was, would himself have thought of lending his features to the most wise king-prophet and builder of the most perfect temple. Perhaps it was Jan Boner (died 1523) or his successor Seweryn who arranged for such symbolism.[35] The *David* – possibly a disguised effigy of Boner – introduced the idea of a musical order, and an allusion to the chapel's choral ensemble, instituted by the king, which sang there until the late nineteenth century.

In the numerous studies devoted to the Sigismund Chapel, the funerary character of the decoration of its upper zone has not been sufficiently stressed. The symbolic character of the dome – its rosettes standing for stars and the whole dome for heaven – and that of the baldachin-like structure of the arches was recognized and analysed by Kalinowski, but the decoration of the lunettes is characterized, in all the existing studies of the chapel, as an expression of the almost pagan joy of life associated with the Renaissance, far removed from the sacred character of a church, and not connected with religious ideas or the symbolism of death.[36] One can agree with Kalinowski that in the upper zone the artist was allowed to give his imagination a free rein. But it seems obvious that Berrecci used that freedom not in opposition to the religious programme in the lower zone, where saints and martyrs await the king's soul in order to lead it to the place of eternal bliss, but to complement the basic religious idea of the chapel by using Classical motifs of related meaning.[37] In the reliefs decorating the upper zone, we may find, if not a comprehensive iconographic programme, at least a message suggestive of the sepulchral and eschatological meaning of the chapel as a whole, and expressing – in terms borrowed from Classical tradition – religious ideas concerning the immortality of the soul.

In the tympanum above the entrance arch, intertwined with the leaves of ornamental acanthus, are two figures, Adam and Eve, tied to the Tree of Knowledge (Fig. 109). In the same panel, putti with tridents attack dragons. Birds – which may be merely ornamental motifs but might also be regarded as emblems of the soul – pick grapes, perhaps connected with Eucharistic symbolism. The remaining four fields are adorned with grotesque decoration, with flowers and sphinxes – motifs often recurring on Roman sarcophagi.

In the upper zone of the west wall, above the niche containing the royal sarcophagi and statues, the three fields in the middle are decorated with grotesques. In the field on the far

Plate II Master of the Behem-Codex: Tannery. Miniature in the *Behem-Codex*, 1505. Cracow, Jagellonian Library, MS 16, Fol. 276r.

right a triton appears, carrying a nude nereid among dolphins and satyrs (Fig. 114), and a cupid with his bow and another nereid are also present. The last field on the left includes a winged female with goat's legs, bearing a basket of fruit on her head. She seems to be a personification of Plenty and she may suggest the Classical idea of Paradise, or the Islands of the Blessed (Fig. 110).

In the lunette above the wall with the royal throne, opposite the entrance arch, the three fields in the middle contain motifs suggestive of plenty: fruit, flowers, amorini and ornamental dragons. An ornamental dragon is also to be found in the field on the far left. But on the right again a powerful triton, his head transformed into an acanthus plant, is shown carrying off a nereid, whose hair and billowing drapery suggest the violence of the movement, while her gestures show her resistance to the rape (Fig. 112). A putto, or a youth, who attacks the triton as if in defence of the nereid, accompanies the group.

On the east wall, above the altar, a similar nereid and triton scene is shown in the field on the left while in the field on the right a group of fighting tritons appears, together with a male human figure. This group is not unlike the fight of the gods with the giants, or perhaps the fight of Hercules with the triton. Above this group hovers a huge monster, in which it is possible to recognize Scylla – as suggested by Kalinowski.[38] In the middle arch, in the centre panel between the two fields filled with ornamental plants, a woman, whom I believe to be a Venus Anadyomene, is revealed (Kalinowski now proposes Daphne), her hair still wet with water (Figs. 111 and 118). She stands between two companions (Cupid and Himerus?) and holds twisting leaves of acanthus. Above her, three more putti appear among the grotesque decorations.[39]

The scenes just described are situated above the projecting cornice, which contains the following inscription (partly restored, with a mistake, in the nineteenth century) running round the chapel: CONFITEANTVR TIBI DOMINE OMNES GENTES. / QVI DAS SALVTEM REGIBVS. / DEVS IVDICIVM TVVM REGI DA. / BEATI QVI IN DOMINO MORIVNTVR. (All the peoples shall praise thee, O Lord / That giveth salvation unto kings / Give the king thy judgment, O God / Blessed are the dead which die in the Lord.) The meaning of this inscription, composed of three quotations from Psalms (137, 1; 143, 1; 71, 1) and one from Revelation (14, 13), may include some political and dynastic allusions.[40] Whether this is so or not, the inscription clearly announces faith in salvation, and it is difficult to believe that, above a text expressive of the king's strong religious feelings and his hope for salvation, a simple decorative medley of Classical motifs would have been placed. The obvious erotic character of these motifs must have been justified by a specific meaning suited to the dignity of a royal mausoleum. Even in the Sassetti tombs in Florence the appearance of pagan motifs was justified by their symbolic significance and their relation to Christian ideas. It seems to me that the upper zone of the Sigismund Chapel contains a message still quite intelligible if approached with that meaning in mind which its Classical motifs are believed to have had in Antiquity – that it paraphrases in humanistic terms the hope of salvation expressed by the inscription in the religious zone below it.

Although there are always sceptics who discount the spiritual meaning of tritons with nereids on their backs, most Classical scholars seem to have returned to the opinion of the older school of archaeologists that tritons and nereids in Classical art expressed the idea of the journey of the soul to the paradise of the ancients – the Islands of the Blessed.[41] It seems plausible to assume that at least some artists of the Renaissance, confronted with numerous

examples of this Classical motif in a sepulchral context (Figs. 115, 116), did interpret it as a death image. The patterns of movement inherent in this motif could hardly fail to appeal to Renaissance artists, and is not improbable that they associated these movements with the journey of the human soul to the after-life. The very manner, so dramatic and violent, in which tritons abduct nereids in the Cracow chapel decorations may be expressive of such an idea.

The dolphins, whose supple forms fill the framing fields of the round windows of the drum (Fig. 113) and which appear in some of the spandrels above the central arches of the lower zone, were almost omnipresent on funerary monuments in Antiquity: they were regarded as bearers of the souls of the deceased and as symbols of salvation. The fantastic world of sea-creatures, of violently fighting tritons, of monsters, and of beautiful women, was probably intended to convey the Classical ideas of the after-life.

Finally, above the altar niche, in a daring counterpart to the Christian idea of salvation, the personification of the Classical idea is, I believe, displayed: Venus Anadyomene (Fig. 118). I have little doubt that it is she who is represented by this nude figure, although it is possible also to identify her as Daphne. Anadyomene appeared on Classical sarcophagi as a focal point, supported in her shell by tritons (Fig. 119). She 'speaks of Birth and Rebirth, of Generation and Regeneration, of Love and Triumph, of Purification and Salvation'.[42] For the Humanists, Venus stood for the highest spiritual values. In Antiquity she was also considered, among other things, as a leader of the souls of the departed.[43] Finally, the amorini in the pageant of Venus and the erotic element in the *Sea-Thiasos* scenes were expressive in Late Classical times of the ideas of generation, rebirth and salvation. It is difficult to believe that a nude female pagan deity could have been represented – however small – above the altar in the sepulchral chapel of the king of one of the most important Catholic countries, had she not been intended as a humanistic expression *all'antica* of the basic Christian idea of eternal life and salvation. If – following Kalinowski – we prefer to interpret the nude figure as Daphne, this Classical 'metamorphosis' motif may also stand for the most important transformation – a passage from one mode of existence into another.

That a spiritual meaning may be attached to erotic subject-matter is known from earlier and later times than the sixteenth century, since Ovidian erotica had been invested with divine and ethical associations in the *Ovide moralisé*. It is, to be sure, a little unexpected to find such symbolism far away from the main Neo-Platonic centres, in an east European capital where, although humanism in literature and scholarship was flourishing, we lack any comparative material, and where there was no Classical tradition in the fine arts. We have to admit that this transplantation of Renaissance mythological symbolism from Italy to Poland must have been the work of the Florentine architect, Bartolommeo Berrecci. He could have known Botticelli's *Venus*, with all her complex symbolism, and other works of the Neo-Platonic movement. He borrowed, for instance, one of the triton and nereid motifs from Raphael's *Galatea* fresco (Fig. 117).[44] It is also possible that Berrecci was encouraged in his projects by the king, who was educated by Filippo Buonaccorsi, nicknamed 'Callimachus', was well acquainted with Italian Renaissance philosophy and especially with the Neo-Platonic movement, and who at the time of his stay at the Buda court may have come in contact with the Hungarian Neo-Platonists.[45] With his collaborators Berrecci created a masterpiece, not only because he transplanted under a northern sky the forms of the Italian High Renaissance, but also because he created a decoration which conveyed a profoundly Christian content through Classical imagery and associations.

In sixteenth-century sources Berrecci was described as 'multis virtutibus, litteris et variis artibus mechanicis ornatus', and as 'vir philosophiae amator'.[46] He must have felt like a pioneer of the style *all'antica* not only in the field of form but also in that of thought. As he worked in a world which must have seemed to him still to belong to the medieval past, he probably felt he was fulfilling a mission and this must have enhanced his self-esteem. He has left a document of his new-found pride in a form not to be met with in Italy and has put his signature in a most unusual place, in the highest ring of the lantern above the dome. There, between a wreath composed of angel heads and the central seraph in the *empyraeum*, a beautiful inscription in Roman characters records the name: BARTHOLO FLORENTINO OPIFICE (Fig. 120).[47]

His pride was justified in still another sense: seen from an historical perspective, he conquered a new province for the Italian Renaissance. Few great works of architecture had such lasting and widespread influence as the Cracow chapel. And there are only rare cases in the history of art where one work can have done so much to change the stylistic character of a whole artistic landscape. There were several reasons for the impact of the Sigismund Chapel in Poland: the specific function for which it furnished a model of ideal fulfilment was to be very much in demand in the years to come. Social and religious reasons – the pride of great and noble families as well as the new piety of the approaching Counter-Reformation brought a great increase in chapel-building. At first, chapels were built only by church dignitaries; from the 1590s on many were erected by noble families.[48]

The impact of the Sigismund Chapel

The royal chapel in Cracow proved an ideal artistic form to be imitated. It was certainly not understood in all its complex symbolism and aesthetic structure. Nowhere in Poland do we find tritons and nereids imitated. What was imitated was the general shape and the Renaissance style. Berrecci himself furnished a simplified version when he erected, some 100 feet (thirty metres) from his masterpiece, a chapel for the bishop of Cracow, Piotr Tomicki, without ornaments or drum (Fig. 121).[49] Both types, the more complicated and the simplified one, were eagerly imitated, especially in the second half of the century and in the early seventeenth century. In the cathedral of Cracow alone several chapels were erected which were variations on the Berrecci motifs. Later the type spread to western and eastern Poland, becoming one of the distinctive features of Polish art (Fig. x). There were workshops producing prefabricated chapels in pieces which were then transported by water to the place of destination and put together there; one such chapel is in Włocławek Cathedral (Fig. 122).

The spell of the Sigismund Chapel continued into the period of the Baroque. The decoration changed: white and grey grotesques gave way to sombre black marbles, and instead of rosettes, heroic effigies of prominent representatives of the family look at us from the dome coffers (Fig. 166);[50] but the architectural shape did not change essentially. In the second half of the seventeenth century, when Poland was ruled by the Vasa dynasty of Swedish origin and the power of the Polish state declined visibly, the country being overwhelmed by the disastrous wars with Sweden and the Ukrainian Cossacks, it was decided to erect a Vasa chapel as an ideological and aesthetic counterpart to the old royal chapel of the Jagellons.[51] One might have expected that the earlier structure would have had to adapt itself to the modern style of its new-born companion. But the opposite

happened and – in a startling act of early historicism – the new Vasa chapel, Baroque inside (fig. 123), received the same exterior shape as its predecessor, so that a symmetrical pair of centralized buildings now forms a monumental frame for the southern entrance to the cathedral (fig. 124). One could argue that it was not so much the artistic value of the Sigismund Chapel that counted, but rather its intrinsic meaning, symbolizing, in the eyes of the seventeenth-century patrons, the heyday of Poland's power. But it remains a fact that it was Berrecci's genius which gave a lasting artistic shape to this unique cultural and political period of Polish history, called ever since its 'golden age'.

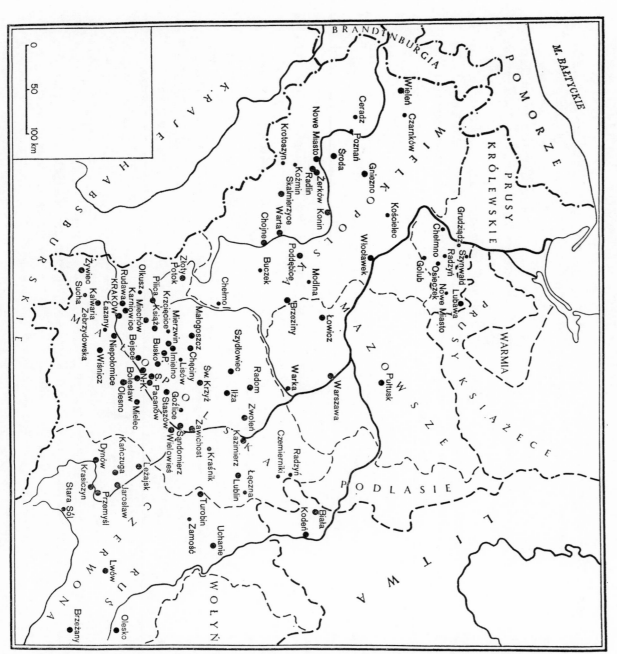

Fig. X Map of the locations of centrally planned chapels in Poland. After J. Z. Łoziński.

4 The Tomb

Early stone slabs

RENAISSANCE TOMBS ARE an art form in which Poland is one of the richest countries outside Italy. In spite of numberless wars and destructions the whole range of funerary art, from the simplest slabs to the most complicated sepulchral structures, has interesting representatives in that country. This is especially striking as the other east European countries are rather poor in this respect and lack individual achievements. Of course that may be due to the almost total destruction of Hungarian monuments of earlier periods, on the one hand, and to the fact that the Reformation did not especially encourage funerary sculpture in Bohemia, on the other. In Poland, however, even judged by German, Dutch or French standards, the abundance of sepulchral monuments is astonishing. Sometimes they were conceived together with the chapels in which they stood. In such chapels the tomb was the most important element and the chapel was meant as an immense canopy, as it were, as an extension and crowning of the tomb. But in spite of the number of new chapels, more often than not the tombs were constructed in already existing churches.

It seems that Poland took advantage of the change typical of the Renaissance attitude to sepulchral art, characterized by Panofsky as a change from the prospective conception of the Middle Ages to the retrospective, modern one.[1] The Italian idea of the tomb conceived as a monument was here adopted and it was principally this commemorative function that contributed to an unprecedented development of funerary art, promoted widely by kings, lords, ecclesiastical and civic dignitaries, gentry and wealthy burghers.

That specific kind of tomb slab whose principal function was that of commemoration of a lord and his family is first found not in Poland but in Hungary. And this in a highly interesting and specific form, to which László Gerevich devoted a study some years ago.[2] It is a monumental slab with centrally located heraldic motifs framed by a wreath of leaves and flowers or otherwise decorated, suspended on bands whose ends, fluttering in the wind, form a symmetrical ornamental pattern. Below there is the commemorative inscription, sometimes on a Classical tablet, sometimes on a plain stone surface. A few such slabs are preserved in Hungary, that of Nikolaus Szentléleki in the church at Csatka (1516), that of an unknown person in the Dominican church at Buda (about 1510; Fig. 125), that of a member of the Szentléleki family from the choir of the same church, that of Bernardo Monelli (1496) in the Castle Museum at Buda (Fig. 126), and that of a certain Nikolaus in the Serbian church at Ráckeve (1525).[3]

Since most Hungarian monuments have been destroyed, we must, in order to get a better idea of the whole group and also to recognize its author, consider first the tomb slabs of Hungarian origin preserved in Poland. In 1515 Jan Łaski, Polish archbishop and cardinal, known to us already, on his way back from the Lateran synod stopped in Esztergom to visit his fellow cardinal Tamás Bakócz. Łaski commissioned at that time six marble slabs, one for himself and the others to commemorate his predecessors, benefactors and relatives.[4] Since his chapel – we remember – built in the cemetery of the Gniezno cathedral, was destroyed in the eighteenth century, the tomb slab commemorating him (Fig. 127) is now preserved inside the cathedral, as are three others; a fifth is in the cathedral at Włocławek, and the sixth, once in Cracow, has disappeared. They are similar to the Hungarian slabs, but better preserved and, what is more interesting, one of them, that of the cardinal, is signed by the sculptor, Joannes Fiorentinus, and dated 1516. This Italian artist was active at Esztergom and there are two other works signed with his name, a baptismal font from

Menyö (1515) now in Bucharest (Fig. 129), and the tomb slab of Gergely Forgách in Felsőelefánt (1515).[5]

The slabs by Joannes Fiorentinus are not very complicated compositions but they are striking in that they are clearly conceived as commemorative monuments, most of them with hardly any reference either to salvation and the after-life or to religion. Three of them, those of archbishops or cardinals, include crosses, the small upper part of which is visible above the coat of arms, and the lower part of the long stem appears below. We may see in these crosses signs of ecclesiastical rank rather than religious emblems, the more so since on the slab of the bishop Krzesław of Kurozwęki at Włocławek Cathedral the cross is replaced by the bishop's mitre[6] and crozier and since the fifth slab, designed not for a bishop but for a relative of the primate, Andrzej Łaski, a canon of the Gniezno cathedral, includes no religious emblem at all (Fig. 128).

These slabs of red Hungarian marble, dignified and abundant in form, are excellent examples of the retrospective attitude which must have been current among the high ecclesiastical dignitaries and humanists both in Poland and Hungary. The type created by Joannes Fiorentinus was imitated and continued in Poland (slabs in Gniezno of Archbishop Maciej Drzewicki, died 1535, and of Erazm Mieliński, died 1579,[7] slab in Włocławek of Jan Karnkowski, 1536[8]). This survival is, however, less interesting than the origins of this kind of tomb slab since it seems to be connected not only with Italian but also with the local, Hungarian, or – as Gerevich puts it – Pannonian Renaissance. The stone panels with coats of arms surrounded by wreaths of leaves appear in Hungary already in the last quarter of the fifteenth century, for instance the coats of arms of the Báthory family (Fig. 130) from Nógrad (1483) and in the cathedral of Vác (1485).[9] Some rather awkward tombstones sculpted at the turn of the fifteenth and sixteenth centuries incorporate coats of arms and inscriptions with ornamental borders in typographic style.[10]

Since there are no Italian Renaissance models for these slabs, Gerevich suggests that they represent an endeavour to revive the specific type of ancient tomb slabs popular in that part of Hungary called Transdanubia, which had belonged to the Roman empire and formed the province of Pannonia.[11] Such tombstones, which date from the first half of the second century A.D., were common in Hungary and were eagerly collected in the fifteenth century (Figs. 131, 132). Some of them were in the royal collection and one has been preserved in the area of the castle.[12] Each of these reliefs is composed of a tendril-framed inscription surmounted by the laurel wreath with fluttering ribbons. Usually the wreath surrounds a rosette, but on one surviving stele, mentioned above, which was formerly in the park of the royal castle, it encircles a portrait bust.[13] It is perhaps going too far to say – as Gerevich does – that Joannes Fiorentinus simply used the tombstones of Pannonian type as models, but it seems likely that they were not without importance for the shape of his own slabs, which, carved from red marble at Esztergom, brought the first glimpses of the Renaissance and of the Antique to central Poland.

The humanistic epitaph

In his well-known book devoted to the history of tomb sculpture Erwin Panofsky discusses the appearance of what he calls the humanistic epitaph, whose typical features, he says, 'reveal an attitude not only purely commemorative but even boastful and almost entirely devoid of religious sentiment'.[14] He sees the pattern of this specific type formulated in the

so-called *Sterbebild*-woodcut representing the German humanist Conrad Celtes (or Celtis), which was made in 1507 by Hans Burgkmair to Celtes's own specifications.[15] This graphic 'pre-epitaph', if one may coin a word, contains quotations from Classical writers as well as images of Classical gods 'which laud Celtes's merits and complain about the interference of Death with Friendship'. The epitaph of Cuspinianus (died 1527) in St Stephen's, Vienna, is given by Panofsky as another example of the new attitude, which stresses 'glorification of intellectual achievements and academic honours' instead of 'expectations for the future of the soul'. One such epitaph in the eastern European area is earlier than that of Cuspinianus and even earlier than the printed one of Celtes. It is the bronze plaque of the Italian humanist Filippo Buonaccorsi, called Callimachus (Fig. 133),[16] active in eastern Europe after he fled from Rome, having been involved in a revolutionary plot against Pope Paul II in 1468. Buonaccorsi (1437–96) was an important representative of Italian humanism, and was connected with the Roman circle of Pomponius Laetus. On his flight from Rome he visited Greece and other countries occupied by the Turks. He stayed in Cyprus and Constantinople and later found a new home in Poland, where he played an important role at the royal court as tutor of the sons of King Kazimierz IV and as royal secretary.[17] He also had connections with Matthias Corvinus, to whom he devoted a poem, *Attila*, in which he developed the rather surprising myth current at the Buda court of Attila as an ideal ruler. The Hungarian historian János Thuróczi even went so far as to call Corvinus a new Attila.[18] Callimachus died in 1496 and was buried in the Cracow church of the Dominican friars, where he is commemorated by a bronze epitaph, which is generally believed to have been designed in Nuremberg by Veit Stoss (who for a long time worked in Cracow and was certainly acquainted with Callimachus), and executed in bronze by the Vischer workshop in that Franconian town. The precise date of execution is difficult to establish, but it is assumed that the plaque must have arrived in Cracow in the first years of the sixteenth century.[19]

The humanist is represented in his studio and vividly recalls representations of Evangelists and of St Jerome; the composition is based on the traditional portrait of a writer in his cell, a type whose origins are to be seen in late Classical and medieval book illumination.[20] Classical funerary reliefs are also known showing intellectuals at work, with their rolls and writing implements (Fig. 134),[21] but the *style* of the Callimachus effigy reveals no traces of the Classical tradition. Although similarities can be found with Italian paintings of St Jerome influenced by Netherlandish art – for example works of Ghirlandaio, Botticelli, Colantonio and Antonello da Messina as well as miniatures like that from the Altichiero circle representing Petrarch in a late fourteenth-century manuscript (Fig. 135)[22] – the sources of the image are obviously to be seen in the art of Jan van Eyck and his followers. The detailed, descriptive realism in the representation of the studio goes back to this,[23] and the motifs of the bottle and the box on the shelf and of the convex mirror hanging on the wall point clearly in that direction.[24] There are also precedents in German art, such as the epitaph of the organist Conrad Paumann (died 1473) in the Church of Our Lady at Munich (Fig. 136),[25] showing the blind musician, surrounded by musical instruments, below an inscription describing his merits.

The type of epitaph stressing artistic or intellectual achievements as special reasons for commemoration existed therefore in the north even before the Cracow plaque, but thanks to Veit Stoss it received an outstanding realization in the Callimachus effigy, the first in

eastern Europe. Moreover, while we meet only northern realism in the Paumann epitaph, the ornaments of the arches enclosing the Cracow effigy are Classical motifs, and also some elements of the ornamental border – better visible on a nineteenth-century drawing, done before part of the border was lost (Fig. 137) – have a Classical flavour, although these motifs could have been transmitted through German prints.[26] This epitaph is an example in which northern realism is linked with early reflections of Italian style in the beautiful Roman script and in the ornaments. The general character of the work permits us to consider it an early example of the type in which stress is laid on intellectual achievements – on earthly glory reaped through authorship and other humanistic pursuits. What is so striking is the complete lack of any religious element.[27]

Thirty years were to pass before the reappearance of similar commemorations – this time, too, rooted in German and not in Italian traditions. And the two examples I should like to discuss appeared in the far west of the area under consideration: in Silesia. In 1533 an unknown master, probably from south Germany, executed the large marble epitaph of the Wrocław cathedral canon, Stanislaus Sauer, in the Church of the Holy Cross at Wrocław (Fig. 138).[28] One year later he carved and signed with the monogram M.F. a similar slab for the town councillor and humanist Heinrich Rybisch in the church of St Elizabeth, also in Wrocław (Fig. 139).[29] Both monuments, not without some likeness to the Cuspinian epitaph of 1527 in Vienna, are devoid of religious symbols – except for inscriptions on Sauer's slab – and display only the portrait of the person commemorated, his coat of arms – in the case of Rybisch also that of his wife – and medallion heads *all'antica*. It should be pointed out that the people represented were still alive at the time of the execution of the reliefs they had commissioned. Later, both these slabs were incorporated into more complicated structures. After Sauer had died in 1535 his relief was set, on a fluted pedestal, between two columns supporting an entablature with an inscription and crowned by a pediment filled with a shell pattern and a profile head *all'antica* of Matthias Corvinus in a medallion. Two similar heads situated on the protruding parts of the entablature above the columns are inscribed as those of Alexander the Great and the Emperor Augustus, in this way promoting Corvinus to the highest rank of monarchs. This transformation must have been the work of a north Italian sculptor, perhaps the first one with a defined personality working in Silesia, who had also been responsible for the front of the Rybisch house in Wrocław (about 1530).[30]

In 1539 Rybisch commissioned the sculptor Andreas Walther I to transform his epitaph into an Italianate structure adjacent to the wall. Its canopy was supported by three columns with two arches, under which the recumbent effigy was placed very high and partly in the shadow (Fig. 140).[31] This stately, although not wholly harmonious monument shows that a still stronger stress was put on the secular character of the programme. Rybisch is represented semirecumbent in the shade of the canopy but he may well not be sleeping (Fig. 141). He is shown in a state of repose, his left elbow resting on a celestial globe, his right holding a tablet: certainly symbols of his interest in the study both of a cosmically conceived nature and of human thought. His coat of arms is set above the canopy and again heads in profile, like Classical medallions, are inserted into the spandrels of the arches.[32]

Variety of free-standing tombs and wall-epitaphs
This tomb, important as the first monument outside Italy commemorating a member of

the upper middle-class and showing him in the recumbent position of the so-called 'Sansovino-type' under a canopy, must have been inspired, although perhaps not directly, by the developments that had taken place in the meantime in Cracow. Its direct prototype was the tomb of the Wrocław bishop Jan V Turzo an important representative of east European humanistic culture (Fig. 142). His tomb, of which only the semirecumbent figure survives in the Wrocław cathedral, placed now on a Late Baroque postament (Fig. 144), was dismantled in the eighteenth century. It was executed in 1537, seventeen years after his death, the figure by an unknown Silesian master, perhaps trained in Cracow, and the architecture by Andreas Walther I. At that time the tomb represented the most modern concept in sepulchral art, showing the bishop asleep, his head supported by his right hand, and the upper part of his body slightly raised,[33] obviously following the type introduced by Andrea Sansovino about thirty years earlier in his Roman tombs, which – leaving aside Spanish precedents – must be considered the starting point for this development of funeral representation in European art. The Turzo tomb was the model for later tombs of ecclesiastic dignitaries in Silesia, the most important of them that of Balthasar of Promnitz (after 1562) in the cathedral of Nysa (Neisse) (Fig. 143).[34]

Both the Turzo and Rybisch monuments must have been inspired by what had been done further east, in Cracow, in the years following the erection of the framing Renaissance structure for the Gothic *gisant* of Jan Olbracht (Fig. 16) and after the Callimachus epitaph had been put in place. By the time Turzo and Rybisch erected their tombs there existed in Cracow models both for the canopy in Renaissance style and for the sleeping figures in quiet repose or in a more dynamic, alert position. Jan Turzo was a native of Cracow and part of his family resided there. For some time he was professor and rector of Cracow University.[35] Perhaps the rhombic ornaments in the pedestals of both the Turzo and Rybisch tombs also came from Cracow, where similar forms decorated the outside walls of the Sigismund Chapel.

During the time that chapel was under construction, on King Sigismund's order the old Gothic canopy above the tomb of his grandfather, Władysław Jagiełło, was replaced by a Renaissance one (Fig. 145). This was done between 1519 and 1524 by a team of Italian sculptors probably under the general direction of Berrecci, but with the important participation of the Sienese Giovanni Cini.[36] The style of the canopy is close to that of the chapel. Above eight subtly carved capitals arches support an entablature and cornice similar to those of the Wawel castle portals (Figs. 60, 61). The decoration of the capitals and of the coffers of the canopy ceiling includes grotesque motifs, sea creatures like those in the Sigismund Chapel, and suitable Roman subjects, such as the Triumph of Caesar (Figs. 146–8). But this type of tomb, although modernized so beautifully, must have reminded the beholder too much of the Gothic tradition. The canopy was actually the same type as that used in other medieval royal tombs, but in the modern style, and it was erected above a traditional Gothic *tumba* with a recumbent *gisant* figure.

It is remarkable that in Poland this medieval type of tomb disappears completely with the coming of the Renaissance, whereas the *gisant* figures, stiffly recumbent, still appear in Cracow and elsewhere in the twenties and thirties. Some of them came probably from the workshop of Berrecci, such as the figure (1521) of the bishop Jan Konarski (died 1525) (Fig. 149),[37] others from the workshop of Bernardino Zanobi de Giannottis, who collaborated with Giovanni Cini, such as those of high dignitaries of the state, Witold Gasztold

(died 1539) in Wilno, Stanisław Lasocki in Brzeziny (died 1535), the chancellor Krzysztof Szydłowiecki in Opatów (died 1532) (Fig. 150), and the Dukes of Mazovia, Stanisław and Janusz (died 1524 and 1526), in the Warsaw Collegiate Church (now cathedral) (Fig. 151).[38] All of them, however, are not put flat on the *tumba*, but inclined and placed in an oblique position on a *tumba* pushed to the wall. This type is known in Poland as the 'lectern tomb'.

It is to be noticed that free-standing *tumba* monuments appear in eastern Europe outside Poland, especially where Netherlandish or German artists coming from the west were employed. In Oleśnica (Oels) in Silesia, Jan Oslev from Würzburg executed in 1557 the free-standing double tomb of the duke Jan Podiebrad and his wife Krystyna Szydłowiecka (Fig. 152). Oslev used Aldegrever's prints as models for his Renaissance ornaments and in general followed the Silesian Gothic tradition,[39] which we see in the monument to Bishop Jacob of Salza in Nysa (1539; Fig. 153).[40] In Prague, Alexander Colijn placed as many as three *gisant* figures on the *tumba* of his tomb of the Habsburg kings in St Vitus's Cathedral (1564–73, 1590; Fig. 154),[41] and in Transylvania an almost Roman tradition was revived in tombs like that of Sofia Pathócsy from Cetatea de Baltă (1583), now in Bucharest (Fig. 155).[42]

The bronze slab of the cardinal Fryderyk Jagellon, brother of King Sigismund, a product of the Vischer workshop, was placed in an unusual location: it is set into the pavement of the elevated choir of the Wawel cathedral in Cracow, protruding above the stairs (Fig. 156).[43] The slab itself is in the traditional Gothic pattern, but its front and side walls, delimiting the tomb against the stairs on the left and right, are excellent examples of the German Renaissance, which came to Cracow at the same time as the Italian one, especially through imported bronzes and paintings. The tomb, commissioned by the king in 1510, shows the use of Albrecht Dürer models in the composition of the front panel and in the figures of St Adalbert and St Stanislaw in the border of the main slab.[44] The drawing of the effigy of the cardinal standing on the lion also recalls works by Dürer or his school. A woodcut of the *Adoration of the Magi* by Hans Kulmbach (Fig. 157) bears a striking similarity to the composition of the front panel (Fig. 158).[45] The side panels, with angels, music-making putti and other putti riding dolphins represent Nuremberg Italianism of the first decade of the sixteenth century at its best. One might, however, hesitate to describe this flat structure, incorporated into the elevated choir, as a free-standing tomb.

There was perhaps only one really free-standing tomb of high quality in Poland, but it was dismantled soon after its erection. This is the altar-tomb of St Hyacinthus in the church of the Dominican friars in Cracow, executed in 1581–3, probably by Jan Biały, a sculptor of Cracow origin who worked mostly in Lwów, or by the Netherlandish carver from Groningen, Hendrik Horst.[46] As early as 1626 the tomb was removed because its excessive weight was considered dangerous on the upper floor, where it had been erected, and it disappeared. However, a long description by Paolo Mucante of 1596 has been discovered and following it Mrs Sinko has ingeniously pointed out that several elements of the tomb, transformed into stalls and portals, are preserved in the church of St Giles in Cracow (Fig. 159). Had it been kept in its original site, the St Hyacinthus monument would rank among the most important tombs of the sixteenth century in eastern Europe. Thanks to the ingenious reconstruction (Fig. 160), we may have at least a glimpse of its majestic structure, which perhaps reflected Italian *arche* of saints or French double-decker tombs, or both.

Vertically-placed tomb slabs with full-length standing figures in relief are quite frequent in Bohemia and Silesia, where they were also developed into statues in the round, standing in architectural *aediculae*, although they rarely have a high artistic value. In Poland this type was represented by the Vischer bronze plaques, one of them, that of Piotr Kmita (Fig. 163), being especially interesting because of the obvious reflection of Dürer's *St Eustace* from the Paumgartner altarpiece.[47]

To the same German tradition belong the two bronze slabs of the court dignitary Seweryn Boner and his wife in the Church of Our Lady at Cracow, of 1538, ascribed to the Hans Vischer workshop, but different in type from his average production (Figs. 161, 162).[48] On tombs executed by Italian sculptors, vertically-placed standing figures are rare: we may note the rather awkward figure in the round of Piotr Kmita the younger (died 1553), obviously based on the statue of St Wacław (Wenceslas) in the Sigismund Chapel;[49] and the certainly more interesting relief figure of Kasper Wielogłowski (died 1564) by Hieronim Canavesi at Czchów (Fig. 164).[50]

In the second half of the century there appeared in Poland effigies of the deceased shown *all'antica* in medallions, niches and recessions of walls. Already about 1557 a profile image of Galeazzo Guicciardini was inserted into an obelisk in his wall tomb in the Dominican cloister in Cracow.[51] This style reached its most plastic realization in the tall structures erected in the choir of the Cracow Church of Our Lady. These tombs of the Montelupi and Cellari (families of Italian extraction) were probably done by artists in the early seventeenth century continuing the Mannerist style of Santi Gucci Fiorentino (Fig. 168) and perhaps they even include some of his own work. With their grave, solid portrait busts (Fig. 165), they strangely recall Late Classical mausolea, like those at Palmyra.[52] But it is not likely that an actual link with these traditions could have existed. Perhaps it was rather some echo of Late Gothic illusionistic sculptures looking out from windows which inspired such tombs. A Roman flavour can be traced in the series of sixteen half-length figures in relief representing members of the Myszkowski family placed in the coffers of the dome in their Cracow chapel, erected by Gucci or his workshop in 1602–14 (Fig. 166).[53]

Panofsky points out in his book that the type of frontally shown, seated image of the deceased alive – what he calls the 'image in majesty' – did not initiate a continuous tradition before the very end of the fifteenth century 'and even then this tradition gave expression to the spiritual power of the popes rather than to the temporal power of kings and em-perors'.[54] It is startling to realize that in Poland the tombs of some hardly outstanding nobles were conceived in obvious imitation of the most famous tombs with 'images in majesty' – those by Michelangelo in the Medici Chapel. The double tomb of the Kryski couple sitting in arcaded niches (Fig. 169), located in the small village church at Drobin (executed 1572–6), was probably a work of Gucci as far as the general idea and architecture is concerned, while the rather weak statues in the niches, inspired by Michelangelo and Montorsoli, must have been carved by an assistant.[55] There are a few such tombs in Italy, such as that of Benavides by Ammanati in Padua (Fig. 170), or that of S. Bartolo by Benedetto da Maiano in San Gimignano, but even in Italy they are extremely rare.[56]

Finally, it may be mentioned that there was even a tomb with two standing figures under arches in Cracow, recalling, it seems, Roman prototypes. But this tomb of the Orlik couple by Canavesi has disappeared and we know it only from an old watercolour (Fig. 167).[57]

One sepulchral monument in Poland is completely unusual and has neither precedents nor followers in east European art: the long, rectangular bronze relief, combined in a rather awkward way with the effigies of the chancellor Krzysztof Szydłowiecki (died 1532) and his young son (died 1530), in the collegiate church at Opatów.[58] There are various proposals to reconstruct the original composition; none, however, is wholly convincing. The relief does not connect with the other preserved elements and seems to stand by itself (Fig. 171).

It shows a scene of mourning, in which the deceased does not himself appear. The people lamenting obviously represent Polish gentry or courtiers – conceived very much *all'antica* – and a bearer of the bad news – *nuntius cladis* (Figs. 172, 173). It is a composition in the tradition of the Classical *conclamatio*, revived in the Italian Renaissance in such monuments as the Sassetti tomb in S. Trinità, Florence, the mourning of Francesca Tornabuoni, or the della Torre tomb reliefs (now in the Louvre)[59] by Andrea Riccio.

The precise meaning of the Szydłowiecki *conclamatio* has never been established in spite of some interesting attempts;[60] nor has its author been discovered. It is important not only because of its artistic quality and Classical flavour, but also because of its enigmatic iconography, unique in an area where iconographic subtleties and riddles are rather scarce, and it belongs to the most original works of the Renaissance in the sepulchral art of eastern Europe.

Popularity of the 'statue accoudée' type

But these rather unusual types are rare exceptions in an artistic landscape in which the semirecumbent sleeping figure absolutely dominated tomb art. We shall therefore now devote our attention to that most popular type. We do so especially because the wide popularity of *statues accoudées* in Poland has escaped the attention of art historians outside Poland.[61] In Panofsky's book on tomb sculpture it is said that tomb statues in such poses are 'sporadically accepted in France from the time of Pierre Bontemps but so unfamiliar in other northern countries that John Webster could ridicule them as late as 1611–12, as a 'new fashion' according to which princes' images on their tombs do not lie, as they are wont, seeming to pray up to heaven, but with their hands under their cheeks as if they had died of the toothache'.[62] If Panofsky's statement is true for the north, it is certainly not so for the east and for Poland in particular. In Poland, in the second half of the sixteenth century, it would be difficult to find figures 'lying so as to seem to pray up to heaven'. The *statue accoudée* won the field extremely early and it remained fashionable down to the middle of the following century.

Its model was created in the royal chapel at Cracow Cathedral, and like that chapel it had an enormous influence. When Bartolommeo Berrecci or collaborators working under his supervision executed the semirecumbent figure of Sigismund I between 1529 and 1531, this was, it seems, one of the first cases of a transplantation of this Italian High Renaissance type outside Italy (Figs. 174, 180).[63] Spanish antecedents notwithstanding, it was Andrea Sansovino who, in his tomb of Pietro Manzi dei Vincenzi in S. Maria in Aracoeli (Fig. 175) and in his S. Maria del Popolo tombs commissioned by Julius II, created the models for representing the deceased neither as dead *en transi*, as was usual in the very numerous Gothic tombs, nor as alert and active, like Pollaiuolo's tomb of Innocent VIII *en majesté* in St Peter's, Rome.

Sansovino's effigies in S. Maria del Popolo were represented as living, but asleep (Fig. 177). One of them – like Pietro Manzi dei Vincenzi in S. Maria in Aracoeli – supported his reclining head on his hand; the head of another rested on the shoulder, his arm sharply bent at the elbow. The impression created is one of quiet, blessed repose. But Sigismund I on his tomb has a somewhat different position, which Polish art historians call 'Michelangelesque' because of its similarity to that of the four allegorical figures in the Medici Chapel. He is seen in the so-called 'Maximilian-armour', semirecumbent, the upper part of his body slightly raised and resting on his right elbow, his legs bent and crossed, his head with half-closed eyes turned upwards. Some strain is visible in the pose: official appearances are kept up in spite of the position, with the king holding the royal orb in his right hand while the left is obviously designed to hold the sceptre, which has been lost.

The closest analogy in Italian art is the figure of the Cardinal of Santangelo (Fig. 178), the upper one of the two in the double tomb designed by Andrea Sansovino and executed by Jacopo Sansovino for S. Marcello al Corso probably around 1520 (after a fire in the church of 1519, although it was begun earlier).[64] The head, the shoulders and the arms of the cardinal are extremely close to the Cracow tomb, but the position of the legs is not clear, as they are covered by an ecclesiastical gown. Some Polish art historians have stressed how difficult it is to find poses similar to that of Sigismund in Italian sculpture of around 1530, and the crossed legs are certainly rather rare in Italy. But it may be pointed out that the position in which Sigismund is seen can be found about half a century earlier in Florentine painting: Botticelli represented the sleeping Mars in precisely the same position (Fig. 179). Similar representations may be found in pictures of the Resurrection of Christ, where sleeping soldiers are depicted in various positions which indicate their sleeping state, and even in sculpture, as in the Brenzoni monument in S. Fermo Maggiore in Verona by Nanni di Bartolo (called Rosso) of 1427–39 (Fig. 176).[65] It is thus wholly possible to expect such an invention from a Florentine artist of Berrecci's generation and stature, especially if one also keeps in mind his outstanding achievements in the field of architecture, which were quite up to date with Italian developments.

While working on the Sigismund Chapel Berrecci – as we remember – also erected a funerary chapel for the bishop Piotr Tomicki.[66] The tomb, which is situated inside, is a riddle (Fig. 181). There is a record of a commission given by Queen Bona Sforza to the second most important sculptor active in Poland at that time, Gian Maria Mosca, called il Padovano (died about 1573), to execute a copy of Tomicki's tomb for the body of his successor, the bishop Piotr Gamrat, Bona's favourite. Therefore it has been assumed that Padovano was also responsible for the original tomb, which served as a model.[67] But the tomb corresponds neither to Padovano's presumed works in Padua or Venice nor to his few documented works in Poland. It would be much more convincing to ascribe the excellent tomb of Tomicki to Berrecci, the documented author of his chapel. What is puzzling, however, is a lack of correspondence between the architecture of the tomb and that of the chapel. Therefore the attribution of this important work oscillates between the two – Berrecci and Padovano.[68]

Tomicki's tomb is a rather simple architectural structure: two columns support a horizontal entablature protruding above them. In the middle a rectangular niche is formed, in which the recumbent statue of the bishop is situated. All the members of the architectural composition are richly ornamented. The most similar Italian tomb is that of the cardinal

Antonio Jacopo Venerio (died 1479) in S. Clemente, Rome, executed by an artist close to Andrea Bregno's workshop (Fig. 183). But in the Roman work the deceased is shown in the stiff, recumbent position of a *gisant*. Tomicki, on the other hand, is represented in the 'Sansovino' position, his head resting on a pillow and supported by his right hand, while the left rests on a big book (Fig. 182).[69] Thus, by 1535 – the date of Tomicki's death is engraved on the tablet of the tomb – there existed in Cracow two examples of the most fashionable conception of recumbent or semirecumbent tomb figures in the Italian style.

The meaning of these particular positions has not been interpreted with certainty, but it is admitted that the idea of death conceived as a sleep separating the earthly life from the future life, after the resurrection of the flesh and the last judgement, may explain the representation of the dead in quiet repose, while Neo-Platonically influenced Christian concepts of a new life to which the deceased will arise are expressed in dynamized positions like that in which King Sigismund is represented.[70] The crossed legs had been connected with the representation of death and with sepulchral iconography from Classical times onwards (this was the subject of a learned controversy in the eighteenth century of which Lessing was one of the protagonists). Because it appears in the English tombs of so-called 'dying knights' of the thirteenth and fourteenth centuries (Fig. 184), Panofsky says of this motif that ', it is permissible to consider it a special distinction bestowed upon those who had died for the faith and thereby achieved a sanctity compared to that of the Holy Martyrs'. Panofsky admits that later 'funerary sculpture extended the motif to knights who had perished in other, from their point of view, equally just wars, and ultimately transferred it to persons who may have died in their beds'.[71]

In Polish tombs such as that of Piotr Boratyński in the Cracow cathedral (Fig. 185), some overtones of the idea of 'miles christianus' cannot be excluded, but one may also consider the possibility that the position with crossed legs symbolizes the state of quiet and blessed repose. In such a context the position is well known from representations of Jonah reposing in a pastoral landscape after having been vomited forth by the whale (Fig. 186).[72] In the elaborate symbolic structure of the royal chapel, which we have analysed in the preceding chapter, the statue of the king could have been the bearer of various strata of meaning. The new pattern of sepulchral representation giving visual form to the king's firm belief in salvation and post-mortal existence, as well as to his role as 'miles christianus' ruling over one of the most important Catholic countries, was perfectly appropriate. But in taking over the fashionable models, the sculptors may or may not have been aware of all these symbolic associations. These were almost certainly unknown to all the second-hand imitators, who took up both the attitude of quiet repose and that of dynamic awakening. Among the imitations of the Cracow prototypes of Renaissance tombs there is one, attributed by many art historians to Gian Maria il Padovano, that deserves to be singled out. If it is actually by him it is perhaps his best work in Poland, and it is certainly one of the most beautiful works of east European funerary sculpture. (An attribution to Berecci, already suggested in 1932, has recently been revived.)[73] Its date is unknown, but it must have been finished after 1536, when the founder of the tomb, the 'hetman' Jan Tarnowski, received the title of Cracow burgrave, with which he is credited by the inscription on the tomb. He had the tomb erected for his young wife Barbara, born Tenczyńska, who died at the age of thirty (Fig. 187).

This most Classical of Renaissance tombs in Poland is a so-called 'suspended' tomb,

situated about five feet above the pavement on the wall of the cathedral of Tarnów, some sixty miles east of Cracow. Supported by two corbels, it has the simple shape of a portico with a pediment. On the sarcophagus the recumbent figure of a sleeping young woman is shown, her head lightly supported by her right hand. The hanging tomb of the bishop Pietro Manzi dei Vincenzi in S. Maria in Aracoeli, Rome, by Andrea Sansovino (Fig. 175) – already mentioned in connection with the Sigismund I tomb – has been cited as a possible Italian model,[74] but the Tarnów tomb is distinguished by its elegant simplicity and a new feature – perhaps inspired by the Venetian tradition – that of inserting red marble panels as decoration into the sandstone of the architectural structure.

Some twenty or more years later this tomb probably served as a source for the composition of another important tomb of a woman. Its author, who belongs to the later stage of Renaissance style, and whose mark the work bears, was not an Italian, but the most outstanding sculptor of Polish extraction working in the sixteenth century. His name was Jan Michałowicz and he came from Urzędów, a small town in the eastern part of the country. We know little about his life and training and must assume that he was trained by Italo-Italian masters, such as Padovano.[75] If the Tarnów monument of Tarnowska is by Padovano this close relation would be confirmed, because one of the earliest works of Michałowicz's shows an obvious dependence on it. This signed tomb, dismantled at an unknown date, was recomposed in our century in the parish church in Brzeziny, where all its parts have been preserved (Fig. 189). From heraldic evidence we can identify the deceased lady as Urszula Leżeńska (whose daughter was a wife of Jakub Lasocki, the owner of Brzeziny).[76] But the Tarnów tomb is not the only source of young Michałowicz's invention. In the easy repose of the figure, the motif of the Sigismund tomb can be traced. Her head, shoulders and arms repeat the slightly alert position of the king, while her legs, covered by the parallel folds of the robe, reflect the composition of the Tarnowska tomb. A rather low arch framed by volutes, like that in the Wawel tomb of Bishop Konarski, closes the niche; a rich ornamental composition crowns the whole. The elaborate escutcheon is conceived in the manner of Netherlandish strap- and fret-work ornament. It seems that Michałowicz took advantage of various motifs he could see in Cracow and its surroundings, but he has transformed them into a completely logical and organic unity.

In his two most important works, the tombs of the Cracow bishops Andrzej Zebrzydowski (1562–3) and Filip Padniewski (c. 1575) in the Wawel cathedral, Michałowicz used the enlarged tomb type with lateral bays. In the former the monumental type of tomb in the shape of a portal has been fully realized (Fig. 188).[77] The upper entablature is supported in the middle by a somewhat strange element – partly a corbel, partly a capital – connecting the main arch of the niche with the entablature (Fig. 190). Above it a tall tempietto crowns the whole tomb. The figure of Zebrzydowski is obviously influenced by that of Tomicki, but his head has sharp features which express his individual character (Fig. 191). In the lateral niches and spandrels there are saints and personifications of virtues. The columns and frames which encompass the inscriptions are, however, crowded with Italian and Netherlandish ornaments. The most unusual motif is found in the architectural support in the middle of the entablature: it is a nude putto riding a wild animal, possibly a panther. Similar motifs may be found among the decorations of the Sigismund Chapel and of the canopy above the Jagiełło monument.[78] But here, situated in the middle, above the two Christian Virtues, does it have some particular meaning?

The second of the two Wawel tombs was erected in the chapel of Bishop Padniewski (Fig. 194), the architecture of which Michałowicz transformed from Late Gothic into Mannerism (Fig. 192).[79] Unfortunately it was remodelled again in the first half of the nineteenth century and the present appearance of the tomb does not correspond to the original design.[80] In a record of 1603 it was described as being above the sacristy door. The door has disappeared. Only the fortunate discovery of drawings showing the monument before the Neo-Classical modernization has made it possible recently to recognize what the original tomb looked like (Fig. 193).[81] It was the richest of all the tombs by Michałowicz. The sarcophagus was set between two columns supported by fantastic terms, between which two doors were visible. One of the doors was a real one, leading to the sacristy (later to the staircase), the other was a false one. Could they have had some symbolic meaning in addition to their practical purpose? Was there any differentiation between the two doors as there is in those represented on the pedestal of Donatello's Gattamelata monument, where one of the doors is ajar, the other closed, and where they obviously symbolize the 'door of death'?[82]

The Padniewski monument has been stripped of all its already Mannerist buoyancy and picturesque decoration. The lateral niches, supported by terms seen in profile, the volutes and putti have been taken away, and a new term was put in the middle of the sarcophagus after the doors had been walled up. The present, strangely Classicistic style of the Padniewski tomb has led scholars to propose a chronology for Michałowicz's works based on the idea that he was developing towards a kind of late cinquecento Classicism.[83] Actually this late tomb was the most complex and most decorated of his works. Together with the chapel, which today preserves the stylistic features of that time only on its outside, the Padniewski tomb was a major statement formulated in the style typical for the last, Mannerist stage of Renaissance art in the east.

Double-decker tomb type

At the time that Michałowicz was already evolving towards Mannerism in his Zebrzydowski tomb of the sixties, Padovano had reached the full development of Classicism – at least in architectural forms – formulated in the north Italian idiom. When Padovano erected his signed double-decker wall tomb of two important members of the Tarnowski family in the Tarnów cathedral between 1560 and 1570, he established a type later specially popular in Poland, that commemorating two persons.[84] But he was not the first to use this scheme. Such tombs had already been erected in the forties, one of the best early examples being that of Jan and Janusz Kościelecki in Kościelec (near Inowrocław; 1559; Fig. 196).[85] In these early double tombs the upper figure is conceived less plastically and the slab with that figure is set almost vertically, while the lower one is more tilted and framed by big volutes. It is also interesting to see that an attempt was made to differentiate the positions of the two figures – the reclining pose with crossed legs in the lower figure is contrasted with a pose recalling that of Sigismund I, but without the crossed legs.

An almost identical juxtaposition may be observed in the exceptional double tomb – or rather triple tomb – of the three Jan Tarnowskis in the Tarnów cathedral,[86] where two figures are placed in a row on the same level, while the small figure of a child is put on the upper level between the inscriptions (Fig. 195). It has been recently, and I think rightly, supposed that this tomb was originally a double vertical structure, which had been in the

choir of the cathedral, and was removed from there when Padovano began to erect his new big monument. Thus this unusual structure probably represents the remains of per-haps the first double-decker wall tomb in Poland.[87]

By 1560 Padovano had started to erect the monument in the choir of the Tarnów cathedral as a single tomb, that of the 'hetman' Jan Tarnowski.[88] He conceived it according to Venetian tradition, as a very high, monumental structure with a protruding portal, shaped like a portico in the Tuscan order, and lateral wings with allegorical statues of virtues and panoplies between pilasters decorated with coloured marble (Fig. 198). The recumbent figure of the knight was placed below a draped curtain. During the construction of the monument the son of the 'hetman', Jan Krzysztof Tarnowski, died and it was decided to include his effigy in the composition. This decision deformed the original idea, since the postament had to be enlarged with a resulting increase in the visual weight of the monu-ment. Nevertheless, as the tomb of a famous military leader and a work of high quality and monumental size the Tarnowski tomb must have contributed to the popularity of the double-decker type (Fig. 199).

It has been observed that the first version of the Tarnowski tomb could have influenced the large and rather Classical tomb of the four members of the Górka family in Poznań Cathedral, by Hieronim Canavesi (Fig. 197), a not very able artist who had his workshop in Cracow and exported his works all over the country.[89] That he must have had some commercial ability is suggested by his signatures, such as that on the tomb of the bishop Adam Konarski (1576) in Poznań Cathedral, where we read on the cornice: 'Opus Ieronimi Canavexi qui manet Cracoviae in platea Sancti Floriani' ('This is the work of H. Canavesi, who lives in Cracow in St Florian Square').[90] In the tomb of the Górkas Canavesi adopted some of Padovano's architectural framework but otherwise his conception was different: he inserted two recumbent figures, one above the other, in the central bay, while in the lateral fields, usually devoted to representations of virtues or saints, he placed two vertical reliefs with effigies of standing bishops of the Górka family. Perhaps these ecclesiastical members of the family were included as if they were intercessors and promoted to the place where allegorical figures of higher spiritual significance or statues of saints used to appear.

The popularity of the double tomb idea was sealed by the fact that the royal tomb in the Sigismund Chapel was transformed in the seventies of the sixteenth century by the addi-tion of the semirecumbent effigy of Sigismund II August (Frontispiece, Figs. 200, 202). The king's last will, dated 6 May 1571, provides, among other instructions about the way the royal body was to be buried, that a tomb similar to that of his father and situated below it was to be erected, with his own effigy modelled after that of Sigismund I.[91] The work was begun by Padovano, but he was old and his contribution was probably limited to some kind of general project. It was the Florentine Mannerist Santi Gucci who completed the work (1574-5), raising the tomb of the former king and adjusting the architectural framework for the second sarcophagus.[92] The figure of Sigismund II August repeats the attitude of his father but fits better into the decorative, rather rigid scheme (Frontispiece, Fig. 201). In this way Mannerism entered the relatively calm interior of the royal chapel. In transforming the single tomb into a double one Gucci more or less preserved, however, the restrained, serene style of Berrecci. He introduced another idea in the tomb of Anna Jagellonica, sister of Sigismund II August and wife of Stefan Batory, a later king

of Poland (Fig. 204). She directed the completion of her brother's tomb and at the same time, 1574–5, ordered Gucci to prepare a tomb for herself in the same chapel.[93] It was set in the only remaining place. Since the entrance wall and the altar wall could not be used, her tomb slab was placed before the royal throne, as its parapet, opposite the entrance arch. In this rather flat relief of red Hungarian marble another idea of dynamization appears. The slightly bent body of the queen is raised on her elbow and shown in an almost completely frontal position. But a violent gust of wind moves the folds of her heavy garments. Her left sleeve and ample robe testify to a movement which can only be understood as an allusion to a new life permeating the body of the deceased.

The same idea, expressive of the strong revival of religious spirit after the Council of Trent, was realized by Gucci in his Manneristic masterpiece in the Wawel cathedral, the tomb of the king Stefan Batory (Fig. 203), which marks the end of the evolution initiated by Berrecci's tomb of Sigismund I.[94] Gucci presented a new variation of the traditional concept of the Cracow royal tomb. Batory's eyes are closed and his legs are crossed in the symbolic position of repose, but their crossing is violent, as is also the whole position of the sharply-bent body (Fig. 205). Against the rich still-life of swords, helmets and shields, the heavy fabric of the royal mantle flutters as if raised by a powerful gust of wind. Thus the tomb seems to be a reminder of the king's dynamic life, devoted to military deeds, and at the same time its form expresses a supernatural power raising his body to a new life.

5 The Town

Urban patronage in the field of painting

IN ITALY THE Renaissance was born in powerful merchant cities, where a new attitude to reality, to the accepted norms of value and to tradition was developed. Although in the fifteenth century humanism was also advanced by princes and *condottieri*, such as the Sforza, Malatesta and Montefeltre, it obviously originated in the upper middle-class of the towns.[1] But when the new movement began to take root in eastern Europe, it was at first a court art, and a court culture, centred around Matthias Corvinus and his humanists and later around Sigismund I and his Cracow court. Having originated in towns, the Renaissance was taken over by the kings and for some time it remained an élite 'symbolic form' of the new attitude adopted by east European monarchs.

The upper middle-class in the towns of the east was, however, developing in a way similar to that in Italy and, thanks to numerous and frequent contacts with Italy or the Netherlands, the intellectual and artistic culture of towns in eastern Europe was prepared to accept the new trends. Bohemian, Hungarian and Polish towns were populated by merchants, artisans and bankers, among them many Germans and Italians.[2] Several wealthy families were established in the east in the late Middle Ages and they played an important part in the advance of new trends, since they maintained strong connections with their places of origin in Italy or Germany. The powerful family of the Cracow burgraves, the Boners, came from Alsace,[3] the Augsburg Fuggers established a family branch in Poland, which remained alive long after the extinction of the Augsburg family – the last Warsaw Fukier died only a few years ago (1959).

The life of an east European town at the turn of an historical epoch is illustrated in a unique document, the so-called Cracow *Codex of Baltazar Behem*, preserved in the Jagellonian Library of Cracow University. It is the book of statutes of the Cracow guilds, written by the town clerk and given by him to the town council in 1505.[4] Behem wrote the codex in his own hand and perhaps painted some of the initials, but there is no reason to credit him with the twenty-five charming miniatures which make his codex perhaps one of the most interesting works of secular book illumination of that time. Seven of the miniatures only show the coats of arms of various guilds, the others depict the artisans at work (Figs. 206, 207, Plate II). They are sometimes shown against landscape backgrounds, but more often inside their workshops, depicted with the analytical realism typical of Flemish painting and book illumination. Human types full of individuality are sometimes borrowed from German prints such as the illustrations for the *Narrenschiff* or the *Ritter of Turn*. The painter used some early Dürer woodcuts as his sources, and was clearly familiar with contemporary artistic trends. His grasp of perspective is rather awkward, which is surprising when compared with his sophistication in colour composition, his lively narrative, and his skill in the description of every detail of the workshops and life of the Cracow artisans.

No convincing attribution has ever been proposed for these excellent illustrations. The borrowings from German and Swiss books and prints give no clue as to the identity of the artist, since these prints were widely known among artists at that time. More significant is the Netherlandish feel in the representation of distant landscapes – the sea, bays and mountains – the atmospheric effect of which is achieved by a masterly use of colour. Zofia Ameisenowa has drawn attention to the similarities which link some of the Behem Codex miniatures with the early work of Hieronymus Bosch, and she rightly rejects Winkler's

fantastic idea that they could have been painted by an unknown *Doppelgänger* of the Late Gothic sculptor Hans Witten, working in Saxony.

The Behem Codex is one of many high-quality illuminated manuscripts produced in Cracow (Fig. 208),[5] but it is exceptional, not only in Cracow but throughout Europe, in that it gives us a *speculum* of town life in all its richness and variety, and of a wide range of social and professional groups.

The strong Netherlandish flavour notwithstanding, Karol Estreicher[6] has pointed out that the world represented by the miniatures of the Behem Codex is rich in German motifs, artistic as well as literary ones known from popular late medieval writings. The strong German element among the burghers often made the towns more inclined to accept the new art in its German or Netherlandish transcription rather than in the original Italian form. The German inclination is especially obvious as regards painting and is connected with town patronage. No really significant Italian – or Italianizing – paintings survive in eastern Europe, except those we have discussed in Esztergom, and of course those bought in later times. Matthias Corvinus certainly invited Italian painters, but neither Vladislav II in Prague nor Sigismund I in Cracow did so. The excellent paintings of the Smíšek chapel at Kutná Hora (Figs. 88–90) contain, we remember, a mixture of Flemish and Italianizing forms, but otherwise even that kind of reflected Italianism is not often to be found. The most important painter working in northern Hungary in the early sixteenth century was an anonymous master known as the Monogrammist M.S., an artist of great talent and strong expressive power, whose style bears the unmistakable imprint of German painting, especially of the Danube school. We know very little about him. His few known pictures come from an altarpiece commissioned by the butchers' guild in the Slovak town of Banská Štiavnica (Selmecsbánya) and are preserved in Hungary and Slovakia (Plate IV, Fig. 209).[7] His feeling for landscape is remarkable and it is striking that no trace of his immediate influence can be found.

The basic stylistic dichotomy characteristic of the east European Renaissance is clearly reflected in Cracow. Here several Italian stonecutters and sculptors worked in the sixteenth century; but the Cracow burghers commissioned paintings from the German Hans Süss von Kulmbach, probably the best they could get from Nuremberg, Dürer being unavailable. There are no records of Kulmbach's stay in Cracow, but the number of his works in the old Polish capital (Fig. 210) makes it probable that he went there once or twice for some length of time.[8]

The king had bad luck in getting Hans Dürer, a rather weak artist, but he succeeded in giving his commission for the altarpiece of the Sigismund Chapel to an excellent Nuremberg workshop.[9] This fact, for which Boner is to be credited, is proof of the impact which the German taste current among the upper middle-class made on court patronage. Hans Dürer made a *Visierung* of the altar, which must have been a design of the general shape adjusted to the architecture of the chapel. The exterior panels of the shutters as well as the fixed wings were painted by Georg Pencz (Fig. 211), while the silver reliefs, of excellent workmanship, covering the interior were executed by Melchior Baier and Pankraz Labenwolf from designs furnished by Peter Flötner (Fig. 212). The altarpiece is probably one of the most perfect works of its kind in existence, and it is significant that, although a great number of Italian sculptors were locally available, a German work should have been commissioned for the chapel which was the finest example of Italian architecture north of

the Alps. There were at least two Renaissance altars in Cracow made by Italian artists: one in stone, known as the Zator Altar, is now a ruin (Fig. 213); the other, the former high altar of the Wawel cathedral, a big wooden structure, is now located in a small church in Bodzentyn (Fig. 214).[10] In Hungary there remains not only the marble work by Ferrucci in the Bakócz chapel in Esztergom (Fig. 95), but also an interesting stone altarpiece in Svätý Jur (Pozsonyszentgyörgy) near Bratislava (Pozsony), Slovakia, dating from 1515–27 (Fig. 215).[11]

It seems that if in Poland funerary art was mostly the field of Italians, for the other types of artistic production, and especially for commissions from town citizens, German craftsmen were preferred.

Renaissance inlay in Slovakia and Hungary

The medieval town was an organized functional unit.[12] It lacked the specific rational and aesthetic exterior order which was introduced into ideal town-planning by the Italians of the Renaissance, but its arrangement was well adapted to its scope and function. The humanistic concept of the ideal town began to bear fruit much later. Even in Italy cases like Palmanova (1593) are rare and late, and that town was laid out for military rather than civic purposes. Therefore it is especially interesting that in eastern Europe some attempts to build ideal towns can be found. However, those of which tangible traces are preserved belong to a late period of the Renaissance.[13] The first attempts to bring medieval towns up to date were of course mostly limited to decoration. It may be claimed that almost throughout the sixteenth century the Renaissance was understood in eastern Europe as a new style of adorning buildings, either existing ones or those newly built.

The life of a medieval town in Bohemia, Hungary or Poland centred round the market-place, which was dominated by public buildings: the church, the town hall, the weigh-house, the cloth-hall. If the form of each individual house expressed the pride of its owner, these public buildings reflected the feelings and ideas of the community, and therefore enable us to study traces of the burghers' patronage. Owing to the almost complete destruction of buildings erected on royal initiative in Hungary, the few monuments preserved in the towns of what was once north Hungarian Slovakia have a double importance for us. First, they constitute precious evidence of the early flourishing of the Renaissance in east European towns; secondly, they are a substitute for the lost splendour of royal palaces.

The small town of Bardejov (Bártfa) in Slovakia, on the southern slope of the Carpathian mountain range and close to the Polish border, preserves the earliest traces of this civic Renaissance (Fig. 216). The Gothic town hall was built in the first years of the sixteenth century but between 1507 and 1509 a master called Alexius was already introducing quite different features.[14] He erected a new entrance with a small Renaissance gate crowned with a semicircular tympanum, a flight of stairs and a kind of oriel above the entrance balcony (Fig. 218). The general character is a mixture of Late Gothic and Renaissance, as are also the individual forms. In particular the portal and the stairs show a kind of distinctively interpreted Renaissance not unlike that which we met at the Wawel castle, but there are also motifs of clearly Late Gothic origin (Fig. 217). In 1508 the big hall received a coffered ceiling (Fig. 219).[15] It is not clear where Alexius could have been in touch with Renaissance models. It has been supposed that he had been in Buda or Esztergom, but Cracow has also been considered. It seems that he knew the modern style from Hungarian sources, as his

second achievement in the same building shows that he knew how to handle the modern forms with an almost Italian taste and restraint.[16] In 1507 he carved the fine frame for the council chamber doors (Fig. 220). Not all the decorative elements are orthodox, but the general character is one of great elegance. Above the cornice a semicircular tympanum is framed by an ornamental arch. Below the cornice, in the frieze above the door, a sentence suitable for the town council is written in clear, beautiful letters: IVSTVM EST AVXILIARI PAVPERI (It is right to help the poor).

The wooden doors have splendid inlays in the Italian spirit. Now the story told by Vasari about Benedetto da Maiano's visit to Matthias Corvinus with a beautiful inlaid chest, which after the wrapping was removed appeared to have been damaged by moisture when at sea, reminds us that the best masters of Italian inlay art came to Buda, and that – in spite of such mishaps as that reported by Vasari – they introduced *tintarsia* work of the highest quality into Hungary.[17]

Between that time and the execution of the Bardejov doors more than twenty years had passed, and the art of *tintarsia* must have become a popular, widely known craft. The square sunken panels of the town hall doors were made in 1509 by Joannes Mensator, whom we also know as the author of a splendid archive-cupboard of 1511 in the same building (and who also probably made the treasure-cupboard, known from a nineteenth-century drawing, dated 1525, once in the Bardejov town hall and later in the museum at Košice). The most popular inlaid works are preserved in or come from churches: they decorate the church stalls founded by the town councils, by rich families, or by ecclesiastical dignitaries. Several of them are preserved in Buda (from Bardejov, 1515–20; Fig. 221); in Levoča (Lőcse) (1516, signed by the carpenter Gregory from Kežmárk, Fig. 222); in Zagreb, a city then belonging to the Hungarian kingdom (1520, by Petrus Pictor et Sculptor and by Nicolaus Carpentarius); in Prešov (Eperjes) (1515–30); in Kežmarok (1544, by Christophorus Langinis). But the most splendid stalls are the very early ones, dated 1511, from the church of the residence of the Báthory family at Nyírbátor, now reconstructed in part in the National Museum in Budapest (Fig. 223), and in part preserved in the Debrecen museum.[18] They must have been perhaps one of the most important outside Italy. Some of the large panels are decorated with candelabra ornaments (Fig. 224); others are conceived as illusionistic pictures showing – like the famous inlay decorations in Urbino and Gubbio – half-open latticed doors and shelves with books, vessels and fruits. Scholars who have made a study of these stalls point out similarities with the famous stalls in Santa Maria in Organo in Verona of 1499 and those of the Monte Oliveto monastery in Siena, of 1501–5 by Giovanni da Verona. This connection is confirmed by the signature of the Nyírbátor stalls: F. MARONE, which may mean 'Frater' or 'Fecit Marone' (Fig. 225). Fra Roberto Marone is known as a pupil of Giovanni da Verona. He was famous, however, for figural rather than ornamental or illusionistic inlay work such as the Nyírbátor panels, and he had two brothers who were also artists. In any case the connection of this splendid work with the school of Giovanni da Verona and with the tradition of the famous Florentine workshop of the Via dei Servi is not subject to doubt.[19]

Parapets in towns and castles
This early introduction of a purely Italian Renaissance style in woodwork was peculiar to

Slovakia and northern Hungary. In the towns of the other countries the development of the new style was much more complicated and much more involved in Gothic traditions. The new style came there by indirect routes, through Austria and Germany. Most buildings, whether public like town halls, or private, still had a similar shape as before, but a Renaissance ornamental imprint was added to them as a symbol of modernity. The Gothic house was organized by vertical accents, its high roof covered by stepped gables. One of the most fundamental aesthetic problems for architects striving for modernity must have been to find a way of avoiding verticality. The solution appeared in several places. It is difficult to say where it was found first and whether the forms it took were independent or interconnected. This solution, for which Gothic precedents existed (Lübeck, town hall, 1315), was not to raise the roof above the building, but to sink it below the horizontal top line of the front, or side wall. To do this the wall had to be raised enough to allow for the inclination of the sunken roof (Fig. XI). This ingenious solution, found and adopted in Silesia, Bohemia, Poland and Slovakia, provided architects and decorators with a large, horizontal field above the top floor, which permitted, and even called for, some kind of decoration. In consequence the so-called decorated parapet or cresting was developed. It represents perhaps the most specific feature of the east European area, merging as it did the Gothic tradition of gables with the Renaissance feeling for horizontal accents and the Renaissance repertoire of decorative forms.

Fig. XI Diagram of the sunken roof house with a parapet of the Polish type

Two main types of parapet were in use in our area in the sixteenth century. These can be called the Silesian (without sunken roof, Fig. 226) and the Polish.[20] The parapets of Bohemia and Slovakia had some special features, but they can be considered as variations of the two main types. It is certainly very difficult to draw conclusions of a more general

character since we know only too well how much of the old town architecture has been destroyed by fire, war and rebuilding. It is recorded, for instance, that in 1475 a Moravian Lord Ctibor from Cimburk had already founded a regularly designed town, the Nové Město in Tovačov in Moravia, which had a regular town square with standardized houses, two floors high and provided with low parapets. This foundation is considered by Czech art historians to be the 'oldest one in the Czechoslovak area already conceived in principle according to Renaissance ideals'.[21] It was destroyed by fire in 1783 and completely built anew in the twenties of the nineteenth century. This early appearance of the Renaissance in Moravia is explained by Lord Ctibor's contacts with the Hungarian royal court. It is recorded that for a whole summer season he was allowed to use the best master from those working at the Nyék castle in Hungary to build his own castle in Tovačov.[22] His example was soon followed elsewhere. Vilém Pernštejn founded the upper town (Horní město) at Přerov in 1479. It was Gothic in style but followed Tovačov in the standardization of the height of the buildings. The same idea was realized in Pardubice, a town in eastern Bohemia, which belonged to the same Vilém Pernštejn. Pardubice burned down in 1507 and again in 1538. From that date on it was rebuilt to a modern design by the master Jiřík from Olomouc, who introduced a standardized type of house and repeated terracotta ornaments produced by the Pernštejn brickyard.[23] A Renaissance parapet of a specific type was prescribed for all the houses (Fig. 227). It is in Pardubice in 1538 that we find the oldest preserved parapets of the type I propose to call Silesian, because it had appeared in Silesia at least ten years earlier and came to enjoy great popularity.

The type which was prescribed for the Pardubice houses, and which had appeared earlier in Silesia, was a modification of Gothic battlements, whose merlons are semicircular at the top, or are formed like two quarters of a circle turned to the outside, making what is called a swallow-tail pattern. While the parapet dated 1538 on the Pardubice Green Gatehouse has simply a row of semicircular merlons (Fig. 228),[24] the oldest parapet recorded in Silesia was more complicated. It decorated the Golden Crown House erected in Wroclaw from 1521 to 1528 (Fig. 226) and was torn down in the early twentieth century.[25] This type of parapet may be studied in old photographs: it is formed of units consisting of one large semicircular merlon accompanied by two quarters of a circle turned outside on its sides. Each unit was connected to the next by a horizontal strip of masonry. At the same time, Benedict Ried, the architect whom we know as the one who first brought Renaissance motifs from Hungary to Prague, was erecting the castle at Ząbkowice (Frankenštejn), Silesia, which then belonged to the kingdom of Bohemia.[26] There he introduced semi-circular merlons very similar to those at Pardubice and like those in Wroclaw (Fig. 229). There are a few parapets preserved in Silesia from around 1540–50: in the Bolków (Bolko-burg) castle[27] a cresting of alternating semicircular merlons and of swallow-tail merlons at Paczków (Patschkau) several on the town gatehouses, on the church library and on the parish church (Fig. 230),[28] Other Silesian buildings, the castles at Grodziec (Gröditz-burg) and at Kamienna Góra (Landeshut), also have semicircular merlons,[29] while a Bohemian castle at Jindřichův Hradec shows a cresting very similar to that at Bolków, but enriched by a pinnacle between the two halves of the swallow-tail motif (Fig. 231).[30]

It should be pointed out that, while in Silesia parapets were mostly used to stress the horizontality of the wall and to disguise the roof, in Bohemia and Moravia the most current type, especially in the middle and in the second half of the century, was that which

may be called the gable parapet (Fig. 232). Instead of using an alternation of several small units, in this type the wall is crowned by one or two heavy and tall units, each composed of rather tall elements ending in semicircular or segmented shapes and arranged like stepped gables, with the highest element in the middle. This is certainly the result of the fact that such gable-parapets disguise traditional, not sunken roofs, single or double, placed perpendicular to the house front as in medieval houses. The sharp forms of the swallow-tail motifs and the intense rhythm of the vertical elements link them obviously with Gothic feeling, even in cases where – for example at the Týn school in the Old Market Square in Prague (Fig. 233) – the tops of the merlons are mostly semicircular (after 1562).

This kind of gable-parapet remained typical for Bohemia and Moravia. One of the most characteristic, beautiful and early examples was erected by Master Pavel on the town hall of Litoměřice (1537–9; Fig. 236).[31] Each wall is crowned by a parapet consisting of three units. On one side there are three gable-parapets of the type described above with round-topped merlons, while on the other the vertical pilasters or pinnacles are connected by curvilinear oblique volutes. As a result the town hall looks like two or three narrow gable houses put together, with a very tall and heavy parapet zone, almost standing by itself and independent, the dense series of vertical accents giving it an unmistakably Gothic appearance. It suffices to look at other similar Gothic gables such as, for example, those on the Trinity church at Gdańsk of 1484 (Fig. 234), to become aware of the strong links connecting these two forms. Not only are elements similar, but similar is also the striking contrast between the cubic simplicity of the walls below and the lively, rich and vibrating zone of vertical stickwork above. Such gable-parapets as those in Litoměřice became very popular in Bohemia and Moravia in the second half of the sixteenth century, not only in town halls and the houses of the burghers, but also in castles and palaces. It seems likely that in the case of castles this motif was borrowed from the artistic world of the towns. One of the first was the Lobkovic-Švarcenberk palace on the Hradshin in Prague (1545–63; Fig. 235), with gables whose strong horizontal divisions introduce a modern note. A row of such gable-parapets also decorated the no longer existing but once nearby palace of the Lords of Rožmberk, built at the same time (1545–63; Fig. 237). Both of them perhaps were influenced by the gable designed for the Vladislav Hall after 1541 and known from the preserved model.[32]

Similar solutions can be found in Poland although they are rather rare. In the Pabianice manor, built by the master Wawrzyniec Lorek between 1565 and 1571, the west and east parapets – in plan perpendicular to the axis of the roof – are composed in a way recalling Bohemian gable-parapets, while the parapet on the lower extension of the building on the west has a regular gable-parapet (Figs. 238; XII, XIII).[33] One finds similar solutions also in later Polish buildings. But the Pabianice manor is interesting not only because it applies a Bohemian type of parapet rare in Poland, but primarily because the Bohemian type is here brought into an organic coexistence with the second principal type, called the Polish parapet. On the longitudinal sides of the manor the upper parts of the walls are crowned by a high attic storey with a narrow and shallow blind arcade articulated by tall pinnacles protruding above the upper cornice and forming a dynamic skyline. When the Pabianice manor was built this type of Polish parapet was a recent innovation. The first known case of its use is dated 1557 and found in Cracow.

It was an old tradition in medieval towns to erect a large market hall in the middle of the

Figs. XII–XIII Wawrzyniec Lorek: Manor, 1565–71, at Pabianice. Parapet of the Polish type (south side), and gable parapets of the Bohemian type (west side)

market square beside the town hall. There were typical examples in Wrocław (Silesia) and Cracow. The Gothic market hall in Cracow, called the Cloth Hall, first built in the thirteenth century and rebuilt around 1390, had to be rebuilt again and modernized after it was damaged by fire in 1555. The remodelling took place from 1556 to 1560 (Figs. 239, 240), and was carried out by local and Italian masters.[34] From the ambiguous records in the sources the participation of Giovanni Maria Padovano has been deduced, but this seems to be certain only for the stairs on the short sides of the building (Fig. 241). Another Italian master, the Florentine Mannerist Santi Gucci, very young at that time, is credited with some work on the masks decorating the cresting (Fig. 243).[35] In the nineteenth century the building was restored again and at that time Neo-Gothic arcaded walks as well as unfortunate other additions were built (1875–9; Fig. 242). This now makes it difficult to appreciate fully the form the Renaissance architects gave to the building. They constructed stairs to the first floor at the short ends of the Cloth Hall, forming a balcony platform on the upper landing, supported by two arches. The first project was carried out by Jan Frankenstein, but it was found unsatisfactory and a second was prepared by Ioannes Maria,

most probably il Padovano, in 1559. All this has now been rebuilt, but at these short sides the present forms largely repeat the original ones. The most important part built at that time was the high wall disguising the roof and giving the building its specific and widely imitated character. The wall may have had a practical purpose, namely protection from fire, since the adjoining market sheds were made of wood. An important municipal law of 7 April 1544, called *de tectis aedium novarum*,[36] stipulated that all new buildings were to have high, fire-protecting walls and sunken roofs in order to prevent the spread of flames. It is quite possible, however, that aesthetic considerations also played a part. How important such structures were considered is shown by the fact that in 1568 the council of the Czech town of Hradec Králové asked the citizens to erect gables on every house, and the bricks could be had without cost from the municipal brickyard.[37]

The high wall of the Cracow Cloth Hall was crowned by a parapet of the Polish type, which found wide diffusion in eastern Europe and was even called the 'Polish parapet' in Slovakia and Hungary. It is divided into two horizontal elements: the lower one, a kind of attic storey, called in Poland a frieze, a rather large zone of masonry articulated by a blind arcade, the arches of which are separated by pilasters topped by a projecting cornice; and, above it, the second element, the cresting which consists of vertical shafts of masonry above every second pilaster, connected by horizontally placed S-shaped volutes. On the shafts alternating masks and vases are placed. In this way the picturesque and dynamic skyline which became one of the typical landmarks of the east European late Renaissance was created. A Gothic tradition is seen in the marked vertical rhythm of the frieze, but the mild dynamism of the horizontally-placed Lombard volutes and the irregular silhouette of masks and vases give it a specific, gay and quite unmedieval character.

It is easy to understand that such innovations, merging the traditional use of merlons with a modern decorative vocabulary, must have been a success. The majestic Cracow building promoted the use of the parapet first in the town halls of southern Poland. At Tarnów the remodelling of the town hall was certainly done by the same workshop as in Cracow and the execution is perhaps even somewhat finer (Fig. 244).[38] It has been connected with Padovano, especially since he was active, we remember, for the Tarnowski family, erecting its tomb in the Tarnów cathedral. This town hall was also restored in the last century, and much of it was rebuilt.

The basic idea, taken over by local architects and stonemasons, underwent manifold variations. The frieze or attic storey was usually formed by a blind arcade, but the cresting of the parapet was conceived in various ways. Sometimes combinations of volutes and vases were used; sometimes series of small pedimented gables alternating with pyramids or other vertical elements topped with spheres or semicircular forms. Not only town halls, such as those in Sandomierz and Szydłowiec, but also fronts of private houses were decorated in such a way, for instance the so-called 'Black House' of Dr Anczowski in Lwów (Fig. 245), and the house of the Baryczka family in Warsaw. We find similar parapets also on castles and palaces, such as those at Baranów and Krasiczyn (Figs. 336, 338), and on town gatehouses, churches, convents, monasteries and synagogues, where parapets were especially often used, e.g. in Żółkiew, Husiatyn, Luboml (Fig. 246) and Brzeżany.[39]

The Polish parapet penetrated into Silesia, where it became very popular. The total number of parapets known from existing monuments or iconographic sources to have existed in Poland is about 150 and the same number is recorded for Silesia (Fig. 247). In

that country the Polish parapet was so widely diffused that it was even accepted by peasants and is found in the countryside, for instance on cemetery walls.[40] In Silesia the Polish parapet had an exceptionally long life, the last examples dating from the late eighteenth century. It is from Poland that this kind of parapet is assumed to have spread to Bohemia, Moravia and Slovakia, or northern Hungary, where it was used from the second half of the sixteenth century and became extremely popular. In Hungarian this type is called the Polish parapet.[41] But in all these countries various types meet. To be sure, in Bohemia and Moravia the gable-type parapet remained the most popular, but parapets at the town hall at Plzeň of 1554–9 (Fig. 249) are similar in general character to the Polish type, although here, too, three gables are ranged along the top of the wall above the cornice and the roof is not sunken. It was built by Hans Vlach (= Italian), who has been identified as Giovanni de Statio from Massagno near Lugano.[42] On the wall enclosing the courtyard of the Lobkovic–Švarcenberk palace in Prague (1563; Fig. 235), on the house at Veselí on the Lužnica (after 1560), on the old town hall of the same town of 1617 (Fig. 248), on the front of the enclosure of the Boskovice castle of 1568 and on the town hall of Český Krumlov of about 1580 (Fig. 250) we find structures which seem to be similar to the Polish parapet. In Prachatice in 1604 a Polish parapet type appears on the Zd'arski house. On the town hall of Sušice, later used as a dean's house, a gigantic parapet of the Polish type was built around 1600 (Fig. 251) with a double blind-arcaded gallery.[43]

In Hungarian Slovakia, the castle at Betlanovce (Bethlenfalva) in the province of Spiš, built in 1564 (Fig. 252), represents the local transformation of Polish or perhaps Silesian models: a simple cresting formed of short vertical elements between two quarters of a circle.[44] Similar parapets are found on several castles, town halls and church towers in the region of Spiš and its surroundings (the castle at Fričovce (Frics) in Slovakia (Fig. 253) and Niedzica (Nedec) in Poland (Fig. 254), the castle in Krępachy and Frydman (Fig. 255) in the Polish Spiš, in Kežmarok and Svíňa). In Hungarian Slovakia some towns, such as Levoča (Lőcse) (the Turzo house) and above all Prešov (Eperjes), adopted the Polish type of parapet and used it in great numbers (Figs. 256–7).[45] The whole structure is sometimes supported there by a series of volute-brackets. This specific feature does not appear in Poland, but sometimes occurs in Bohemia (for instance, in Telč).

Specialists have tried to find the sources of this specific motif.[46] Certainly the swallow-tailed battlements were current in Italy (Fig. 258),[47] and battlements with semicircular merlons, more developed and perhaps not so closely connected with the old tradition of crenellation, appear in Venice on the Scuola di San Marco and on the basilica of the same saint (Fig. 259). Was this motif really brought to Silesia and to Bohemia from Italy? The cathedral at Halle, built from 1520 to 1523, has a series of semicircularly topped panels around the roof base (Fig. 260),[48] and Mieczyslaw Zlat in his excellent study of Silesian parapets points out other preceding or parallel cases in Germany, in the castles at Bernburg and Bückeburg. There are also similar forms to be found in Lower Austria, for example in Stein (Fig. 261). Dr Zlat however holds to a north Italian source. It seems that the problem has not been solved and I do not think it impossible that the Silesian parapet could have been developed from the Gothic tradition by northern architects.[49] To introduce round or semicircular forms was normal in some trends of Late Gothic architecture and we can point out examples in the Parler buildings in Prague as well as in Gothic structures in Gdańsk or Malbork. It would also correspond to the main tendencies of the much discussed

Romanesque revival. That Silesia influenced Bohemia is quite possible. In her history of Czech architecture of the Renaissance Dr Šamánková assumes that the Silesian type was brought to Bohemia from Wrocław by the architect Jiřík of Olomouc, working at Pardubice.[50]

Another problem is posed by the Polish parapet with its outspoken Renaissance motifs of volutes, masks and vases. These must have been created by an Italian master, and, since no exact Italian precedents are known, by an imaginative one. It is therefore understandable that the name of Padovano has been proposed.[51] As we do not know any works by Padovano which could serve as support for such an attribution, no answer, positive or negative, is possible. If we leave aside such a specific decoration as that by Michelangelo on the Porta Pia, the only building in Italy which has been mentioned in connection with the Polish parapet is the Palazzo Emo Capodilista in Montecchia, near Padua, built by Dario Varotari (Fig. 262).[52] It too has a sunken roof and a parapet of not dissimilar shape, but without a frieze. The Polish parapet had Italian sources, but it was formulated in Poland and achieved its splendid development in eastern Europe, obviously ideally suiting the local Gothic tradition, as well as the need for playful and picturesque modernity.

Town halls: the importance of Poznań town hall

Except for their parapets the new buildings erected in towns were rarely original. Some of them, such as the town hall in Plzeň, had a sober proportional symmetry, but most were composed mainly from the inside, which was adapted to the needs of the owners, the outside being a kind of negative shape. Sometimes Renaissance motifs were inserted into a Gothic structure, as in Wrocław, where an oriel quite correctly designed in the Renaissance style and not without reminiscences of the Wawel Renaissance was built on the town hall in 1548, probably by the architect Lorenz Gunter (Fig. 263). In the same building portals, which were obviously a result of the endeavour to be up to date, were built in 1528; a similar portal, leading from the aisle to the sacristy of the Wrocław cathedral was already erected in 1517. Their style, however, originating not from the Cracow Renaissance with its considerable purity but from Saxon or other German sources, represents a hybrid combination of Classical motifs with a Late Gothic tendency towards complication and ornamentation.[53]

Since the Brzeg town hall was considerably transformed in later times, there is perhaps only one really outstanding town hall of the Renaissance in eastern Europe, that in Poznań, western Poland, built by an architect representing – in contradistinction to the Florentine tradition so prevalent in Cracow – the north Italian taste current in northern Europe. He was Giovanni Battista Quadro and came from Lugano in the Lombard Lake district.[54]

If the Renaissance transformations of Slovak town halls in Upper Hungary introduced porticoes on the upper floor, as in Banská Bystrica (Besztercebánya) (1564–5), or on both the ground and upper floors, as much later in Levoča (Löcse) (1615; Fig. 264),[55] in Poznań Quadro based his architectural composition on the juxtaposition of two basic motifs: arcaded loggias on all three floors and a huge parapet crowning the façade above (Fig. 265). Quadro was not free to compose the building as he wanted, since he was only charged with a Renaissance transformation of a Late Gothic town hall, the powerful square tower of which is still visible above the parapet. He had to adjust the new Renaissance coat to the old building and he did so in a masterly way, both outside and inside.

The Gothic building, too, is recorded to have had loggias like the town halls in Brunswick or Brussels; but the way Quadro composed the façade in Poznań is deeply rooted in the Renaissance theory and practice of architecture.[56] On a rather high substructure covered with illusionistic rustication there are two storeys of arcades, each of five arches, with narrower blind arches at the sides. The arches rest on pilasters which flank Doric, or Doric-Tuscan, engaged columns supporting the entablature above the lower floor. The second storey is articulated differently, since the third storey is composed of arches only half as wide as the two lower rows. Here the engaged columns stand on high, narrow pedestals, which are continued below by pilasters descending alternately to the capitals of the columns on the second floor and to the keystones of the arches of that storey. Between the second and the third storey there is a kind of long frieze divided by those narrow pilasters into panels, which were decorated with sgraffiti. This lower part of the façade consists then of three storeys of arcaded loggias framed on both sides by narrow blind bays. Several elements of this part derive from Serlio's architectural treatise, as has been shown in the analysis of the building by Jerzy Kowalczyk. He points out especially the idea of the superimposed loggias and the details of their architectural orders; the semicircular stairs, which seem to be a partly-adopted scheme of the famous 'escalier à double mouvement inverse', published by Serlio and popularized by his treatise not only in Europe, but even in Ecuador; the illusionistic rustication; and the paint imitating marble, which appears on the third storey. Serlio's motif also influenced other elements of the building, such as the portals leading from the second floor loggia to the great entrance hall (Fig. 267), and the composition of the coffers decorating the vault of that hall (Fig. 268).

If the lower part of the façade is Classical in motifs and Italian in origin, the upper part has a different character (Fig. 269). Above the third storey there is a recess covered by a narrow roof, and a gigantic parapet serves as the crowning element of the whole. It is, however, very different from all the types of parapet we have analysed until now. It consists of a high wall divided horizontally into three zones and surmounted by a cresting composed of palmettes supported by triangle-forming volutes. The parapet wall is flanked by two octagonal towers, continuing as it were the short flanking bays of the lower part of the façade, while the centre is accentuated by a third tower, also polygonal but with a broad front wall decorated with a (later) clock. The towers are twice as high as the parapet wall without the cresting. What results is strikingly similar to the composition of city gates (like that in Lublin; cf. Fig. 266) and to the coats of arms of many towns. It is a very great *corona muralis*, like the section of a city wall with towers and a gate, a symbol of the independence and authority of the town and its government.[57]

The three storeys of arcades ruled by the harmonic principles of Classical architecture introduced the motif of Classical order, giving its authority to the seat of municipal administration called the *praetorium*. The crowning element is of a different character; it too is composed of Italian motifs, some of them, such as the palmette, of Classical origin, even connected with the composition of antique pediments. But its crenellated skyline and the powerful towers seem to recall the medieval tradition, and the whole is like a summary of symbols uniting the principle of rational order with that of authority and power.

When Quadro erected this masterpiece between 1550 and 1560 there were no Renaissance town halls with arcaded loggias in northern Europe; the one in Cologne was to be built in 1568–71 and the one in Stuttgart in 1575–93. The whole concept must have been

too far removed from the taste of Polish burghers, with all its picturesqueness achieved by the fantastic skyline and by the moralizing reliefs, painting and sgraffiti. No imitations of this building are known and it remains the only genuine Renaissance town hall in eastern Europe. The fact, however, that such a structure could have been erected is evidence of the deep transformation of the spirit and culture of the townspeople. The humanistically-trained representatives of the upper middle-class wanted to transform the medieval market place of the town into a well organized, representative modern plaza.[58]

The educated and cultured burghers could erect a magnificent building symbolic of their ideology of the well-ordered town, but they were of course unable to make the idea of a new ideal town a reality. This was possible only for a great lord. And perhaps it was just in Poland, at the time when the independence, economy and power of towns began to decline under the pressure of the gentry introducing the refeudalization of the country, that a highly intelligent and humanistically educated, powerful magnate, chancellor of the kingdom and great hetman of the army, could venture to do what was so rarely done even in Italy: to build a new, ideal town from scratch.

Ideal town planning in eastern Europe: Zamość

Jan Zamoyski was educated in Paris and Padua. He wrote a scholarly study of the Roman senate and after returning home he became one of the most prominent dignitaries of the state.[59] He accumulated an immense fortune and to make sure that it would not be dispersed he introduced a rule of inheritance by the eldest son and prohibited the division of his possessions. He also decided to erect a new residence in the middle of his estate, together with a new town and a new fortress.

This town, Zamość, was not the first Renaissance town in eastern Europe,[60] but of the first two or three not much remains. We have already spoken of towns rebuilt in a systematic lay-out in Moravia and Bohemia.[61] There was also a regular town built in Győr (Fig. 270), which is known from an illustration in Speckle's treatise on fortifications, of 1589. A famous example was that of Nové Zámky (Ersekujvár), a Hungarian fortress in Slovakia, erected from about 1562 by a famous specialist in military architecture, Ottavio Baldigara, who enclosed a regular grid of streets in the hexagonal plan, with a large square in the centre and two small ones at the ends of the transversal axis, close to the city gates (Fig. 271).[62]

In Poland, too, there was a somewhat earlier example of a new regular town, founded by the royal secretary Krzysztof Głowa in 1570 and called Głowów. But this was very simple and without any artistic merit,[63] whereas Zamoyski's initiative resulted in something that was very rare: an ideal town not only in exterior shape but in intrinsic meaning as well.[64] He found an excellent collaborator who put his ideas into practice and gave them a fully developed artistic shape: the Venetian architect, Bernardo Morando, who had built some early works in Warsaw and elsewhere and who agreed, on 1 July 1578, to erect a castle at Zamość for the chancellor.[65] It was an open stretch of countryside at that time and Zamoyski had chosen the site because it was roughly midway between Lublin and Lwów, which was important from a commercial point of view. It seems that at first the castle was projected as separate from the town; as is to be seen from the reconstruction of the original plan by Teresa Zarębska, a specialist in the history of Polish town-planning, it was a hexagonal composition, similar to Nové Zámky (Fig. 274).[66] Both Francesco di

Giorgio Martini's and Pietro di Giacomo Cattaneo's plans of ideal towns (Fig. 272) are considered possible sources of inspiration to Morando.[67] But then it must have been decided to combine town and castle in a unit – an idea that was not foreign to Renaissance urbanistic theory. What resulted was a juxtaposition of the rectangular scheme of fortifications surrounding the castle and what remained of the hexagonal shape of the town. Topographical conditions and later changes caused other deformations and what was built between 1587 and 1605 is more regular inside than in the shape of the enclosing fortifications with the seven Italian bastions, which were the most up to date in Poland and very modern in Europe as a whole (Fig. 273).[68]

The 'head' of the town, in the west, was the castle of the lord. In the east the city was organized by two axes crossing at the main square, with the town hall standing at one side. The longitudinal axis connected the eastern central bastion with the centre of the castle. The transversal axis united the central square with two additional market squares, the salt and the water markets. Between the town proper and the castle a 'spiritual zone' was inserted, if we may call it so: two 'temples' were visible to everybody approaching the castle from the town: to the left the collegiate church (Fig. 275),[69] to the right the now completely transformed academy, the newly founded university, with its own printing house.[70] In this way Zamoyski not only built a new town uniting the most modern system of fortification with rational regular urbanism, but also created a whole civic unit, uniting religion (to which he was as strongly devoted as to humanism), education, commerce and defence.

Zamoyski wanted to give a consistent artistic shape to this new organism. Morando erected the church, transplanting to Poland the early Venetian Mannerism of a Sanmicheli or Falconetto,[71] and a town hall, which no longer exists, having been replaced by the present one in the early seventeenth century. He also designed a distinctive house type, unifying the whole by the north Italian porticoes running not only along the walls of the square but also along other streets (Fig. 276).[72] Throughout the town he used the same module of one Polish rope, roughly 50 yards long (45·5 metres).[73] The church has precisely that length.[74]

The castle strongly dominated the whole scheme, and although the town was based on Renaissance tradition, the style in which it was built already included elements of Mannerism.

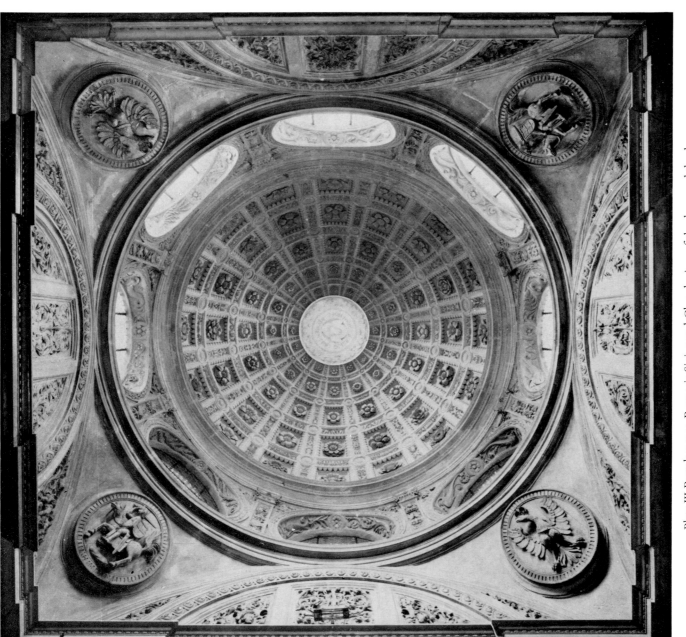

Plate III Bartolommeo Berrecci: Sigismund Chapel, view of the drum and the dome

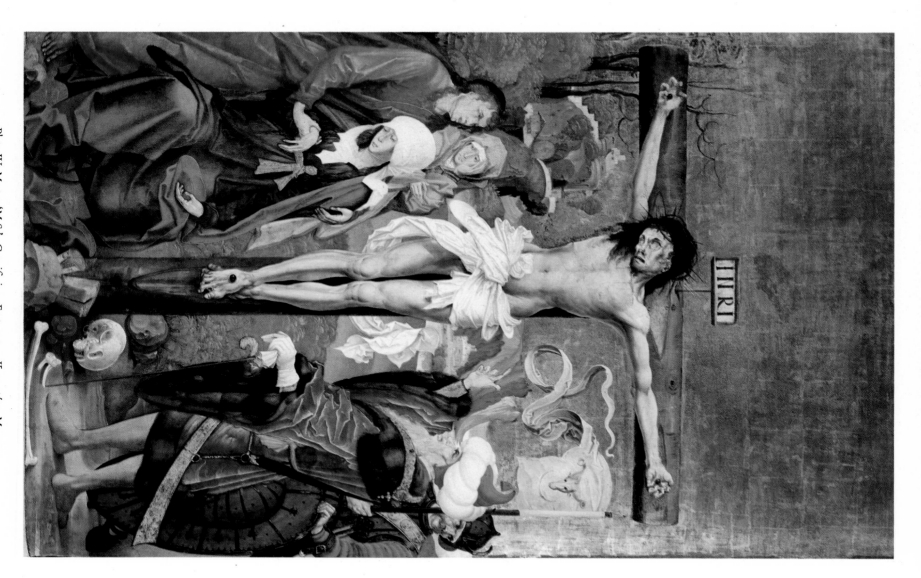

Plate IV Master 'M.S.': Crucifixion. Esztergom, Keresztény Museum

The High Renaissance villa and the Mannerism of Wohlmut

WHEN BENEDICT RIED died in Prague in 1534, the political situation was quite different from that which had constituted the background for his buildings on the Hradshin, where the first Renaissance motifs had appeared. After Vladislav II's death his son became king of Hungary and Bohemia under the name of Louis II. But the young king's reign was short and ended tragically in the terrible battle at Mohács, which was won by the invading Turkish army in 1526. As a result large areas of Hungary were occupied by the Moslem forces and the remains of the Hungarian state were split into a more or less independent Transylvania, which recognized Turkish sovereignty, and the small areas in the west and north of the country, which had to rely on the Habsburgs for their defence (Fig. XIV). And the Habsburgs took this opportunity to fill the vacuum left both in Hungary and in Bohemia. In 1526 the Austrian ruler, Archduke Ferdinand, brother of the Emperor

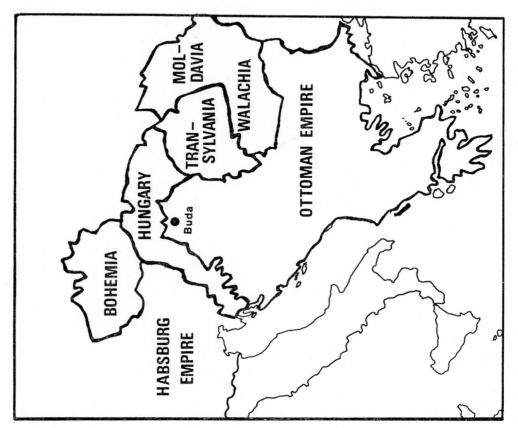

Fig. XIV Map of south-eastern Europe after the Battle of Mohács, 1526, and the occupation of Buda by the Turks, 1543

Charles v, and husband of Anne, the daughter of Vladislav II, received the crown of Bohemia in Prague and became king of the reduced north-western part of Hungary.

This opened a new period not only in the political history of central and eastern Europe but also in Bohemian art. The Renaissance had come there previously in its Florentine version through Buda and Esztergom. Now Ferdinand hired north Italian architects and sculptors – partly from Vienna[1] – and in 1538 construction started in Prague of what was to become the first among the preserved secular Renaissance buildings in the Italian style built in eastern Europe 'fuori le mura' of the castle (Fig. 279).

It was as early as 13 November 1534 – a fortnight after Ried's death incidentally – that Ferdinand I wrote to his burgrave in Prague that he intended to arrange a garden outside the castle. He hired Italian artists and builders for that purpose and ordered the grounds to be prepared. It was pointed out by Pollack long ago, in his study of Prague Renaissance architecture, that the date 1534 thus receives a symbolic meaning.[2]

The king's choice was Paolo della Stella of Genoa, who in 1537, while still in Italy, designed the garden villa and in 1538 started to construct it with a team of thirteen Italian stonemasons. At the time of his death in 1552 the ground floor with loggias was finished. The villa, called the Belvedere or summer palace (Letohrádek) of Queen Anne, situated on a hill close to Hradčany, but separated from it by a moat (the so-called Stag Moat), was included in the regular garden scheme with a Mannerist fountain (Fig. 281). It is a simple two-storey building, its ground floor screened by a beautiful arcaded loggia running round it, and with a terrace surrounded by a balustrade on top. The upper floor and the roof, somewhat recalling Italian roofs like that of the Palazzo della Ragione in Padua, or Palladio's basilica in Vicenza, but not without some traditional Late Gothic curvilinear design, were constructed later by Stella's successor Bonifaz Wohlmut (1556–63; Fig. 280). Details were changed, but the general character of the villa must have already been decided upon in the first stage of construction.

Stella combined in his work a High Renaissance design of exquisite elegance with details and ornaments in the Mannerist style (Fig. 282), for which he relied on recent pattern books by Serlio, who introduced solutions that were to become very popular in eastern Europe. But as a whole the villa with its outspoken Classicism was and remained something foreign to the artistic landscape of that area, and no imitation of it is known. Compared with the tremendous influence exercised by the Wawel castle and the royal sepulchral chapel in Cracow, this complete lack of resonance from the Prague royal villa must be interpreted as a symptom of the radical separation of the first Habsburg monarch and his court from Bohemian society.

To be sure, the Belvedere was not the earliest Italian villa in eastern Europe. We know little about the *villa marmorea* constructed outside the castle of Buda for Matthias Corvinus[3] or about the lodges built later for the same monarch at Nyék near Buda,[4] but the remains of these buildings, brought to light by excavations, show an extremely high quality of workmanship (Figs. 19, 54). One of them had wooden arcades outside, like the hunting lodge built by Ried for Vladislav II at Bubeneč in Prague, but completely rebuilt in later times.[5] Excavations and written records give evidence of several Renaissance country houses built for Polish dignitaries of church and state in the neighbourhood of Cracow, some of them situated in the picturesque valley of the Prądnik river.[6] The only one still in

existence is the villa built for Jost Ludwik Decius (about 1485–1545). He was of German extraction, director of royal mints in Cracow, secretary to King Sigismund I and author of economic treatises and of a history of Sigismund's reign.[7] Decius's villa was erected near Cracow in a place called Wola Justowska after his first name. Its present shape goes back to a seventeenth-century remodelling (about 1616–21), but there is no reason to think that a very radical change in its form was made at that time (Fig. 277).[8] The front consists of a three-storeyed loggia between two short lateral wings; its plan seems to be a simplification of Serlio's Poggio Reale design (Fig. 278). Nevertheless, from the present shape of the building we cannot draw reliable conclusions as to its original form.

Stella's villa in Prague introduced a fully developed north Italian Classicism, not without Quattrocento reminiscences and in its general idea similar to Palladio's villa style. Its appearance in Prague at the end of the first half of the sixteenth century brought the Bohemian Renaissance up to date.[9]

This specific kind of elegant style rooted in Early Renaissance tradition was continued in the more Manneristically minded Classicism of Stella's successor, Bonifaz Wohlmut, a south German master (from Iberlingen in Baden), who came to Prague from Vienna in 1554 to become the royal architect. Everything he built in Prague shows a style unexpected from a northerner, a style imbued with Italian post-Classical tendencies, but also manifesting a considerable freedom in the use of the stylistic repertoire of his time and, in the restrained austerity of decoration and noble sense of monumentality, approaching in some way the estilo desornamentado of Habsburgian Spain. Wohlmut's main works were the completion of the Belvedere Villa, the erection of the organ loggia in St Vitus's Cathedral, the rebuilding and furnishing of the Parliament wing in the Prague castle, the construction of the Ball Court in the Hradshin Garden, and the completion of the most interesting Manneristic project – the Star-Villa Hvězda outside Prague.[10]

What Wohlmut built at the Belvedere Villa (1556–63) seems at first glance to harmonize extremely well with the already existing ground floor (Figs. 279, 280), but it nevertheless represents a different approach to architecture, one which appears there for the first time in eastern Europe. Stella's arcaded loggia had been conceived as an aggregate, while Wohlmut's upper storey presents a solid wall with alternating windows and concave niches carved deep into the material of the wall. This Roman compositional motif, recalling Bramante's Tempietto, introduced an architecture conceived in terms of sculpture, and Wohlmut's subsequent works developed this style.[11] His masterpiece is the Royal Ball Court in the garden, of 1567–9 (Fig. 283), a monumental block organized by the regular rhythm of heavy engaged Ionic columns, which seem to be carved from the same hard mass of stone into which the deep niches are opened. Six bays in the middle of the façade have large arches running through their whole height while the two exterior bays at each end of the façade contain arched windows surmounted by niches. This contradicts the uniform rhythm of columns and introduces a tripartite division. The sturdy and sculptural character of the building is overstressed today, owing to the almost complete disappearance of the sgraffito decoration that once covered the niches, arcades, walls and spandrels with dynamic and delicate patterns, as if to counteract the massive seriousness of the structure with brittle Mannerist ornamentation.[12] Some parts of the decoration have been restored and they allow one to visualize the original shape of the building (Fig. 284).[13] The architectural articulation goes back to Palladio, but it is handled with considerable freedom, as

for instance when Wohlmut makes the cornice protrude above each capital, thus stressing the balance between vertical and horizontal divisions.

Still more powerful in expression is Wohlmut's organ loft in Prague Cathedral (1556–61), removed to its present location in the left transept in the early twentieth century (fig. 285).[14] Two storeys, each composed of three arcades in the shape of triumphal arches, constitute a monumental, sculptural structure, sturdy and flat at the ground floor, where heavy pillars are decorated with pilasters, while in the upper storey again massive engaged columns emerge from the wall, into which arches are cut, and support the simple entablature crowning the composition. The startling thing is that inside this severe Classical loggia there is Late Gothic rib-vaulting (fig. xv). Wohlmut's Classicism, serious and true as it was, concerned the sculptural exterior shape of his structures. When confronted with vaulting problems, he reverted to the Gothic traditions, in which he had grown up. He did this again in the Parliament Hall of the Hradshin Castle (1557–63).[15]

Fig. XV Bonifaz Wohlmut: Organ loft. Prague, St Vitus's Cathedral. Plan of the vaulting of the ground and second floors, following O. Pollak

The contrast of stylistic modes has an opposite character there. While in the organ loft the exterior structure was Classical and the interior vaulting was Late Gothic, in the Parliament Hall the vaulting is again Late Gothic, but inside this space a splendid Classical piece of architectural furniture is erected: the lodge of the Secretary of State, in the shape of a free-standing structure with its main long wall organized according to the triumphal arch pattern (fig. 286). Its three arches are separated and framed by four engaged Ionic columns typical of Wohlmut, which support an overcrowded entablature, its frieze bursting with dynamic, lively winding tendrils, leaves and flowers, which recall Roman imperial decorations.

Wohlmut's contribution to east European art remained a local phenomenon limited to royal patronage; it has precedents in the Austrian Renaissance, for example the portals in the so-called Schweizertor of Vienna's Schweizerhof, probably by Pietro Ferrabosco (1552–3; Fig. 287).[16] The only parallels to Wohlmut's style are two majestic castles of Bohemia, in Kačeřov and Nelahozeves, built by an unknown architect, probably of Viennese origin, for the secretary of the Bohemian chancellery, Florian Griespach from Tyrol.

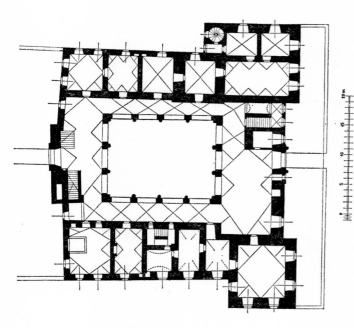

Fig. XVI Plan of the castle of Florian Griespach, 1540–56/8,
Kačeřov. The right-hand side faces north

Castle architecture in Bohemia, Moravia and Poland

The castle of Kačeřov was started in 1540 and was completed by 1556 or 1558 (Fig. XVI).[17] Neglected since the eighteenth century, it burned down in 1912 and is today a ruin in the course of restoration. But it still testifies to the high ability of its builders. The east entrance portal with its heavy rustication, combined with Tuscan columns, and the west entrance with an obviously Mannerist play of empty rectangles framed by thick stone posts above the deep chiaroscuro of rustication (Fig. 288) have a powerful effect, recalling Giulio Romano or Peruzzi.

Kačeřov was conceived as a four-winged structure with an arcaded courtyard in the middle (Fig. 289). At Nelahozeves, where work began in 1553 and lasted until 1572 (though the east wing portal was not built until 1613–14), the plan is considered to have been inspired by French rather than Italian models. The southern wing is missing, and the result is an open-court type, similar to the plans found in Ducerceau's model books (Fig. XVII).[18] The imposing castle has rustication in the form of quoins on the corners, window frames, and the basement storey (Fig. 290). The west wing is crowned by a protruding cornice supported by lunettes. In the courtyard, above the heavy rusticated arches of the ground floor, there is an elegant loggia, two arches in each bay between Ionic columns with stone bands (Fig. 291). In the rustication of the west gate as well as in the spandrels of the pillars of the courtyard, escutcheons framed with thick 'rollwerk' ornaments introduce a Mannerist note reconfirmed by the long, smooth Michelangelesque volutes linking the second floor arcades with the cornice above. Both these castles are unique in the Bohemian area, and their form remains a riddle. Having been built for a foreigner, a dignitary of the Habsburgs, they found few imitators. It is true that some features of Nelahozeves have been picked up: the lunette cornice, which is of a type used at the same time in Lobkovic Castle at Prague; the rustication of the ground floor of the arcaded courtyard; and – perhaps most important – the fact that the courtyard is open on one side, a French feature that became very popular in Bohemia and Moravia.

Another castle, that at Kostelec nad Černými Lesy, was built first for the king from 1549 on, then continued for Jaroslav Smiřický ze Smiřic by Hans Tirol and later by Ulrico and Gian Maria Aostalli (Avostalis). It was finished by 1560, but very much transformed in the Baroque period and in the eighteenth century (Fig. 292). This castle belongs to a much greater degree than Kaceřov and Nelahozeves to the typical architectural repertory of Bohemia.[19] Its general shape goes back to that quite traditional idea of a quadrangle with round towers at the angles. It has three storeys of arcaded loggias on one side of the courtyard and in this it represents typical features of the area. The traditional medieval four-tower scheme became common in the east European area – in Poland, Hungary and Slovakia[20] – and castles with three storeys of arcaded loggias constitute a quite numerous group, which is especially well represented in Moravia.

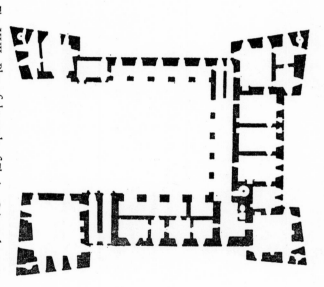

Fig. XVII Plan of the castle of Florian Griespach, 1553–72? and 1613–14, Nelahozeves. North is at the bottom of the plan

It is a splendid sequence of architectural achievements: in Moravský Krumlov (1557–62, perhaps by Leonardo Garda da Biseno; Fig. 294), in Opočno (1560–7; Fig. 293), in Bučovice (1567–82, designed by Pietro Ferrabosco, built by Pietro Gabri; Fig. 299), in Litomyšl (1568–73, by Giovanni Battista and Ulrico Aostalli [Avostalis], Fig. 297), in Pardubice (after 1560), in Náměšť nad Oslavou (1573–8; Fig. 295), in Rosice (1570–97), in Jindřichův Hradec (about 1580; Fig. 296), in Velké Losiny (1580–9), in Uherský Ostroh (1590s), in Dřevokostice (end of the sixteenth century), and in Ivanovice (1608–11), to name only some of them – three storeys of splendid loggias piled one above the other on two or three, never four, sides of the courtyard. They are often identical or almost identical in shape, sometimes differentiated according to the traditional Coliseum scheme of three orders, or with more sturdy, rusticated pillar arcades on the ground floor.[21] It would be difficult to find outside Italy so rich a group of Renaissance castles in the sixteenth century, and in

Italy itself the three-storey arcaded court is rather an exception. These castles differ considerably in their exterior shapes (which were sometimes quite original but often adapted from medieval structures) and sometimes in their general character. The idea of the arcaded courtyard, however – perhaps still inspired by the Cracow castle or imported through Austrian structures like the Porzia Castle in Spittal an der Drau, Carinthia (started about 1553 but finished much later), the Landhaus in Graz by Domenico dell'Allio (1556–63) or the Vienna Stallburg (1559–65) – found a wider acceptance in Bohemia and Moravia than anywhere else in Europe.[22] It is also significant that in Poland, the country where the idea appeared earliest, repetitions of the three-storey arcaded courtyard, like those at Pieskowa Skała (about 1580; Fig. 300) or Wiśnicz (1621), as well as two-storey ones like those in Niepołomice (1550–71), Żywiec (1569), and Sucha (1614), are not nearly so numerous as in the Czech area and do not have such a high artistic quality as the arcades of the Moravian castles.[23]

While the arcaded courtyards are a belated echo of the Renaissance, the Mannerist way of thinking makes its appearance in Bohemia at an early date. Mannerist motifs can be traced in the castles with arcaded courtyards, for instance in the Serlian type of pilasters at Kostelec nad Černými Lesy,[24] at Litomyšl,[25] in the so-called Michelangelesque stairs at Náměšt' (Fig. 301), or the portals of the same building.[26] The portal of the Litomyšl castle (Fig. 325) developed the idea, which had appeared at Kačerov and Nelahozeves, of a heavy diamond rustication and shallow concave niches on both sides of the door. In the Hungarian Sárospatak castle the typical Serlian motif of a large shell between two bird wings was adopted (Fig. 302).[27] But all these are Mannerist decorative ideas rather than true Mannerist architecture. There are, however, at least a few examples of an abstract conception of architecture. The earlier one is, it is true, due more to the whim of a dilettante patron than to the professional sophistication of an ambitious artist; the result is nevertheless remarkable. A hunting lodge was built for Archduke Ferdinand of Tirol, governor of Bohemia, on behalf of his father, the Emperor Ferdinand I, outside Prague at a place called White Mountain, which was soon to become a symbol of Czech disaster: the battle fought there in 1620 was to put an end and even to the partial independence of the Bohemian kingdom.

The villa, built in 1555–6 under the direction of Hans Tirol by two Italian architects, Juan Maria del Pambio and Giovanni Lucchese, was designed by the archduke himself in the shape of a six-pointed star (his design is preserved in the Nationalbibliothek, Vienna; Fig. XVIII); the palace was called accordingly 'Star' ('Hvězda') (Fig. 303).[28] This unusual shape was extremely inconvenient for any practical arrangement of the interior, and what the architects finally erected, following the idea born of the prince's fancy, must be acknowledged as a very skilful solution. Six rhombic, irregular interiors surround the central polygonal room, with which they do not communicate, making a composition with neither front nor rear, a unified suite of awkwardly-shaped rooms that creates the impression of a labyrinth, each spatial unit following the other without differentiation. The rich, monochrome stucco decoration of the central room with its outspoken Classicizing character contrasts with the sober simplicity of the stereometrical exterior (Fig. 304).[29] The very low and dense relief is divided in a way which stresses the polygonal shape of the room. But the final touches were given to the Hvězda castle by the architect of the Ball Court and the organ loft – Bonifaz Wohlmut. He surrounded the villa with a fortification system of Italian origin, with four corner bastions, and added the so-called *sala terrena* (1556–8; Fig. XIX).

Mannerism was brought to Poland by the very original Italian architect and sculptor, Santi Gucci, whom we have already met as the author of the tomb of the king Stefan Batory. Gucci was, like so many Italians coming to Cracow, a Florentine, and – arriving soon after the middle of the century – he brought to Poland the recent stylistic ideas developed in the circle of Ammanati and Buontalenti.[30] He also brought considerable originality and the ability to use the Italian tradition established in Cracow by his predecessors. Gucci's art was Mannerist in a way typical of the aristocratic Florentine decorative trend. It expressed itself in an a-functionally conceived architecture, in sculpture which was opposed to naturalism – we remember the hysterical mobility of King Batory's figure (fig. 205) – in linear form as opposed to a composition developed in deep space.[31] He liked volutes, which he used as ornamental motifs, and he brought to Poland a specific brand of escutcheons and cartouches with strapwork derived from Florentine art but developed in an individual way.

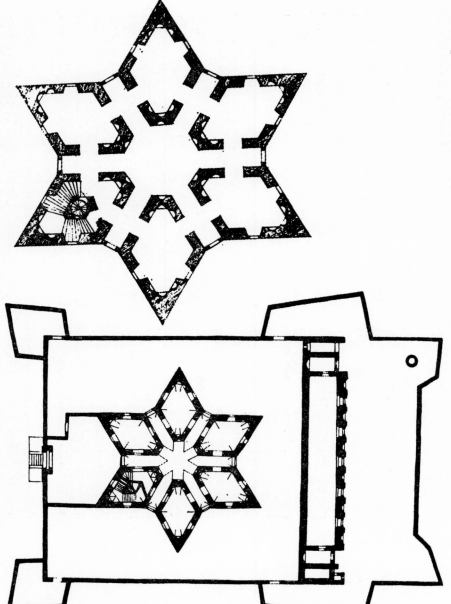

Fig. XVIII Archduke Ferdinand of Tirol: Design for the Hvězda castle. Vienna, Nationalbibliothek

Fig. XIX Bonifaz Wohlmut: Plan of the fortifications surrounding the Hvězda castle, 1556-8

Several buildings of Gucci's have been destroyed or completely rebuilt.[32] The only remaining one – also transformed in the early nineteenth century – is a castle called Mirów in Książ Wielki, fifty miles north of Cracow, built from 1585 to 1595 for the Bishop of

Cracow Piotr Myszkowski (Fig. 305).[33] There is nothing similar in Bohemia or Hungary, or – for that matter – in Poland. The Książ castle represents a type of residence which has been rightly connected with Florentine palaces of the mid-century, such as Poggio a Cajano, or the Palazzo Pitti as transformed by Ammanati, or the no longer existing Pratolino.[34]

The powerful volume of the castle, with the two lower storeys covered with heavy rustication and the upper one without articulation, is conceived as a composition of large cubic blocks. The basic structure has narrow vertical additions at the centre of both its long and short sides. It is a compact composition of blocks situated on a hill, with a garden enclosed by fortifications on the side of the steep slope, and with a large area on the other side serving as an approach to the residence. The Neo-Gothic crenellation and the slim towers were added to the central block in 1841–6 by Friedrich August Stüler, who removed the original gables with their soft, harmonious outlines. The whole composition is spanned by a longitudinal axis, while just in front of the castle a transverse axis is suggested by two lower pavilions placed to the left and right at right angles to the façade (Fig. 306). These elegant, delicate pavilions are small structures with polygonal apses and Gothic windows, their gabled façades screened at ground level with arcaded loggias. They contain the chapel on one side and the library on the other – symbols as it were of the fundamental concerns of the humanist bishop. The contrast of the heavy, powerful rustication of the main block with the brittleness of the side pavilions seems to create a true Mannerist effect.[35]

This architectural style was continued by Gucci's workshop, which erected a chapel mausoleum at the Cracow Dominican Friars church for the same Myszkowski family.[36] A strapwork-framed inscription panel is inserted into the rusticated block of the chapel as its only decoration (Fig. 307), while inside, above the bare walls of dark brown polished marble with Michelangelesque coupled columns at each corner, an unusual gallery of family portraits in relief decorates the lowest coffers of the dome (Figs. 308, 166). While the idea may have been suggested by similar effigies of the Gonzaga family – with which the Myszkowski were connected – at Sabbioneta,[37] the style of the Cracow portraits unites a certain vernacular naïvety with the tradition of heroic effigies *all'antica*. A similar chapel of the Tenczyński family at Staszów, again using the model of the royal chapel at the Wawel cathedral, transforms it into a Mannerist steep composition with a high drum and tall main body, both covered with rustication (Fig. 309).[38]

Mannerist character and some features of Venetian Classicism may also be found in the architecture of the Valachian church at Lwów, built from 1591 onwards by Paolo Dominici of Rome, with an earlier tower erected from 1572 to 1582 (last storey end of the seventeenth century) by Pietro di Barbona (Fig. 310).[39]

The Netherlandish impact in Gdańsk: Northern Mannerism

Between 1586 and 1588 Hans Kramer from Dresden erected the High Gate in Gdańsk, whose façade was designed and decorated (in 1586–8) by Willem van den Blocke (died 1628) from Malines, an outstanding sculptor from the circle of Cornelis Floris.[40] The High Gate is a powerful, sturdy structure composed according to the triumphal arch pattern, its façade divided into three unequal bays, its walls and dividing pilasters carved out of the rough rusticated walls (Fig. 311). The central arch is situated in the largest bay, the side bays with quite small open arches are about half the size of the central one. To the left and

right of the outside pilasters there are shorter strips of rusticated wall. The cornice with the inscription, protruding above the pilasters, is supported by thick striped corbels. So far the building is in harmony with the north Italian Mannerist Classicism of Sanmicheli, with whose Verona gates it has been compared.[41] But above the cornice rises a second part of the composition, almost half the height of the lower part. It consists of a parapet-like zone of masonry, whose dividing bands continue the vertical accents of the pilasters and – like metal ribbons – envelop the protruding cornice of the roof and are sealed at their ends with figures of lions. Between the dividing bands, in the three fields of the parapet, large cartouches supported by unicorns, angels and lions parade the coats of arms of Gdańsk, Prussia and Poland. The cartouches are adorned with strap- and fretwork ornaments and introduce an obvious note of northern taste.

At that late stage of the sixteenth century, inspiration was coming to eastern Europe not only from Italy but also from the north – from Germany and the Netherlands. Dutch and Flemish architects and sculptors, among them Cornelis Floris, the Boy and van den Blocke families, and Anthonis van Opbergen, were invading the Baltic Sea area, and the Netherlandish style of decoration was also penetrating eastwards through Germany and Silesia. German artists and German patrons implanted forms of Saxon or Augsburg origin in Bohemia.

The mostly Protestant towns of northern Poland, Gdańsk and Toruń, and the east Prussian metropolis of Königsberg (now Kaliningrad) had almost no links with the Italian masters working in the southern part of the country. Traditionally involved in commercial and cultural relations with the Netherlands, they relied on Dutch and Flemish artists, for whom the Baltic towns were a welcome expansion area. While Sweden used north Italian masters from Lugano or the Como area, who – coming from Silesia or Mecklenburg – were employed for the construction of the castles at Stockholm and Kalmar,[42] in Denmark, Pomerania, northern Poland and east Prussia Dutch and Flemish artists had no real competitors. Cornelis Floris exported his magnificent tombs to Danish Roskilde as well as to east Prussian Königsberg (Duke Albrecht's tomb, 1568–74; Fig. 316);[43] Jan Vredeman de Vries spent some years in Gdańsk decorating the splendid Red Room of the Town Hall, with his virtuoso perspective pictures (Fig. 320);[44] and Anthonis van Opbergen, who had built the Kronborg castle of the Danish kings at Elsinore (1577–85), was entrusted with the construction of the Gdańsk arsenal (Figs. 313–15). This splendid structure, erected from 1602 to 1605, is one of the most perfect examples of this north European style.[45]

The repertoire of forms used by Opbergen goes back ultimately to the Italian Renaissance. The 'Rollwerk' cartouche had made its appearance in the Raphael School at Rome, and was taken over in Genoa and in the Galerie François I at Fontainebleau. The 'Beschlagwerk' and 'Stabwerk' probably have their roots even in late Roman, grotesque ornament. The caryatids, terms, obelisks, heavy rustication and volutes – they all come from Italy.[46] But the result is completely different. The main effect is in the contrast of the brickwork with the stone used for frames of windows and decorative sculpture. Columns and architectural orders hardly appear, and if they do they are conceived in a most fantastic way, according to the spirit of Serlio's libro extraordinario. The whole has a colourful, toy-like character, with a great quantity of small elements put together or inserted into each other, as if it were a large piece of furniture executed by a cabinet-maker and iron-worker. Still,

the general harmony of such buildings as the Rosenborg castle, Copenhagen, the Frederiksborg castle at Hillerød, Denmark, or the Gdańsk arsenal is achieved by the use of symmetry as the main rule. Seen from the side, they seem to be a fantastic piling-up of various shapes and ornaments; seen from the front, they are unexpectedly well ordered, their two halves corresponding exactly, like mirror images.

The van den Blocke family left in Gdańsk several masterpieces of this style, but in contradistinction to Opbergen they favoured a more Italianized version, as seen in Willem's High Gate building. His son Abraham's Golden Gate (or Long Street Gate) of 1612–14 (Fig. 312) with its refined play of several layers of forms on the façade – the order of columns and entablatures being something added from the outside – is perhaps even more Italianate in style than the High Gate.[47] The van den Blockes also played a role in the introduction of the tomb with kneeling figures into eastern Europe (the Kos monument attributed to Willem in Oliwa and the Bahr monument by Abraham in Gdańsk; Figs. 317, 318).[48]

This type of tomb remained rare, however; indeed it must have been so unusual that the founder of the Bahr monument, the burgomaster Hans Speymann, had to use all his authority to persuade the church council to give permission for such a tomb to be erected in the church. The usual type of Protestant epitaph in northern Poland, Silesia and Bohemia was of course quite different: it was a cartouche-like, mostly wooden composition with inscriptions, and sometimes with pictures – in such cases the appearance being not unlike that of the emblems, popular at that time – and surrounded by a very rich, elaborate frame of strap– and fret–work.[49] Splendid examples of such epitaphs are found in Silesia, such as that of Nunhart in Wrocław (about 1560; Fig. 319), which includes a free copy of Sebastiano del Piombo's *Flagellation of Christ* from San Pietro in Montorio,[50] and in Bohemia, such as that of Florian Griespach – the patron who built Kačeřov and Nelahozeves – of 1593 at Kralovice.[51]

How far is it justified to call this northern art Mannerism? This concept is certainly applicable to works of Italians like Gucci, of the artists from Tacca's circle responsible for the Bučovice fountain (Fig. 321),[52] and of Italian-trained Netherlandish and German masters working at the court of Emperor Rudolph II in Prague at the end of the sixteenth century, such as Adriaen de Vries, Hans von Aachen, or Bartholomaeus Spranger, a group which, because of its international character, is not included in our study. But what name should we give to all the other artistic phenomena which no longer corresponded to the harmonious art of humanism?[53]

The period of the international decorative style which developed in northern Europe from the Lowlands, through Germany to Scandinavia, and which is found also in Silesia, Bohemia and Poland, was once called by Hedicke 'das Zeitalter des Dekorativen' – the age of decorative tendencies.[54] Forssman, in his remarkable book *Säule und Ornament*, has proposed to name this style not 'Northern Renaissance', as it used to be called, but 'Northern Mannerism'.[55] It is right to point out that Mannerism may be as readily differentiated into national stylistic shadings as any other style.[56]

If we look at the buildings in Gdańsk, and if we recall Scandinavian castles, we cannot deny that they were built for people of quite subtle and sophisticated taste, executed with excellent craftsmanship and conceived with intricate symbolic programmes parading sometimes emblematic conceits.[56a] Are not Shearman's and Smyth's definitions of Mannerism

as an artificial, artful style exemplified, more or less closely in such works? Are not the fantastic *Kunstschränke* (Fig. 323), the incredible ivory structures of interpenetrating cubes, polyhedrons and spheres, the intricate metalwork (Fig. 322), artefacts which have no other purpose than to show the skill of the artists?[57]

One may then propose to distinguish two types of international Mannerism: one of them was mainly Italian, or of Italian origin; it was practised by artists following the ideal of *maniera*, and it found expression mainly in painting and sculpture and in the form of the human nude. The second one was northern, although its roots are also to be found in Italian architecture and ornamental models. It appeared mainly in the decorative arts, since even architecture was conceived mostly in terms of decoration. Both of them were highly artificial, refined and sophisticated, and in spite of considerable differences in formal aspects, it is perhaps reasonable to call them by the same name.

As in a piece of polyphonic music, we may observe that the new stylistic trends in the sixteenth century in eastern Europe enter the scene one after the other and do not disappear. Rather, each of them, having created one or two important buildings or works of sculpture, leaves behind a host of imitations: to use George Kubler's terminology, they create prime objects which provoke replications.[58] They appeared one after the other and continued simultaneously: the early Albertian or Urbino manner as transformed in the Buda workshops, the specific High Renaissance of Berrecci, the north Italian Classicism of Padovano and Stella, the severe Mannerist Classicism of Wohlmut, the lively Florentine Mannerism of Gucci, and the northern Mannerism coming to the east in various forms – from Augsburg in its more southern version as well as from the Netherlands in its more northern one. Against that background of imported forms was created a local, vernacular style, of great originality and independent beauty, striving after picturesque, dynamic, colourful expression, which – in Bohemia and Poland – produced its most interesting results both in towns and for noble patrons.

Such genuine local idioms of the period could hardly be formulated in Hungary, which was locked at that time in a highly dangerous struggle for life against the Turks, who occupied large parts of the country. Only a few monuments like the Sárospatak castle survive. All energies were directed to coping with problems of defence; architects and patrons concentrated on fortifications and fortresses.[58a] The traditional type of castle with four towers at the corners but with modern Italian bastions became popular in Hungary and Slovakia. Except for some sgraffito decorations they were mostly functional, and different from the style developed in Bohemia, Moravia and Poland. In these countries – in spite of differences in detail – perhaps the last common artistic expression of the area to which this book is devoted was formulated. Finally, therefore, let us turn our attention to that specific trend.

'Vernacular' style as opposed to Mannerism

The variety of forms and artistic sources is great indeed, but the qualities of typical products of the vernacular trend may be considered the opposites of those typical of Italian Mannerism.[59] The vernacular works of art are naïve and direct in contrast to the refinement and sophistication of Mannerism; they are straightforward and sometimes even awkward as opposed to the virtuosity and '*terribilità*' of Mannerism; they are free and spontaneous, narrative and coarse as against Mannerist self-control and complexity; they

are popular or connected with the middle class rather than courtly, as is most Mannerist art.

The vernacular trend shows a lack of interest in space composition, an enthusiasm for ornament, a lack of functional thinking, a disruption of links between form and content and a neglect of Classical norms and rules. It seems that we can observe in that art what A. Goldschmidt once called 'disintegration of form'.[60] He said that such a process occurs when forms created to express a certain content are taken over in a milieu where acquaintance with the original content has been lost and the actual meaning and function of form are no longer understood. Thus the phenomenon of the provincial transformation of art forms may sometimes result in structures superficially similar to highly sophisticated compositions. It would not be right, however, to define the vernacular trend in negative terms alone, since the buildings and works of art produced by it have a picturesque or fantastic character of their own, which makes them the best representatives of the *genius loci* of eastern Europe.

In Bohemia that trend, called by historians the 'Czech Renaissance',[61] is especially apparent in a group of castles which includes the no longer existing castle of the Lords of Rožmberk on the Hradshin,[62] and the Lobkovic-Švarcenberk castle, also on the Hradshin, and the castles in Litomyšl and Horšovský Týn. Typical is the use of large and complicated gables with strong, mostly horizontal divisions made by protruding cornices. The gables are – in contradistinction even to works of northern Mannerism – often used in an asymmetrical grouping. This obviously reflects the irregular growth of these castles, most of which were built around a medieval nucleus.[63]

One can easily guess the underlying Gothic design in Horšovský Týn (Fig. 324). The chiaroscuro effect of the gables goes together with the painterly sgraffito decoration – most of it damaged and restored – to create an illusion of diamond rustication. The Litomyšl portal (Fig. 325), mentioned before, is a striking example of the transition between actual and illusionistic rustication: the portal itself has a thick stone frame of diamond-shaped blocks with cut tops, while the wall around it repeats the same motif in the illusionistic sgraffito technique.

In this castle at Litomyšl, built between 1568 and 1573 by Giovanni Battista and Ulrico Aostalli (Avostalis), the combination of sgraffito rustication and picturesque gables was perfected.[64] Inside it has a typical three-storey arcaded courtyard, like those in Moravian castles (Fig. 297). Its front wing is partly a curtain wall with arcaded walks, which are cut through the façade at the upper floor and transformed into a panoramic loggia, a main accent of the façade (Figs. 326, 327). But Avostalis did not care about strict symmetry, and the outside of the building has elements of that irregularity typical of the vernacular trend. The splendid rotunda built by Giovanni Maria Faconi and Antonio Cometta in the garden of the castle at Jindřichův Hradec in the last decade of the century (1591–3; Fig. 329), although mostly conceived in the Italian Mannerist idiom, gains a picturesque note thanks to its use of gables. Its interior has a splendid grotesque decoration, a reflection of the type of ornamentation common in Italian villas of the time (Fig. 328).[65]

In Bohemia sgraffito decoration and gables were the main characteristics of the vernacular trend. The Polish vernacular shows a greater diversity of means and its sources are more varied. In the last decades of the sixteenth and in the seventeenth century there coexisted in Poland several stylistic trends, inspired by the local Italian Renaissance tradition (central

chapels), by Mannerist Italian models (Gucci, impact of Serlian prints), and by the decorative patterns of northern Mannerism (gables decorated with strapwork). Against the background of these trends and using various quite old traditional elements, the vernacular trend formulated popular solutions, which brought the modern artistic language even to small provincial centres.[66]

In Bohemia ecclesiastical architecture played only a marginal role in the development, although there was a late revival of Gothic in that field.[67] In Poland, however, under the fresh impact of the Counter Reformation, but before the Early Baroque Italian models became widely popular, a simple type of church was created, usually with one nave and Gothic proportions but with a distinctive type of decoration in the gable crowning the façade and on the vault (Fig. 330).[68]

This type of vault decoration, although it has some parallels in Germany and the Netherlands, nowhere took forms like those popular in Poland. It is a kind of net of thick bands, reminiscent both of Late Gothic net rib-vaulting and of Renaissance coffers or medallions, but differing from both. The ornamental patterns are designed on the vaulting in forms made of stucco and painted. Often a white or yellow design is seen against a blue, green or grey background. This design includes abstract motifs such as rosettes as well as symbolic ones such as angels, stars, the initials of Jesus or coats of arms. The patterns introduced on the vaults of the first Renaissance churches built by Italians in Masovia, like those at Pułtusk (Fig. 331) or Brok, may have had some significance for the development of this kind of decoration.[69] Its first preserved example is the vault of the Lublin St Bernard Friars church, rebuilt in 1603–7 (Fig. 332).[70] The Lublin workshops seem to have been a centre of this kind of decoration, and the vogue soon reached western Poland, where Kalisz (Fig. 333) became another centre, and examples may be found all over the country. This vogue continued far into the seventeenth century, one of its exponents being the workshop of Jan Wolff, who was active in Zamość and its surroundings, and whose work in the church at Uchanie (about 1625; Fig. 334)[71] is a good example.

Another trend of the vernacular derived from Gucci. The excellent architect of Książ Castle and sculptor of the Batory tomb introduced some motifs for which hardly any models can be found in Italy. In the Batory tomb (Fig. 203), as well as in that of the Kryski family at Drobin (Fig. 169), there are picturesque cartouches, round knobs filling the fields of lesenes or pilasters, and arches whose borders are cut and bent like paper or leather.[72] Gucci introduced colourful marbles as decorative motifs in sandstone structures and he used feather-like, unusual elements at the ends of the arcades. These appear in the stalls of the Lady Chapel in the Wawel cathedral (Fig. 335), where the Batory tomb is placed. These motifs were eagerly taken up and used by the Gucci workshop, for instance in the tomb of the Branicki family at Niepołomice, which is a kind of mixture of motifs from the Batory tomb and from the stalls of his chapel (Fig. 340).[73]

The castle at Baranów in southern Poland (Fig. 336), one of the best examples of the Polish picturesque vernacular style, unites the Renaissance tradition of an arcaded courtyard with elements of Mannerist composition and Gucci's decorative motifs.[74] The rectangular plan with four cylindrical towers at the corners is traditional, recalling Bohemian designs like Kostelec nad Černými Lesy.[75] A typically Mannerist main portal leads upstairs to the courtyard, which is situated at a higher level than the entrance. Inside, as is often the case in Bohemia, the wing opposite the front has no arcaded loggias; the startled visitor

has to turn round to find that it is the rear of the front wing which has the character of an interior façade, with rather bizarre arcaded stairs leading up to the first floor loggias (Fig. 337). The exterior façade is decorated with a parapet, whose cresting is shaped as a series of small gables, not unlike the big ones which appear at the sides of the façade and belong to the roofs of the transversal wings, a feature recalling Litomyšl.

A somewhat similar idea underlies the composition of the castle of Krasiczyn (1598 to 1633) in the south-eastern corner of present-day Poland (Fig. 338). It has a large courtyard, four cylindrical towers at the corners and a square gate-tower in the centre of the western curtain wall.[76] Also the southern wall is a curtain. Towers as well as walls are adorned with decorative parapets and crestings, and that of the southern wall with its unique pattern of large circular forms between turrets is perhaps the most ingenious of all Polish crestings (Fig. 339).[77] Krasiczyn with its picturesque towers, with a ruined sgraffito decoration, with the symbolism of its towers (they were named after God, the Pope, the King and the Nobleman), is a showpiece of Polish vernacular with all its haphazard growth and fanciful lack of unified design.

The decoration of Krasiczyn is almost completely gone, only a shadow of the sgraffiti remains. At Baranów there are some well-preserved sculptural details, like the masks on the postaments of the courtyard columns, and the imaginative portal frames, which are typical of the ornamental repertoire of the Pińczów workshops (Fig. 341). Gucci's motifs here become animated, they have an unexpected vitality, with the feathered cartouches transformed into dragon heads. This development, perhaps not without some oriental influences, leads to the more and more complicated solutions seen in several tombs made by this workshop, such as those of Zofia and Mikołaj Mniszech at Radzyń (Fig. 342) or of Arnulf and Stanisław Uchański at Uchanie (Fig. 343).[78] Nowhere does the zoomorphic trend of the vernacular reach such buoyant density and fantastic dynamism as in the sepulchral chapel of Mikołaj and Elżbieta Firlej at Bejsce,[79] where the sober simplicity of the exterior contrasts with the almost Asiatic exuberance of the interior (Fig. 346). The chapel entrance has unexpected geometrical decorations recalling the early medieval transennas (Fig. 344); inside, however, everything is full of ornament and movement (Fig. 345). The tomb, the altar, the baptismal font: motifs coming from Gucci are combined with those from Dutch pattern books, but the dragons, snakes and bird claws or wings are so unusual that no direct source for them can be pointed out.

The Polish vernacular style is represented in all the functional types to which our preceding chapters have been devoted: it left its imprint on castles and on chapels, on tombs, and also on town architecture. And in this last field it had perhaps its longest life. A unique example is the town hall in the northern Polish town of Chełmno (1567–70), where 'the illogical play of Classical architectural elements reaches the limits of the possible. The cube of the town hall is transformed into a kind of toy-like dream structure, recalling the fantastic and crazy *Kunstschränke* of the German Mannerism' (Figs. 347, 348).[80]

At a time when one of the first imitations of the Gesù church north of the Alps was already nearing completion in Cracow, when Early Baroque was being introduced at the Wawel castle, and when Prague was radiant in a short-lived splendour, due to the international group of Mannerist artists brought together by the strange patron Rudolph II,[81] excellent, but completely foreign to the long local tradition – at this late stage the Polish vernacular was being more and more transformed by the provincial workshops, until it

almost reached the level of folk-art, and produced works amazing for their unusual combination of imagination and primitivism.

By 1615 several new private houses had been built in Kazimierz Dolny, the rich harbour town on the Vistula.[82] Some of them still remain. The two most important ones are those built on the market square for the Przybyła brothers (Fig. 349). The ground floor is an arcaded sidewalk, the second floor has irregularly-placed windows, and above the cornice oversize parapets with immense crestings are the most important elements of the composition. Christian symbols, images of saints, inscriptions of a humanist character and mythological and legendary elements are crowded on these façades, together with Italian candelabra and grotesque ornamentation, and with Netherlandish strap- and fret-work (Fig. 351). A striving for concrete forms dominates this decoration: it is plastic, convex, tactile, not painterly but picturesque. As if made of pastry by a naïve hand, these reliefs do not show any intermediary planes, nor any subtlety of stratification in depth. But they had to be tactile. No abstract sign was allowed: to show that St Christopher is walking through water the artists represented crabs and fishes, and inserted them in the cloud-like shape which covers the saint's feet (Fig. 350).[83]

It seems that only then the new visual world of the Renaissance had been fully accepted by even the most simple-minded artisans. Its sense and meaning was almost lost in this long process of adaptation. But it ceased to be limited to the élite and became completely popularized. By that time, however, eastern Europe was no longer the unity it could be considered to have been about 1500. Hungary had ceased long ago to play an active role. Bohemia was soon to enter a gloomy period after the tragic battle at the White Mountain in 1620. The only link which by 1600 still united the Polish and Czech artistic cultures was this distinctive picturesque interpretation of Renaissance and Mannerism. In this vernacular art, with its dynamism and buoyant strength, the germ of a new artistic attitude was already alive; and the patterns of the Baroque were just coming from the south. The art of the Renaissance in eastern Europe had run its full course.

Notes

Chapter One

1 A. Hahr, 1913; A. Hahr, 1915; A. Hahr, 1940. A. Angyal, 1961, summarizes the general cultural history of eastern Europe in the whole period of the Renaissance and the Baroque in fifty pages. There exists also a recent account of the 'art treasures', in eastern Europe: A. Rhodes, 1972.

2 O. Benesch, 1945, republ. 1965.

3 I. Golenishtchev Kutusov, 1958; hereafter I refer to the Polish edition of 1970.

4 L. Beltrami, 1925; E. Lo Gatto, 1934; V. N. Lasarev, 1959. Generally: M. Gukovskij, 1967.

5 Traditionally the authorship of the 'Faceted Palace' used to be attributed to Solari and Marco Ruffo. Lasarev (1959, p. 427) has proved the apocryphal character of 'Ruffo'. This name is thought to have resulted from the corruption of 'Rosso' and this was the name of an Italian diplomat in Russia and not of an artist. The builder who started the palace was Marco Friasin.

6 S. Bettini, 1944; G. Fiocco, 1956; and S. Bettini, 1964. Lasarev, 1959, p. 439 is sceptical about this identification.

7 N. Ernst, 1928; Lasarev, 1959.

8 S. Shervinskij, 1917; A. Vlassiuk, 1952; Lasarev, 1959.

9 C. Budinis, 1936, p. 35f.

10 For Branda Castiglione see R. Mols, 1949; for Scolari: J. Balogh, 1923–6; F. Banfi, 1940, p. 828; for a general account: J. Balogh, Wealthy Patrons, 1966; J. Balogh, 1970.

11 C. Budinis, 1936, p. 35f.

12 On humanism in Hungary the basic work is by T. Kardos, 1955; a general account in Golenishtchev Kutusov, 1970, p. 167–224. Recently: J. Bérenger, 1973.

13 Golenishtchev Kutusov, 1970, p. 172.

14 On Vitéz the basic monograph is by V. Fraknói, 1879; Golenishtchev Kutusov, 1970, pp. 174–7.

15 The best account of these relations is in Golenishtchev Kutusov, 1970. See also V. Novak, 1953 and V. Filipović, 1958; recently: R. Feuer-Tóth, 1972 and A. Horvat, 1972.

16 Golenishtchev Kutusov, 1970, p. 168; A. Gabriel, 1969.

17 Golenishtchev Kutusov, 1970, p. 177. See also several papers grouped in the section called 'Academia Istropolitana a školstvo na Slovensku' (Academia Istr. and the Schools in Slovakia) in: L. Holotík and A. Vantuch, ed., 1967, pp. 5–127 and A. Gabriel, 1969.

18 J. Dąbrowski, 1954; E. Kovács, 1960; J. Dąbrowski, 1963.

19 T. Kardos, 1955, pp. 123–49; Golenishtchev Kutusov, 1970, pp. 178–89.

20 The basic work concerning the artistic culture of Matthias Corvinus's time is the excellent, rich collection of source material published by J. Balogh, 1966. As the third volume with the actual text of Balogh's study has not been published as yet, one also has to rely for historical and artistic problems of Corvinus's times on older works of varying value: C. Csányi, 1922; A. Berzeviczy, 1928; A. Solmi, 1928; E. Schaffran, 1932–3; E. Schaffran, 1933; G. Delogu, 1936; H. Horváth, 1940; I. Lukinich, ed., 1940; T. Kardos, 1940–1; T. Gerevich, 1942; E. Schaffran, 1953; L. Elekes, 1956; G. Entz, 1963; and of course on all the studies by J. Balogh. A summary of the third volume of her study (scheduled for publication soon at Graz) appeared recently: J. Balogh, 1972.

21 A. de Hevesy, 1911; A. de Hevesy, 1923; G. Fraknói and others, 1927; G. Szabó, 1960; K. Csapodi-Gárdonyi, 1962; I. Berkovits, 1964; J. Balogh, 1966, pp. 312–19; I. Berkovits, 1970; Cs. Csapodi and K. Csapodi-Gárdonyi, 1970; Cs. Csapodi, 1971; Cs. Csapodi, 1973.

22 A. de Bonfini, ed. 1936. Excerpts relating to Corvinus's buildings are given in Balogh, 1966.

23 L. B. Alberti, De re aedificatoria, Modena, Bibl. estense, Cod. lat. 419 (Royal workshop at Buda, 1485–90); J. Balogh, 1966, p. 482, Fig. 5. – The same work executed in the workshop of Attavante, 1485–90, Olomouc, Domská a Kapitolni Knihovna; J. Balogh, 1966, p. 483, Fig. 4. – Filarete (Antonio Averlino), De architectura libri xxv, Venice, Bibl. Marciana, Cod. lat. 2796 (Royal workshop at Buda, 1489): J. Balogh, 1966, p. 521, Fig. 6 (our Fig. 4).

24 Quoted in J. Balogh, 1966, p. 495.

25 J. Balogh, 1966, p. 485-7 gives sources. See now: Feuer Tóth, 1973.

26 S. Meller, 1955; L. Gerevich, 1965; J. Balogh, 1966, pp. 288-91, Figs. 403-4. J. Balogh, 1928, pp. 66-9, considers the reliefs as works of a Lombard sculptor of the Sforza court. She thinks they were done after medals.

27 Quoted in P. Meller, 1963, p. 61 For the complicated discussion of the Alexander and Darius reliefs see among other recent studies: G. Passavant, 1969, pp. 47f., 209-11. On their triumphal symbolism: J. Kropáček, 1972 (Umění), p. 270.

28 I. Genthon, 1962; J. Balogh, 1966, pp. 336-42; A. Somogyi, 1967, pp. 22-3.

29 J. Balogh, 1966, pp. 390-2.

30 C. Carnasecchi, 1903; J. Balogh, 1966, p. 513-14 (sources); Ch. Seymour, 1966, p. 178; Ch. Seymour, 1971, pp. 25, 168, says the fountain was intended as a gift from Corvinus to the Medici. G. Passavant, 1969, p. 208 considers the putto's attribution to Verrocchio doubtful and admits the possibility it might be attributed to Benedetto da Maiano.

31 G. Vasari, Le Vite, G. Milanesi, ed., III, Firenze, 1878, pp. 334f.; J. Balogh, 1966, pp. 483f.

32 J. Balogh, 1967.

33 Now at Munich, Bayerische Nationalbibliothek, ill. in C. Budinis, 1936, pl. XLIV.

34 T. Gerevich, 1921; P. Voit, 1958.

35 C. Budinis, 1936, p. 62; T. Gerevich, 1948, pp. 239-41; A. Somogyi, 1967, p. 23.

36 A. Leopold, 1944; J. Balogh, 1948. On Italian Renaissance painting in Hungary see recently É. Szmodis-Eszláry, 1972.

37 K. Prijatelj, 1957; K. Prijatelj, 1959; J. Balogh, 1960; K. Prijatelj 1961; C. Fisković, 1967.

38 J. Balogh, 1933, p. 274; K. Prijatelj, 1957, pp. 27f.; J. Balogh, 1966, pp. 282-3.

39 Found and published by J. Komáromy, 1960; J. Balogh, 1966, p. 282; L. Gerevich, 1967, p. 130, Fig. 11 on p. 127.

40 J. Balogh, 1960, Figs. 3, 15, 22, 27-30. P. Meller, 1948, attributed the Visegrád Hercules fountain to Dalmata. This is not accepted by

Balogh, who stresses the difference in handling the marble and gives the Visegrád fragments to the 'Master of the Marble Madonnas' (by some scholars identified with Tommaso Fiamberti). For the Visegrád Hercules Fountain see the following chapter.

41 A. Forbáth, 1918-19 (on the Pécs tabernacle); L. Némethy, 1890; J. Balogh, 1938 (on the Pest tabernacle).

42 J. Balogh, 1967, considers the Báthory Madonna a work of a Hungarian sculptor trained with the Italians. On Hungarian noble patrons in general see J. Balogh, 1967.

43 A. Pawiński, 1893; A. Divéky, 1960. A short but well-informed account of Sigismund as a patron of art has been published in English by K. F. Lewalski, 1967.

44 Franciscus Florentinus and the Olbracht tomb: F. Kopera, 1898; S. Zahorska, 1922; Z. Hornung, 1959; L. Gerevich, 1959, pp. 323f.

45 Source study of the Folleville tomb: G. Durand, 1906. The data are summarized by A. Blunt, 1953, pp. 6f. Recently see H. W. Kruft, in Actes Congrès Budapest, 1969, 1972.

46 J. Balogh, 1956.

47 This was observed by S. Zahorska, 1922, but she thought the Esztergom fragments to be earlier than the Cracow tomb. The actual origin of the frieze was established by J. Balogh, 1956, p. 62, Figs. 104-5 on p. 109.

48 This fragment of the balustrade-pilaster from Nyék (Budapest, Castle Museum) is reproduced in L. Gerevich, 1959, Fig. 21 and in J. Balogh, 1966, Fig. 206.

49 Illustrated in Balogh, 1956, Fig. 106.

50 As pointed out by Z. Hornung, 1959, p. 71. For Benedetto da Rovezzano's tomb of Pier Soderini (before 1509) see W. and E. Paatz, 1952, pp. 212 and 276 and A. Venturi, 1935, pp. 450ff.

51 See the following chapter.

52 A general survey of Polish patrons of the Renaissance is given by S. Komornicki, 1932. On individual patrons see: M. Sokolowski, 1900 (Krzycki); J. Kieszkowski, 1912 (Szydlowiecki); H. Kozakiewiczowa, 1961 (Łaski); J. Smacka, 1963 (Turzo).

53 J. A. Miłobędzki, 1970, p. 228. The same author touched upon this question in his other publications: Miłobędzki, 1959, 1967, 1968, 1971. H. Horváth, 1940, p. 192, also points out the 'Renaissance' character of the Gothic architecture in Hungary.

54 J. Dutkiewicz, 1932, pp. 4–12.

55 J. Dutkiewicz, 1932, p. 10, gives some examples of woodcuts in books published in Cracow.

56 E. Trajdos, 1960 and 1961, takes as *terminus post quem* 1511, but the woodcut in question (B. 82) was probably made in 1504–5 (according to E. Panofsky, 1945, ii, p. 38, No. 302).

57 S. Kozakiewicz, 1959.

Chapter Two

1 J. Balogh, 1952; L. Gerevich, 1954; J. Balogh, 1966, pp. 23–149; L. Gerevich, 1967; L. Gerevich, 1971, pp. 101–16.

2 A. Bonfini, ed. 1941, iv, pp. 136–7, quoted in Balogh, 1966, pp. 38–9.

3 Casparis Ursini Velii, *De Bello Pannonico libri decem* (1527), A. Fr. Kollar ed., Vindobonae, 1762, p. 16, quoted in Balogh, 1966, pp. 39f.

4 For the candelabras see J. Balogh, 1966, pp. 144–5. For the Coecke van Aelst woodcuts in his *Moeurs et fachons des Turcs* (woodcut vii) see G. Marlier, 1966, p. 71, Fig. 14. Marlier also quotes Cornelius de Schepper's account (before 1536) about the Constantinople Hippodrome: 'Ibi sunt columnae ex aere abblatee [sic] ex Buda cum imaginibus Herculis' (see de Schepper, ed. 1857, p. 119).

5 G. Vasari, *Le Vite*, ed. G. Milanesi, ii, Firenze, 1878, pp. 334–5. It is also quoted in J. Balogh, 1966, pp. 486f. Recently on Camicia see: Feuer Tóth, 1973.

6 Astrological decorations are mentioned or described in several sources adduced by J. Balogh, 1966; A. Bonfini, ed. 1941, iv, p. 137 (Balogh, p. 37); Franciscus Omichius, 1572 (Balogh, p. 64); Stephan Gerlach d.A., 1573 (Balogh, p. 64); Reinhold Lubenau, 1587 (same place); Salomon Schweigger, 1577 (same place); Vaclav Vratislav z Mitrovic, 1591 (Balogh, p. 65). In the Library of Matthias Corvinus (called by Bonfini (p. 189): *Musarum Sacellum*) there was an astrological painting with representations of the sky at the moments of Corvinus's birth and of his receiving of the Bohemian crown. See also S. Mossakowski, 1974.

7 L. Gerevich, 1967, p. 126.

8 J. Balogh, 1956, p. 124.

9 See bibliography in note 37 of chapter i.

10 The text of King Matthias's letter in which the donation of Maykovecz Castle to Dukhnović is announced was first published by I. Kukuljević Sakcinski, 1868, i, p. 70. It has been reprinted a few times, e.g., in J. Balogh, 1966, p. 489. Ludovicus Tubero (1746, pp. 163f.) relates the fact that Dalmata was knighted, in his *Commentaries* (1490–1522).

11 On Visegrád: D. Dercsenyi, 1951 and 1958, pp. 396–479; N. Héjj, 1954 and 1970.

12 N. Olahus, ed. 1938, pp. 10–12, quoted in J. Balogh, 1966, pp. 225f.

13 P. Meller, 1948; J. Balogh, 1950; J. Balogh, 1966, p. 248–50.

14 P. Meller, 1948; Letter of Bartolommeo de Marieschi, 25 October 1483 in S. Katona, 1793, p. 522, quoted in J. Balogh, 1966, p. 224.

15 P. Meller (1948) ascribed the fountain to Giovanni Dalmata, which was accepted by K. Priljatelj, 1957, pp. 28f. and by several other authorities. J. Balogh (1950) has connected it with the Master of the Marble Madonnas (Tommaso Fiamberti?).

16 J. Balogh, 1966, pp. 161–7; J. Holl, 1959.

17 J. Balogh, 1967. On the later developments of Hungarian domestic architecture see: M. H. Takács, 1970.

18 On the Buda–Prague relations see G. Fehr, 1961, pp. 24f., 112ff. On the Renaissance architecture in Prague: O. Pollak, 1910/11; E. Šamánková, 1961, pp. 7–17; E. Šamánková, 1967. Recently: J. Kropáček, 1972. For the artistic culture of the Vladislav Jagiellon period see: Truhlář, 1894; Pešina, 1972 and 1974; Hořejší and Vacková, 1968, 1971, 1972 and 1973; Hořejší, 1972; Vacková, 1972.

19 G. Fehr, 1961, pp. 24–33; J. Hořejší, 1973.

20 The date 1493 was still considered as not related to the Renaissance forms by M. Morelowski, 1961, but is now accepted in the recent scholarship (Fehr, 1961, p. 32; Šamánková, 1961).

21 G. Fehr, 1961, pp. 112–15, Figs. 99–105.

22 G. Fehr, 1961, pp. 33–6.

23 G. Fehr, 1961, p. 35.

24 G. Fehr, 1961, p. 33.

25 See Chapter 1, note 44, for literature concerning Franciscus Florentinus. For the Cracow Wawel Castle see: S. Komornicki, 1929; S. Tomkowicz, 1908; A. Chmiel, 1913; T. Dobrowolski, 1953 and 1956; J. Szablowski, ed. (Katalog), 1965; J. A. Miłobędzki, 1968, pp. 120–2.

26 J. A. Miłobędzki, 1979, pp. 253f.

27 L. Gerevich, 1959, pp. 318–20; illustrated in J. Balogh, 1956, Fig. 107 on p. 111; L. Gerevich, 1959 reproduces it on p. 322, Figs. 19–20. The Wawel fragment: Gerevich, 1959, p. 323, Fig. 23.

28 For the Hungarian influence on the Polish Renaissance see: A. Divéky, 1910; J. Lechner, 1913; S. Zahorska, 1922; T. Gerevich, 1936; E. Horváth, 1939; J. Dąbrowski, 1963; J. Ross, 1963.

29 B. Przybyszewski, 1955.

30 A. Divéky, 1914, p. 179; S. Komornicki, 1932, p. 543.

31 A. Divéky, 1910, p. 7.

32 J. Szablowski, ed., 1965, p. 35.

33 Jodocus Justus Decius's description of 1518 (reprinted in S. Tomkowicz, 1908, p. 413): 'Hec ad faciem pulchro ex artis columnis lapidei cinguntur valtato ambitu, ex quo per primos gradus itur in aulam, ex ea vero in estuarium in quo regium erat convivium (et ad alias habitationes) preterea in ambitum secundum.'

34 J. Szablowski, loc. cit.

35 The recent monograph on Collegium Maius was published by K. Estreicher, 1968.

36 L. Gerevich, 1971, pp. 104, 108.

37 Z. Hornung, 1959, p. 81, stresses the similarity to the courtyard of the Palazzo Strozzi in Florence.

38 As observed by S. Kramarczyk, 1962, p. 328. The upper floor is now attributed to Raphael (O. Foerster, 1956, p. 180). For the drawing by Maerten van Heemskerck, of 1533, showing the Cortile's wing see C. Hülsen and H. Egger, 1916, II, Pl. 130, pp. 68–73.

39 O. Sosnowski, 1935.

40 T. Dobrowolski, 1953 and 1956, tried to see in the buttresses an aesthetically positive element, but wrongly. On the aesthetic deficiencies of the courtyard: Z. Hornung, 1959.

41 J. A. Miłobędzki, 1968, p. 122.

42 J. Szablowski, ed., 1965, pp. 53f.

43 J. Szablowski, ed., 1965, Fig. 80.

44 J. Szablowski, ed., 1965, Figs. 81–6.

45 J. Białostocki, 1956. See Szablowski, ed., 1965, Fig. 83.

46 J. Szablowski, ed., 1965, Figs. 82 and 84.

47 J. Szablowski, ed., 1965, Fig. 84.

48 J. Szablowski, ed., 1965, Fig. 85.

49 J. Szablowski, ed., 1965, Fig. 86.

50 B. Przybyszewski, 1948.

51 Zabytki Sztuki, 1959, pp. 235–42; H. Rutkowski, 1958; T. Jakimowicz, 1972.

52 Zabytki Sztuki, 1959, p. 242, Fig. 227.

53 This has been suggested by H. Rutkowski, 1958, but not taken for granted by T. Jakimowicz, 1972.

54 I. Kuhn, 1954, Fig. 9; M. Zlinsky Sternegg, 1966, Fig. 1. See Chapter 5.

55 J. A. Miłobędzki, 1967. Several of them are reproduced by H. Kozakiewiczowa, 1961, who however unconvincingly attributes them to Berrecci.

56 In Dobrowoda (1524–5: Miłobędzki, 1967, p. 77, Fig. 21); Tarnów (1524: J. Szablowski, ed., 1953, Fig. 132); Piasek Wielki (1521: H. Kozakiewiczowa, 1961, Fig. 7); Goryslawice (about 1535: H. Kozakiewiczowa, 1961, Fig. 8).

57 J. Pavel, 1953, Fig. on p. 15. This is disfigured by a Late Renaissance illusionistic painted architectural framing.

58 E. Šamánková, 1961, Fig. 18, also Fig. 20: Portal of the church of St Mark in Litovel (1532).

59 A. Bochnak and J. Samek, 1972, Fig. 66.

60 J. Szablowski, ed., 1972.

61 S. Mossakowski, 1973, and in an as yet unpublished paper, read in June 1972 in Cracow, first tried to build up an interpretation of these frescoes.

62 K. Sinko Popielowa, 1937; D. Richter, 1944; T. Mańkowski, 1957.

63 J. Szablowski, ed., 1965, p. 57.

64 J. Szablowski, ed., 1965, loc. cit.

65 S. Mańkowski, 1950 (with a wrong attribution to the Netherlandish sculptor Loye); A. Misiąg Bocheńska, 1953 and 1955.

66 In the above quoted paper by S. Mossakowski a new interpretation is proposed, but it has not been published as yet; see also Mossakowski, 1974.

67 A. Misiąg Bocheńska, 1955.

68 T. Gostyński, 1950. About this type of ceiling decoration generally there is now a good article by M. Paszkiewicz, 1974.

69 G. Entz, 1963, p. 484.

70 See Chapter I, note 52.

71 H. G. Meinert, 1935; I. Pijaczewska, 1953; M. Morelowski, 1961; M. Zlat, 1965, 1967 and 1968.

72 K. Bimler, 1934; M. Zlat, 1960 and 1962; S. Kramarczyk, 1962.

73 J. Zachwatowicz, 1966, Fig. 112.

74 S. Kozakiewicz, 1959.

75 S. Kozakiewicz, 1959 (ad vocem in his list of architects and stonemasons). The first to devote attention to the Parr family was A. Hahr, 1908 and 1915.

76 The reconstruction of the original appearance of the courtyard by H. Kunz (1885) is far from wholly reliable; it is reproduced by A. Hahr, 1915.

77 M. Zlat, 1962.

78 B. Steinborn, 1959, pp. 68ff, Fig. 18.

79 J. Łomnicki, 1955.

80 J. Kębłowski, 1960, pp. 145f.; J. Kębłowski, 1967, pp. 120–5.

81 M. Zlat, 1962.

82 J. Kębłowski, 1967, p. 123.

83 A. Hahr, 1915.

Chapter Three

1 J. Krása, 1958; J. Vacková, 1968; Ch. Salm, 1969, pp. 374–92; J. Krása, 1971.

2 J. Vacková, 1971; Ch. Salm, 1969, pp. 371–2.

3 Ch. Sterling, 1959, p. 18, pp. 135f., J. Pešina, 1959, pp. 233–6.

4 J. Pešina, 1939.

5 J. Vacková, 1971; J. Pešina, 1971; J. Vacková, 1972.

6 J. Pešina, 1939, p. 1.

7 A. Stange, 1958, pp. 144f. (who misreads the name of the chapel's patron as 'Miskov'); J. Pešina, 1960, p. 215.

8 R. Wittkower, 1949; S. Sinding Larsen, 1965.

9 J. Z. Łoziński, 1972 and 1973.

10 J. Balogh, 1956, has written a basic monograph on that chapel. All the facts in my text are taken from that work.

11 J. Balogh, 1956, p. 12. The quoted text is given on p. 176.

12 J. Balogh, 1956, pp. 28–9, Figs. 21–2.

13 Strictly speaking it had to remain walled, as it had already been walled since the destructions of the cathedral.

14 Evlia Tchélébi's text is quoted in Italian translation in Balogh, 1956, p. 176. Its wording seems to have been influenced by the Byzantine tradition of 'ekphrasis'.

15 J. Balogh, 1956, pp. 127–9, Figs. 138–40.

16 Dr Balogh was able to distinguish five or more

individual styles of stone carving. On the façade of the chapel, built about 1508 and no longer existing, there were some reliefs, now preserved in fragments in the crypt of the new cathedral, whose character recalls the rich and subtle flower and tendril ornament current in Venice and its surroundings in the late Quattrocento, and represented by the works of Mauro Coducci in S. Michele in Murano, the Pietro Lombardi Studio in S. Maria dei Miracoli or those by Ambrogio da Milano. Dr Balogh does not think however that there were direct relations between Venetian art and Esztergom. Ambrogio da Milano brought this style to Urbino after 1476 and by the time of the construction of the Bakócz chapel Benedetto da Rovezzano (and other Florentines) had taken over this type of ornament from the north and developed it to a still greater subtlety and richness (tomb of Antonio and Oddo Altoviti, SS. Apostoli, 1507–10; remains of the tomb of S. Giovanni Gualberto, S. Trinita, 1505–13).

17 J. Balogh, 1943, *ad vocem* in the Catalogue; V. Vătăşianu, 1959, pp. 558–60; Gh. Sebestyén and V. Sebestyén, 1963, pp. 35, 97; V. Vătăşianu, 1968, p. 414.

18 H. Kozakiewiczowa, 1961; J. Z. Łoziński, 1973, pp. 34f.

19 Published by H. Kozakiewiczowa, 1961.

20 See the following chapter, page 46 below.

21 H. Kozakiewiczowa, 1961, tried to find a representation of the dome in a print of 1847, but its connection with the chapel has been denied by T. Jakimowicz and E. Linette, 1969, p. 62f.

22 The basic bibliography on the Sigismund Chapel is as follows: J. Depowski, 1918; S. S. Komornicki, 1931 (1932); Z. Hornung, 1949; A. Bochnak, 1953; L. Kalinowski, 1961.

23 The Latin text is given in S. Komornicki, 1931, p. 9, after *Acta Tomiciana*, IV, Posnaniae, 1855, p. 198. There is no day and month indicated.

24 S. Komornicki, 1931, pp. 40–1.

25 H. Kozakiewicz[owa], 1967; *Słownik Artystów Polskich*, I, 1971, *ad vocem*.

26 For the Hungarian alternative: S. Komornicki, 1931, pp. 10–11 and H. Kozakiewiczowa, 1961. See also W. Tomkiewicz, 1963 and K. Lewalski, 1967.

27 L. Kalinowski, 1961, p. 27.

28 L. Kalinowski, 1961, p. 64; J. P. Richter, *The Literary Works of Leonardo da Vinci*, 2nd ed., Oxford, 1939, pl. LXXXVII, Fig. 4.

29 S. Wiliński, 1972.

30 For the Chapel of the Cardinal of Portugal see F. Hart, G. Corti, and Cl. Kennedy, 1964, Pl. 7.

31 L. Kalinowski, 1961, pp. 29–50.

32 L. Kalinowski's suggestion, pp. 20ff.

33 S. Wiliński, 1967 and 1970, has drawn attention to this connection. For the relations between Erasmus and Poland see the bibliography given by K. F. Lewalski, 1967, p. 53. The following are studies in western languages: A. Jobert, 1961; M. Cytowska, 1962; K. Zantman, 1965.

34 P. S. Allen, H. M. Allen, W. H. Garrod, *Opus epistolarum Desiderii Erasmi Roterodami*, Oxford, 1906–58, No. 2533.

35 J. Ptaśnik, 1905.

36 A. Bochnak, 1953; L. Kalinowski, 1961, pp. 99–106.

37 Here I am partly repeating what I have said in Białostocki, 1967 and 1969.

38 L. Kalinowski, 1961, p. 100.

39 For the iconography of Anadyomene see W. S. Heckscher, 1956. For the Daphne-hypothesis and the other Classical motifs in the Sigismund Chapel see L. Kalinowski, 1972.

40 L. Kalinowski, 1961, p. 82–3.

41 The conflicting opinions have been reported by Białostocki, 1967 and 1969.

42 W. S. Heckscher, 1956, p. 3.

43 Tibullus, *Carmina*, I, III, 57f.: 'ipsa Venus campos ducet in Elysios'.

44 J. Pagaczewski, 1937, pp. 66f.; L. Kalinowski, 1961, p. 105.

45 On Hungarian Neo-Platonism see J. Huszti, 1930; on the contact between Platonism in Buda and Cracow: T. Kardos, 1934.

46 L. Kalinowski, 1961, p. 180; S. Tomkowicz, 1908, p. 265.

47 For the developments in the social position of

the artist and in aesthetic thinking which may have prepared such a bold kind of signature, see: E. H. Kantorowicz, 1961. It has been recently claimed by K. Estreicher, in a paper read in Warsaw in spring 1972, that the authenticity of the inscription is doubtful. There are no reasons for such an assumption, the more so as the type of signature Berrecci had introduced was imitated soon in the Padniewski chapel by Jan Michałowicz and in the chapel at the Włocławek cathedral. The wording of the Berrecci signature given in Białostocki, 1967, is marred by a misprint ('orfice' instead of 'opifice').

48 J. Z. Łoziński, 1972 and 1973, studies this process in detail.

49 J. Szablowski, ed., 1961, pp. 91f.; J. Z. Łoziński, 1973, pp. 45–8.

50 I have in mind the chapel of the Myszkowski family in the Church of the Holy Trinity (Dominican Friars) in Cracow; see A. Fischinger, 1956; J. Z. Łoziński, 1973, pp. 144–69. Our fig. 308.

51 J. Szablowski, ed., 1961, pp. 82–4; J. Z. Łoziński, 1973, p. 279. M. Rożek, 1973 and 1974. The erection of the chapel was decided after the death of Queen Anna of Austria, first wife of Sigismund III. She died in 1598, but the actual construction was only started in 1664. The altar was consecrated in 1676.

Chapter Four

1 E. Panofsky, 1964, pp. 67ff.

2 L. Gerevich, 1959.

3 L. Gerevich, 1959, Figs, 5, 6, 8, 11, 12. These works have been studied by Gerevich, who also gives detailed reasons for their attribution to Joannes Fiorentinus.

4 S. Zahorska, 1922; W. Kieszkowski, 1936; L. Gerevich, 1959; H. Kozakiewiczowa, 1961; T. Ruszczyńska, A. Sławska and others, 1963, p. 22, Figs. 366–9.

5 V. Bunyitay, 1886; J. Balogh, 1943, I, pp. 211–14; L. Gerevich, 1959, pp. 31ff. The font has been recently transferred from the museum at Oradea (Nagyvárad), Transylvania, to the new Historical Museum at Bucharest.

6 H. Kozakiewiczowa, 1961, p. 8, Fig. 6 on p. 9.

7 T. Ruszczyńska, A. Sławska and others, 1963, p. 22, Figs. 371–2.

8 W. Kieszkowski, 1936; L. Gerevich, 1959, p. 320, Fig. 17.

9 L. Gerevich, 1959, p. 324, Fig. 28 on p. 326.

10 L. Gerevich, 1959, p. 313, Fig. 9, p. 315.

11 L. Gerevich, 1959, pp. 331ff.

12 L. Gerevich, 1959, pp. 333–4.

13 L. Gerevich, 1959, p. 334, Fig. 42, p. 335.

14 E. Panofsky, 1964, p. 69. The following quotations come from here.

15 For this woodcut see E. Panofsky, 1942.

16 I have already discussed this problem in my review of E. Panofsky, 1964: Białostocki, 1967 (Art Bulletin).

17 K. Kumaniecki, 1953; J. Garbacik, 1948.

18 I. Golenishtchev Kutusov, 1970, pp. 194–5. For the parallel: Corvinus-Attila, see L. Vayer, 1967.

19 K. Simon, 1906, p. 25; S. Meller, 1925, pp. 130f.; L. Lepszy, 1926; A. Bochnak, 1956; P. Skubiszewski, 1957, pp. 77–91; S. Dettloff, 1961, pp. 101–5. There exists a letter of a Florentine residing in Cracow, Ottaviano Gucci de' Calvani, to a friend of Callimachus, the Neo-Platonic philosopher Lattanzio Tedaldi, which is undated but seems to have been written fairly soon after the death of the humanist, and which gives the text of the inscription and says that his epitaph is 'in bronzo con la sua figura al naturale' (A. Bochnak, 1956, p. 132, after J. Garbacik, 1948, pp. 30 and 137). Another letter by Rustinimicus to Celtes, written on 1 September 1500, also mentions the epitaph, but the preserved transcript of Rustinimicus's letter refers to the text as given in the letter of the humanist Sommerfeld to Celtes of 26 March 1499, which is different from the actual inscription and hence probably refers to another – perhaps provisional – tomb. It is therefore not possible to consider (as P. Skubiszewski does) the date of Rustinimicus's letter as a terminus ante quem (see H. Rupprich, 1934, pp. 355–6 and 415–16). This has been observed by Dettloff, 1961, p. 101.

20 S. Dettloff, 1935, pp. 29–31 and the same, 1961, I, pp. 101–5, 206.

21 Several examples in H. I. Marrou, 1938 (repr. 1964); also E. Panofsky, 1964, Fig. 118.

22 S. Dettloff, 1935, Fig. 23.

23 J. Maurin Białostocka, 1957.

24 I. Bergström, 1957.

25 S. Dettloff, 1935, Fig. 22.

26 P. Skubiszewski, 1957, pp. 77–91. The drawing by J. N. Danielski of 1829 shows the epitaph before its border lost the upper part and before the side strips were exchanged by mistake during the transfer of the work to another location. The drawing is reproduced in S. Dettloff, 1961, II, Pl. 162.

27 We learn from the above mentioned letter of Ottaviano Gucci (see note 19) that 'sopra alla sepoltura e una tavola dipinta con la figura di Nostra Donna chol bambino imbracciato et chon la figura di Chalimacho al naturale in ginochioni con un epitaphio in versi in detta tavola'. It has been concluded that the bronze plaque was put into the pavement below the painted epitaph, but this does not seem likely, and it may be supposed that it was rather the actual tomb or grave of the humanist which was meant by the word 'sepoltura'. Anyhow it is clear that the religious picture, showing Callimachus on his knees before the Virgin, was separated from his representation as a humanist. We are confronted with a moment of transition: the old religious epitaph, in which the hope for the salvation of the deceased is put under the protection of the Virgin, is still preserved, but at the same time another representation of him – a kind of monument – proclaims his secular and intellectual merits as a claim for another kind of eternal life: that in the memory of the later generations.

28 H. G. Meinert, 1935, pp. 18f.; p. 36; J. Kębłowski, 1959; the same, 1960 (Sauer); the same, 1967, pp. 51–4; M. Złat, 1967, p. 211.

29 J. Kębłowski, 1960 (Sauer); the same, 1967, pp. 51–4; M. Złat, 1967, p. 211.

30 J. Kębłowski, 1960 (Sauer); the same, 1967, pp. 46–50. For the portrait of Matthias Corvinus on the Sauer tomb see V. Fraknói, 1891.

31 J. Kębłowski, 1960 (Walther); the same, 1967, pp. 58–61.

32 M. Złat, 1968, pp. 23–7.

33 J. Kębłowski, 1960 (Walther), p. 145, 162–3; the same, 1967, pp. 55–9; M. Złat, 1968, p. 23.

34 J. Kębłowski, 1967, pp. 87–8.

35 J. Smacka, 1963.

36 S. Cercha and F. Kopera [1917]; K. Estreicher, 1933; J. Szablowski, ed., 1965, pp. 70–1, J. Kowalczyk in an unpublished paper read in Cracow in June 1972.

37 J. Szablowski, ed., 1965, p. 88.

38 R. Zdziarska, 1952; H. Kozakiewiczowa, 1959. This tomb is unique, as far as I can see, as it includes two male recumbent figures. Its iconography has not been studied as yet.

39 J. Kębłowski, 1967, pp. 83–7; M. Starzewska, 1963, pp. 127f.

40 J. Kębłowski, 1961; J. Kębłowski, 1967, pp. 75–9; M. Złat, 1968, p. 27.

41 O. Pollak, 1910/11, p. 141; J. Morávek, 1959.

42 J. Balogh, 1943, *ad vocem* in the Catalogue.

43 S. Meller, 1925, pp. 134ff.; S. Dettloff, 1938; H. Stafski, 1958, pp. 16–19; A. Bochnak, 1960, pp. 141ff.; J. Szablowski, ed., 1965, p. 71; K. Oettinger, 1966, pp. 18ff.; P. Skubiszewski, 1972, p. 291. S. Meller attributed the front relief to H. Vischer the younger; Stafski and Oettinger to the anonymous Master of the Nürnberg Madonna.

44 S. Dettloff, 1938.

45 For this woodcut see: F. Winkler, 1941, p. 26.

46 K. Sinko Popielowa (in collaboration with S. Świszczowski), 1948, transcribes (pp. 71–4) Giov. Paolo Mucante's description (of 1596) from the MS. in the Czartoryski Library in Cracow (Ms. 2134). For Jan Biały see: *Słownik Artystów Polskich*, I, 1971 *ad vocem*. On the remains of the tomb there is a signature: LEOPOLIEN FABRE CONSTRV (cf. A. Bochnak and J. Samek, ed., 1971, pp. 142–3).

47 K. Simon, 1906; S. Meller, 1925, pp. 126–8 (attributed to Hermann Vischer the younger); S. Dettloff, 1938.

48 The slabs are situated in St John the Baptist's Chapel. J. Ptaśnik, 1905; A. Bochnak and J. Samek, ed., 1971, p. 26; W. Bochnak, 1972.

49 J. Szablowski, ed., 1965, p. 71, Fig. 636. The architectural frame is nineteenth century.

50 K. Sinko, 1936, Fig. on p. 142.

51 J. Kowalczyk, 1969, p. 134; T. Dobrowolski, 1971, p. 316, Fig. 223 on p. 315.

52 A. Fischinger, 1969, pp. 72–4.

53 A. Fischinger, 1956; J. Szablowski, 1962; A. Fischinger, 1969, pp. 67–70.

54 E. Panofsky, 1964, p. 86.

55 H. Kozakiewiczowa, 1956; Z. Hornung, 1962, p. 229; A. Fischinger, 1969, pp. 57–60. H. Kozakiewiczowa, 1972, drew attention to similarities of the Drobin statues with the figures at the right and left on the upper level of the Julius II tomb in San Pietro in Vincoli in Rome.

56 A. Fischinger, 1969, p. 102.

57 K. Sinko, 1936, pp. 133–6, Fig. 1 on p. 133 (a watercolour by J. K. Wojnarowski of 1847 in the Jagellonian Library in Cracow).

58 J. Bołoz Antoniewicz, 1922; H. Kozakiewiczowa, 1959; W. Tomkiewicz, 1960.

59 Sassetti tomb: F. Burger, 1904, Pl. XIV, 1; E. Panofsky, 1964, Figs. 314–15; the reliefs from the Tornabuoni tomb by the Verrocchio workshop are in the Museo Nazionale in Florence, repr. F. Burger, 1904, Fig. 223, E. Panofsky, 1964, Fig. 316; the reliefs from the tomb of Girolamo della Torre in S. Fermo, Verona, are in the Louvre; repr. of the 'conclamatio' scene: E. Panofsky, 1964, Fig. 295. A Classical 'conclamatio' relief from Palazzo Montalvo, Florence, is reproduced in F. Burger, 1904, Pl. XIV, 2, and a somewhat similar Meleager sarcophagus in the Ostia-Museum in E. Panofsky, 1964, Fig. 312.

60 The last one is by W. Tomkiewicz, 1960.

61 On this type especially M. Zlat, 1969.

62 E. Panofsky, 1964, p. 81.

63 Z. Hornung, 1949; S. Lorentz, 1953; A. Bochnak, 1953; Z. Hornung, 1959; A. Fischinger, 1964.

64 K. Sinko, 1939; Z. Hornung, 1949, pp. 142f. The Sansovino tomb is reproduced in G. Mariacher, 1962, Fig. 21.

65 Ch. Seymour, 1966, Pl. 41. H. and S. Kozakiewicz, 1953, have indicated similarities with the Late Gothic versions of the same subject.

66 See Chapter 3, note 49.

67 K. Estreicher and J. Pagaczewski, 1937; J. Eckhardtówna, 1937; F. Kopera, 1938, pp. 234–7; A. Bochnak, 1960 (*Mediaevalia*), p. 418.

68 The attribution to Berrecci: J. Eckhardtówna, 1937. J. Szablowski, ed., 1965, p. 92: as attributed either to Padovano or to Berrecci. T. Dobrowolski, 1971, pp. 240–1, inclines to attribute the work to Padovano, but leaves the possibility open that it could have been done in Berrecci's workshop. J. Z. Łoziński, 1973, p. 47, draws attention to the lack of harmony between the architecture (which is certainly by Berrecci) and the tomb.

69 J. Żarnecki, 1945.

70 M. Zlat, 1969.

71 E. Panofsky, 1964, p. 57.

72 E. Panofsky, 1964, Figs. 162f. and several other Early Christian examples. For the knights with crossed legs see S. Lundwall, 1960 and J. Białostocki, 1967 (*Art Bulletin*), p. 260. It is interesting to note that the tomb of P. Boratyński in the Wawel Cathedral, mentioned in the text (J. Szablowski, ed., 1965, Fig. 640) represents him lying on the stony ground, precisely like the English fourteenth-century warriors (cf. E. Panofsky, 1964, Fig. 220: tomb of Sir Roger Kerdeston in St Mary's, Reepham, Norfolk).

73 J. Dutkiewicz, 1932, pp. 23–32; F. Kopera, 1938, pp. 250–2 and K. Estreicher and J. Pagaczewski, 1937, attribute it to Padovano. Against this attribution: J. Eckhardtówna, 1937; Z. Hornung, 1957. S. Komornicki, 1932, p. 564, considered the tomb to be a work of the Berrecci workshop, which was recently accepted in the as yet unpublished papers by M. Zlat and A. Fischinger.

74 K. Estreicher and J. Pagaczewski, 1937, pp. 159–62.

75 On Michałowicz: J. Pagaczewski, 1937; W. Kieszkowski, 1950; E. Kozłowska Tomczyk, 1967.

76 H. Kozakiewiczowa, 1963, has identified the person.

77 J. Pagaczewski, 1937, pp. 16–26; J. Szablowski, ed., 1965, p. 97.

78 J. Pagaczewski, 1937, p. 17.

79 J. Pagaczewski, 1937, pp. 30–8; J. Szablowski, ed., 1965, p. 79.

80 J. Szablowski, 1966; J. Z. Łoziński, 1973, pp. 80–5.

81 A. Rottermund, 1970. J. Szablowski, 1972, presented the first considerations originating from this discovery.

82 On this problem: E. Panofsky, 1964, pp. 35, 85, and J. Białostocki, 1968 and 1974.

83 J. Pagaczewski, 1937.

84 H. Kozakiewiczowa, 1955, has studied this type.

85 H. Kozakiewiczowa, 1955, pp. 9ff.

86 J. Dutkiewicz, 1932, pp. 13–23.

87 I refer to a hypothesis formulated by A. Fischinger, 1972 and 1974, where the tomb has been attributed to Berrecci.

Chapter Five

1 H. Kauffmann, 1954.

2 J. Ptaśnik, 1922, 2nd ed. 1959.

3 J. Ptaśnik, 1905.

4 Z. Ameisenowa, 1933, pp. 72ff.; F. Winkler, 1941; Z. Ameisenowa, 1958, pp. 166ff.; the same, 1961; J. Białostocki, 1970 (in G. Kauffmann, pp. 206–7).

5 The most important of the mostly anonymous miniature-painters in Cracow was Stanisław Samostrzelnik (born between 1480–90, died 1541), a monk from the Cistercian monastery in Mogiła near Cracow, from which he was temporarily released (1511–35) to serve the Chancellor of the Crown, Krzysztof Szydłowiecki. He illuminated several Books of Hours: for King Sigismund (British Museum), for Queen Bona Sforza (Oxford, Bodleian Library), for K. Szydłowiecki (Archivio Storico Civico, Milan), for the Lithuanian Chancellor Witold Gasztołd, as well as the history of the Szydłowiecki family the so-called *Liber geneseos* (Kórnik, Library of the Polish Academy of Sciences). Samostrzelnik was influenced by the Hungarian art milieu, where he probably was, and by German graphic art. He also painted the wall paintings in his monastery church at Mogiła. See: B. Przybyszewski, 1951; Z. Ameisenowa, 1967; J. Białostocki, 1970 (in G. Kauffmann, p. 207).

6 K. Estreicher, 1933.

88 J. Dutkiewicz, 1932, pp. 32–51; F. Kopera, 1938, pp. 253–4; H. Kozakiewiczowa, 1955, p. 17.

89 On Canavesi see: K. Sinko, 1936; *Słownik Artystów Polskich*, 1, 1971, *ad vocem*. For the Górka tomb see K. Sinko, 1936, pp. 139–42; H. Kozakiewiczowa, 1955, pp. 17ff.

90 K. Sinko, 1936, pp. 136–9.

91 Z. Hornung, 1949, p. 134.

92 K. Sinko, 1933, pp. 18–21; A. Fischinger, 1964 and 1969, pp. 47–52.

93 A. Fischinger, 1969, pp. 53–7.

94 K. Sinko, 1933, pp. 7–11; A. Fischinger, 1955, pp. 349–65; J. Eckhardówna, 1955; A. Fischinger, 1969, pp. 38–44.

7 D. Radocsay, 1955, pp. 149–63, 422–5, and 1967; M. Boskovits, 1962; D. Radocsay, 1964, pp. 59–61; Z. S. Urbach, 1964; M. Mojzer, 1965, 1966 and 1967; F. Severová, 1968; J. Białostocki, 1970 (in Kauffmann), pp. 207–8.

8 J. Muczkowski and J. Zdanowski, 1927; F. Stadler, 1936; T. Dobrzeniecki, 1954; W. Drecka, 1957; F. Winkler, 1959; P. Strieder, 1961, pp. 97–138.

9 I. Beth, 1910 (wrong attribution to Hans Dürer); T. Kruszyński, 1933–4 (first attribution to Pencz); F. Winkler, 1936; A. Bochnak, 1960, pp. 179–201.

10 Zator altar: S. Świszczowski, 1955 (dated about 1521, attributed to the workshop of Berrecci). Bodzentyn altar: A. Bochnak, 1960, pp. 218–25 (dated 1545–8 and attributed to Padovano and Cini).

11 For the altar in the Bakócz chapel, see Chapter 3, p. 32. For the altar at Svatý Jur: J. Hofman, 1930, p. 59, Pl. 44. Generally on the Renaissance in Slovakia: A. Güntherová-Mayerová, 1955, pp. 97–114, with the reproduction of the altar. The dating of Svatý Jur altar varies between 1515 and 1527.

12 H. Saalman, 1968.

13 T. Zarębska, 1964. The recent paper by L. Puppi, 1972, is rather disappointing.

14 J. Hofman, 1930, p. 53; E. Křižanová, 1956 (Bardejov). On the relations of the Bardejov centre to the Polish Renaissance architecture see now J. Ross, 1972.

15 Illustrated in *Kunst in der Slowakei*, 1939, Fig. 669.

16 E. Križanová, 1956 (Bardejov); V. Myskovszky, 1880.

17 M. Zlinszky-Sternegg, 1966.

18 P. Voit, 1961; M. Zlinszky-Sternegg, 1966, p. 59f.; P. Voit, 1969.

19 As established by P. Voit, 1961 and 1969.

20 W. Husarski, 1936; M. Zlat, 1955 (the summary of the same publication in Italian by S. Kozakiewicz and M. Zlat, 1956).

21 E. Šamánková, 1961, p. 10. On this development see also V. Mencl, 1957. Recently: I. Hlobil, 1974.

22 E. Šamánková, 1953, p. 126; A. Jůzová-Škrobalová, 1957, thinks the date 1492 on the Tovačov portal refers only to the tower and she dates the portal from the first quarter of the sixteenth century. Her thesis was not accepted in more recent literature (E. Šamánková, 1961 and later studies).

23 E. Šamánková, 1961, pp. 18–19; J. Pável, 1954, pp. 22–4; D. Líbal, 1971, pp. 23f.

24 G. Fehr, 1961, p. 62.

25 M. Zlat, 1955, p. 55.

26 G. Fehr, 1961, pp. 50–1; M. Zlat, 1955, pp. 55–7; E. Šamánková, 1953; E. Edgar, 1954.

27 B. Guerquin, 1957, pp. 35–8; M. Zlat, 1955, Fig. 8, p. 57.

28 M. Zlat, 1955, p. 56.

29 B. Guerquin, 1957, pp. 42–9.

30 E. Šamánková, 1961, Fig. 156.

31 E. Šamánková, 1961, pp. 22–3.

32 E. Šamánková, 1961, Fig. 60.

33 For the Pabianice manor see J. Z. Łoziński, 1955.

34 S. Świszczowski, 1948 and 1955 (Sukiennice).

35 A. Fischinger, 1969, pp. 61–2.

36 This law was first taken into consideration in an art historical study by W. Łuszczkiewicz, 1896, p. v; W. Husarski, 1936, p. 19.

37 E. Šamánková, 1961, p. 22.

38 S. Świszczowski, 1948, p. 306; J. Szablowski, ed., 1953, p. 443.

39 W. Husarski, 1936, p. 24.

40 M. Zlat, 1955, pp. 71, 74.

41 J. Dąbrowski, 1954, p. 153. These parapets were called 'lengyel végződés'. E. Horváth, 1939, pp. 65f., says it is impossible to establish the direction of influences.

42 E. Šamánková, 1961, pp. 40 and 122.

43 E. Šamánková, 1961, Figs. 128, 129, 251, 247.

44 D. Menclová, 1953; M. H. Takács, 1970, p. 174.

45 Levoča: B. Kovačovičová and A. Cidlinská, 1956; Prešov: E. Križanová, 1956.

46 W. Husarski, 1936; M. Zlat, 1955.

47 Examples are extremely numerous; to name a few: in Lombardy – Soncino near Cremona, after 1470; in Veneto – Villa Porto Colleoni in Thiene near Vicenza, 1490–1500; in Rome – Belvedere of Innocent VIII, 1484–7; in the south – Sciacca near Agrigento, Palazzo lo Sterpinto.

48 H. J. Krause, 1967; E. Ullmann, 1972. On this type of cresting, called in Germany 'Welsche Giebel', see recently E. Unnerbäck, 1971.

49 One has also to consider the appearance of similar forms in German Renaissance architecture in the Weser river region. See: A. Breyer and H. Masuch, 1958 and P. Müller, 1961.

50 E. Šamánková, 1961, p. 21.

51 S. Świszczowski, 1948. It was W. Łuszczkiewicz, 1899, who first proposed this attribution.

52 W. Husarski, 1936, p. 34, Fig. p. 38. For the Villa Emo Capodilista see B. Brunelli and A. Callegari, 1931, and the recent small monograph by M. Botter, 1967.

53 M. Zlat, 1967, pp. 209, 203–4.

54 W. Bettenstaedt, 1913; A. Kronthal, 1913; A. Warschauer, 1913; W. Maisel, 1953; A. Rogalanka, 1954; W. Maisel, 1965; T. Jakimowicz, 1967; J. Kowalczyk, 1968; the same, 1970; T. Jakimowicz, 1970, pp. 19–28.

55 Banská Bystrica (Beszterczebánya): B. Kovačovičová and L. Šášky, 1955; V. Hyhlík, 1957,

Fig. 97. Levoča (Lőcse): B. Kovačovičiová and A. Cidlinská, 1956, pp. 104–5 (plans). A view of the Levoča town hall before its romantic nineteenth-century pseudo-Renaissance transformation is reproduced in *Pamiatky a Múzea*, V, 1956, p. 168.

56 Our analysis follows J. Kowalczyk, 1970.

57 J. A. Miłobędzki, 1969, pp. 129–30. Some sceptical reservations about this interpretation have been expressed among others by A. Rogalanka, 1968.

58 J. A. Miłobędzki, 1969, p. 130.

59 On Jan Zamoyski see: S. Łempicki, 1952, pp. 255–405; M. Lewicka, 1957; J. Kowalczyk, 1970.

60 S. Herbst, 1954.

61 E. Šamánková, 1961, p. 10; V. Mencl, 1956; D. Líbal, 1967; D. Líbal, 1971, pp. 11f.; V. Mencl (with air photographs by E. Vasiliak), 1970.

62 L. Gerő, 1953, 1955 and 1959; T. Zarębska, 1964; K. Krajčdvičova, 1974.

Chapter Six

1 K. Chytil, 1922; K. Chytil, 1925; R. Wagner-Rieger, 1959.

2 O. Pollak, 1910–11, p. 97. On the construction of the Belvedere villa see: A. Mihulka, 1935 and 1939; Z. Wirth, 1961, p. 97; E. Šamánková, 1961, pp. 28, 34; J. Krčálová, 1964, pp. 90–1.

3 J. Balogh, 1966, pp. 100–1.

4 S. Garády, 1932, 1932–3 and 1941; J. Holl, 1959; J. Balogh, 1966, pp. 161–7.

5 V. Mencl, 1969, p. 104–5; J. Krčálová, 1974, pp. 49f.

6 W. Zin and W. Grabski, 1967; M. Dayczak-Domaniasiewicz, 1968.

7 J. Decius, *De Sigismund regis temporibus*, 1521. On Decius see *Polski Słownik Biograficzny, ad vocem*.

8 B. Krasnowolski, 1969.

9 J. Krčálová, 1964, p. 91.

10 O. Frejková, 1941; E. Šamánková, 1961, pp. 34, 36; J. Krčálová, 1972.

11 O. Frejková, 1941, pp. 85–91, 111–13; J. Krčálová, 1964, p. 91.

63 S. Herbst, 1954; F. Kotula, 1954.

64 A. Miłobędzki, 1953; J. Kowalczyk, 1962.

65 M. Lewicka, 1952; W. Tatarkiewicz, 1956; M. Lewicka, 1959; J. Kowalczyk, 1967.

66 T. Zarębska, 1964.

67 A. Miłobędzki, 1953.

68 S. Herbst and J. Zachwatowicz, 1936.

69 J. Kowalczyk, 1968.

70 W. Zin and W. Grabski, 1968.

71 J. Kowalczyk, 1968.

72 W. Zin and W. Grabski, 1967, have gathered arguments to prove that the arcaded walks were first built in Zamość in the seventeenth century after the death of both Zamoyski and Morando.

73 J. A. Miłobędzki, 1953.

74 J. Kowalczyk, 1962.

12 O. Frejková, 1941, pp. 105–11. J. Krčálová, 1964, p. 97. Recently: J. Svoboda and V. Procházka, 1975.

13 P. Janák, 1953.

14 K. Hilbert, 1909; O. Frejková, 1941, pp. 91–4; J. Krčálová, 1964, pp. 95–6.

15 O. Frejková, 1941, pp. 94–100.

16 R. Wagner-Rieger, 1959. J. Krčálová, 1969.

17 O. Frejková, 1941, pp. 52–4; E. Šamánková, 1961, pp. 29–30; O. Stefan, 1961, pp. 241–51; J. Krčálová, 1964, pp. 91–2.

18 O. Vaňková-Frejková, 1941; O. Frejková, 1941, pp. 54–7; E. Šamánková, 1961, pp. 30–1; J. Krčálová, 1964, pp. 92–3. J. Krčálová in her recent contribution (1972, pp. 307–10) attributes to Wohlmut the west and north wings of the Nelehozeves castle. Also Krčálová, 1974, p. 38.

19 M. Lejsková-Matyášová, 1956.

20 J. Balogh, 1954 (Várkastélyok). For the tradition of such castles see D. Menclová, 1958.

21 E. Šamánková, 1961, pp. 44–52. For Opočno: A. Hejna, 1953; for Bučovice: D. Menclová and

M. Lejsková-Matyášová, 1954; for Litomyšl: H. Hanšová, 1963; for Pardubice: J. Pavel, 1954; for Jindřichův Hradec: A. Bartušek, 1954.

22 R. Wagner-Rieger, 1959; P. v. Baldass, R. Feuchtmüller, W. Mrazek, 1966. H. G. Franz, 1943, pp. 9–12, considers these castles, which were built by Italian masters for Moravian or Czech patrons, as a 'German Special Renaissance' in Moravia ('Der Schlossbau der deutschen "Sonderrenaissance" in Mähren', loc. cit.), but he does not give any reason for annexing this art for Germany. The patrons of these castles are known and it may be useful to give their names: the family of Pernštejn (Pardubice, Litomyšl, Jindřichův Hradec), Boskovic (Moravská Třebová, Bučovice), Žerotín (Náměšť nad Oslavou, Rosice, Velké Losiny), Lobkovic (Horšovský Týn), Berka of Duba and Lipé (Moravský Krumlov), Trčka (Opočno), Smiřice (Náchod, Kostelec nad Černými Lesy). For these data see Z. Wirth, 1961, p. 100 (*Historia*). All these patrons were prominent representatives of the Czech nobility. Only F. Griespach, the secretary of the Habsburg king, was a foreigner, and his castles of Kačeřov and Nelahozeves are very different from the Moravian group and from the Czech castles like Kostelec, or Horšovský Týn. There were obviously some other, less important, foreigners.

23 J. Szablowski, ed., 1953, pp. 401–3, Figs. 31–2 (Pieskowa Skala); pp. 64–6, Fig. 33 (Wiśnicz); pp. 53–4, Figs. 23, 24, 44 (Niepołomice); p. 544, Fig. 25 (Żywiec); pp. 536–8, Figs. 29–30 (Sucha).

24 M. Lejsková-Matyášová, 1956.

25 The main portal in Litomyšl: H. Hanšová, 1963, back side of the cover; our Fig. 325.

26 Náměšť; E. Šamánková, 1961, Fig. 88.

27 L. Gerő, 1954, Fig. 62, p. 174.

28 J. Morávek, 1954; J. Krčálová, 1974, pp. 51–7.

29 M. Lejsková-Matyášová, 1963.

30 K. Sinko, 1933; A. Fischinger, 1969.

31 A. Fischinger, 1969, pp. 86–90.

32 The most important of them, the royal castle not far from Cracow, at Łobzów; see W. Kieszkowski, 1935–6; A. Fischinger, 1969, pp. 15–18.

33 A. Fischinger, 1969, pp. 18–24. I am following Fischinger in several points.

34 A. Fischinger, 1969, pp. 97–100.

35 J. Białostocki, 1965, p. 51.

36 A. Fischinger, 1956; A. Fischinger, 1969; J. Z. Łoziński, 1973, pp. 144–69.

37 J. Szablowski, 1962.

38 J. Z. Łoziński, 1973, pp. 144–69.

39 J. A. Miłobędzki, 1968, pp. 152–3.

40 L. Krzyżanowski, in: *Słownik Artystów Polskich*, I, 1971, pp. 179–81.

41 J. A. Miłobędzki, 1968, p. 141.

42 A. Hahr, 1913.

43 R. Hedicke, 1913; G. von der Osten and H. Vey, 1969, p. 280.

44 E. Iwanoyko, 1963.

45 J. A. Miłobędzki, 1968, pp. 139–40. See for general considerations my forthcoming article 'The Baltic sea area as an artistic region in the sixteenth century' (to appear in *Hafnia*, Copenhagen).

46 Concerning this style see E. Forssmann, 1955; L. Krzyżanowski, 1968 (*Sztuka gdańska*).

47 J. A. Miłobędzki, 1968, p. 141. On Abraham van den Blocke see L. Krzyżanowski, in *Słownik Artystów Polskich*, I, 1971, pp. 178–9.

48 Krzyżanowski, 1968 (*Gdańskie nagrobki*). Mikołaj Kos died 1599. It is recorded on 19 January 1600 that he was buried in the Oliwa church 'ubi nunc eius epitaphium extat'. This tomb first stood in the main nave and consisted of figures of Kos, his wife, and their little son Jan. After 1618 the figure of another son, Andrzej, was added. Probably after 1831 the tomb was moved to the north aisle and remodelled. The attribution of the Kos tomb to Willem van den Blocke has been established by comparative stylistic analysis taking account of Willem's documented tomb figure of the Swedish king Jan III Vasa, now in Uppsala Cathedral (but it remained for almost two centuries in the Gdańsk Arsenal). The second tomb with kneeling figures is that of the Gdańsk family Bahr. It was erected by Abraham van den Blocke in the Church of Our Lady. Models for such tombs were known in Hans Vredeman de Vries's model book as well as in several existing tombs, like those by Robert Coppens

49 B. Steinborn, 1967; J. Białostocki, 1968 (Kompozycja emblematyczna).

50 B. Steinborn, 1967, No. 20, pp. 86–7.

51 E. Šamánková, 1961, Figs. 177–81.

52 O. Blažíček, 1954.

53 Here I am repeating some observations made in J. Białostocki, 1970 (*Mannerism*).

54 R. Hedicke, 1913.

55 E. Forssmann, 1955.

56 N. Pevsner, 1946. His formulation is quoted in Białostocki, 1965, p. 51.

56a See M. Stein, 1972 and 1973.

57 L. Möller, 1956.

58 G. Kubler, 1962.

58a For these castles and fortifications see C. Csorba, 1972.

59 Here I am summarizing the results of my analysis in J. Białostocki, 1965.

60 A. Goldschmidt, 1937.

61 E. Šamánková, 1961, pp. 41–77; O. Stefan, 1964.

62 A. Kubíček, 1953.

63 J. Hořejší, 1969.

64 H. Hanšová, 1963; J. Krčálová, 1964, p. 98.

65 E. Šamánková, 1961, pp. 49–50. The design is probably by Baldassare Maggi from Arogno. The interior decoration of the cupola in stucco: Giovanni Pietro Martinola (1594–6). Terracotta decoration of the walls: Georg Bendel. The no longer extant decoration of the exterior walls: painter Georg Widman (1595–7). The arcades connecting the rotunda with the castle were built by Cometta. For all those data see J. Krčálová, 1972 ('Kruh'), and 1974, pp. 18–26.

66 For instance to Lublin: see K. Majewski and J. Wzorek, 1969; for Pińczów centre, see F. Stolot, 1970.

in Schwerin or Lauenburg) and situated on walls (like those by Floris in Breda or by Filip Brandin in the Güstrow cathedral). Of course Floris's tomb of Duke Albrecht of Prussia (in Königsberg, now Kaliningrad) was also important, although it included only one kneeling person. See also note 43.

67 V. Korbba, 1970.

68 W. Tatarkiewicz, 1926 and 1937–8.

69 J. Chyczewski, 1936.

70 J. A. Miłobędzki, 1968, pp. 160–1; J. Kowalczyk, 1957.

71 J. Kowalczyk, 1962 (*Wolff*).

72 A. Fischinger, 1969, pp. 38–44, 57–60.

73 K. Sinko, 1933, pp. 11–15, 31–5, and 1938; A. Fischinger, 1969, pp. 70–1.

74 A. Fischinger, 1969, pp. 74–9. Gucci's share in the transformation of the Baranów castle has not been cleared up. Probably the works done between 1591 and 1606 were executed from Gucci's designs by some local workshop, perhaps that at Pińczów, which was strongly influenced by Gucci. For Baranów see: T. Gostyński and B. Guerquin, 1953, and A. Majewski, 1969.

75 For which see M. Lejsková Matyášová, 1956. The similarity has been noticed by J. Ross, 1963, Figs. 6 and 7, pp. 540 and 541, and plans 'h' and 'j' on the table on p. 544.

76 M. Zlat, 1963; J. Frazik, 1968 (*Przemiany*), 1968 (*Zamek*) and 1969.

77 Very much ruined, this cresting was almost completely restored in the twentieth century (by the architect Adolf Szyszko Bohusz), but there exist original fragments which prove the correctness of the reconstruction. See J. Frazik 1968 (*Zamek*), pp. 82–3.

78 For Uchanie see J. Kieszkowski, 1922, pp. 78–83; for the Radzyń tomb: H. Kozakiewiczowa, 1955, Fig. 35, p. 43. (I illustrate this tomb as shown in the watercolour in the Stronczyński Album of the mid-nineteenth century.)

79 A. Kurzątkowska, 1968; F. Stolot, 1970; J. Z. Łoziński, 1973, pp. 125–32.

80 J. Białostocki, 1965, p. 53. For the dating see E. Gąsiorowski, 1965.

81 K. Chytil, 1904; see also the recent papers collected in *Umění*, XVIII, 1970, pp. 105ff.

82 W. Husarski, 1950; W. Husarski, 1953.

83 Some observations are here repeated from J. Białostocki, 1965. Similar solutions may be observed in the provincial works of fifteenth-century painting, for example in Spain.

ILLUSTRATIONS

Humanism and Early Patronage 1–25

The Castle 26–87

The Chapel 88–124

The Tomb 125–205

The Town 206–276

Classicism, Mannerism and Vernacular 277–351

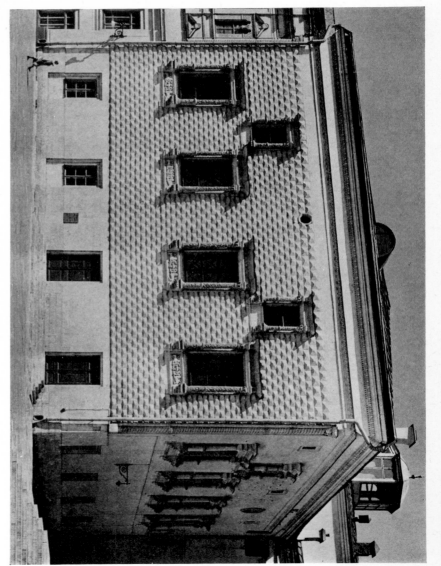

1 Marco Friasin and Pietro Antonio Solari: Faceted palace, 1487-91 (remodelled later, window frames 1682). Moscow, Kremlin

2 Alevis Novyi (Alvise Lamberti da Montagnana?): Iron Gate, 1503. Bakhchisaray, Demir Khapu Palace

3 Alevis Novyi (Alvise Lamberti da Montagnana?): Cathedral of St Michael the Archangel, after 1504. Moscow, Kremlin

INCIPIT ORDO
MISSALIS SECVN
DVM CONSVET
DINĒ ROMANAE
CVRIAE DOMINI(C
PRIMA DE ADVĒ
TV STAT ADSAC
TAM MARIÂ MA
RORĒ IN TROITVS

5 Attavante degli Attavanti: Frontispiece of a Missal with God the Father, a Roman nereid sarcophagus and a portrait of Matthias Corvinus, 1485. Brussels, Bibliothèque Royale, Ms 9008, fol. 8v.

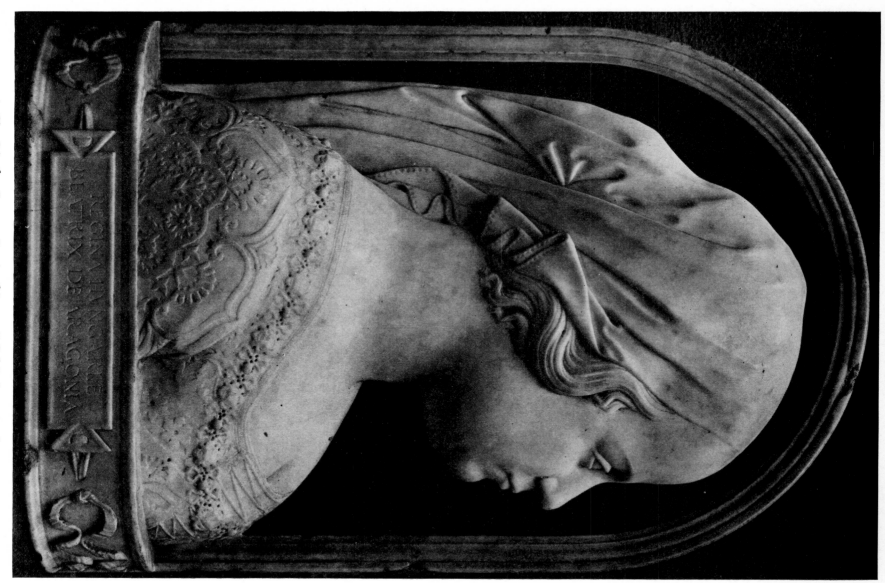

6 Gian Cristoforo Romano: Beatrix of Aragon. Relief. Budapest, Castle Museum

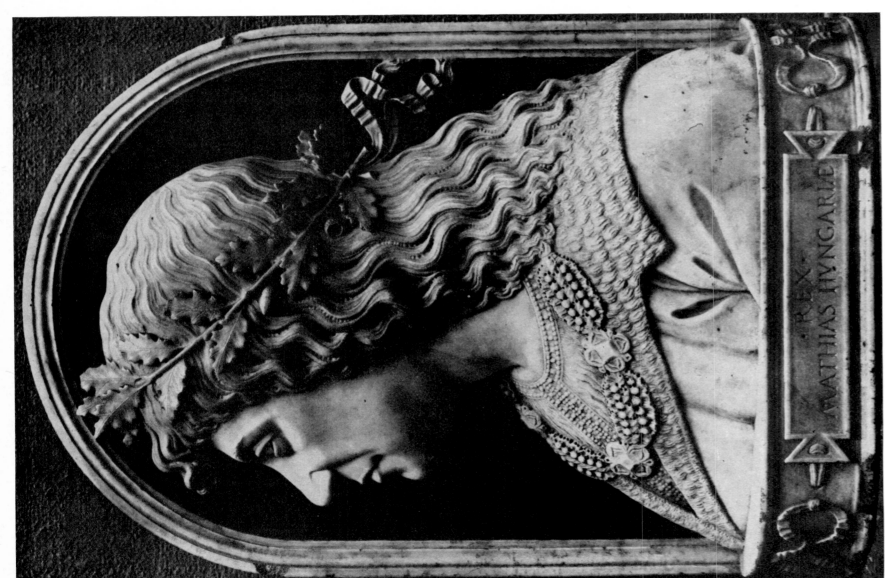

7 Gian Cristoforo Romano: Matthias Corvinus. Relief. Budapest, Castle Museum

8 Lombard or Florentine artist: Substructure of the Crucifixion group: sphinxes, dolphins and astrological representations (Crucifixion by a Paris workshop, before 1404). Esztergom, Cathedral (treasury)

9 Bolognese goldsmith, after a design by Francesco Francia: 'Apostolic Cross.' Esztergom, Cathedral (treasury)

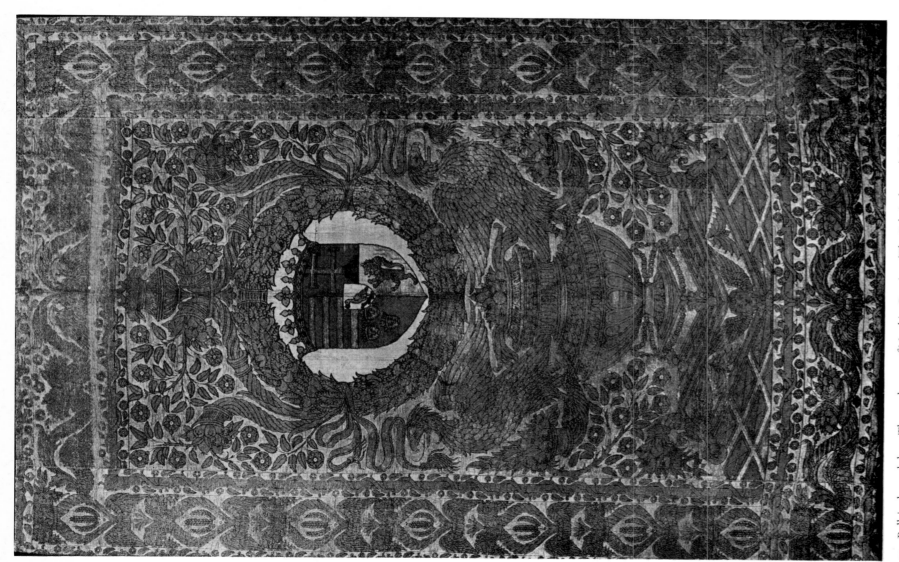

12 Ivan Duknović (Giovanni Dalmata): 'Diósgyör Madonna.'
Miscolc, Diósgyör Castle. Museum

11 Italian artist (Master Albertus Florentinus ?): Allegories of
Virtues. Frescoes, about 1494–5. Esztergom, Castle

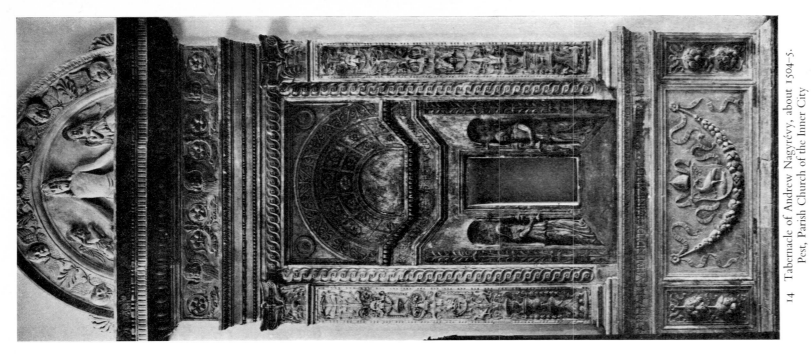

14 Tabernacle of Andrew Nagyrévy, about 1504–5. Pest, Parish Church of the Inner City

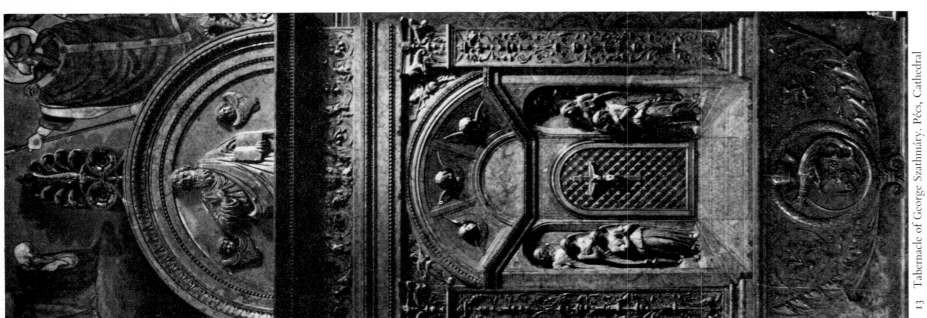

13 Tabernacle of George Szathmáry. Pécs, Cathedral

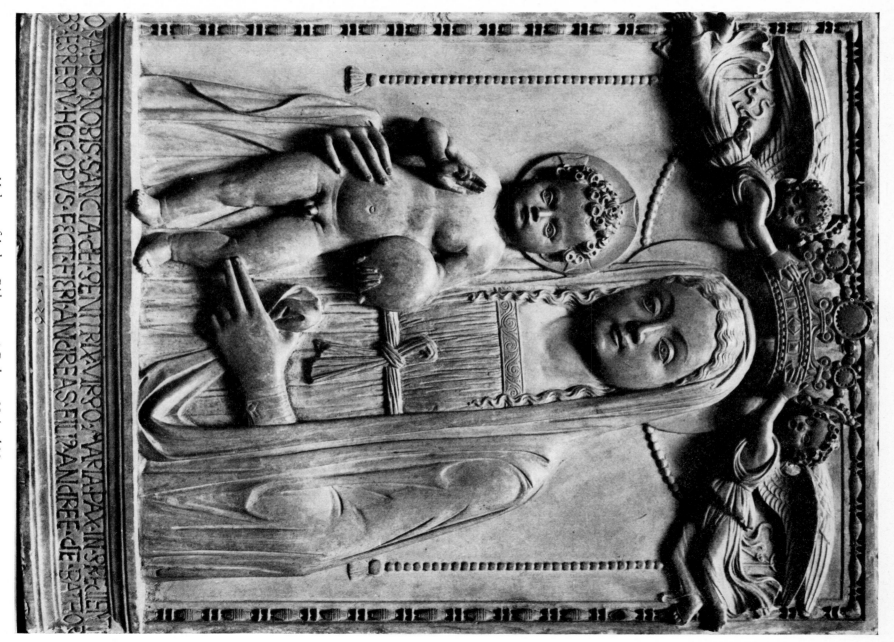

15 Madonna of Andreas Báthory, 1526. Budapest, National Museum

16 Franciscus Florentinus: Tomb of Jan Olbracht, 1502–5 (the effigy of the king probably by Jörg Huber). Cracow, Wawel Cathedral

18 Benedetto da Rovezzano: Tomb of Gonfaloniere Soderini, c. 1509, Florence, S. Maria del Carmine

17 Antonio della Porta and Pace Gaggini: Tomb of Raoul de Lannoy, begun 1507–8, assembled before 1524. Folleville, near Amiens

19 Detail of the balustrade with a candelabrum from the Nyék hunting lodge.
Budapest, Castle Museum

20 Frieze with cornucopias, from the façade of the chapel of Cardinal Bakócz, 1507–8. Esztergom, Cathedral (crypt)

21　Castle of Jakub Dębiński, 1470–80, slightly remodelled in the seventeenth and nineteenth centuries. Dębno, east of Cracow

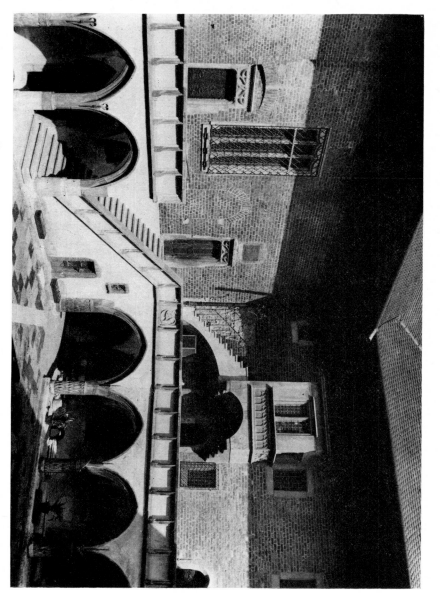

22　Collegium Maius of the Jagellonian University, 1492–7 and 1518–40. Cracow

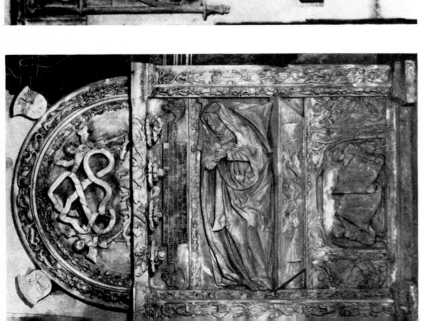

23 Tomb of Barbara Tarnowska from Rożnów, about
1520. Tarnów, Cathedral

24 Southern portal of Tarnów Cathedral, after 1505

25 Albrecht Dürer: Marriage of the Virgin. Woodcut
from the *Life of the Virgin*, about 1504–5

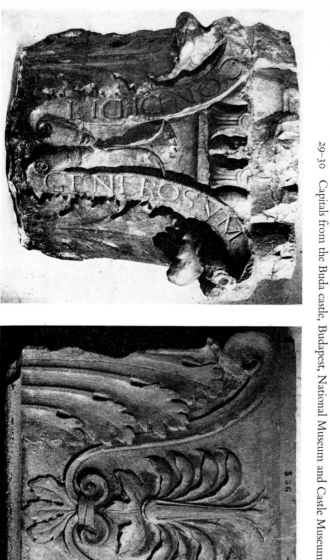

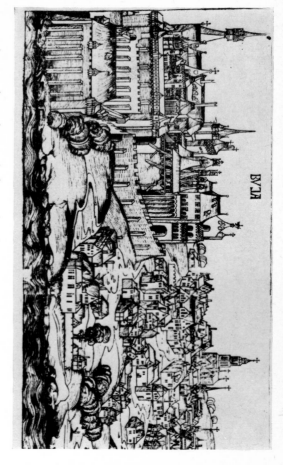

BVDA

26 Buda Castle. Detail of a woodcut from Schedel's *Chronicle*, c. 1470

27 Pieter Coecke van Aelst: Detail of View of Constantinople, showing statues of the pagan deities in bronze brought from Buda and melted in 1536. Woodcut from *Moeurs et façions des Turcs* after Marlier

28 Italian, second half of the fifteenth century: Candelabrum from the Buda castle. Istanbul, Hagia Sophia

29–30 Capitals from the Buda castle, Budapest, National Museum and Castle Museum

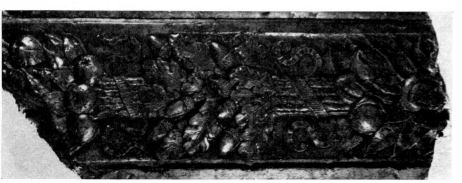

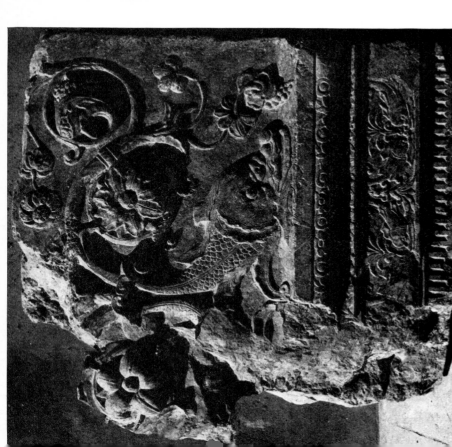

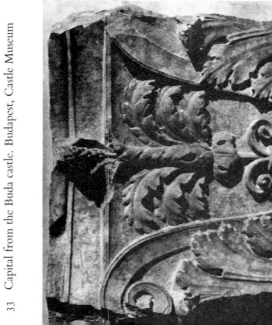

31–32 Frieze with dolphins and candelabrum ornament with fruits from the Buda castle. Budapest, Castle Museum

34 Leon Battista Alberti: Capital from San Sepolcro, Cappella Ruccellai, 1467. Florence, San Pancrazio

33 Capital from the Buda castle. Budapest, Castle Museum

35 Ceramic pavement from the Buda castle. Reconstructed in the Budapest Castle Museum

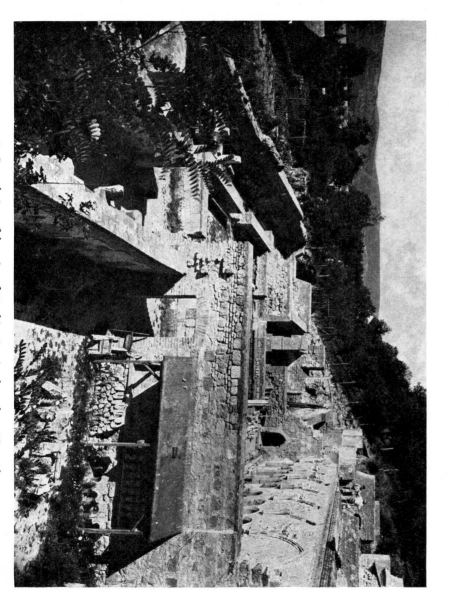

36 General view of the ruins of Matthias Corvinus's castle at Visegrád

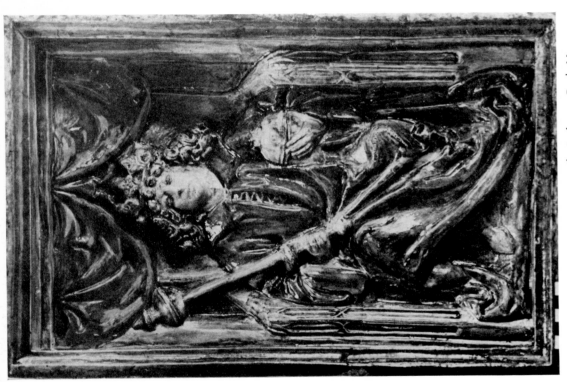

37 Effigy of Matthias Corvinus. Stove tile. Budapest, Castle Museum

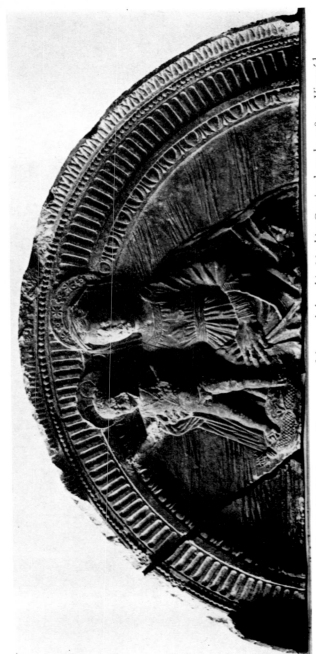

38 Master of the Marble Madonnas: Tympanum of the royal chapel in Matthias Corvinus's castle, 1480–5. Visegrád, Museum of King Matthias

40 Hercules and the Lernaean Hydra, group from the Hercules fountain in Matthias Corvinus's castle, Visegrád. Visegrád, Museum

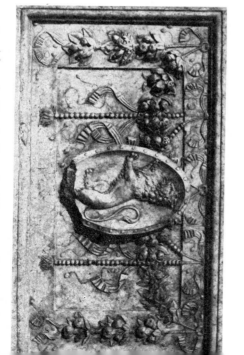

41 Panel from the Hercules fountain with Corvinus' coat of arms, 148. Visegrád, Castle

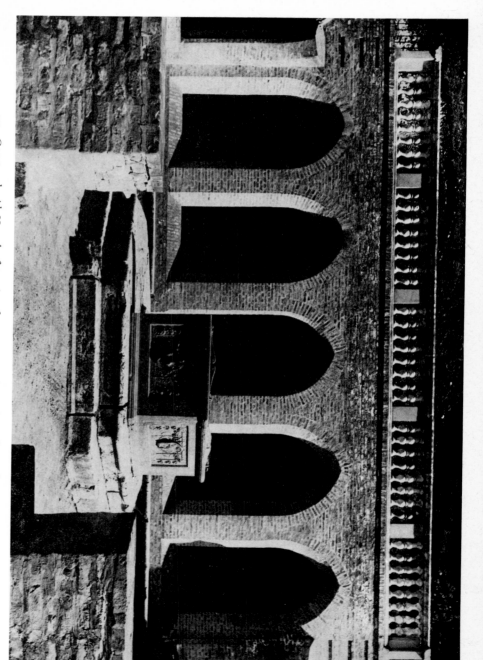

39 Courtyard with Hercules fountain, after reconstruction. Visegrád, Matthias Corvinus's castle

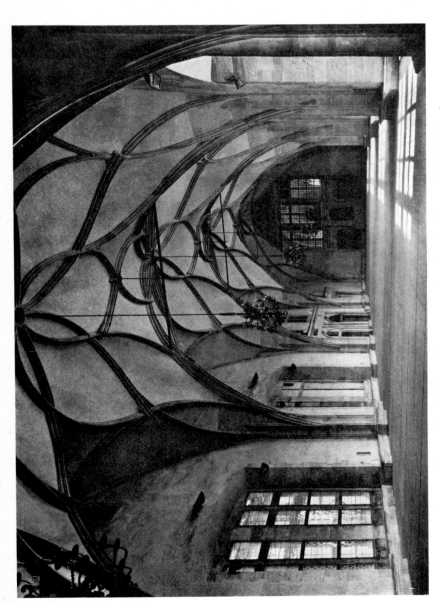

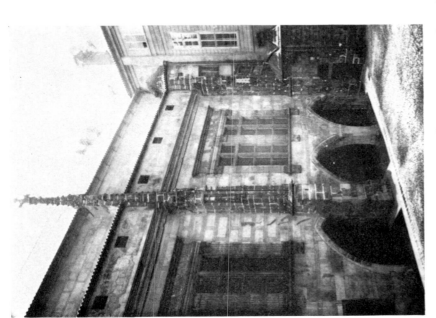

42 Benedikt Ried: Vladislav Hall, 1493–1502. Interior view. Prague, Hradshin Castle

43–44 Benedikt Ried: Vladislav Hall, 1493–1502. View from the north and view from the south. Prague, Hradshin Castle

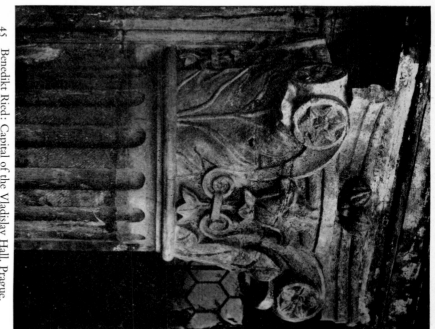

45 Benedikt Ried: Capital of the Vladislav Hall, Prague, Hradshin Castle

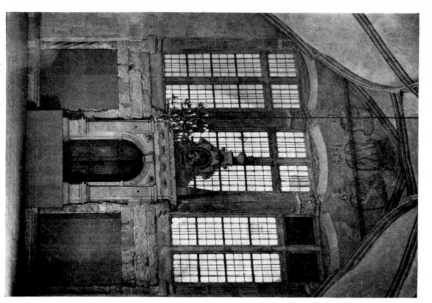

47 Benedikt Ried: Triple window inside the Vladislav Hall, east wall (portal added in 1598 by Giovanni Gargioli), Prague, Hradshin Castle

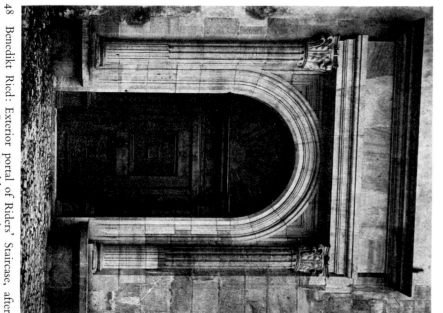

48 Benedikt Ried: Exterior portal of Riders' Staircase, after 1500, Prague, Hradshin Castle

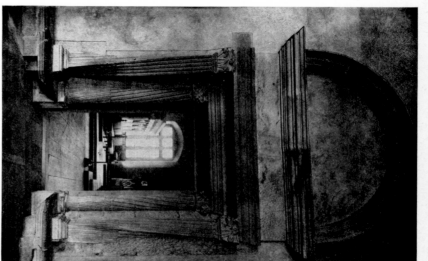

46 Benedikt Ried: Portal between the Vladislav Hall and the old Parliament room, about 1500, Prague, Hradshin Castle

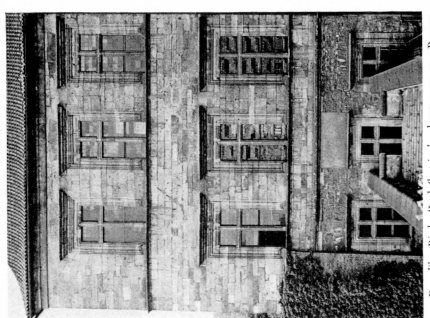

50 Benedikt Ried: 'Ludvík-wing', about 1500–10. Prague, Hradshin Castle

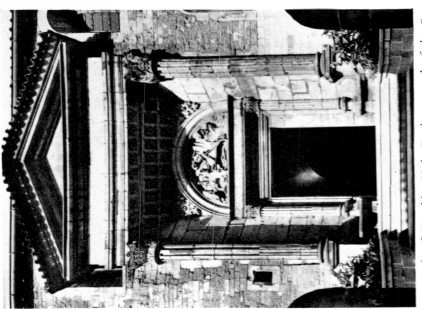

51a Style of Benedikt Ried: Southern portal of the St George's Church, about 1520. Prague, Hradshin

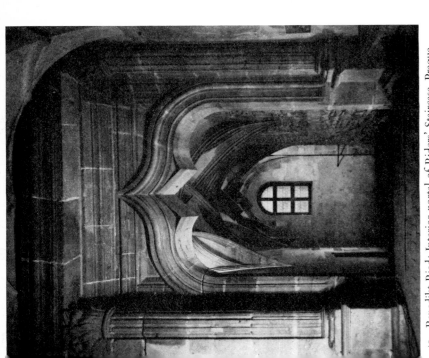

49 Benedikt Ried: Interior portal of Riders' Staircase. Prague, Hradshin Castle

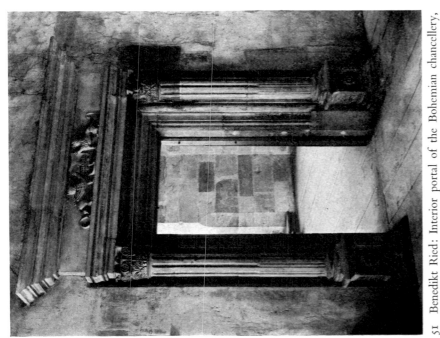

51 Benedikt Ried: Interior portal of the Bohemian chancellery, 1509. Prague, Hradshin Castle

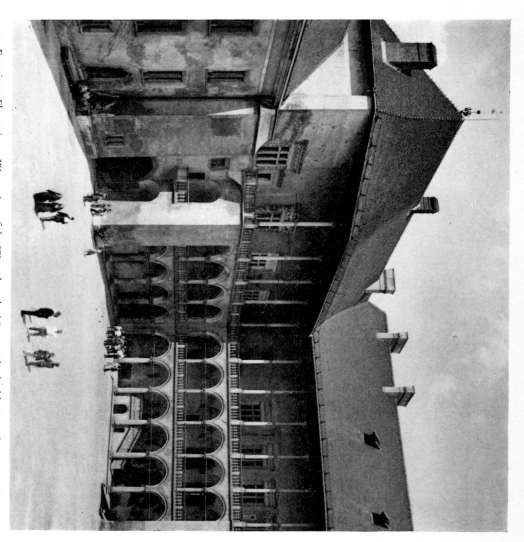

52 Franciscus Florentinus: West wing of the Wawel castle, 'Queen Elizabeth's House', 1502–7. Cracow

53 Franciscus Florentinus' workshop: Tendril ornament from a window frame. Cracow, Wawel State Art Collections (Lapidarium)

54 Detail of architectural decoration with tendril ornament from the hunting lodge at Nyék. Budapest, Castle Museum

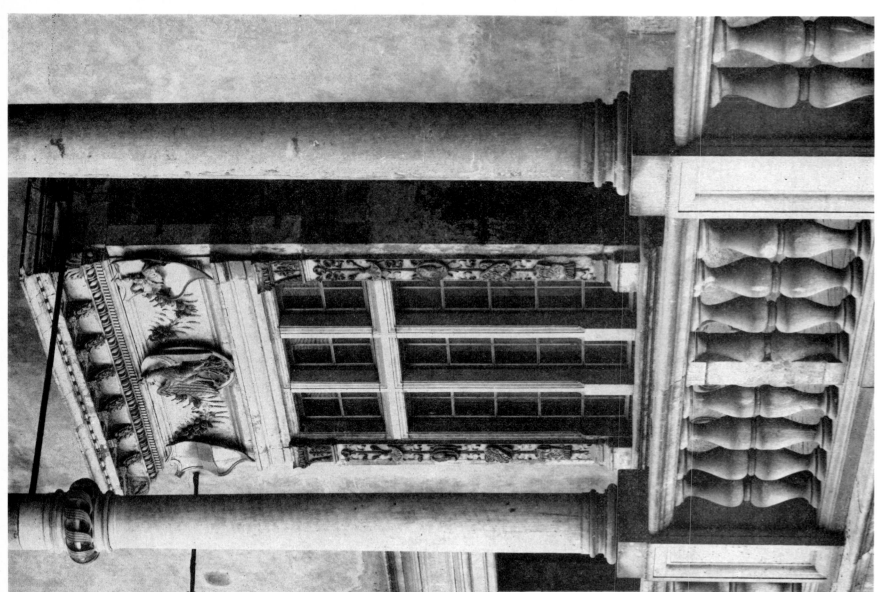

55 Franciscus Florentinus: Oriel in the west wing of the Wawel castle. Cracow

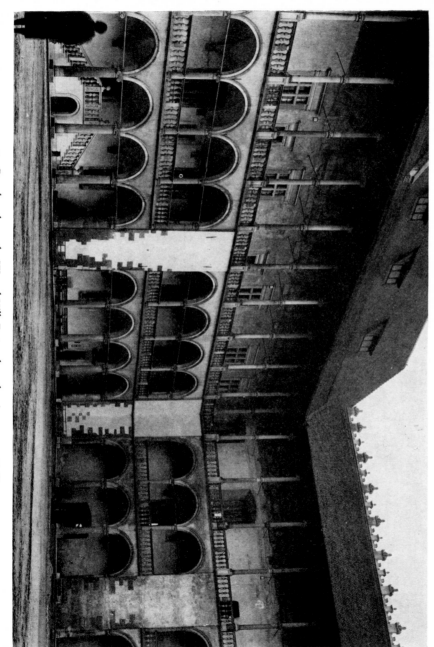

57 Royal castle on the Wawel Hill. East and south wing, 1507–36. Cracow

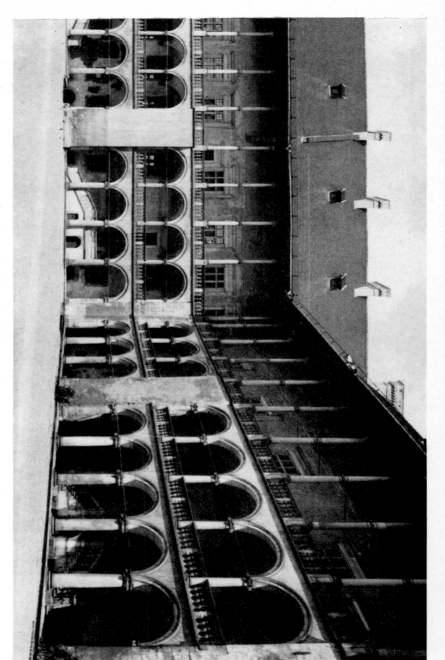

56 Royal castle on the Wawel Hill. North and east wing, 1507–36. Cracow

58 Royal castle on the Wawel Hill. General view from the north. Cracow

59 Maerten van Heemskerck: View of the Vatican with the wing of the Cortile di San Damaso. Drawing, 1533. Vienna, Albertina

61 'Wawel-type' portal, later group, 1523–9. Cracow, Wawel Castle

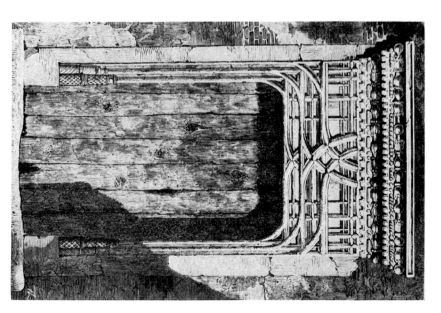

62 'Wawel-type' portal, 1520–35, in Piotrków castle. Nineteenth-century woodcut

60 'Wawel-type' portal, earlier group, 1507–16. Cracow, Wawel Castle

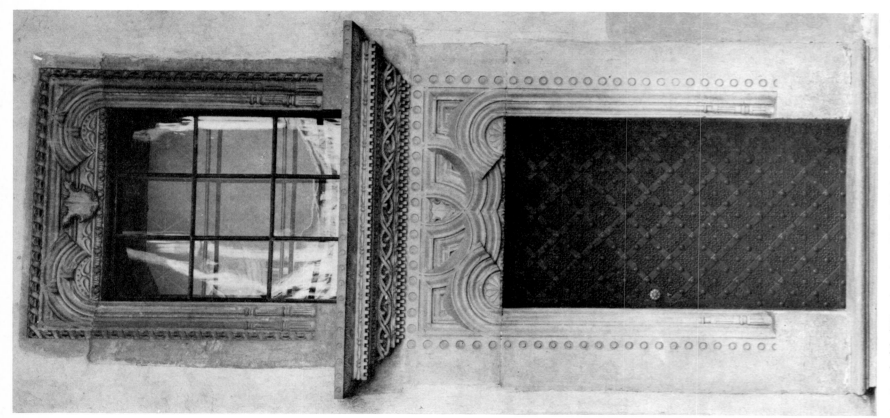

63 Portal of the 'Wawel-type' combined with the window. Cracow, Wawel Castle

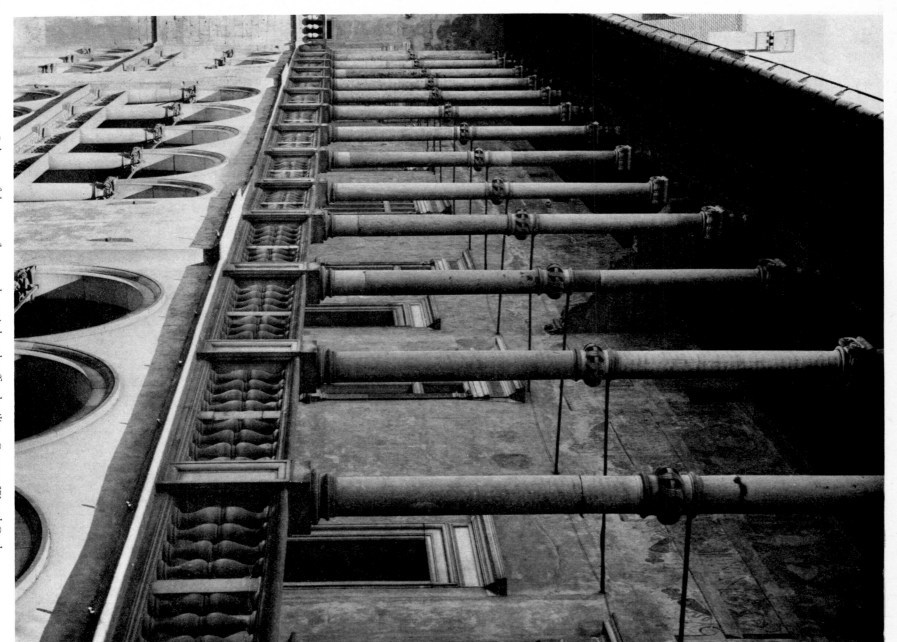

64 Columns of the upper floor arcade, capitals and coffered ceiling, Cracow, Wawel Castle

65 Master Benedikt: Castle at Piotrków, 1511–19. Early nineteenth-century drawing. Warsaw, University Library (Print Room)

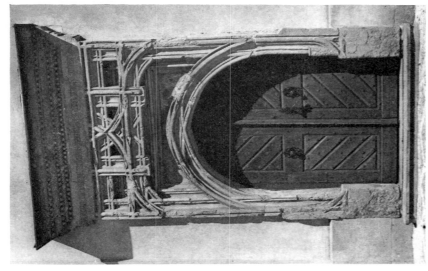

67 'Wawel-type' portal, about 1540. Jaroměř, Church

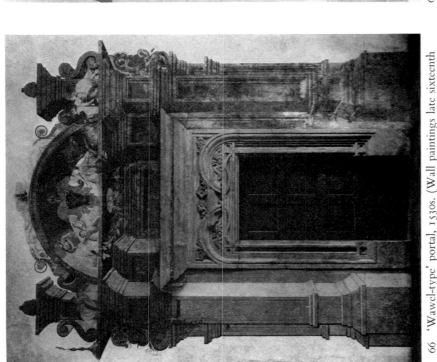

66 'Wawel-type' portal, 1530s. (Wall paintings late sixteenth century.) Pardubice, Castle

69 Dionizy Stuba: Medallions with Roman emperors and empresses. Third floor arcade, wall paintings outside, 1536. Cracow, Wawel Castl

68 Balustrade of the choir, 1510–20. Cracow, Church of Our Lady, St Lazarus's Chapel

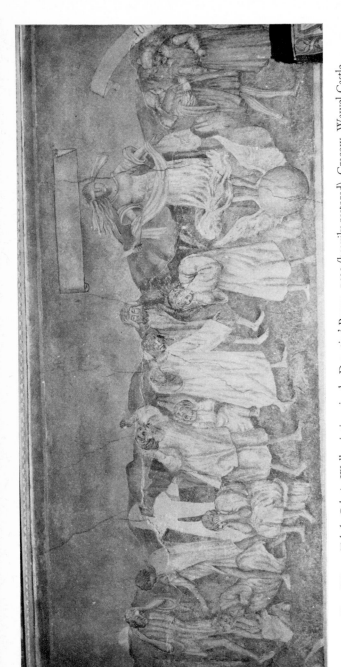

70 Hans Dürer: *Tabula Cebetis*. Wall paintings in the Deputies' Room, 1532 (heavily restored). Cracow, Wawel Castle

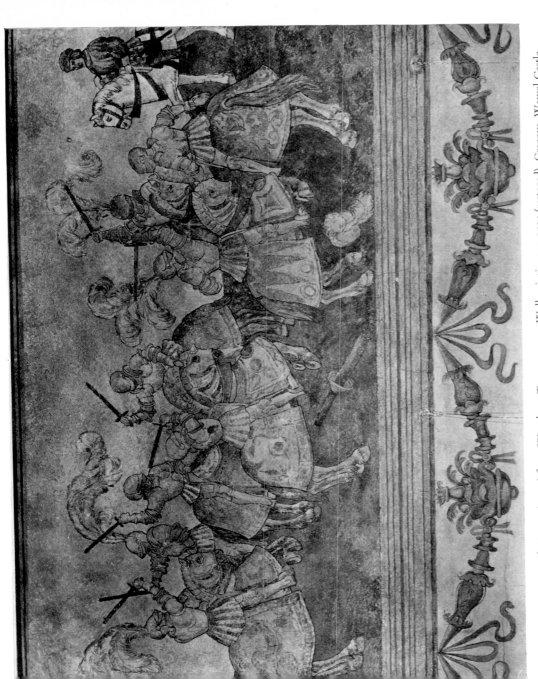

71 Hans Dürer and Master Antoni from Wrocław: Tournaments. Wall paintings, *c.* 1535 (restored). Cracow, Wawel Castle

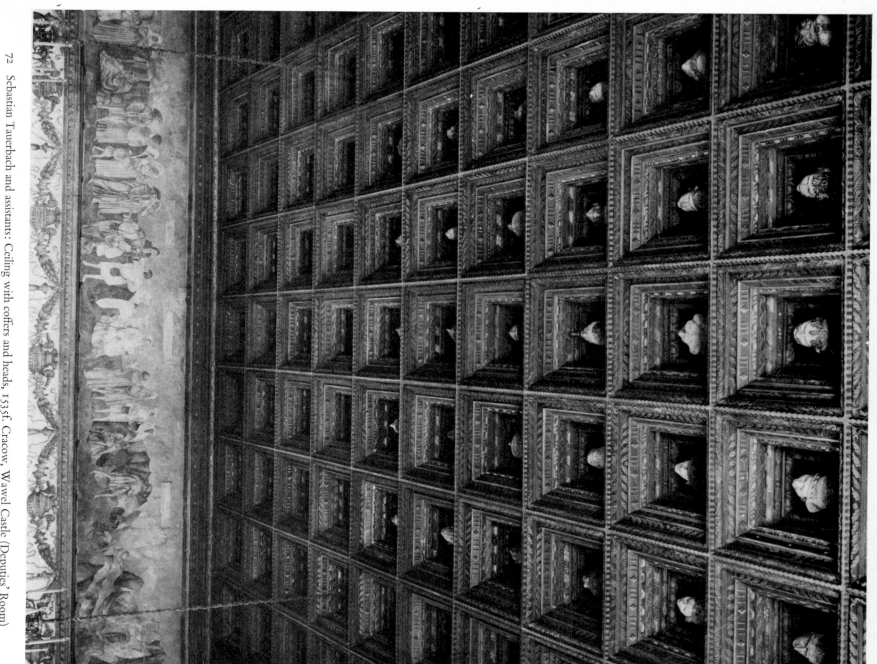

72 Sebastian Tauerbach and assistants: Ceiling with coffers and heads, 1535f. Cracow, Wawel Castle (Deputies' Room)

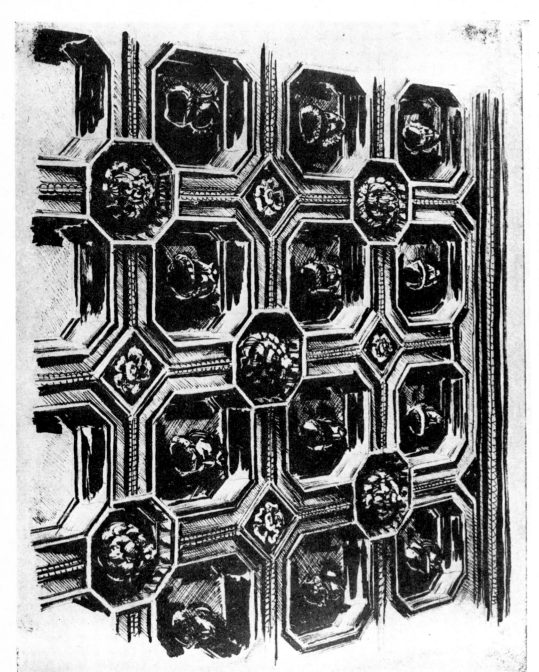

73 Hypothetical reconstruction of the original composition of the ceiling with heads in the Deputies' Room, Wawel Castle, by Dr A. Misiąg Bocheńska

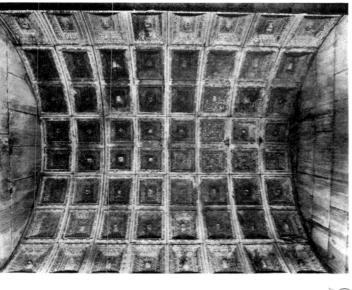

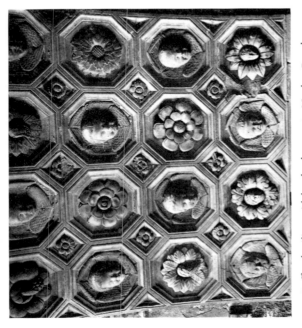

74 Coffered ceiling with heads, about 1465. Naples, Castelnuovo, (Triumphal Arch of Alfonso I)

75 Coffered ceiling with heads. Split, Baptistery (formerly Temple of Jupiter)

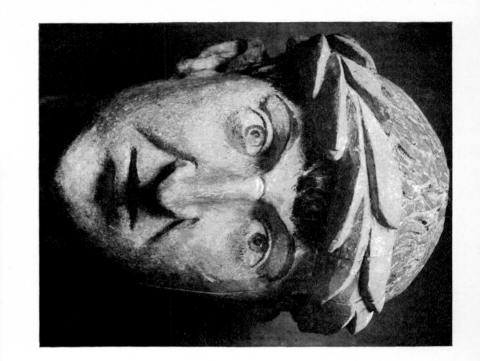

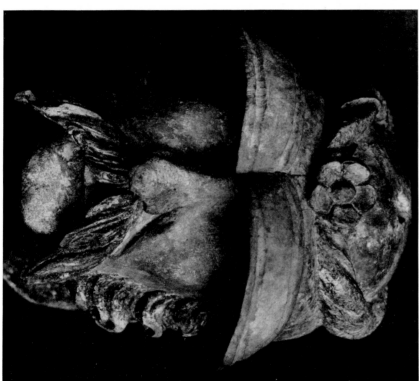

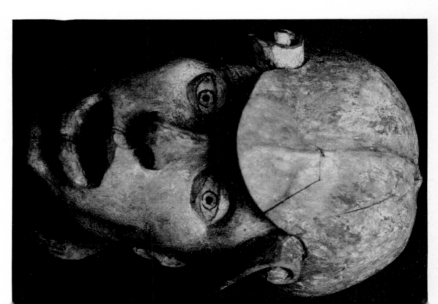

76–78 Sebastian Tauerbach and assistants: Three of the heads from the ceiling of the Deputies' Room, 1535f. Cracow, Wawel Castle

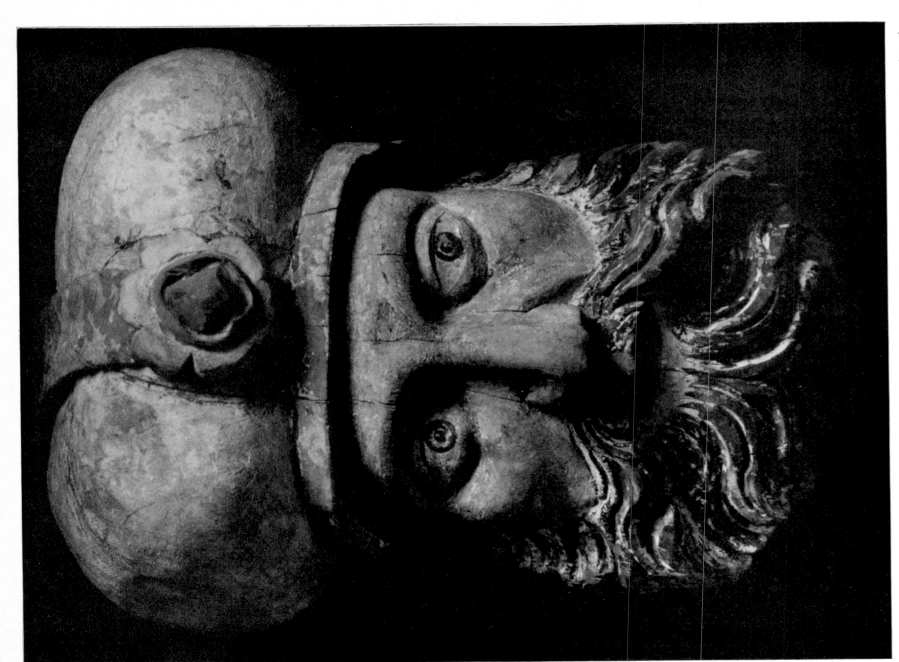

79 Sebastian Tauerbach and assistants: One of the heads from the ceiling of the Deputies' Room, 1535f. Cracow, Wawel Castle

81 Portal between the rooms of the ground floor, 1536, of the castle at Brzeg (Brieg)

80 Portal between the rooms of the ground floor, 1536, of the castle at Brzeg (Brieg)

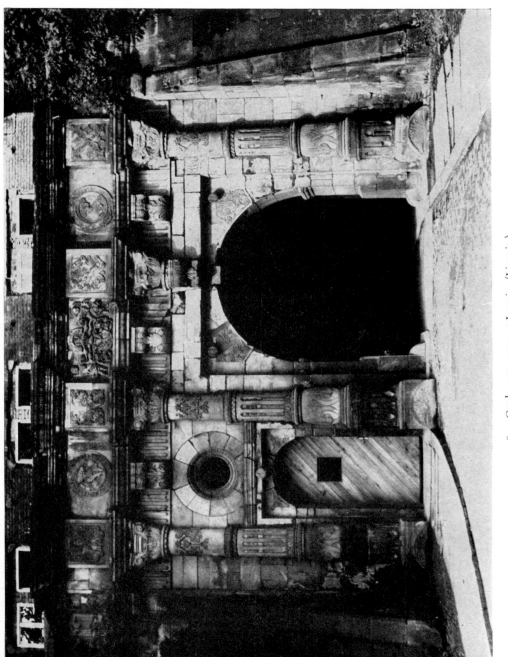

82 Castle gate, 1533, at Legnica (Liegnitz)

83 Medallions with the heads of the Roman emperors. Brzeg (Brieg), Castle

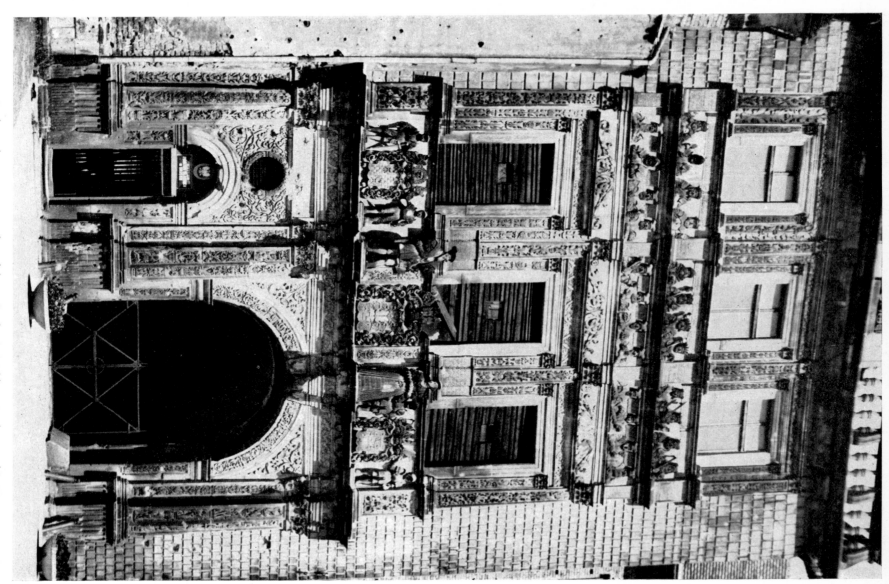

84 Castle gatehouse, 1551–3, sculptural decoration by A. Walther, K. Khune and J. Wester. Brzeg (Brieg), Castle

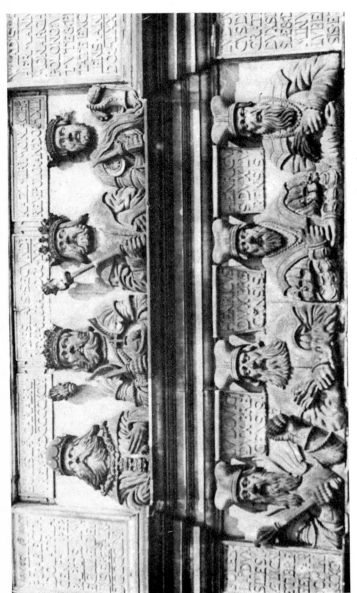

85 Gallery of the rulers of the Piast dynasty. Brzeg, Castle gatehouse

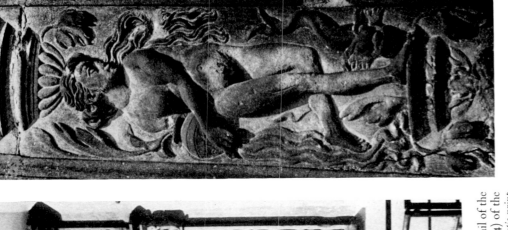

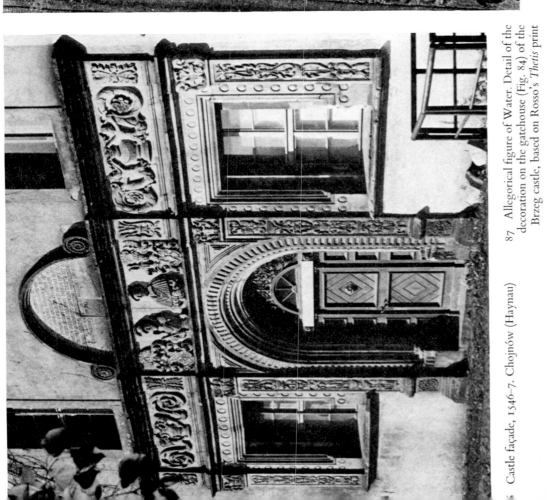

86 Castle façade, 1546–7. Chojnów (Haynau)

87 Allegorical figure of Water. Detail of the decoration on the gatehouse (Fig. 84) of the Brzeg castle, based on Rosso's *Thetis* print

General view of the wall paintings, about 1496, Kutná Hora, Cathedral (Smíšek chapel)

89 Three men fulfilling liturgical functions (?). Lower register of the wall paintings. Kutná Hora, Cathedral (Smíšek chapel)

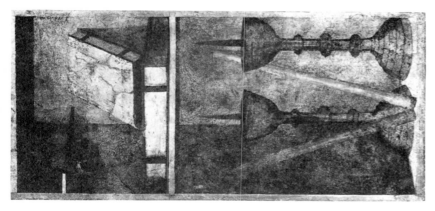

90 Niche with chandeliers, candles and books. Wall painting. Kutná Hora, Cathedral (Smíšek chapel)

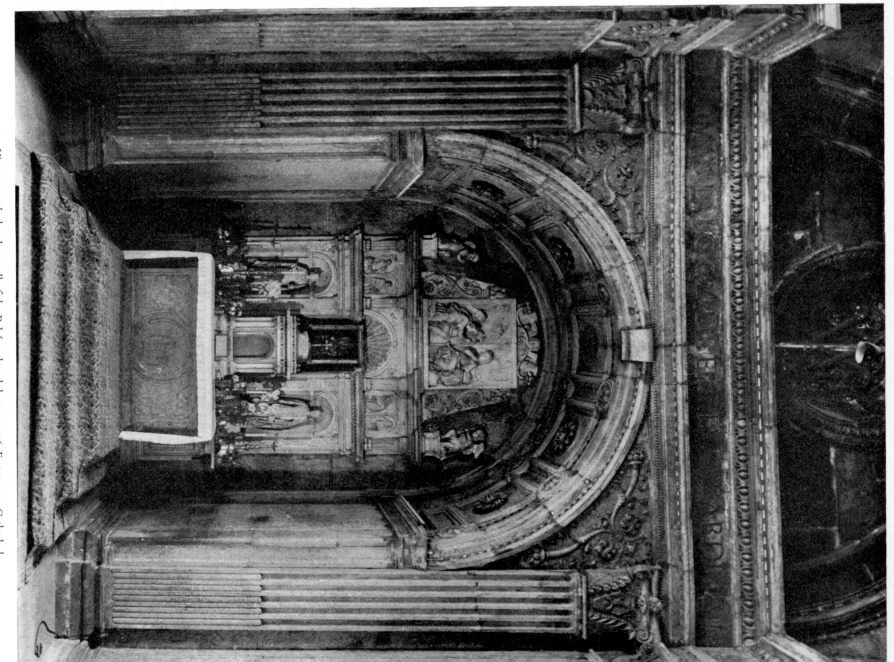

91 View towards the altar wall of the Bakócz chapel, begun 1506. Esztergom, Cathedral

92 Stall wall of the Bakócz chapel before transformation. Drawing by J. B. Packh, 1823. Budapest, Museum of Fine Arts

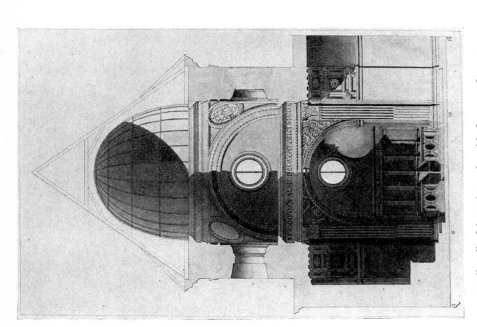

93 Walled up façade of the Bakócz chapel towards the interior of the cathedral. Drawing by J. B. Packh, 1823. Budapest, Museum of Fine Arts

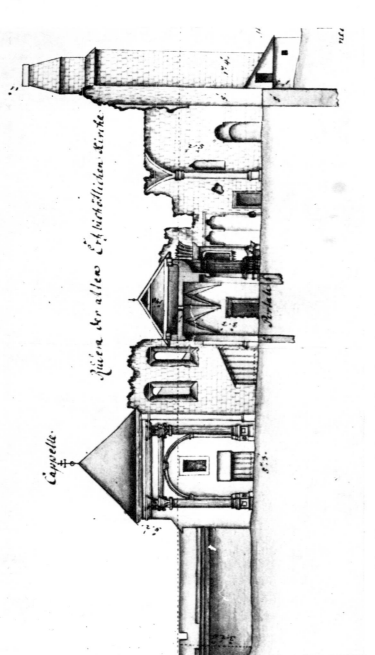

94 Ruins of the old Esztergom cathedral with the Bakócz chapel. Drawing by J. A. Krey, 1756. Vienna, War Archive

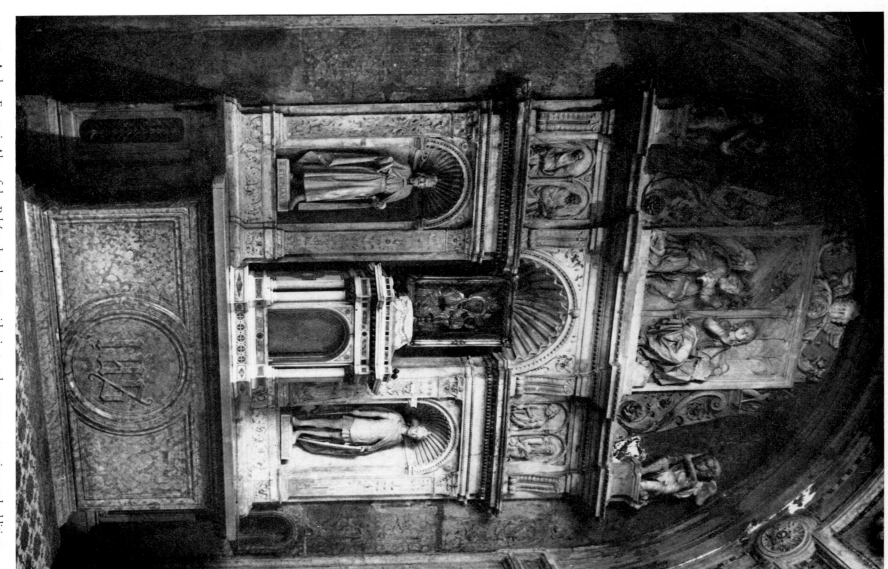

96 Arches and capitals with a part of the inscription frieze. Esztergom, Bakócz chapel

97 Interior of the Bakócz chapel: the wall with the two doors and a window. Esztergom

98 Giuliano da Sangallo: Cappella Barbadori in the sacristy of Santo Spirito, 1489–97. Florence

99 Chapel of János Lázói, 1512. Small west portal. Alba Julia (Gyulafehérvár)

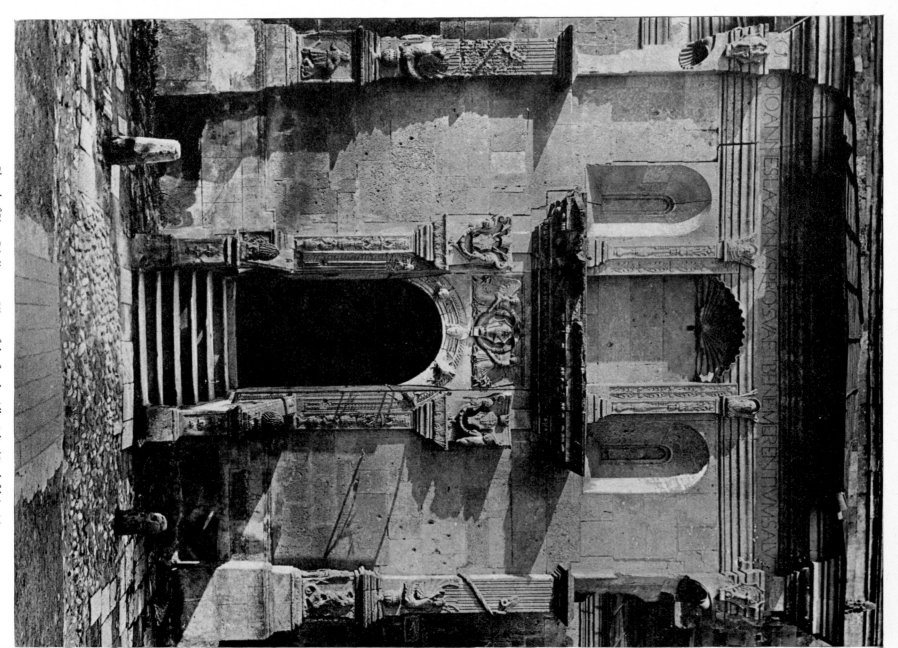

100 Chapel of János Lázói, 1512. View of the façade. Alba Julia (Gyulafehérvár)

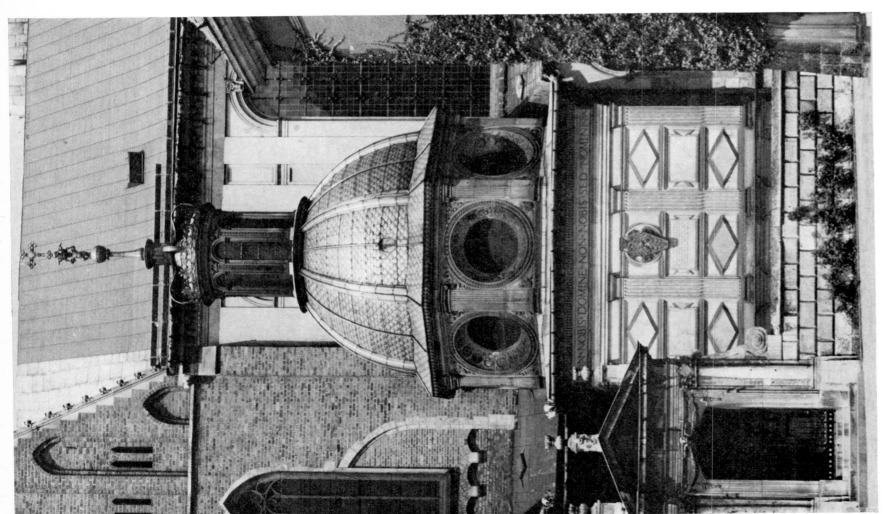

101 Bartolommeo Berrecci: Sigismund Chapel, 1517–33. Cracow, Wawel Cathedral

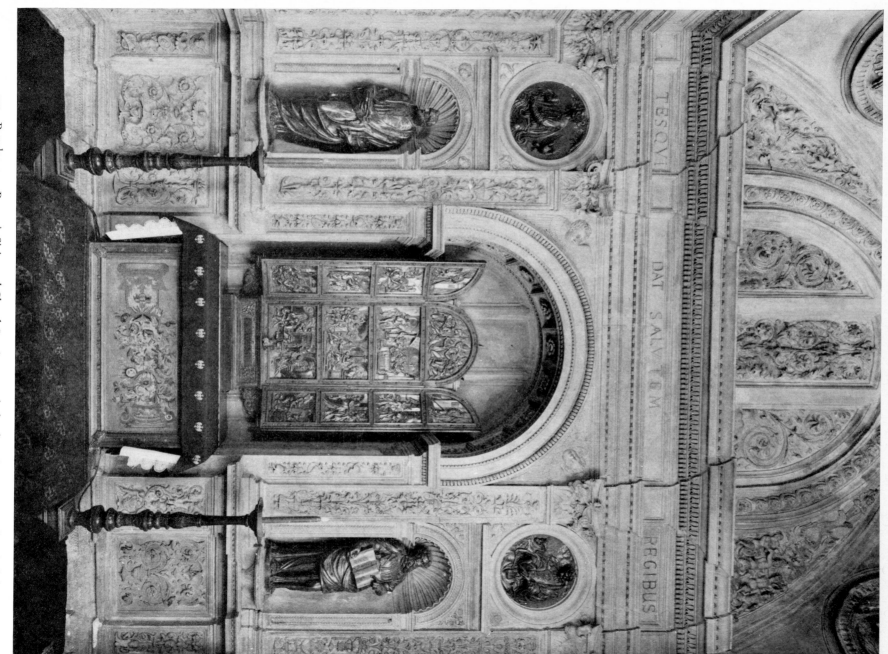

102 Bartolommeo Berecci: Sigismund Chapel. Interior towards the altar. Cracow, Wavel Cathedral

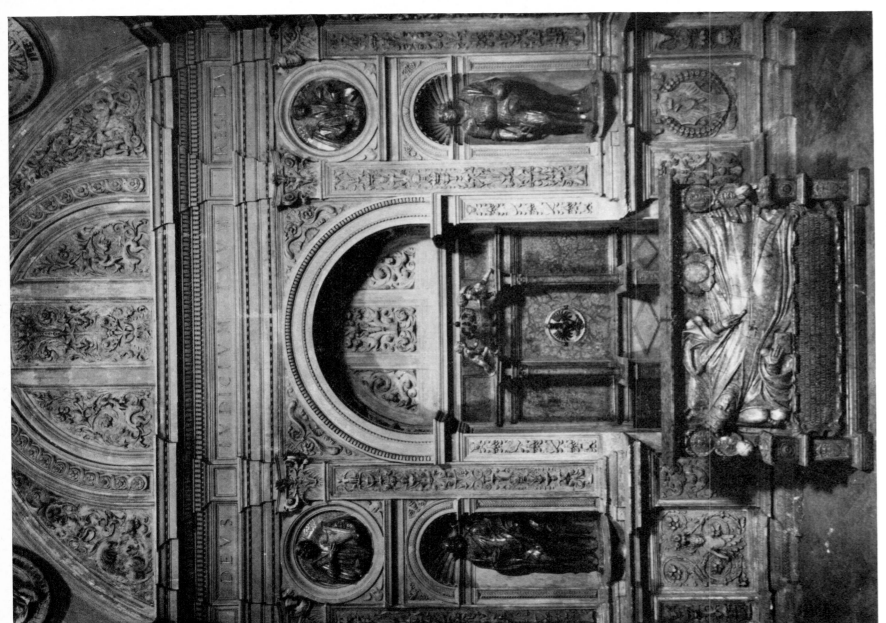

103 Bartolommeo Berrecci: Sigismund Chapel. Interior towards the royal throne. Cracow, Wawel Cathedral

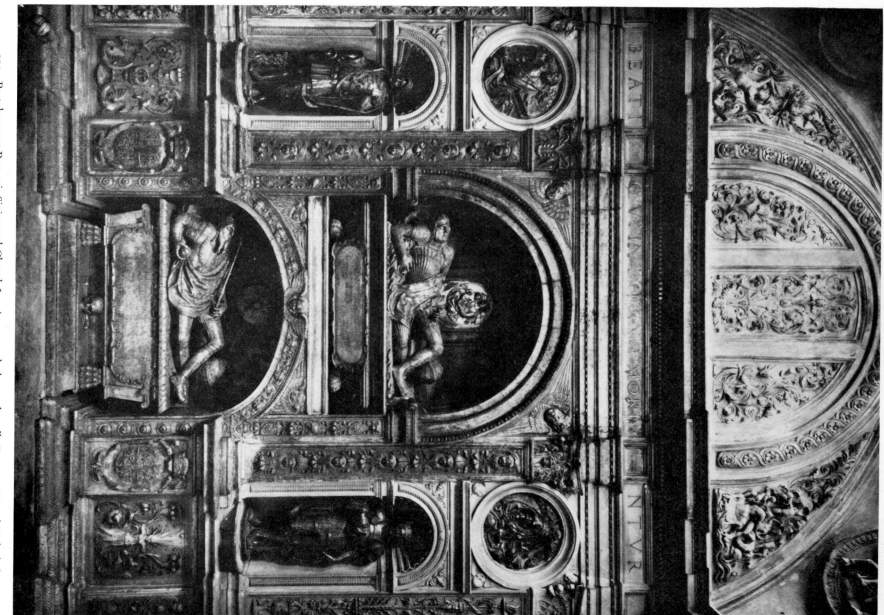

104 Bartolommeo Berrecci: Sigismund Chapel. Interior towards the tomb wall. Cracow, Wawel Cathedral

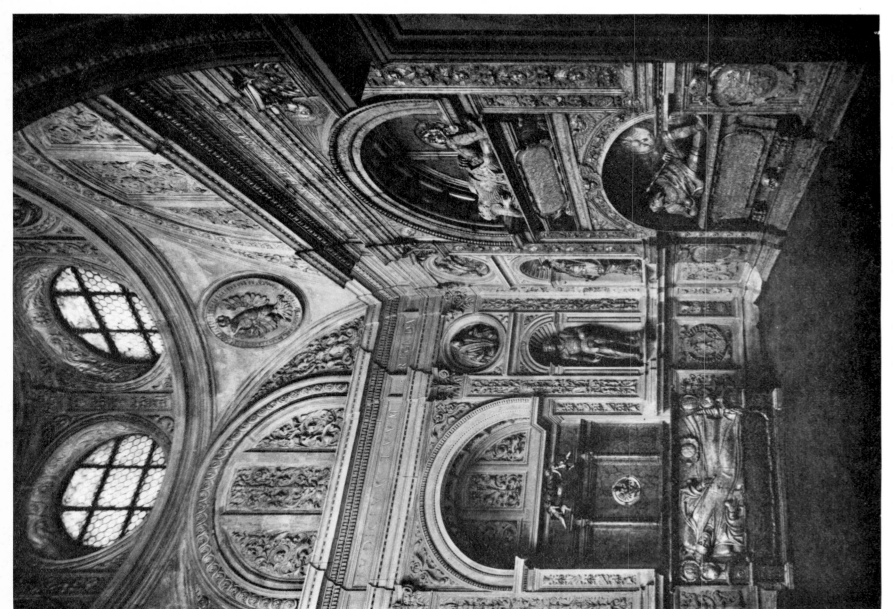

105 Bartolommeo Berrecci: Sigismund Chapel. Corner of the royal throne wall and the tomb wall. Cracow, Wawel Cathedral

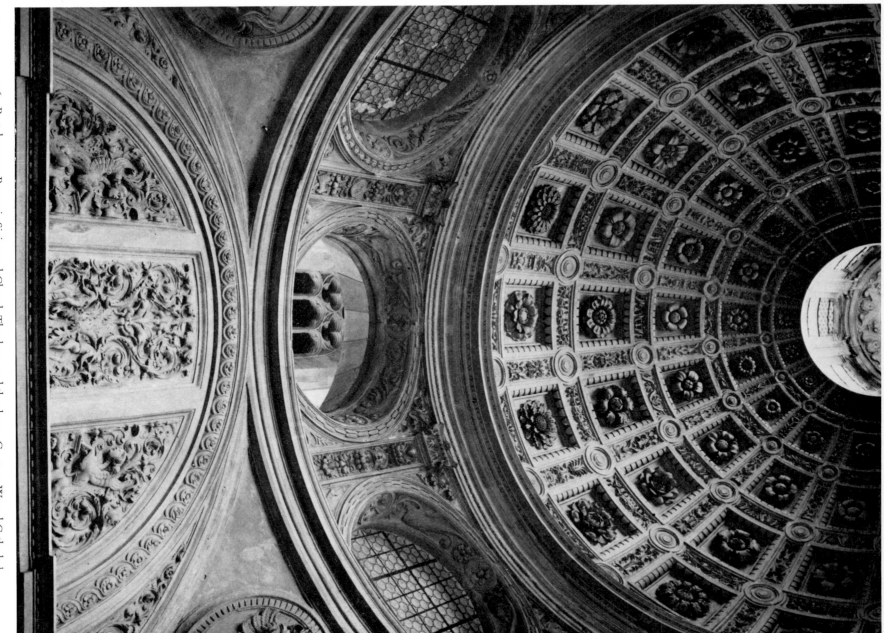

106 Bartolommeo Berrecci: Sigismund Chapel. The drum and the dome. Cracow, Wawel Cathedral

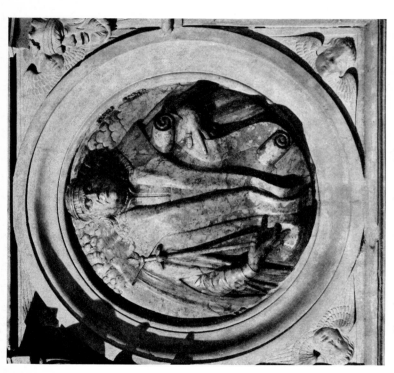

107 Bartolommeo Berrecci or his workshop: King Solomon relief. Cracow, Wawel Cathedral, Sigismund Chapel

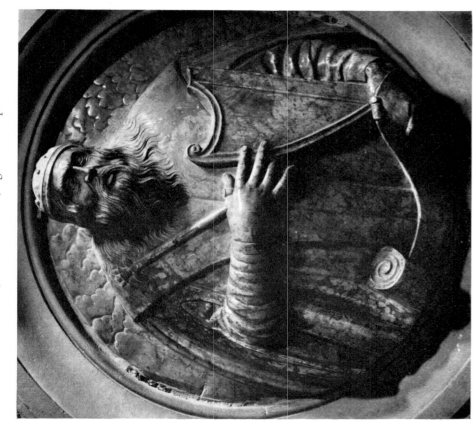

108 Bartolommeo Berrecci or his workshop: King David relief. Cracow, Wawel Cathedral, Sigismund Chapel

110 Bartolommeo Berrecci and his workshop: Allegorical figure of Plenty (?). Left field in the tympanum above the tomb wall. Cracow, Wawel Cathedral, Sigismund Chapel

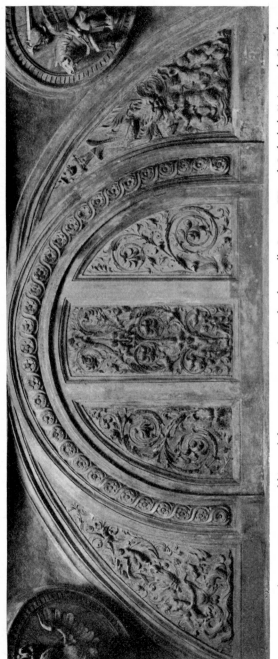

111 Bartolommeo Berrecci and his workshop: Tympanum above the altar wall. Cracow, Wawel Cathedral, Sigismund Chapel

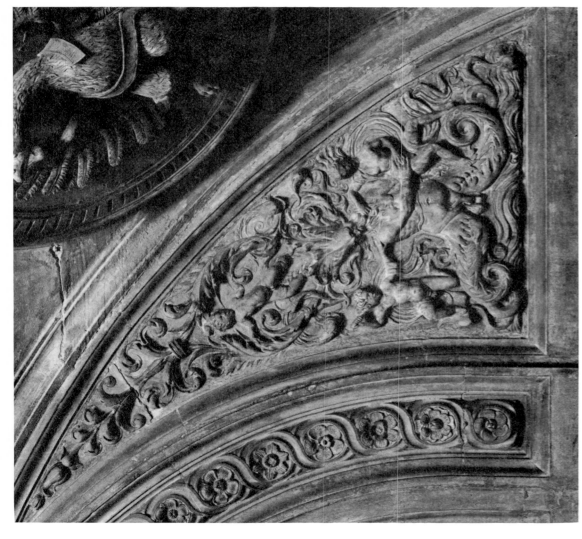

112 Bartolommeo Berrecci and his workshop: Triton and nereid. Field to the right in the tympanum above the throne wall. Cracow, Wawel Cathedral, Sigismund Chapel

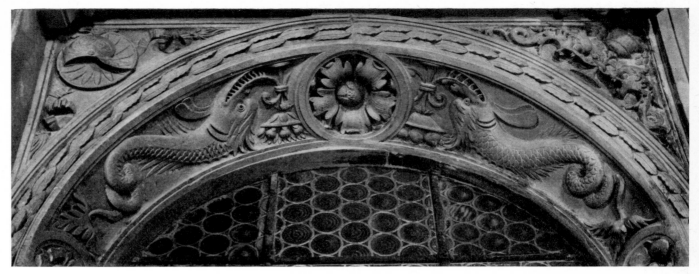

113 Window frame with dolphins, Cracow,
Wawel Cathedral, Sigismund Chapel

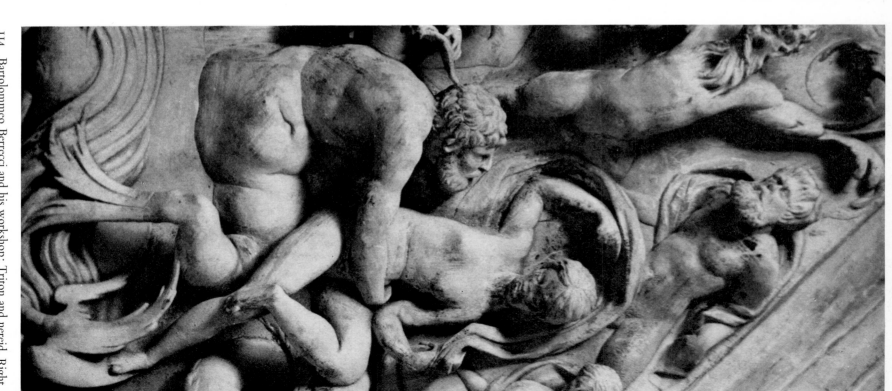

114 Bartolommeo Berrecci and his workshop: Triton and nereid. Right
field in the tympanum above the tomb wall, Cracow, Wawel Cathedral,
Sigismund Chapel

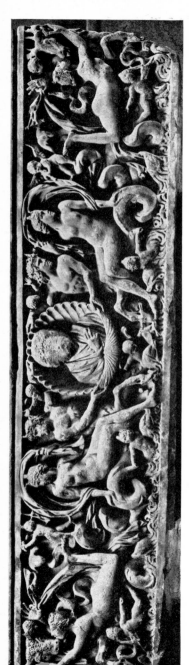

115 Roman sarcophagus with tritons and nereids, beginning of third century A.D. Rome, National Museum

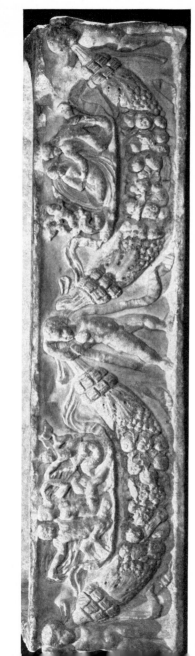

116 Roman sarcophagus with tritons and nereids, first to second century A.D. Boston, Museum of Fine Arts

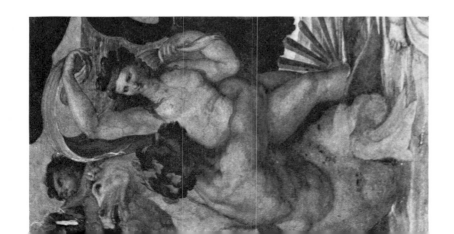

117 Raphael: *Galatea* (detail: Triton and nereid) Rome, Villa Farnesina

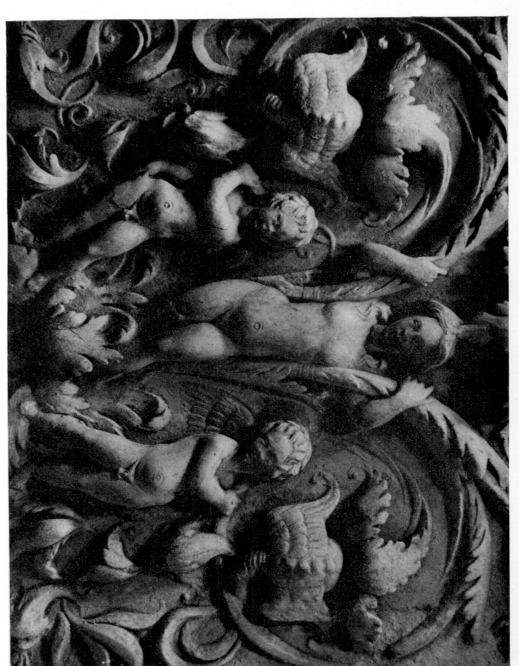

118 Bartolommeo Berrecci: Venus Anadyomene (?). Tympanum above the altar wall. Cracow, Wawel Cathedral, Sigismund Chapel

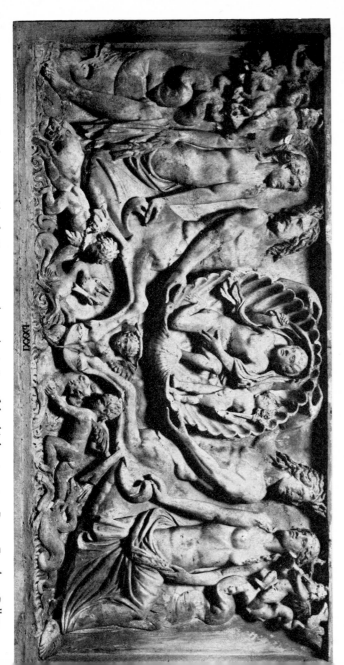

119 Venus Anadyomene, side of a Roman sarcophagus, beginning of the third century A.D. Rome, Borghese Gallery

120 Bartolommeo Berrecci: Signature in the lantern of the Sigismund Chapel. Cracow, Wawel Cathedral

122 Samuel Świątkowicz: St Mary's Chapel, 1603–11. Włocławek, Cathedral

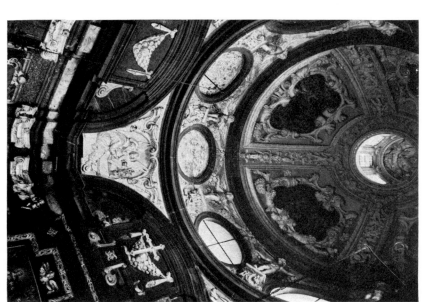

123 Vasa Chapel, 1664–76. Vault. Cracow, Wawel Cathedral

121 Bartolommeo Berrecci: Chapel of Bishop Piotr Tomicki, about 1530. Cracow, Wawel Cathedral

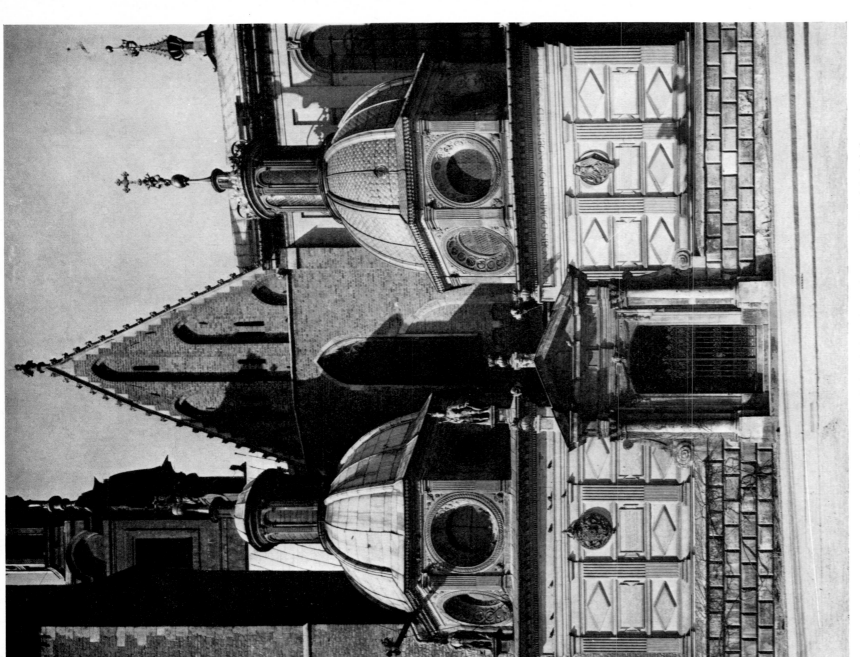

124 Vasa Chapel and Sigismund Chapel, from the south. Cracow, Wawel Cathedral

125 Joannes Fiorentinus: Epitaph, c. 1510, from the Dominican Friars Church, Buda

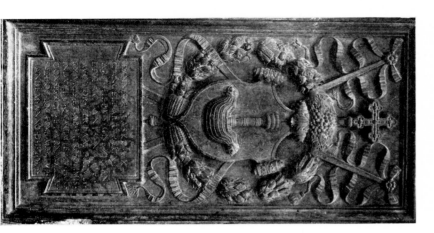

127 Joannes Fiorentinus: Epitaph of Jan Łaski, 1516, Gniezno, Cathedral

126 Joannes Fiorentinus: Epitaph of Bernardo Monelli, 1496, Budapest, Castle Museum

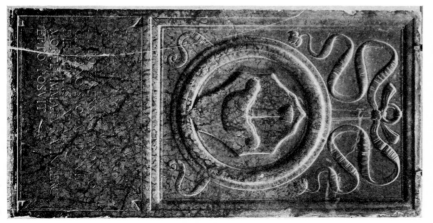

128 Joannes Fiorentinus: Epitaph of Andrzej Łaski, Gniezno, Cathedral

130 Coat of arms of Nicolaus Báthory, Bishop of Vác, 1483. Balassagyarmat, Pálóc Museum

132 Pannonian tomb stele of Herennius Pudens. Budapest, Castle Museum

129 Joannes Fiorentinus: Baptismal font from Menyő, 1515. Bucharest, Historical Museum (formerly in the Museum in Oradea-Nagyvárad)

131 Pannonian tomb stele from the castle garden in Buda. Budapest, Historical Museum

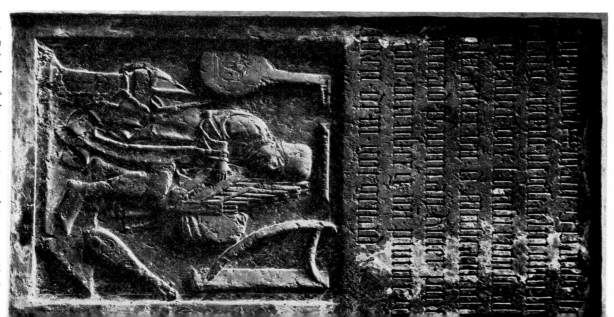

135 Circle of Altichiero: Petrarch in his study. Illumination. Darmstadt, Library

133 Veit Stoss: Epitaph of Filippo Buonaccorsi, called Callimachus (executed in the Vischer workshop, Nuremberg), 1500–10 (see Fig. 137). Cracow, Church of the Dominican Friars

136 Epitaph of the organist Conrad Paumann (died 1473). Munich, Church of Our Lady

134 Surgeon in his study, from a Roman sarcophagus, c. 300–330 A.D. New York, Metropolitan Museum of Art

The engraved inscription text (rotated along the right edge of the illustration) reads:

PHILIPPVS CALLIMACH S EXPERIENS NATIONE HETRVSCVS PLORENTINVS VIR DOCTISSIMVS

VETVSQVE ET NOVAE FORTVNAE EXEMPLVM IMITANDVM MAGNI OMNIS VITE SVCATOR

PRECIPVVS DVM OLIM CASIMIR ET IOHANNIS ALBERTI POLONIE REGVM

SECRETARIVS ACCEPTISSIMVS RELIGIONI AC RERVM A SE

GESTARVM PLVRIBVS MONVMENTIS CVM SVMMO OMNIVM BO

NORVM MERORE ET REGIE DOMVS ATQVE EIVS REIPVBLICE

INCOMODO 8 ANNO SALVTIS NOSTRE M CCCCC LXXXXVI GAL I

ENDIS NOVEMBRIS VITA DEGEDENS HIC SEPVLTVS EST

137 Veit Stoss: Epitaph of Filippo Buonaccorsi (see Fig. 133). Original form as shown in the drawing by J. N. Danielski, 1829

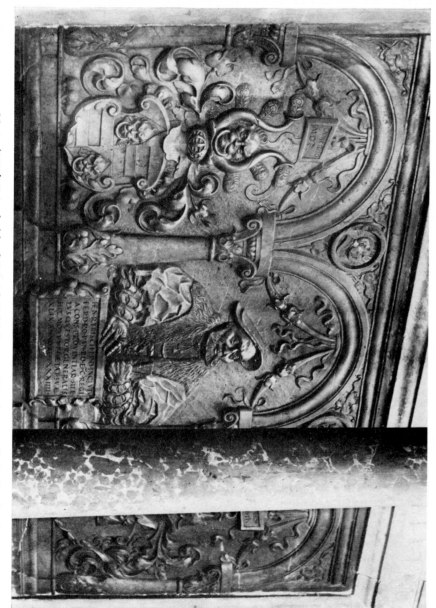

139 Master 'M.F.': Epitaph slab of Heinrich Rybisch, 1534, Wrocław, St Elizabeth's Church

138 Master 'M.F.': Tomb of Stanislaus Sauer, 1533, remodelled after 1535. Wrocław, Church of the Holy Cross

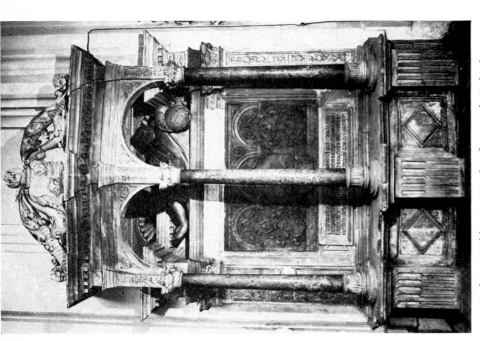

140 Andreas Walther I: Tomb of Heinrich Rybisch, 1539, incorporating the slab of 1534 (Fig. 139). Wrocław, St Elizabeth's Church

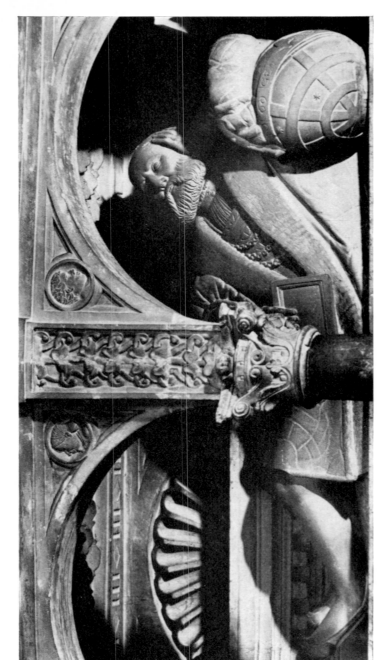

141 Andreas Walther I: Effigy of Heinrich Rybisch (detail of Fig. 140)

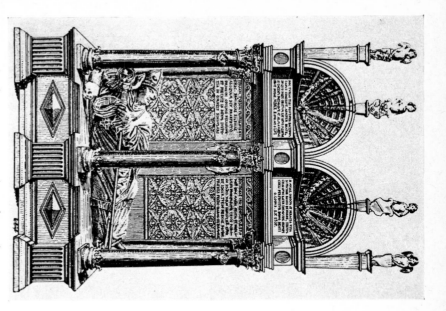

142 Tomb of Jan V Turzo, Bishop of Wrocław, 1537. Figure by an unknown artist, architecture by Andreas Walther I. Wrocław, Cathedral (after H. Lutsch)

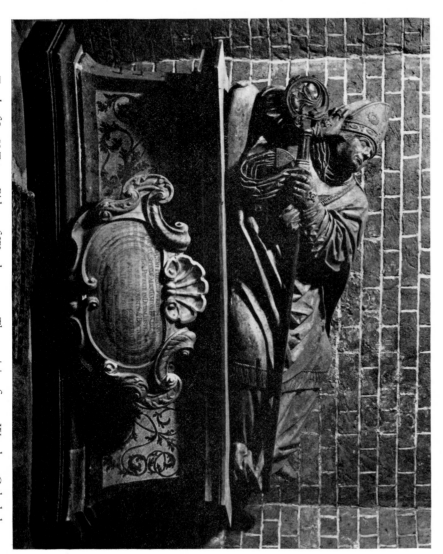

144 Tomb of Jan V Turzo, Bishop of Wrocław, 1537. The surviving figure. Wrocław, Cathedral

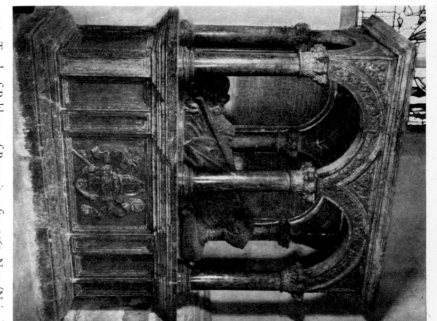

143 Tomb of Balthasar of Promnitz, after 1562. Nysa (Neisse), St Jacob's Church

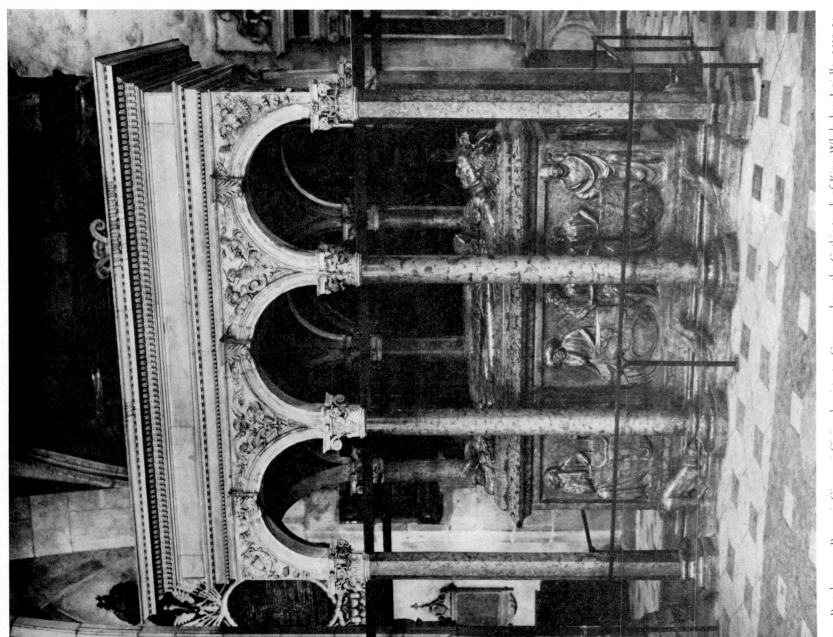

145 Bartolommeo Berrecci, Giovanni Cini and assistants: Canopy above the Gothic tomb of King Władysław Jagiełło, 1519-24. Cracow, Wawel Cathedral

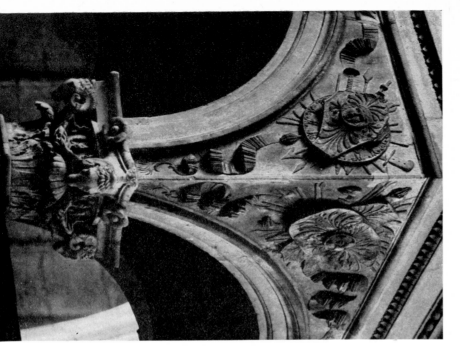

147 Detail of the capitals of the canopy shown in Fig. 145

148 The Triumph of Caesar. Detail of the ceiling of the canopy shown in Fig. 146

146 Ceiling of the canopy of the Wladyslaw Jagiello tomb (detail of Fig. 145)

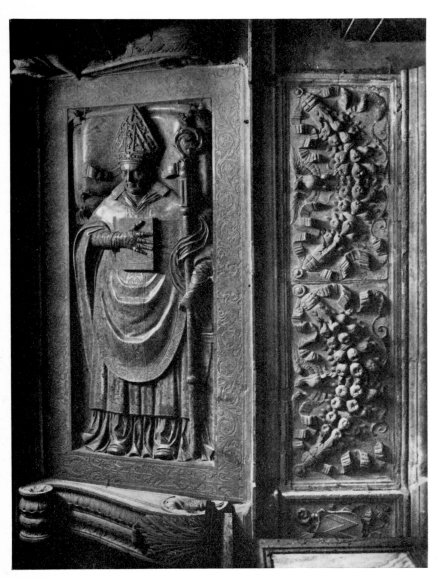

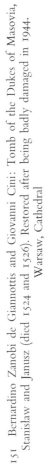

149 Bartolommeo Berrecci (?): Tomb of Jan Konarski (1521). Cracow, Wawel Cathedral

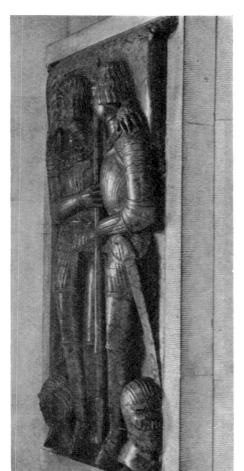

150 Bernardino Zanobi de Giannottis and Giovanni Cini: Effigy from the tomb of the chancellor Krzysztof Szydłowiecki (died 1532). Opatów, Collegiate Church

151 Bernardino Zanobi de Giannottis and Giovanni Cini: Tomb of the Dukes of Masovia, Stanisław and Janusz (died 1524 and 1526). Restored after being badly damaged in 1944. Warsaw, Cathedral

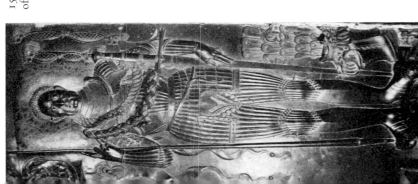

152 Jan Oslev: Tomb of Duke Jan Podiebrad and his wife Krystyna Szydłowiecka, 1557. Oleśnica (Oels), Castle Church

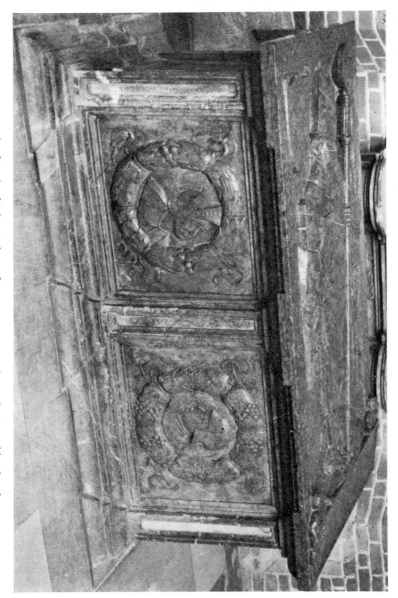

153 Tomb of Jacob of Salza, Bishop of Nysa, 1539. Nysa (Neisse), St Jacob's Church

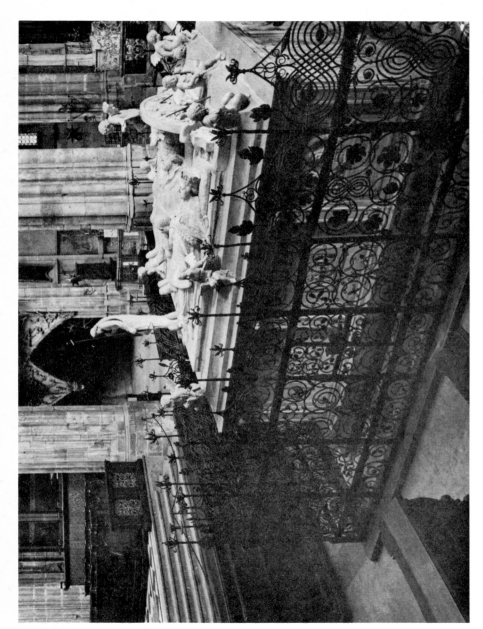

154 Alexander Colijn: Tomb of the Habsburg rulers, 1564–73 and 1590. Prague, St Vitus's Cathedral

155 Tomb of Sofia Pathócsy, 1583, from Cetatea de Baltă. Bucharest, Historical Museum (formerly in the museum in Cluj-Kolozsvár)

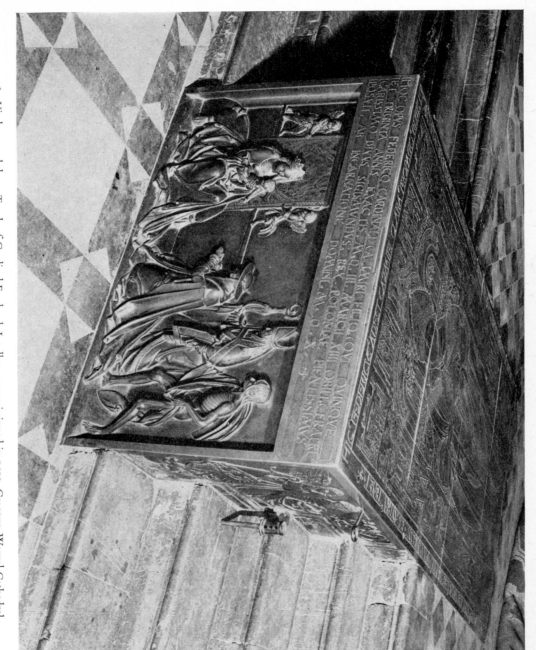

156 Vischer workshop: Tomb of Cardinal Fryderyk Jagellon, commissioned in 1510. Cracow, Wawel Cathedral

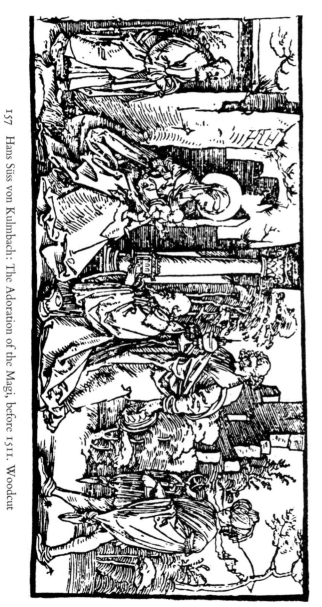

157 Hans Süss von Kulmbach: The Adoration of the Magi, before 1511. Woodcut

HOC OPVS FEDERICO CARDINALI CAZIMIRI FILIO (CVI QVINQVE
ET TRIGINTA ANNIS EXACTIS M.D.III MARCII XIII OBIT C FRATRI
CARISSIMO DIVVS SIGISMVNDVS REX POLONIAE PIENTISSIMVS
POSVIT AB INCARNATIONE DOMINI M.D.X

158 Vischer workshop: St Stanisław presenting Fryderyk Jagellon to the Virgin and Child. Relief from the tomb of Cardinal Fryderyk Jagellon. Cracow, Wawel Cathedral

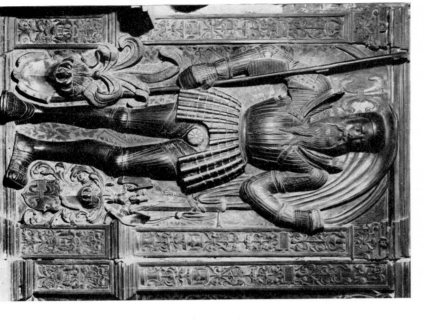

161–162 Vischer workshop (with assistance of Peter Flötner ?): Bronze plaques of Seweryn Boner and Zofia Bethman Boner, 1535–8. Cracow, Church of Our Lady

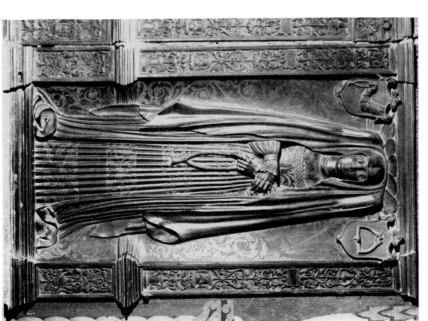

159 Jan Biały(?): Stalls and portals, 1581–3. Elements of the former tomb of St Hyacinthus. Cracow, Church of St Giles

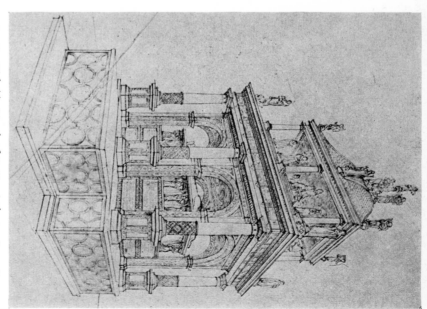

160 Jan Biały(?): Tomb of St Hyacinthus, 1581–3. Reconstruction of the original form in the chapel of the Dominican Friars Church (after K. Sinko and S. Świszczowski)

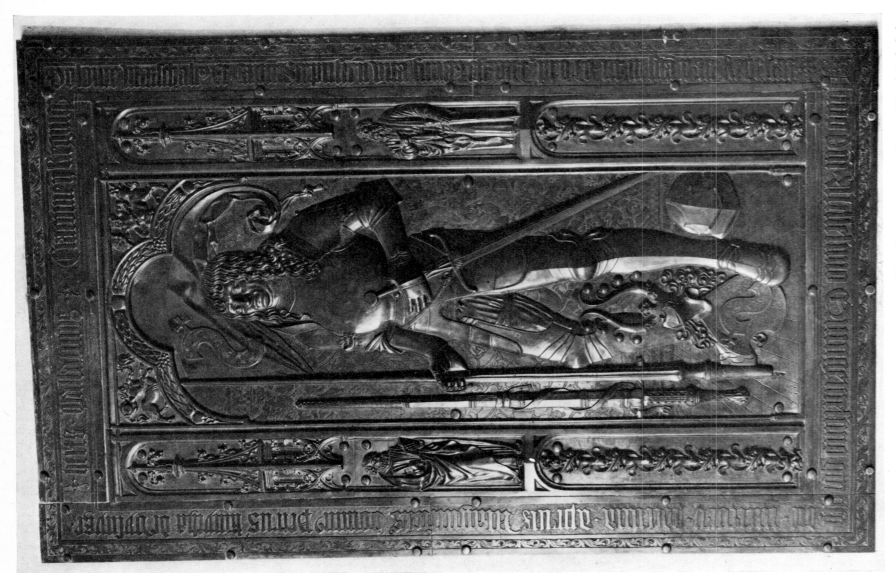

163 Peter Vischer the Elder's workshop: Bronze plaque of Piotr Kmita, after 1505. Cracow, Wawel Cathedral

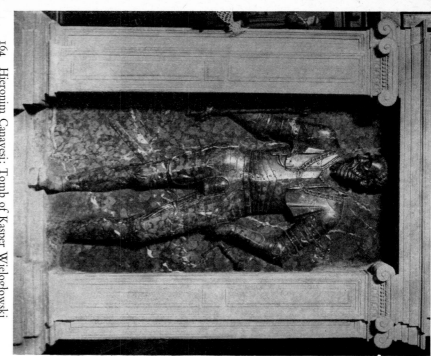

164 Hieronim Canavesi: Tomb of Kasper Wielogłowski (died 1564). Czchów, Parish Church

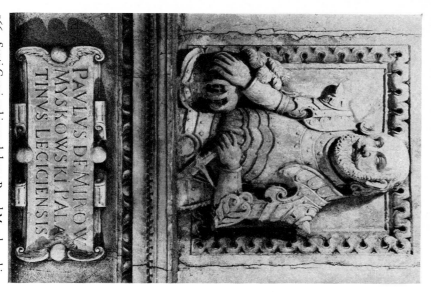

166 Santi Gucci or his workshop: Paweł Myszkowski. One of the relief effigies of the Myszkowski family in the dome of its chapel, 1602–14. Cracow, Dominican Friars Church

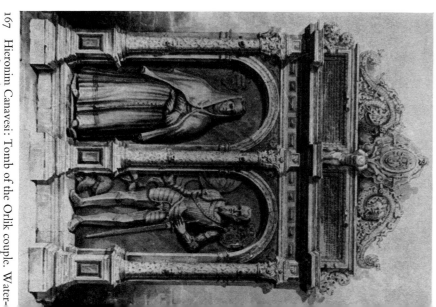

167 Hieronim Canavesi: Tomb of the Orlik couple. Water-colour by J. K. Wojnarowski, 1847. Cracow, Jagellonian Library

165 Followers of Santi Gucci: Walerian and Anna Montelupi. Detail from the Montelupi Tomb (Fig. 168). Cracow, Church of Our Lady

168 Followers of Santi Gucci: Tomb of the Montelupi family, early seventeenth century. Cracow, Church of Our Lady

169 Santi Gucci and his workshop: Tomb of the Kryski family, 1572–6. Drobin, Parish Church

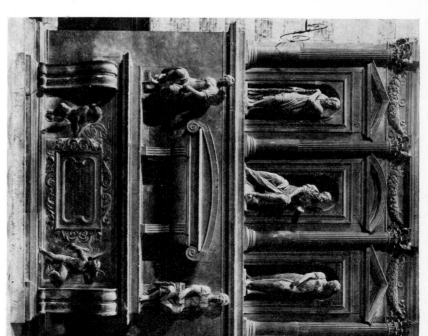

170 Bartolommeo Ammanati: Tomb of Marco Mantoa Benavi... 1546. Padua, Eremitani Church

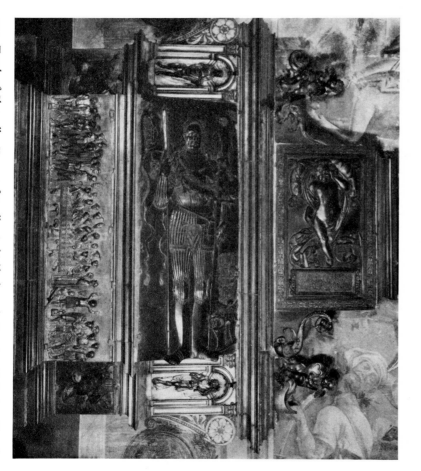

171 Tomb of Chancellor Krzysztof Szydłowiecki (died 1532). Opatów, Collegiate Church

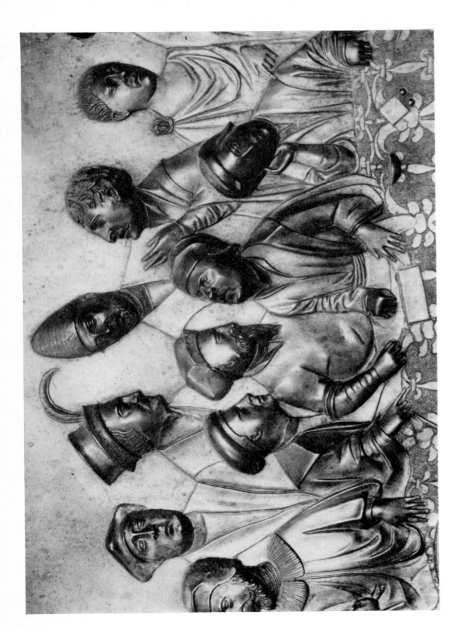
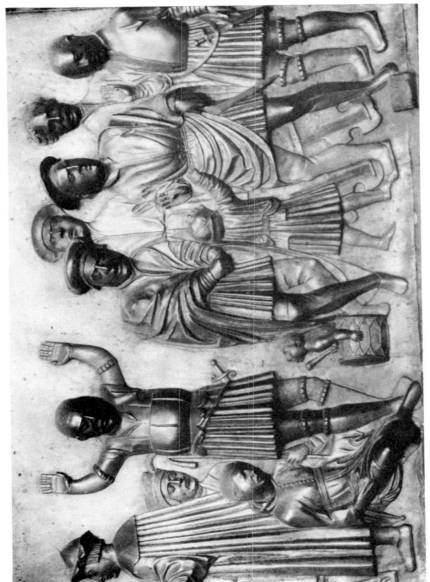

172–173 Mourners. Two details from the bronze relief at the bottom of Fig. 171

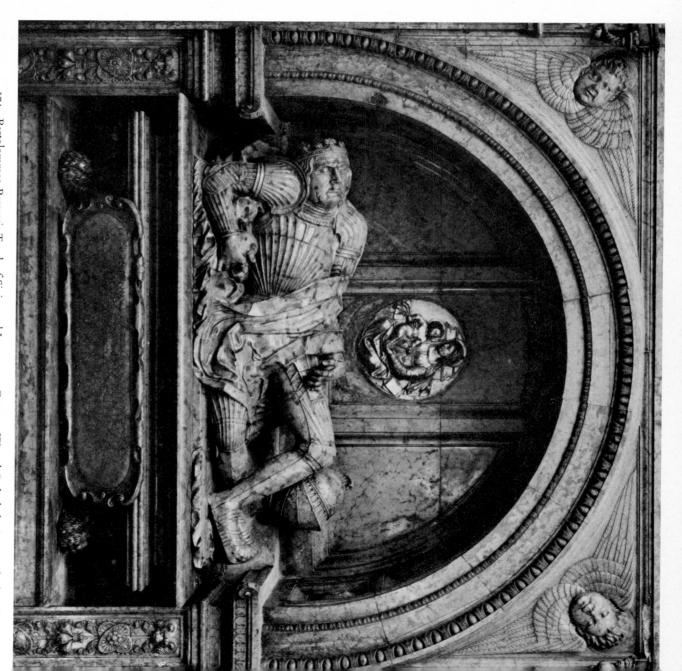

175 Andrea Sansovino (?): Tomb of Cardinal Pietro Manzi dei
 Vincenzi, after 1504. Rome, S. Maria in Aracoeli

176 Nanni di Bartolo (called Rosso): Sleeping soldier from the
 Brenzoni monument, 1427-39. Verona, S. Fermo Maggiore

174 Bartolommeo Berrecci: Tomb of Sigismund I, 1529-31. Cracow, Wawel Cathedral, Sigismund Chapel

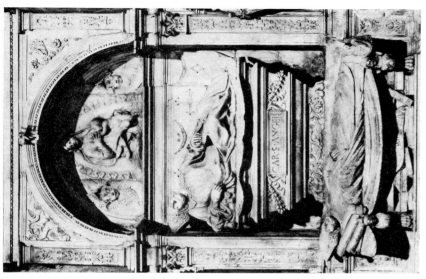

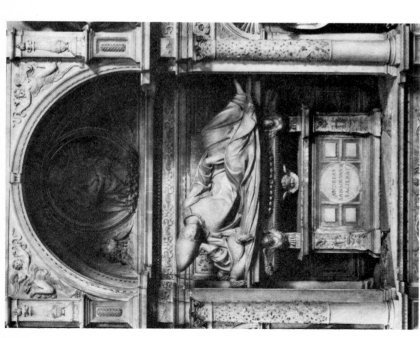

177 Andrea Sansovino: Tomb of Ascanio Sforza, commissioned
1507. Rome, S. Maria del Popolo

178 Jacopo Sansovino: Cardinal of Santangelo. Statue
from the double tomb designed by Andrea Sansovino,
about 1520. Rome, S. Marcello al Corso

179 Sandro Botticelli: Mars and Venus. London, National Gallery

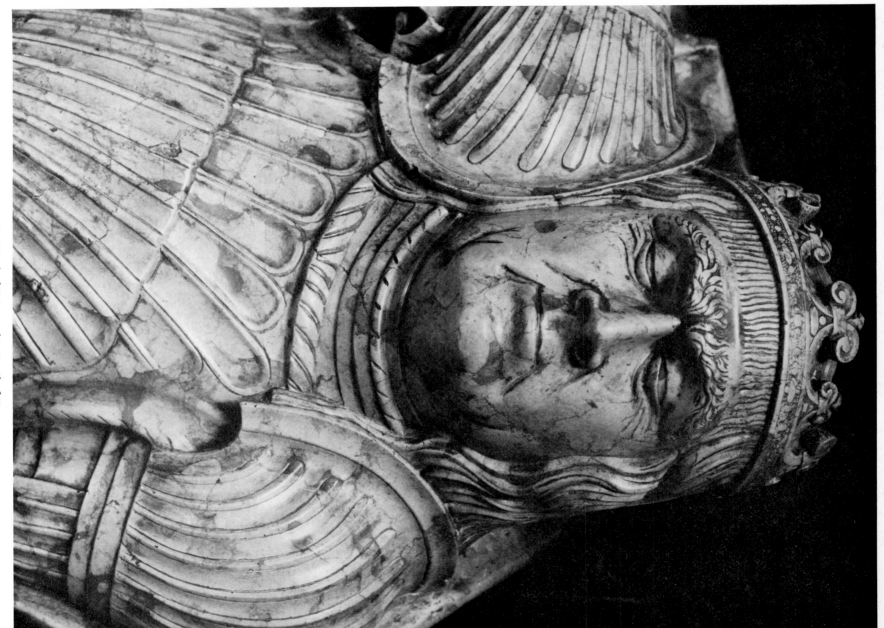

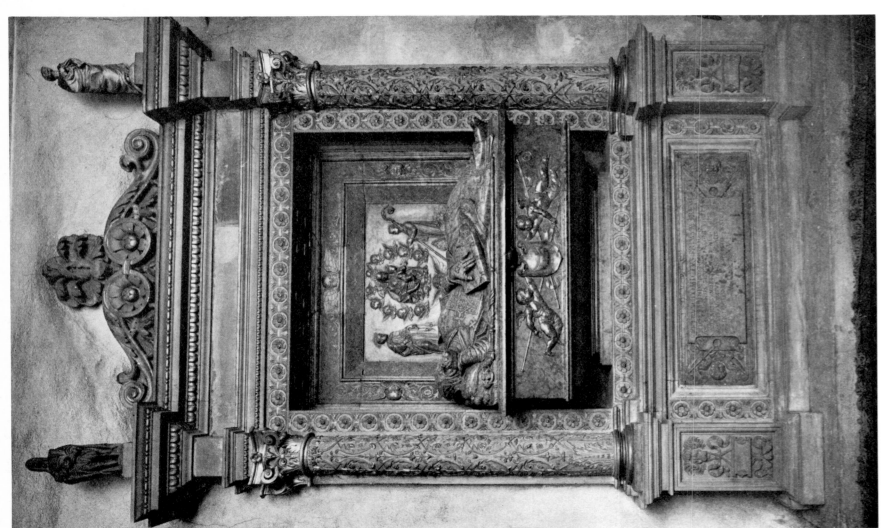

181 Bartolommeo Berrecci (or Gian Maria Padovano): Tomb of Bishop Piotr Tomicki in his chapel, about 1535. Cracow, Wawel Cathedral (see also Fig. 121)

183 Sculptor from the circle of Andrea Bregno: Tomb of Cardinal Antonio Jacopo Venerio (died 1479). Rome, S. Clemente

184 Tomb of Sir Roger de Kerdeston, 1337. St Mary's Church, Reepham, Norfolk

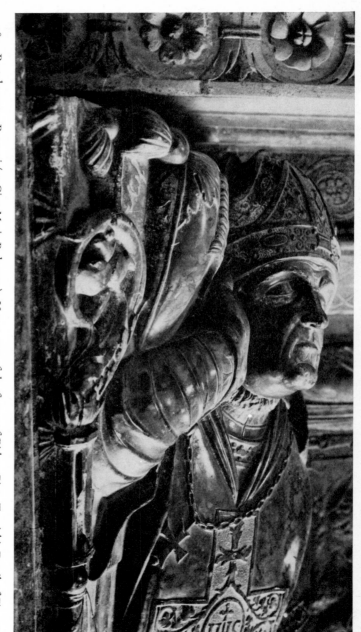

182 Bartolommeo Berecci (or Gian Maria Padovano): Upper part of the figure of Bishop Piotr Tomicki. Detail of Fig. 181

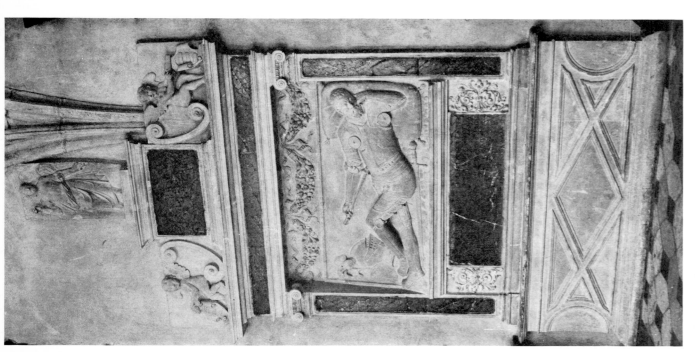

185 Tomb of Piotr Boratyński, 1558. Cracow, Wawel Cathedral

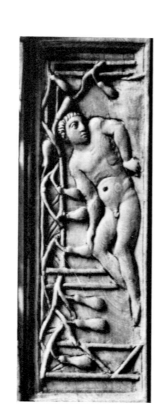

186 Jonah under his bower of gourds. Detail from the back of a lipsanoteca. Brescia, Museo Civico

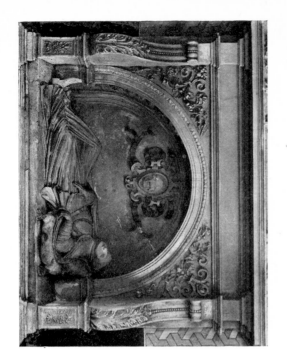

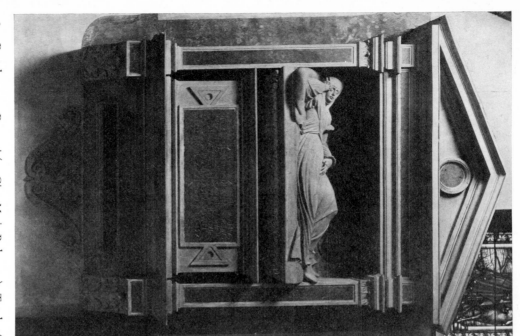

187 Bartolommeo Berrecci (or Gian Maria Padovano): Tomb of Barbara Tarnowska (born Tenczyńska), after 1536. Tarnów, Cathedral

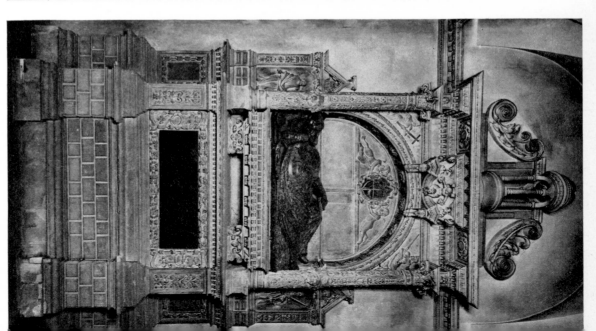

188 Jan Michałowicz of Urzędów: Tomb of Bishop And Zebrzydowski, 1562–3, Cracow, Wawel Cathedral

189 Jan Michałowicz of Urzędów: Tomb of Urszula Leżeńs Brzeziny, Parish Church

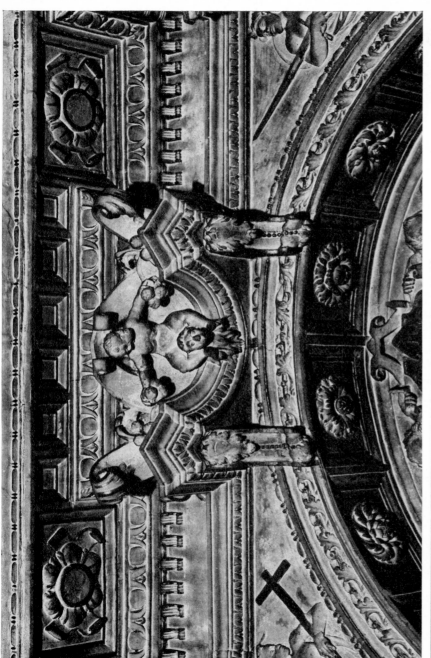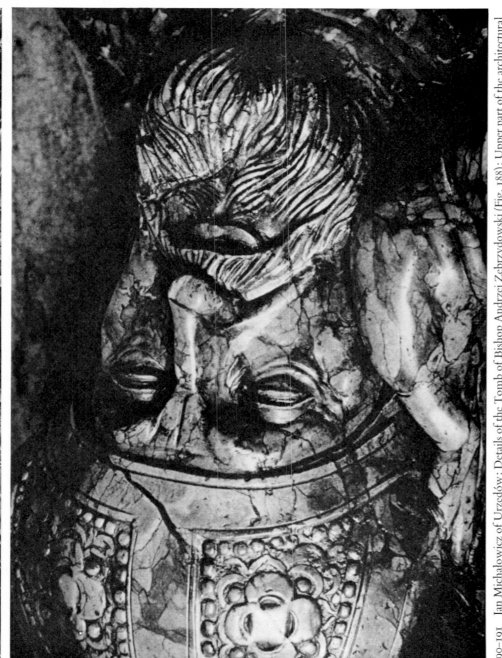

190–191 Jan Michałowicz of Urzędów: Details of the Tomb of Bishop Andrzej Zebrzydowski (Fig. 188): Upper part of the architectural decoration with the putto on a panther; Head of Andrzej Zebrzydowski. Cracow, Wawel Cathedral

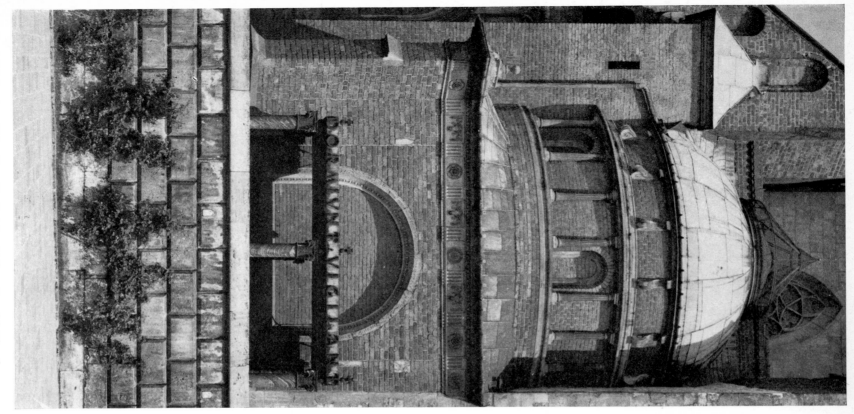

192 Jan Michałowicz of Urzędów: The Padniewski (later Potocki) Chapel, 1572–5. Exterior view. Cracow, Wawel Cathedral

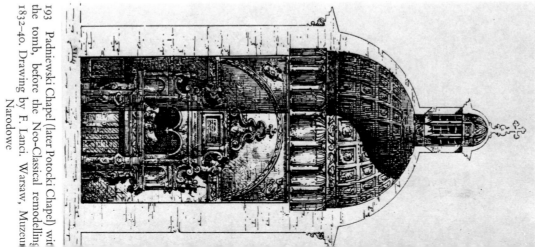

193 Padniewski Chapel (later Potocki Chapel) with the tomb, before the Neo-Classical remodelling 1832–40. Drawing by F. Lanci. Warsaw, Muzeum Narodowe

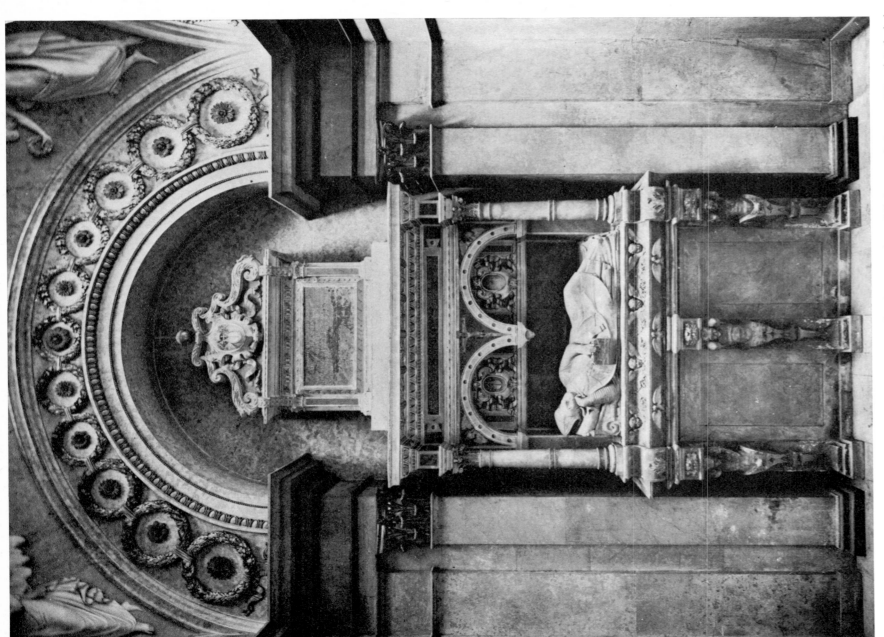

194 Jan Michałowicz of Urzędów: Tomb of Bishop Filip Padniewski, about 1575 (remodelled 1832–40). Cracow, Wawel Cathedral

195 Bartolommeo Berrecci (?): Tomb of the three Jan Tarnowskis. Tarnów, Cathedral

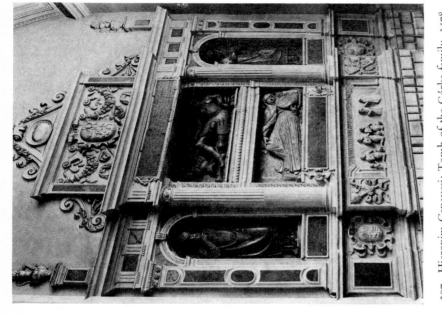

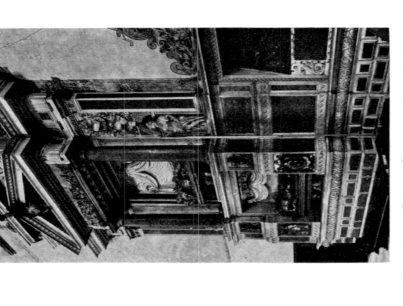

197 Hieronim Canavesi: Tomb of the Górka family, 1578. Poznań, Cathedral

196 Tomb of Jan and Janusz Kościelecki, 1559. Kościelec, near Inowrocław, north-central Poland

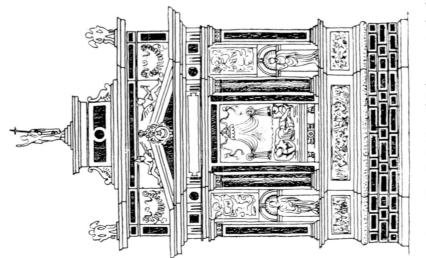

198–199 Gian Maria Mosca il Padovano: Tomb of Jan and Jan Krzysztof Tarnowski, 1560–70. Reconstruction of the original design of 1560, and the present form. Tarnów, Cathedral

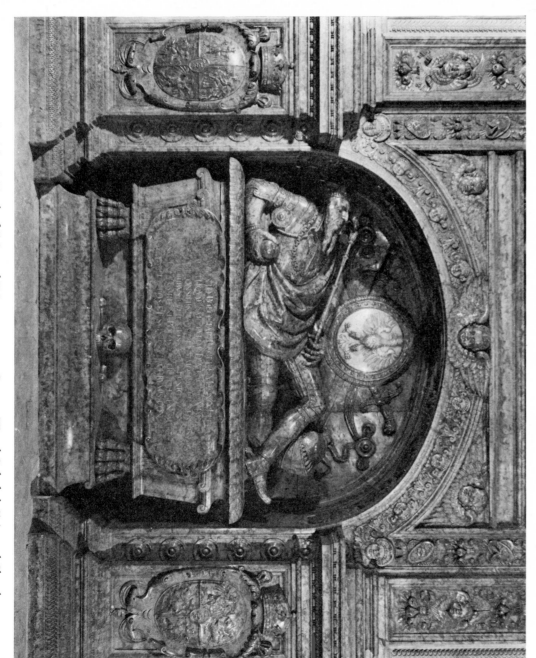

201 Santi Gucci: Tomb of Sigismund II August, 1574–5. Cracow, Wawel Cathedral, Sigismund Chapel

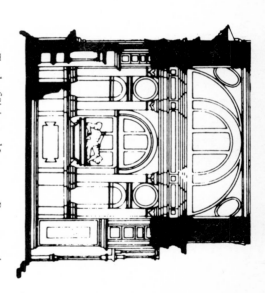

200 Tomb of Sigismund I, 1529–31. Reconstruction of the original form. Cracow, Cathedral

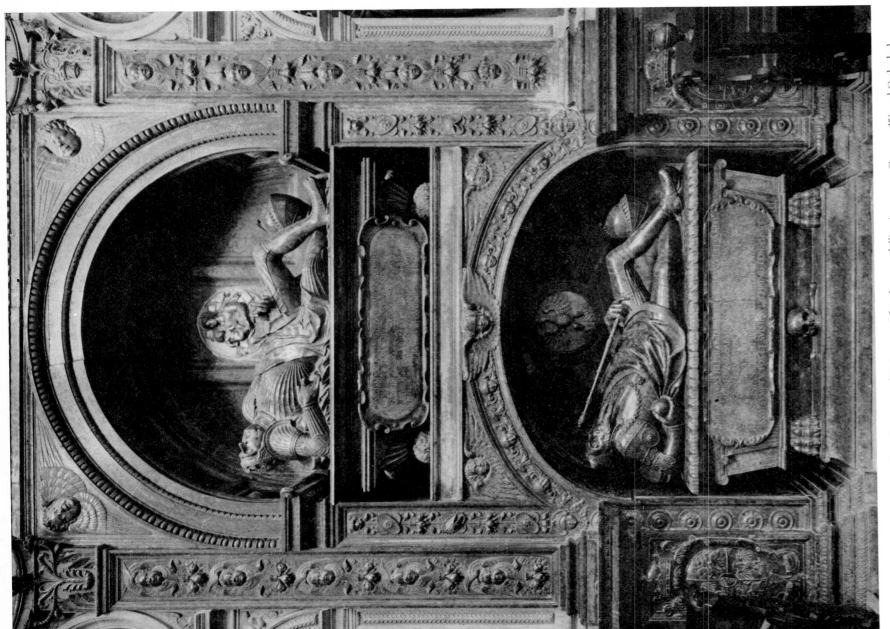

202 Double tomb of Sigismund I and Sigismund II August. After the remodelling in 1571–5. Cracow, Wawel Cathedral, Sigismund Chapel

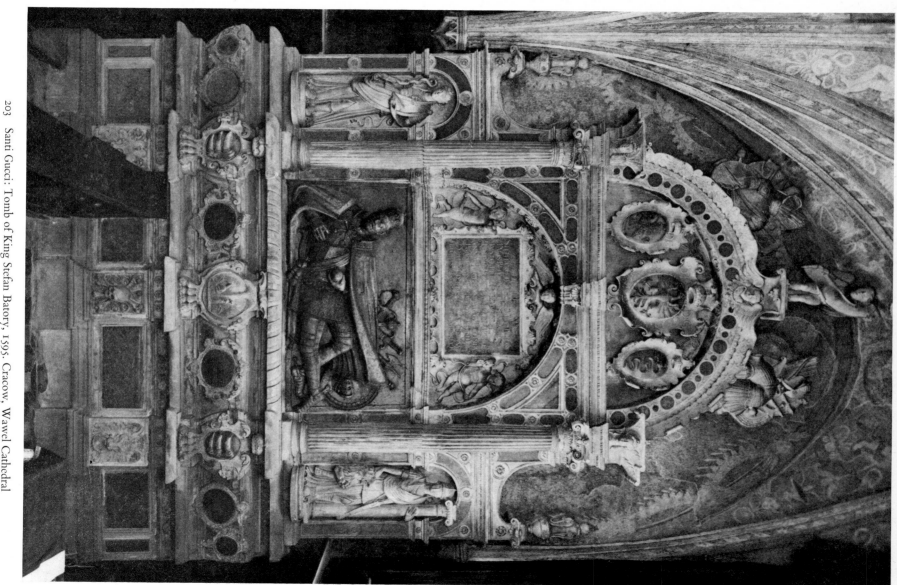

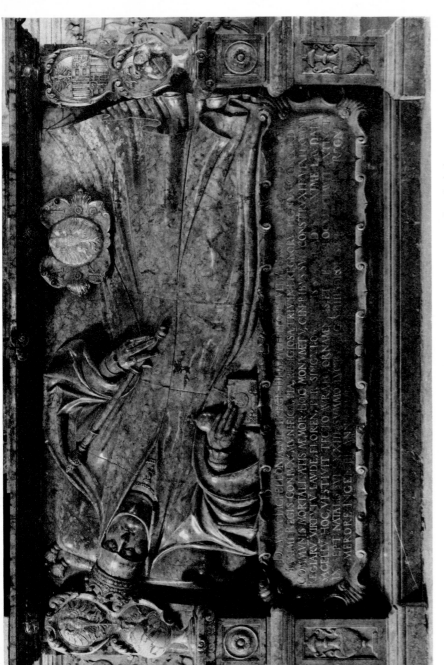

204　Santi Gucci: Tomb of Anna Jagellonica, 1574–5. Cracow, Wawel Cathedral

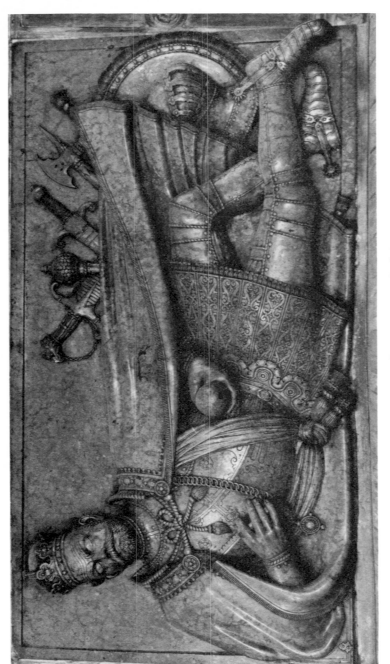

205　Santi Gucci: King Stefan Batory. Detail of Fig. 203

206 Master of the Behem Codex: Foundry. Miniature in the Behem Codex, 1505. Cracow, Jagellonian Library, MS. 16, fol. 281r. Original size, 176 × 140 mm.

207 Master of the Behem Codex: Shooting yard. Miniature in the Behem Codex, 1505. Cracow, Jagellonian Library, MS. 16, fol. 295r. Reproduced in the original size

209 Master 'M.S.': Christ falling under the Cross. Esztergom, Ecclesiastical Museum

210 Hans Süss von Kulmbach: The Assumption of St Catherine, 1515. Cracow, Church of Our Lady

208 Stanislaw Samostrzelnik: Sigismund I adoring Christ. Miniature, Sigismund I Book of Hours. London, British Museum Ms. Add. 15281, fol. 59r.

211 Georg Pencz: Painted wings of the silver altar, 1531–8. Cracow, Wawel Cathedral, Sigismund Chapel

212 Pankraz Labenwolf and Melchior Baier (design by Peter Flötner): Reliefs of the silver altar, 1531–8, seen open. Cracow, Wawel Cathedral, Sigismund Chapel

213 Altar from Zator Castle, about 1521. Detail. Cracow, Wawel State Art Collections

215 Altar of St George, 1515–27. Svaty Jur (Pozsonyszentgyörgy), near Bratislava

214 Altar from the Wawel cathedral, 1545–6. Bodzentyn, Parish Church

216 Market square with town hall and St Giles's Church in Bardejov (Bártfa)

217 Master Alexius: Detail of the ornaments of the entrance loggia at the town hall, 1501–9, at Bardejov (Bártfa)

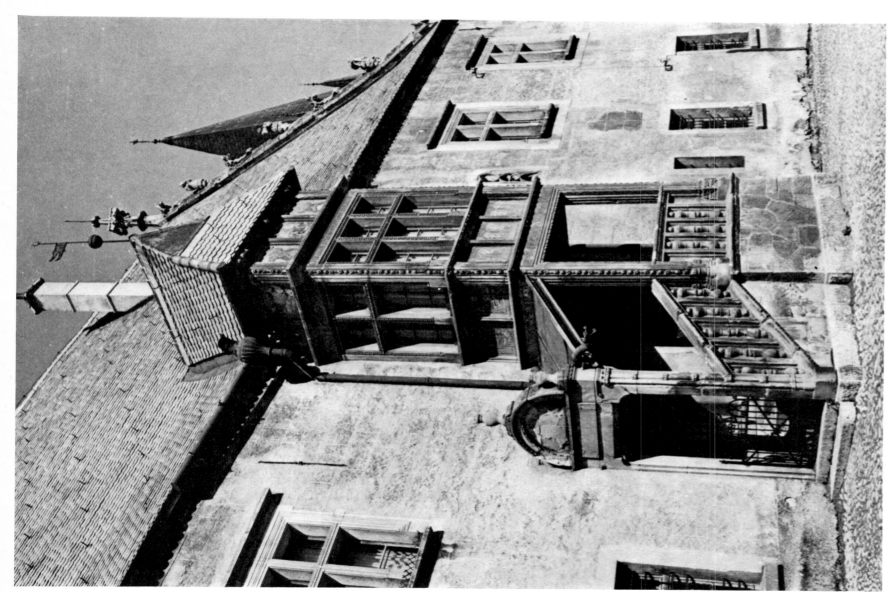

218 Master Alexius: Entrance loggia to the town hall at Bardejov (Bártfa), 1501–9

220 Master Alexius: Doorway of the council chamber, 1507. Inlay panels by Johannes Mensator. Bardejov (Bártfa), Town Hall

221 Stall from St Giles's Church at Bardejov (Bártfa), 1515-20. Budapest, National Museum

219 Master Alexius: Coffered ceiling of the big hall, 1508. Bardejov (Bártfa), Town Hall

222 Gregory of Késmárk: Perspective inlay on a stall, 1516. Levoča (Löcse), St Jacob's Church

223 F. (?) Marone: Stall from Nyírbátor, 1511. Budapest, National Museum

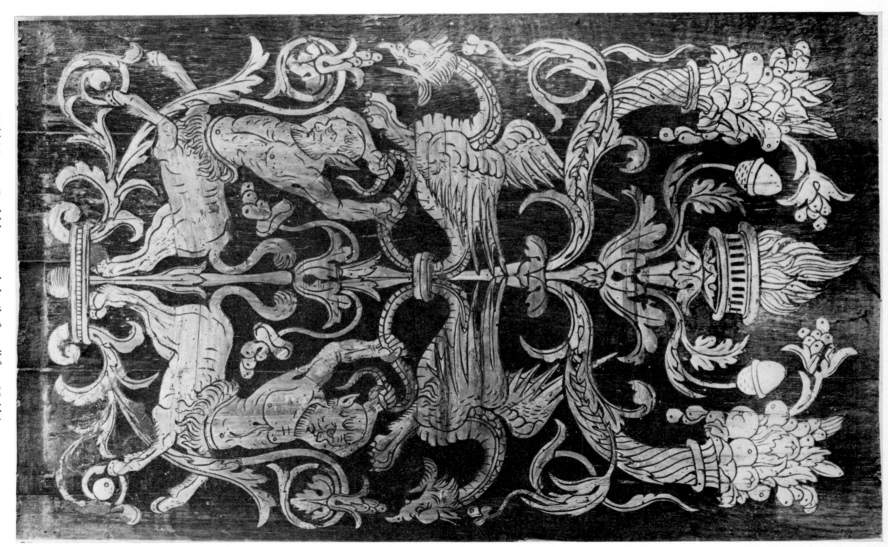

224 F. (?) Marone: Candelabrum panel, detail of a stall from Nyírbátor, 1511. Budapest, National Museum

225 F. (?) Marone: Illusionistic panel with signature, detail of a stall from Nyírbátor, 1511.
Budapest, National Museum

227 Market square with parapet houses of various dates in Pardubice

226 Golden Crown House, 1521–8. Silesian type of parapet. Wrocław (photographed before demolition in 1904)

228 Green Gatehouse, 1538, in Pardubice

229 Benedikt Ried: Castle at Ząbkowice (Frankenštejn), 1522–32

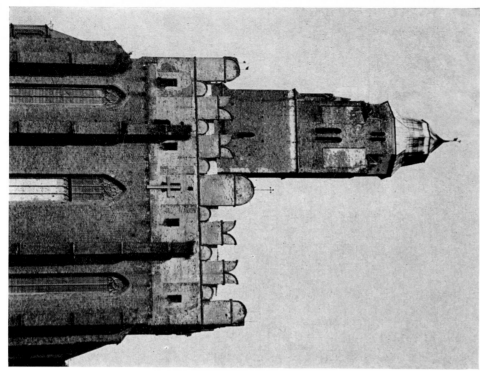

230 Parish church with parapet, 1529, Paczków (Patschkau)

231 Cresting of the castle wing at Jindřichův Hradec

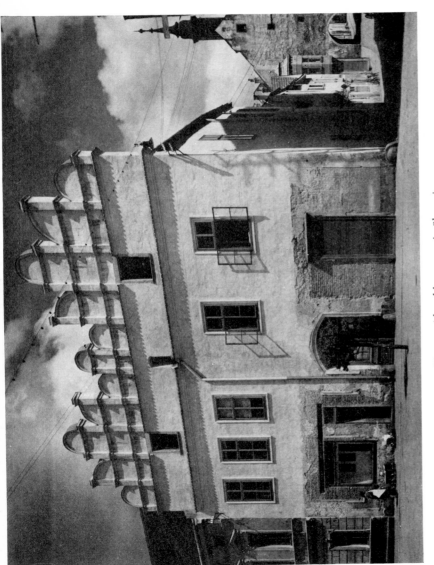

232 House with gable parapet in Slavonice

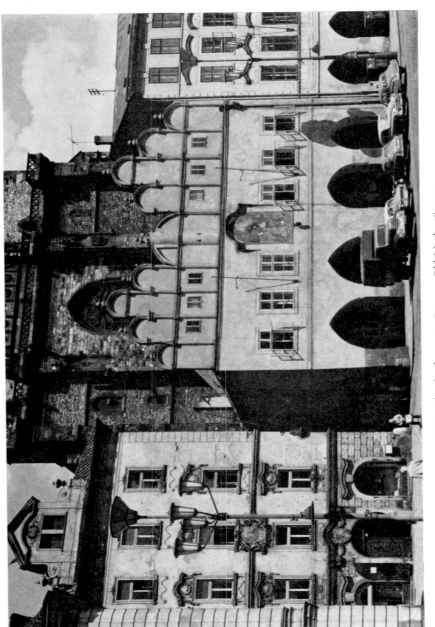

233 Týn school, after 1562. Prague, Old Market Square

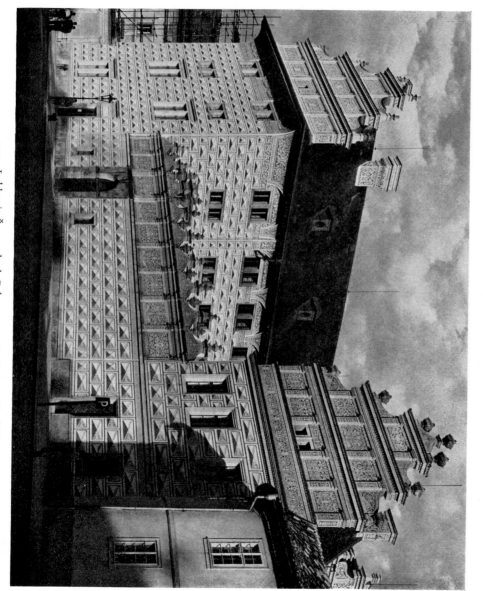

235 Lobkovic–Švarcenberk Palace, 1545–63. Prague, Hradshin

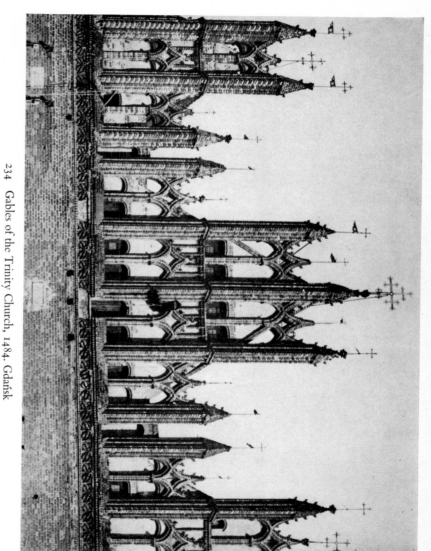

234 Gables of the Trinity Church, 1484. Gdańsk

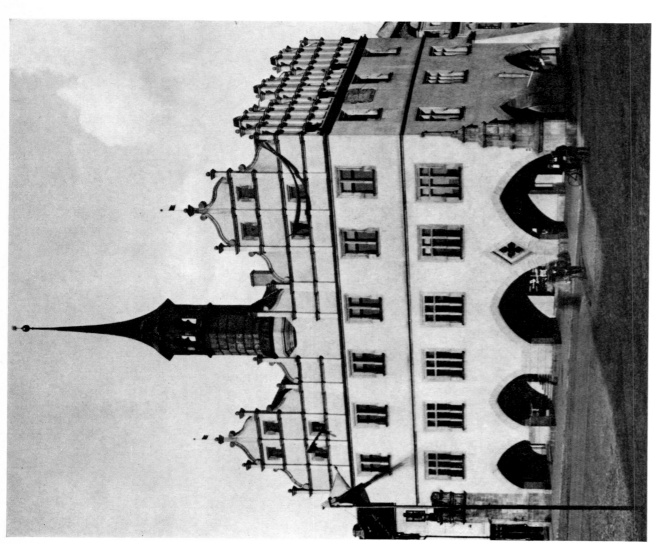

236 Master Pavel: Town Hall, 1537–9. Litoměřice

237 Palace of the Lords of Rožmberk, north façade, 1545–52 and 1557–63. Prague, Hradšin (drawing of 1738)

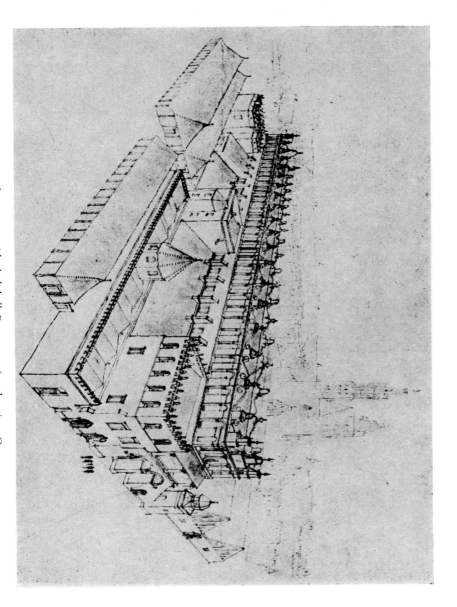

239 Market square with cloth hall. Reconstruction drawing. Cracow

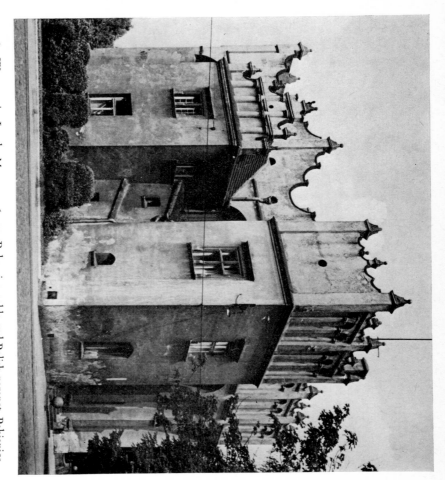

238 Wawrzyniec Lorek: Manor, 1565–71. Bohemian gable and Polish parapet. Pabianice

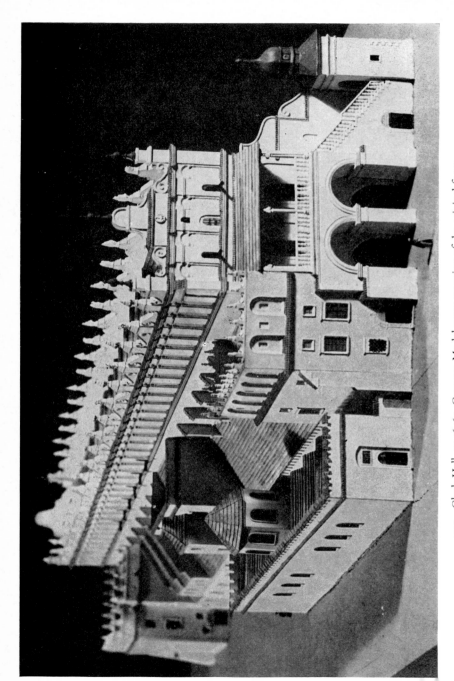

240 Cloth Hall, 1556–60. Cracow. Model reconstruction of the original form

241 Cloth Hall. Short side from the south, probably by Gian Maria Mosca il Padovano. Some alterations of 1875–9. Cracow

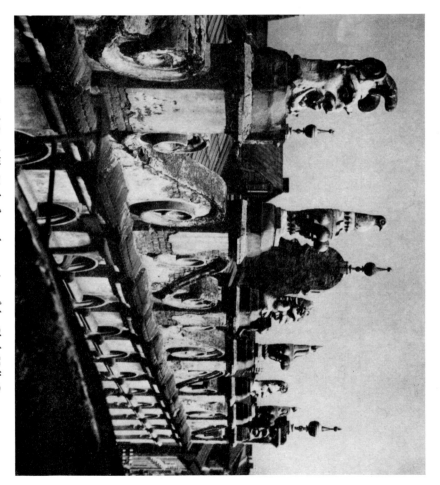

243 Santi Gucci (?): Masks from the cresting of the Cloth Hall, Cracow

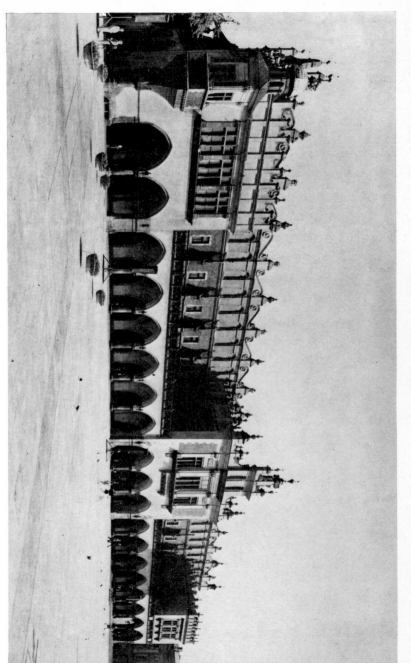

242 Cloth Hall. Long side seen from the east, with Neo-Gothic and Neo-Renaissance additions by T. Pryliński, 1875–9, Cracow

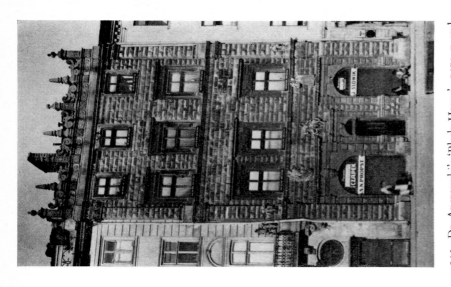

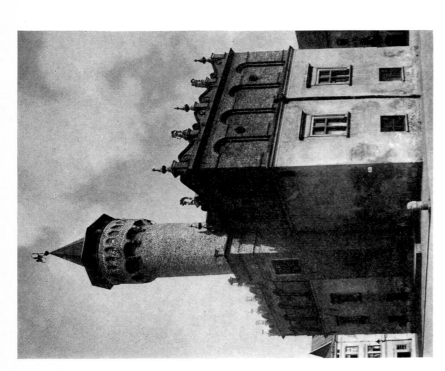

244 Gian Maria Mosca il Padovano (?): Town hall, mid-sixteenth century. Tarnów

245 Dr Anczowski's 'Black House', 1575–7 and 1675–9. Lwów

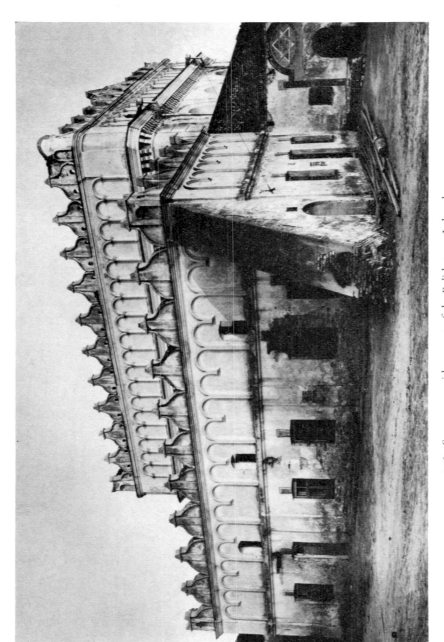

246 Synagogue with parapet of the Polish type. Luboml

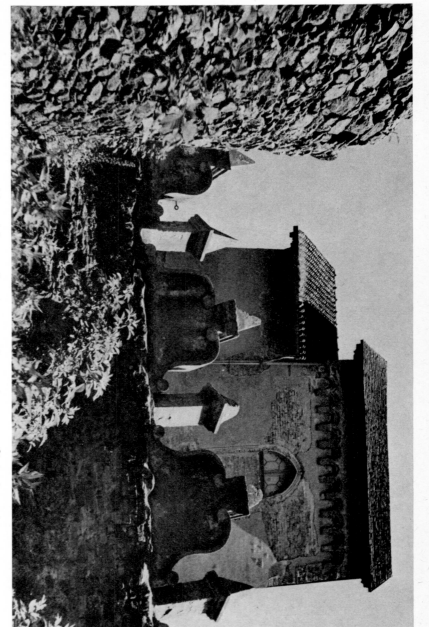

247 Parapet of the Polish type, about 1570, Grodno Castle, Zagórze Śląskie (Kynau)

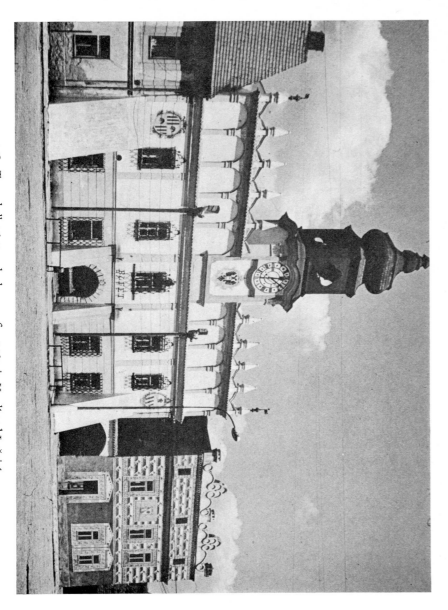

248 Town hall, 1617, and a house, after 1560, in Veselí nad Lužnicí

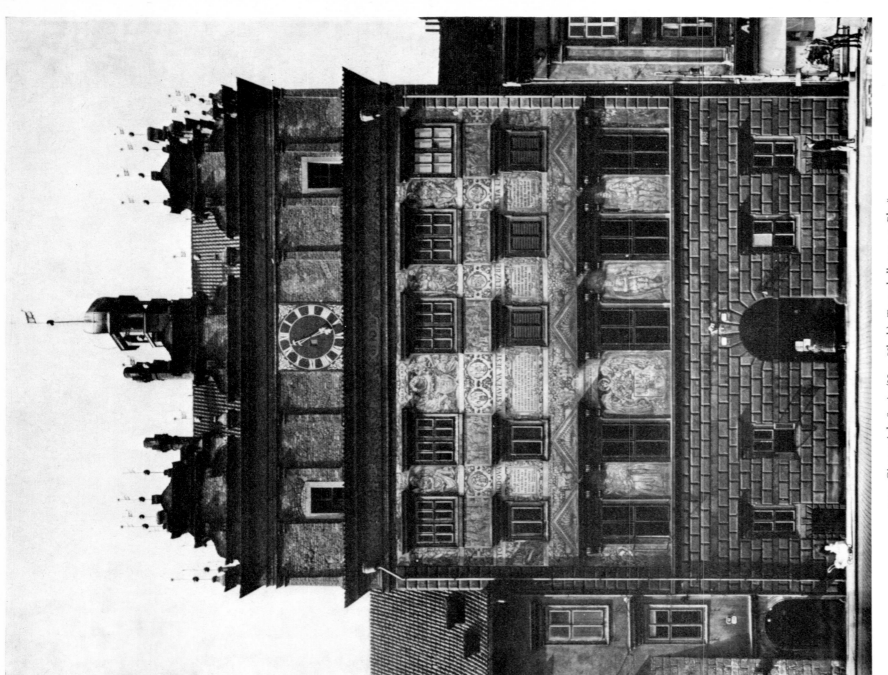

249 Giovanni de Statio (Hans Vlach): Town hall, 1554–9. Plzeň

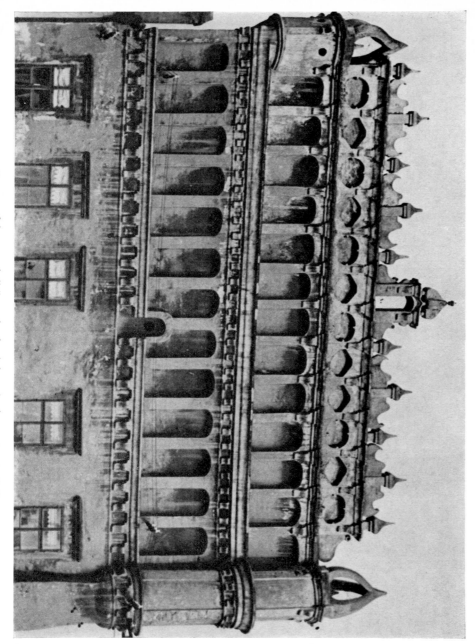

251 Parapet of the town hall (later the dean's house), about 1600, in Sušice

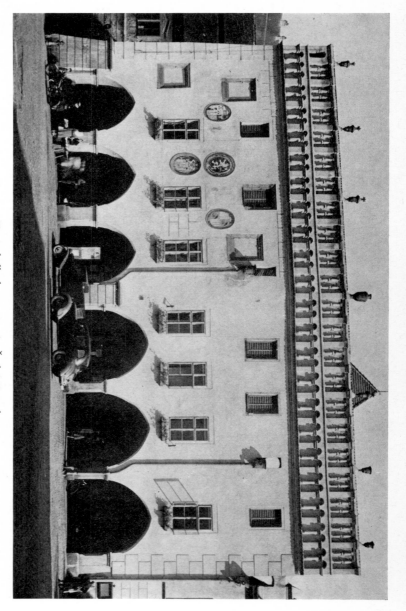

250 Town hall, about 1580, in Český Krumlov

252 Castle of the Turzo family, 1564, at Betlanovce (Bethlenfalva)

253 Castle, 1625, at Fričovce (Frics)

254 Parapet of the castle (early seventeenth-century) at Niedzica (Nedec)

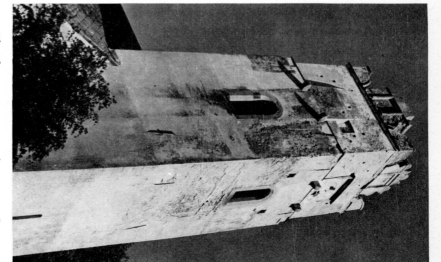

255 Church tower, parapet early seventeenth century at Frydman (Frigyesvágás)

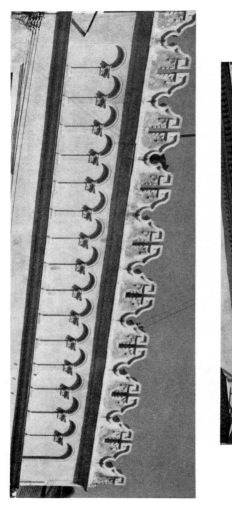

256–257 Parapets of houses on the market square in Prešov (Eperjes)

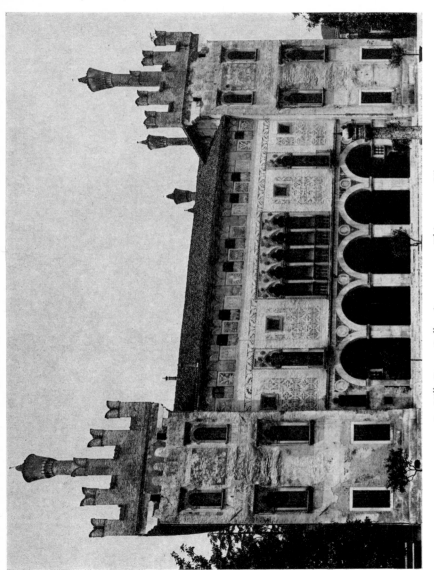

258 Villa Porto Colleoni, 1490–1500. Thiene, near Vicenza

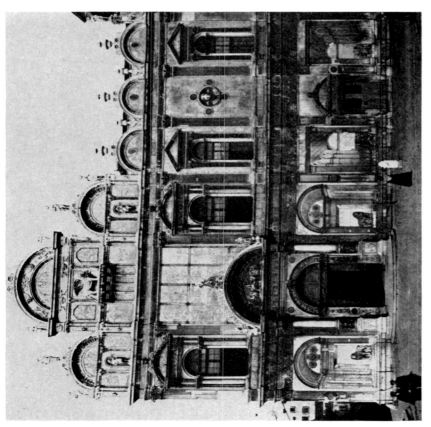

259 Scuola di San Marco, 1485–95. Venice

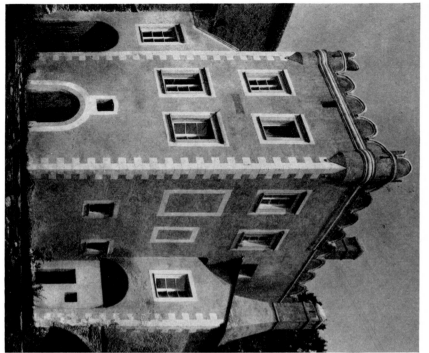

261 Passauer Hof, mid-sixteenth century. Stein on the Danube, Lower Austria

262 Dario Varotari: Palazzo Emo Capodilista, after 157... Montecchia

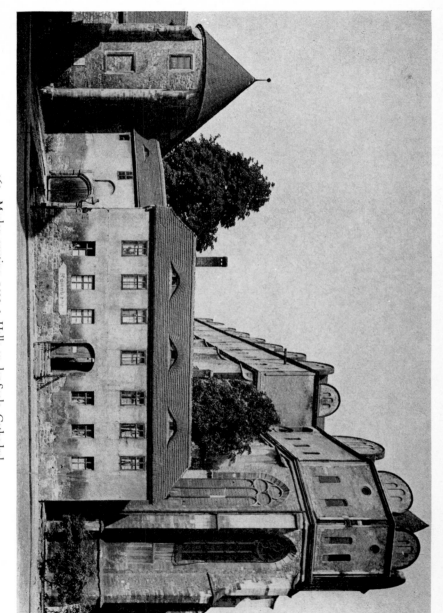

260 Merlon cresting, 1520-3. Halle an der Saale, Cathedral

263 Lorenz Gunter (?): Oriel on the town hall, 1548. Wrocław

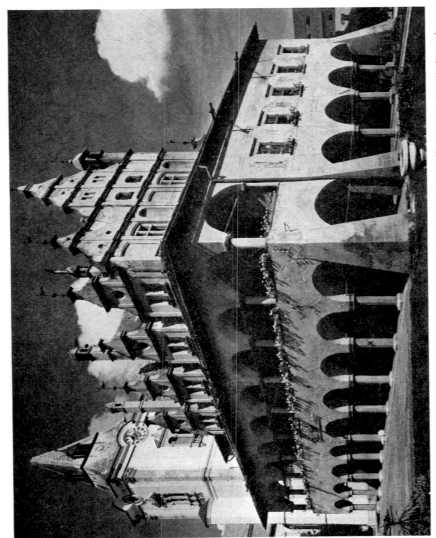

264 Renaissance arcades of the town hall, 1615. Roof structures, nineteenth century. Levoča (Lőcse)

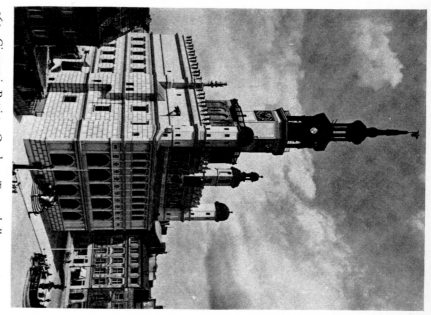

265 Giovanni Battista Quadro: Town hall, 1550–60, at Poznań

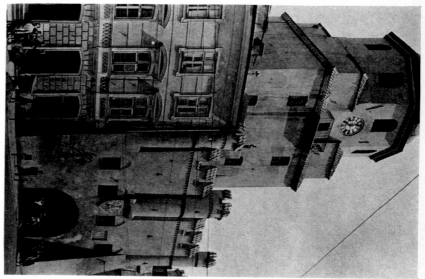

266 Cracow Gatehouse, 1574–8, rebuilt 1782 and nineteenth century. Lublin

267 Giovanni Battista Quadro: Portals of the Serlio type. Poznań, Town Hall

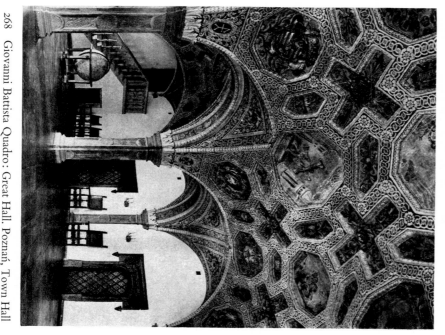

268 Giovanni Battista Quadro: Great Hall. Poznań, Town Hall

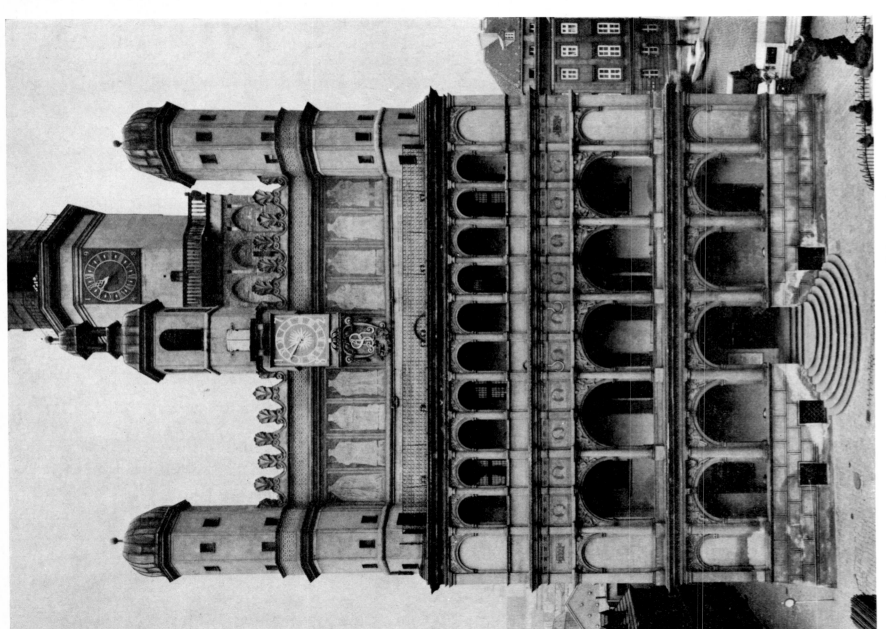

269 Giovanni Battista Quadro: Façade of the town hall, Poznań (see Fig. 265)

270 Regular plan of the town Györ. After Speckle's Treatise on Fortifications, 1589

270 Regular plan of the town Györ. After Speckle's Treatise on Fortifications, 1589

271 Plan of the town Nové Zámky (Érsekujvár), 1562, designed by Ottavio Baldigara. Plan by G. Ssicha, after 1663

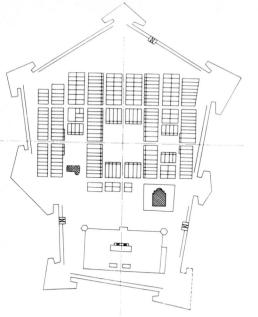

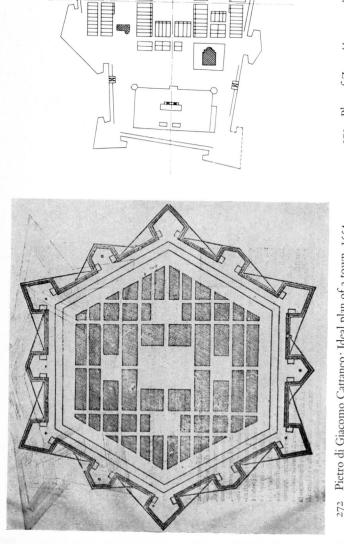

272 Pietro di Giacomo Cattaneo: Ideal plan of a town, 1554

273 Plan of Zamość as actually realized, 1587–1605

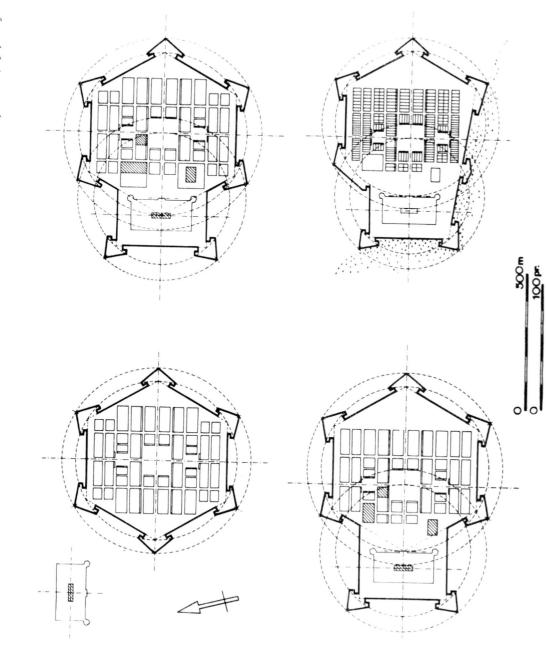

500 m

100 pr.

274 Development of the plan of Zamość. Hypothetical reconstruction by T. Zarębska

276 General view of the main square of Zamość with town hall, 1591–1600, 1639–51 and later

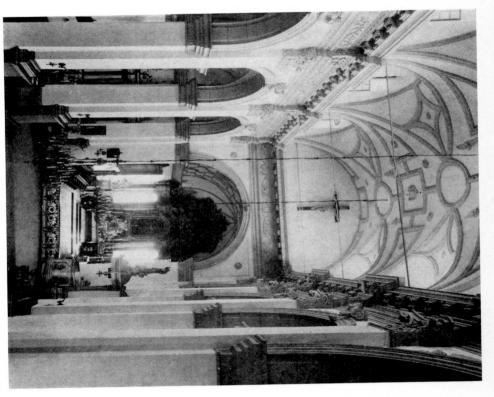

275 Bernardo Morando: Collegiate Church, 1587–after 1600. Zamość

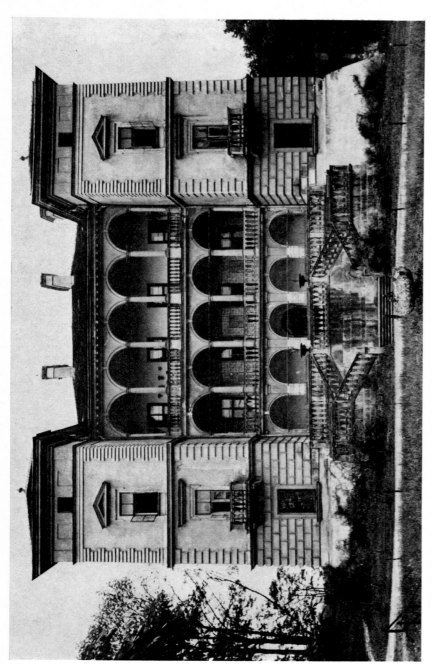

277 Villa built for Jost Ludwik Decius, first half of the sixteenth century: remodelled 1616–21. Cracow, Wola Justowska

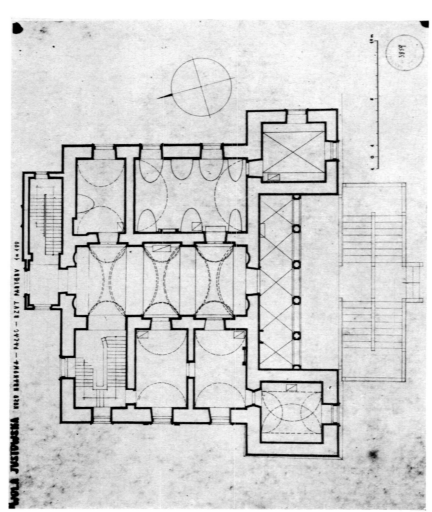

278 Villa built for Jost Ludwik Decius. Plan. Cracow, Wola Justowska

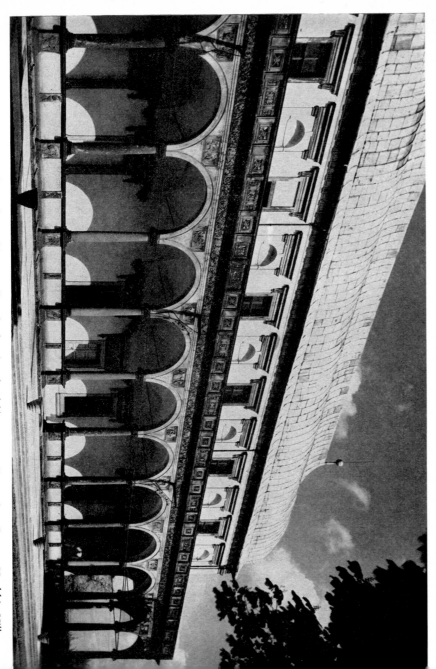

280 Paolo della Stella and Bonifaz Wohlmut: Villa Belvedere (Letohrádek), 1538–63. Front view. Prague, Hradshin Hill

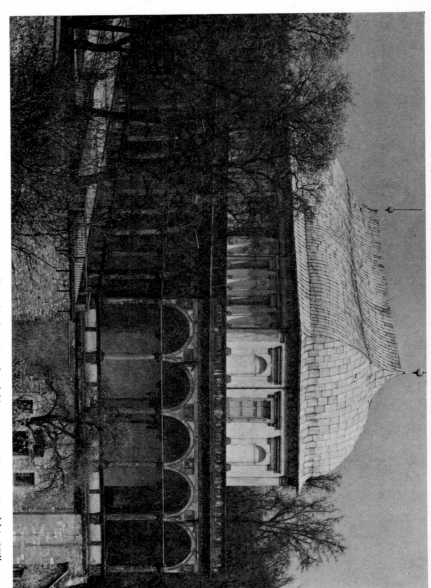

279 Paolo della Stella and Bonifaz Wohlmut: Villa Belvedere (Letohrádek), 1538–63. Prague, Hradshin Hill

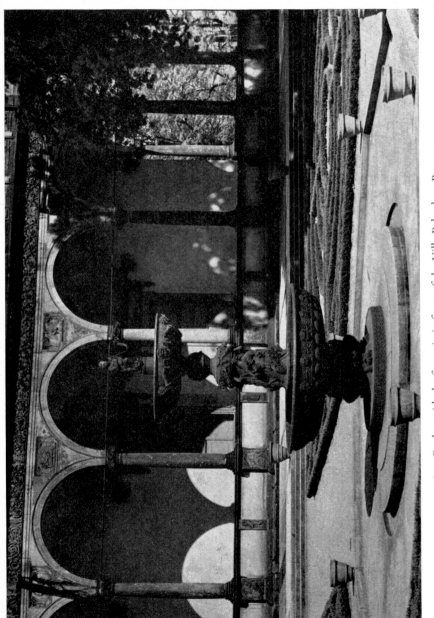

281 Garden with the fountain in front of the Villa Belvedere, Prague

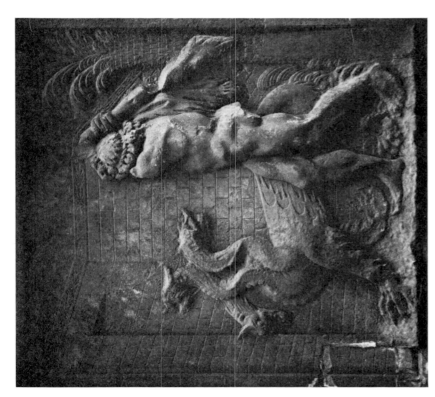

282 Paolo della Stella: Hercules and Cerberus. Relief of the Villa Belvedere. Prague

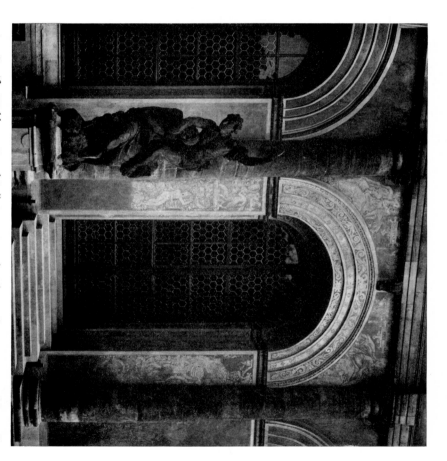

284 Bonifaz Wohlmut: Royal Ball Court. Portal with sgraffiti. Prague, Hradšin Hill

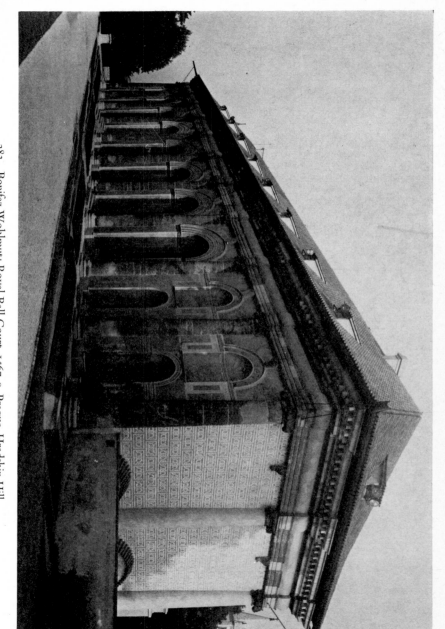

283 Bonifaz Wohlmut: Royal Ball Court, 1567–9. Prague, Hradšin Hill

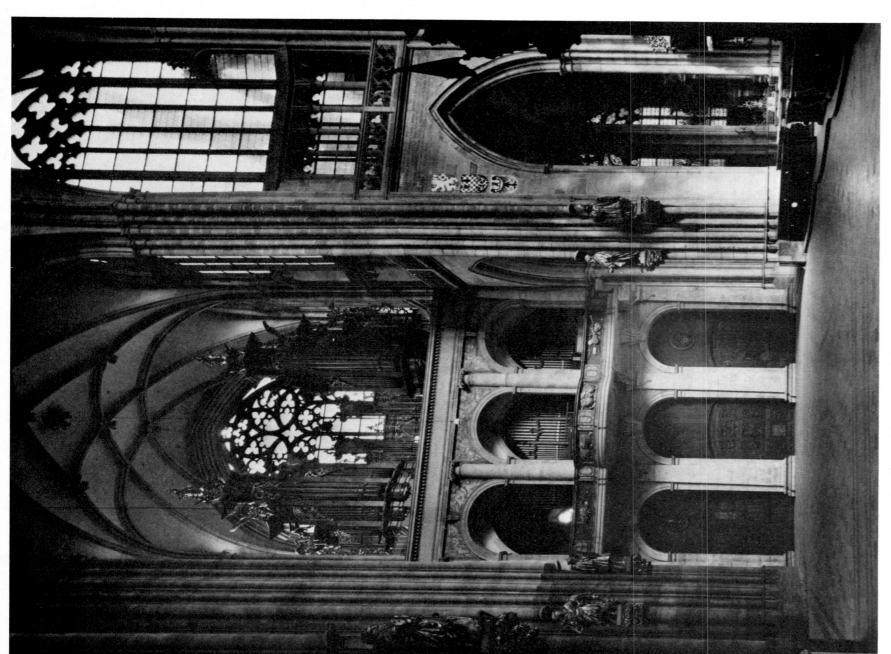

285 Bonifaz Wohlmut: Organ loft, 1556–61. Prague, St Vitus's Cathedral

286 Bonifaz Wohlmut: Parliament Hall and the lodge of the Secretary of State, 1551–63. Prague, Hradshin Castle

287 Pietro Ferrabosco (?): Schweizertor, 1552–3. Vienna, Burg

288 West portal of the castle at Kacečov

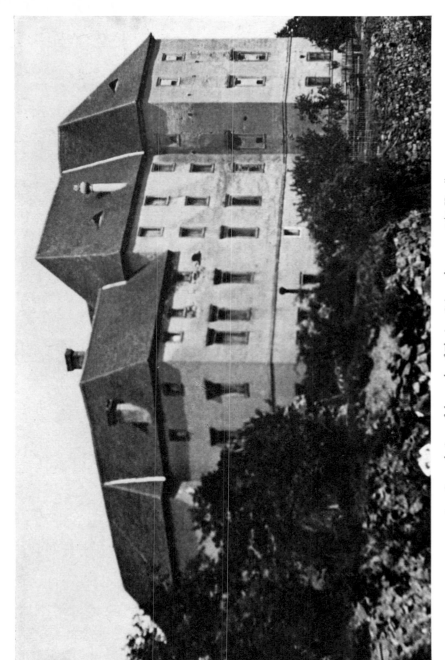

289 General view of the castle of Florian Griespach, 1540–56/8, Kacečov

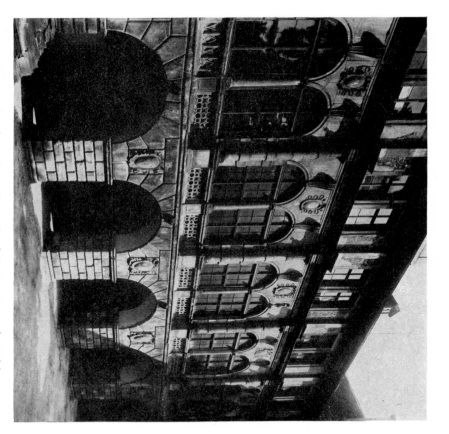

291 Courtyard with arcades in the castle of Florian Griespach. Nelahozeves

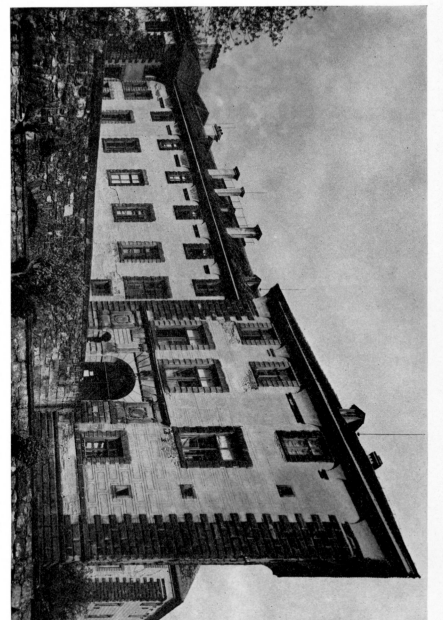

290 Entrance to the west wing of the castle of Florian Griespach, 1553–72 and 1613–14. Nelahozeves

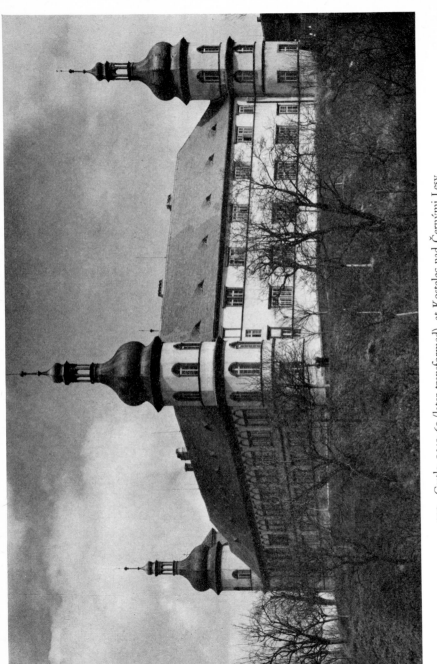

292 Castle, 1549–60 (later transformed), at Kostelec nad Černými Lesy

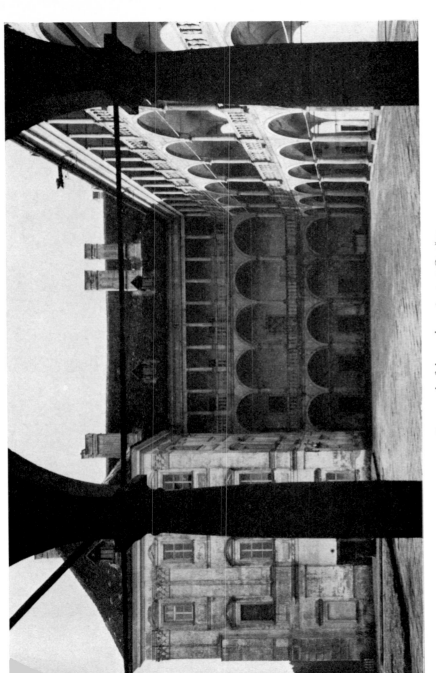

293 Courtyard of the castle, 1560–7, at Opočno

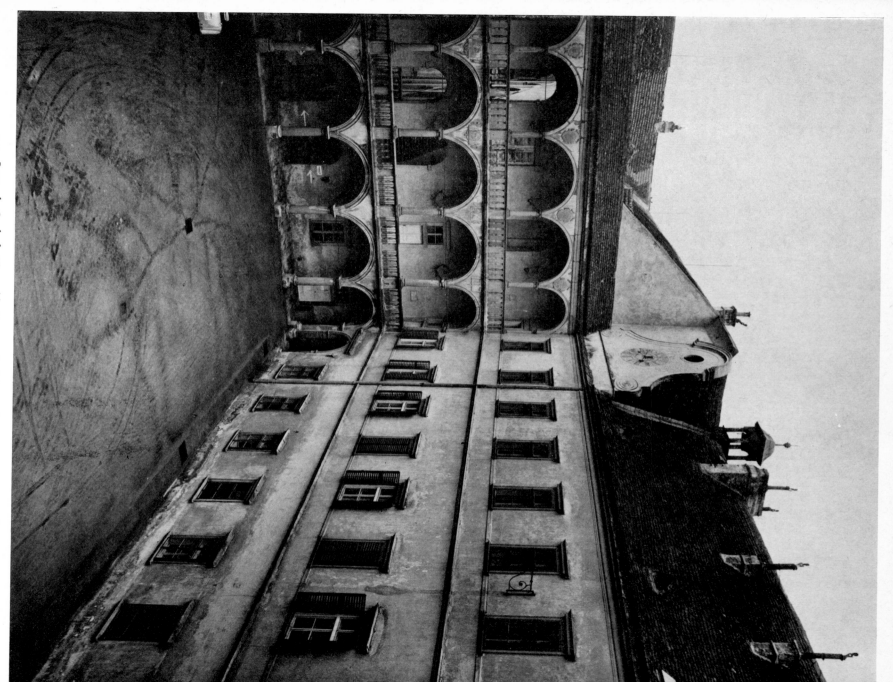

294 Leonardo Garda de Biseno (?): Courtyard of the castle, 1557–62, at Moravský Krumlov

295 Courtyard of the castle, 1573–8, at Náměšť nad Oslavou

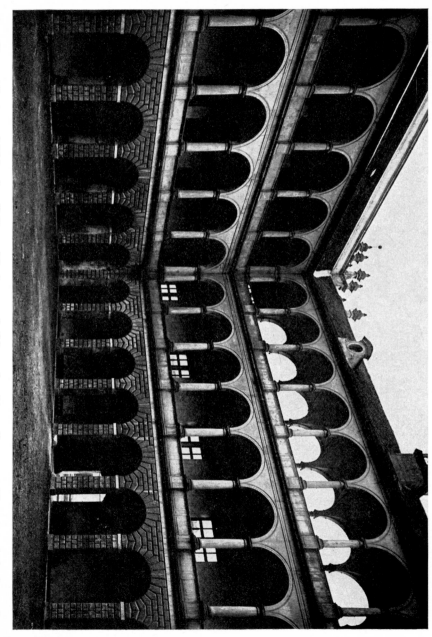

297 Giovanni Battista and Ulrico Aostalli (Avostalis): Courtyard of the castle at Litomyšl, 1568–73. View towards the front wing

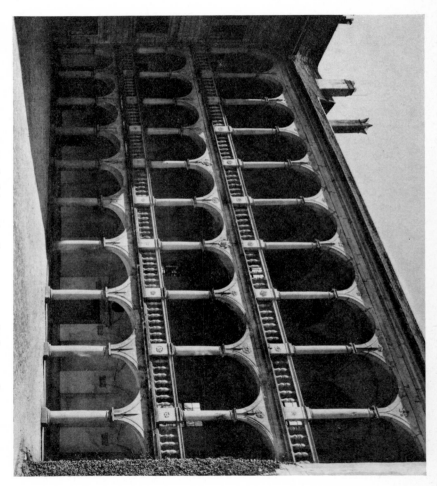

296 Courtyard of the castle, about 1580, at Jindřichův Hradec

298 Pietro Ferrabosco (design) and Pietro Gabri (construction): Castle at Bučovice, 1567–82. View from the garden

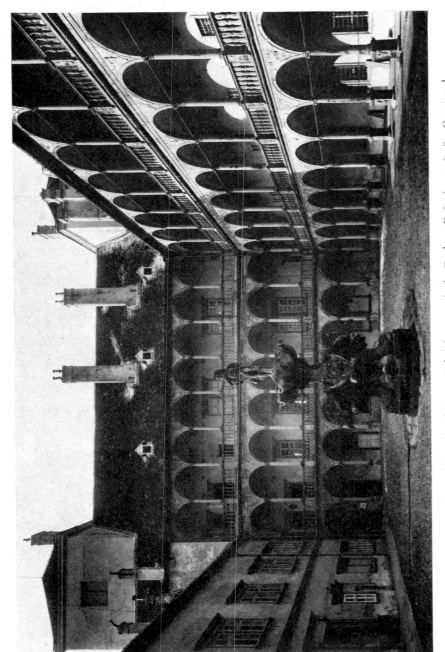

299 Pietro Ferrabosco (design) and Pietro Gabri (construction): Castle at Bučovice, 1567–82. Courtyard

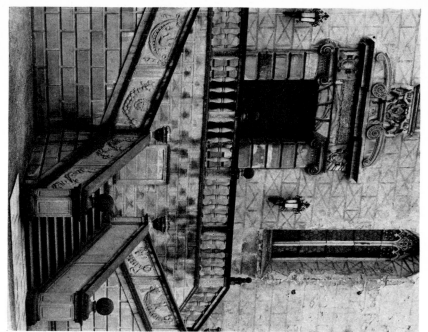

301 Staircase and portal of the castle, 1573–8, at Náměšť nad Oslavou

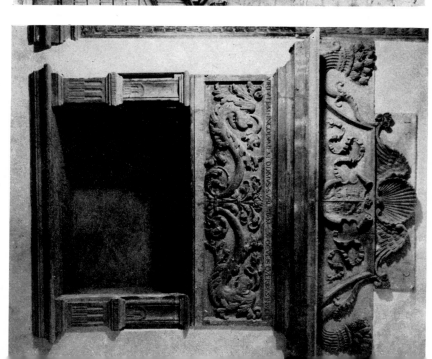

302 Fireplace in the castle of the Rákóczy family at Sárospatak, 15

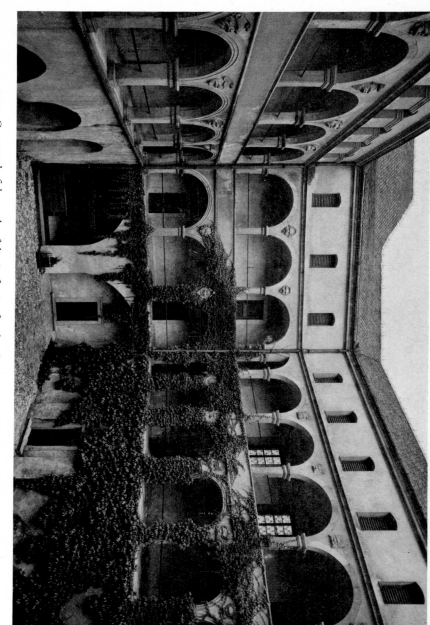

300 Courtyard of the castle of the Szafraniec family, about 1580, at Pieskowa Skala, near Cracow

303 Hans Tirol, Juan Maria del Pambio and Giovanni Lucchese: Hvězda Castle, 1555–6. Outskirts of Prague

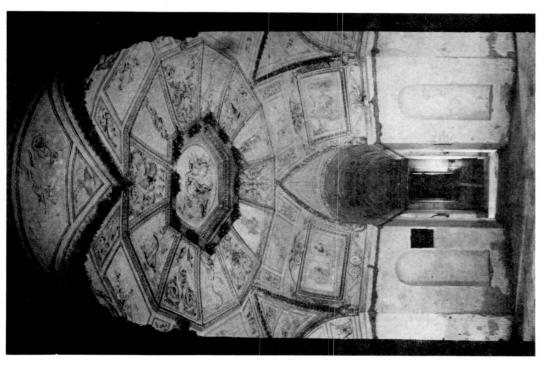

304 Hvězda Castle. Interior (see Fig. 303). Before restoration

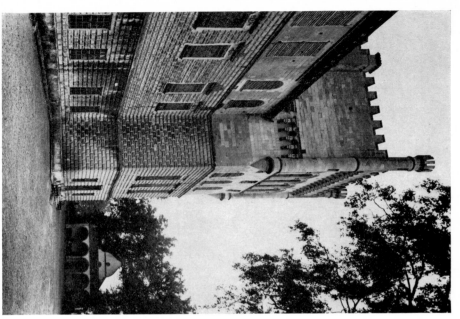

306 Santi Gucci: Castle. Main building and side pavilion. Książ Wielki

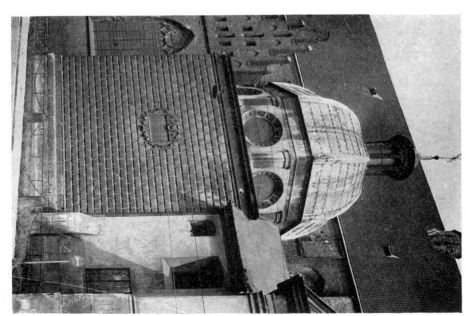

307 Santi Gucci: Myszkowski Chapel, 1602–14. Cracow, Dominican Friars Church

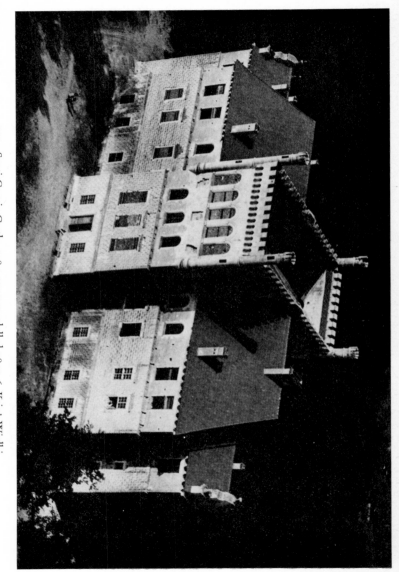

305 Santi Gucci: Castle, 1585–95; remodelled 1841–6. Książ Wielki

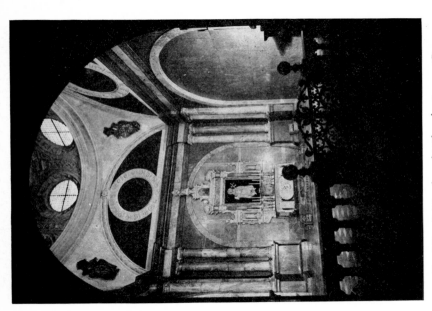

308 Santi Gucci: Myszkowski Chapel, 1602–14. Cracow, Dominican Friars Church

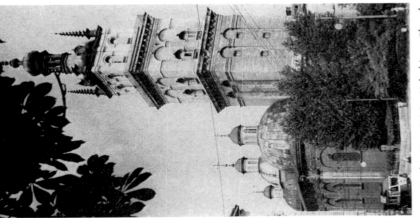

310 Paolo Dominici: Valachian Church, 1591–1629. Tower by Pietro di Barbona, 1572–82, and remodelled in the seventeenth century. Lwów

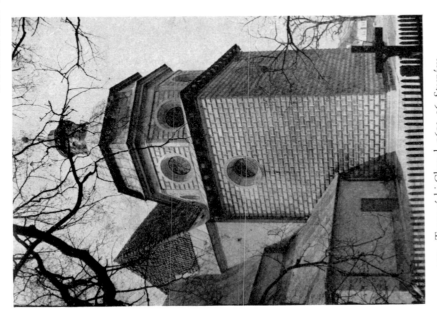

309 Tenczyński Chapel, 1613–16. Staszów

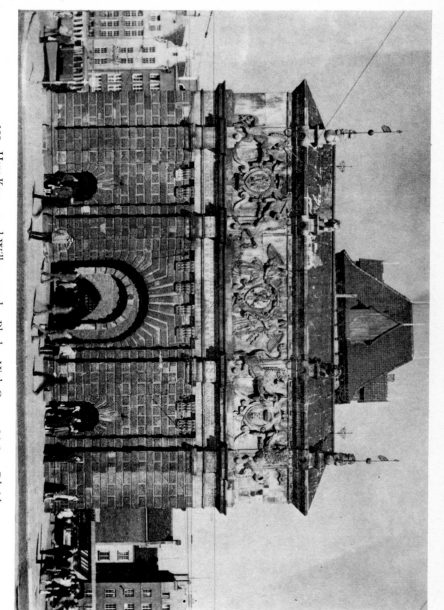

311 Hans Kramer and Willem van den Blocke: High Gate, 1586–8, at Gdańsk

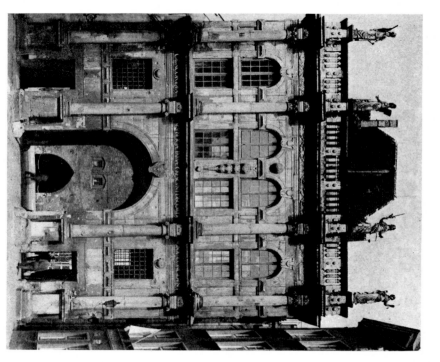

312 Abraham van den Blocke: Golden Gate (Long Street Gate), 1612–14, at Gdańsk

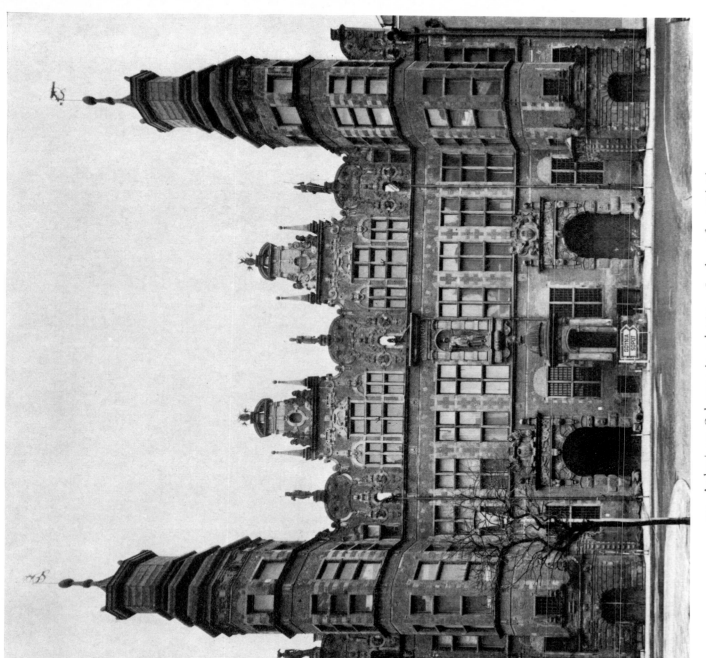

313 Anthonis van Opbergen: Arsenal, 1602–5. South-east front. Gdańsk

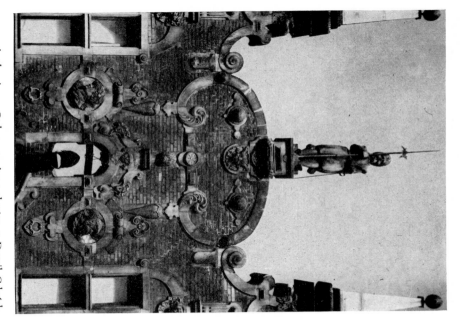

315 Anthonis van Opbergen: Arsenal, 1602–5. Detail. Gdańsk

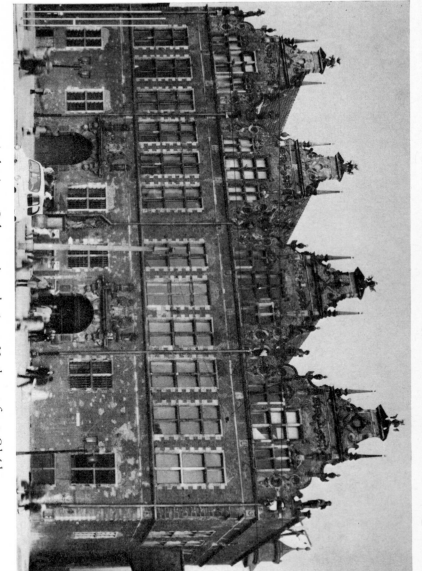

314 Anthonis van Opbergen: Arsenal, 1602–5. North-west front. Gdańsk

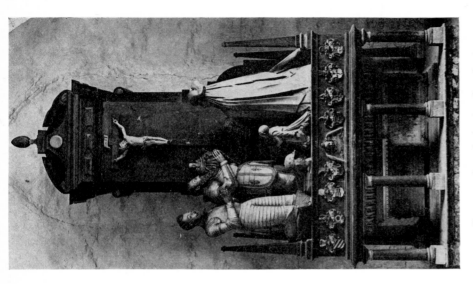

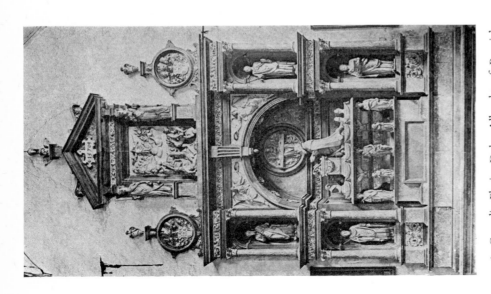

316 Cornelis Floris: Duke Albrecht of Prussia's tomb, 1568–74. Kaliningrad (Königsberg)

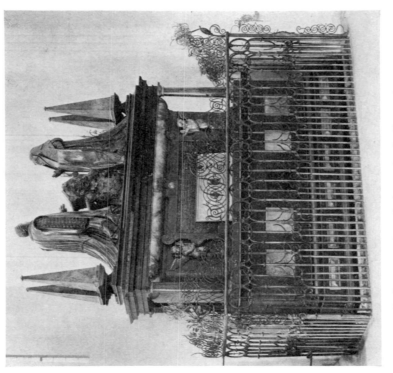

317 Willem van den Blocke (attributed to): Kos family tomb, 1600. Oliwa, Cathedral

318 Abraham van den Blocke: Bahr family tomb, 1614–20. Gdańsk, Church of Our Lady

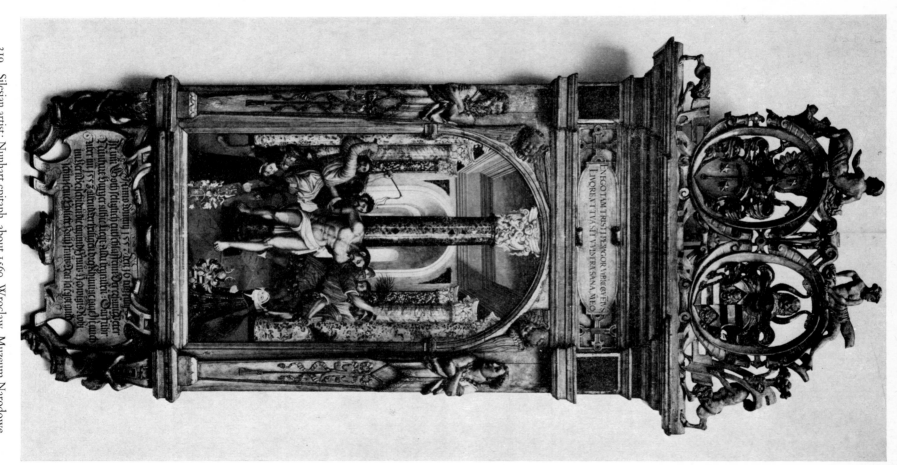

319 Silesian artist: Nimhart epitaph, about 1560. Wrocław, Muzeum Narodowe

320 Jan Vredeman de Vries: Allegory of lawful and unlawful behaviour. Decorative painting in the town hall, 1593–4. Gdańsk

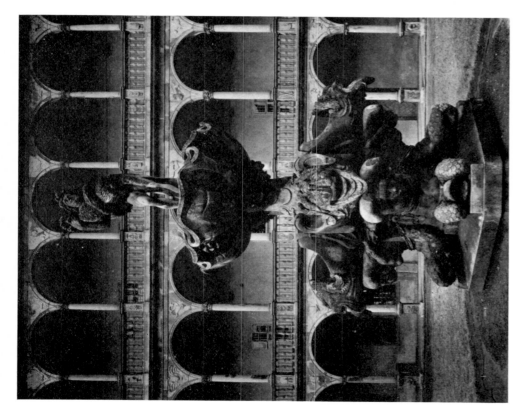

321 Circle of Pietro Tacca: Fountain with monsters, 1637, in the courtyard of the castle at Bučovice

323 German intarsia work, the so-called 'Wrangelschrank', late sixteenth century, Münster, Landesmuseum

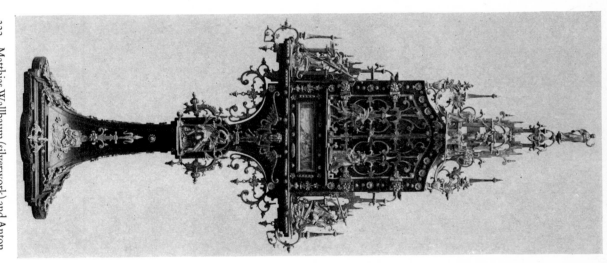

322 Matthias Wallbaum (silverwork) and Anton
Mozart (miniatures): Shrine, 1598, Augsburg.
New York, Metropolitan Museum of Art

324 Castle, after 1547, at Horšovský Týn

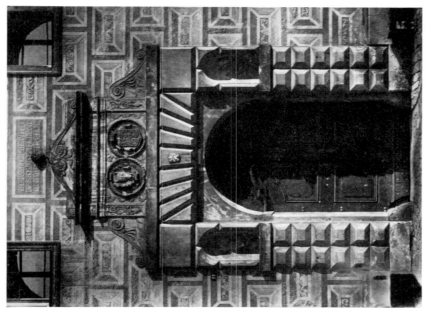

325 Giovanni Battista and Ulrico Aostalli (Avostalis): Main portal and illusionistic rustication, 1568–73, in Litomyšl Castle

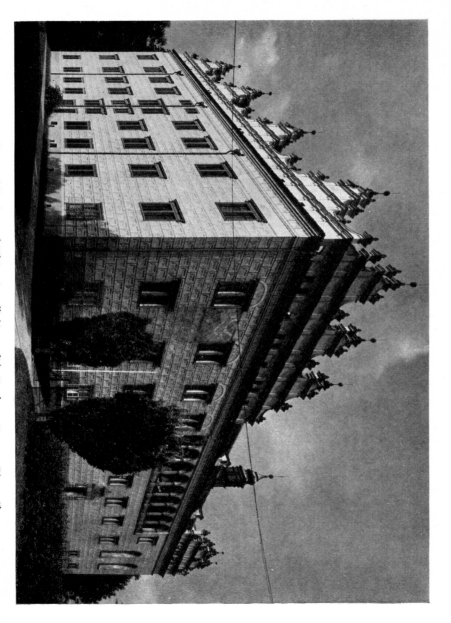

327 Giovanni Battista and Ulrico Aostalli (Avostalis): Castle, 1568–73, at Litomyšl

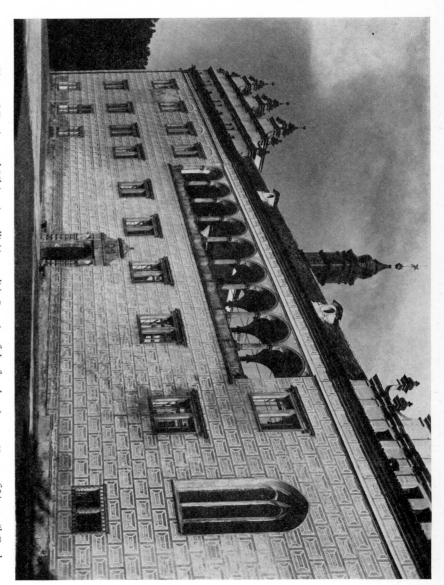

326 Giovanni Battista and Ulrico Aostalli (Avostalis): Loggia of the façade wing, 1568–73, of Litomyšl Castle

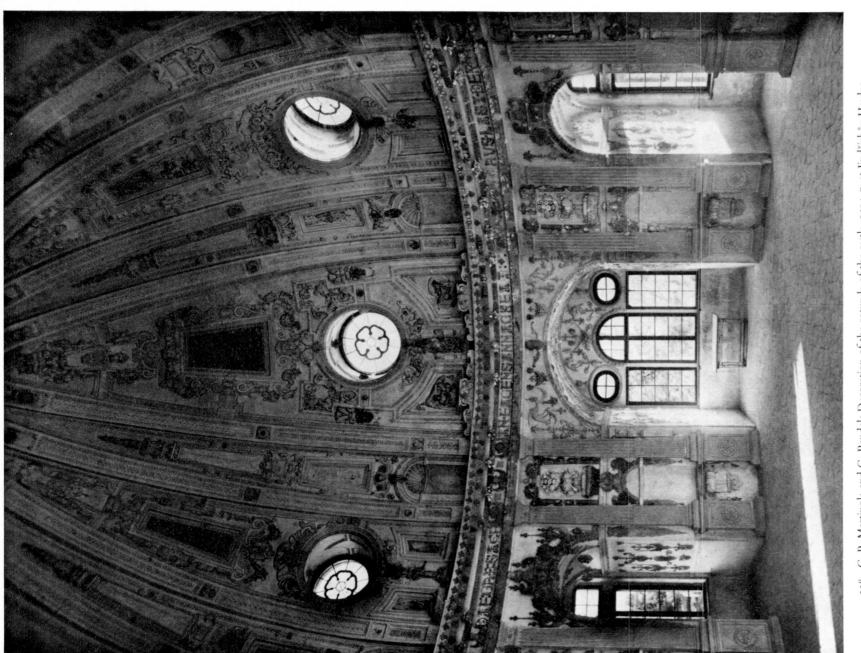

328 G. P. Martinola and G. Bendel: Decoration of the rotunda of the castle, 1594–7, at Jindřichův Hradec

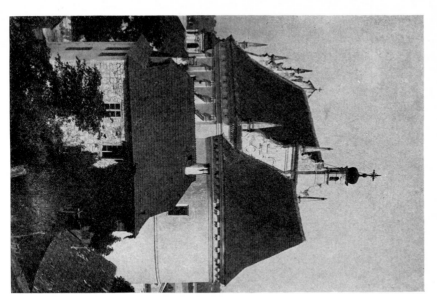

330 Jacopo Balin: Parish church, 1586–9 and 1610–13. Kazimierz Dolny

331 Giambatista of Venice: Collegiate Church, 1560. Pułtusk

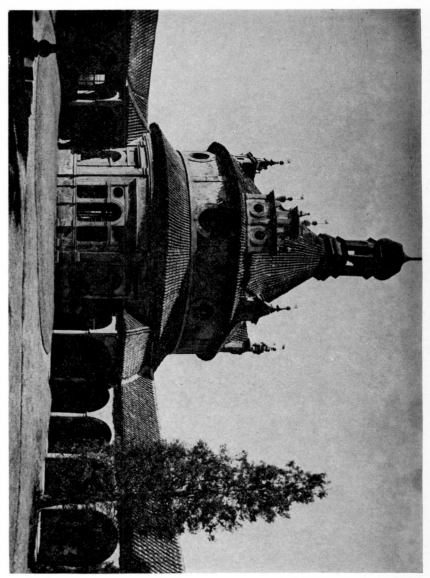

329 Giovanni Maria Faconi and Antonio Cometta: Rotunda at the castle, 1591–3. View from outside. Jindřichův Hradec

332 Vault decoration, painted stucco, 1603–7. Lublin, St Bernard
Friars Church

334 Jan Jaroszewicz and Jan Wolff: Vault decoration, painted
stucco, about 1625. Uchanie, Parish Church

333 Albin Fontana: Vault decoration, painted stucco, 1599–
1632. Kalisz, Franciscan Friars Church

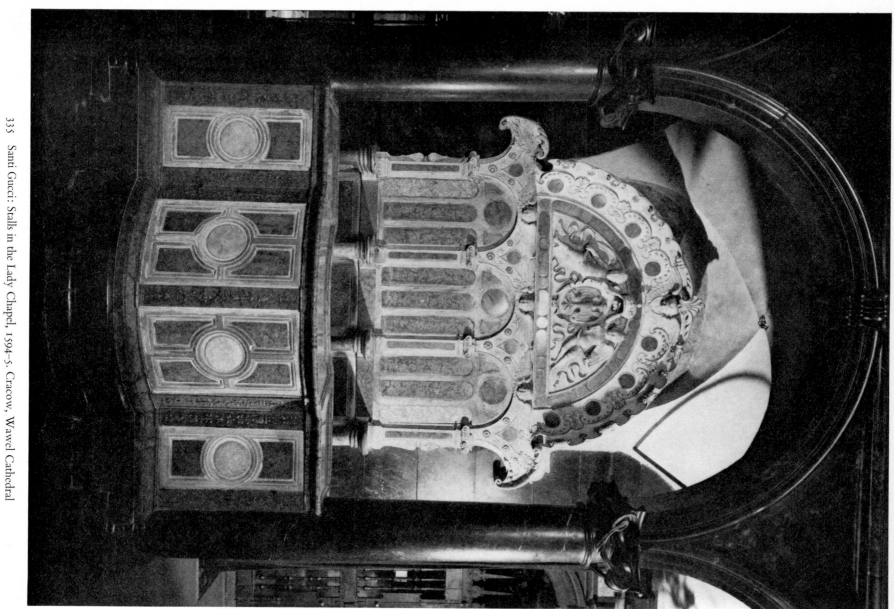

335 Santi Gucci: Stalls in the Lady Chapel, 1594–5. Cracow, Wawel Cathedral

336 Castle (last remodelling, of the parts shown here 1591–1606) at Baranów

337 Courtyard of the castle, 1591–1606, at Baranów

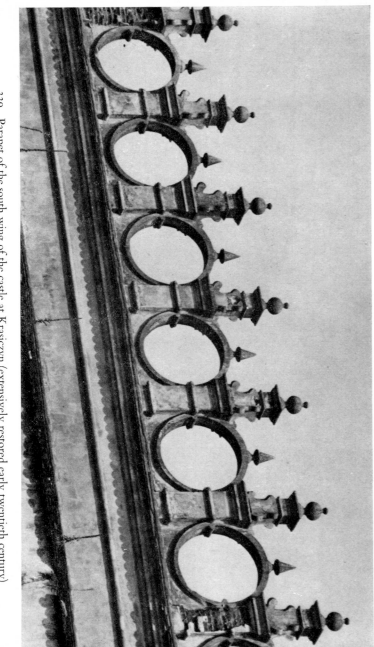

339 Parapet of the south wing of the castle at Krasiczyn (extensively restored early twentieth century)

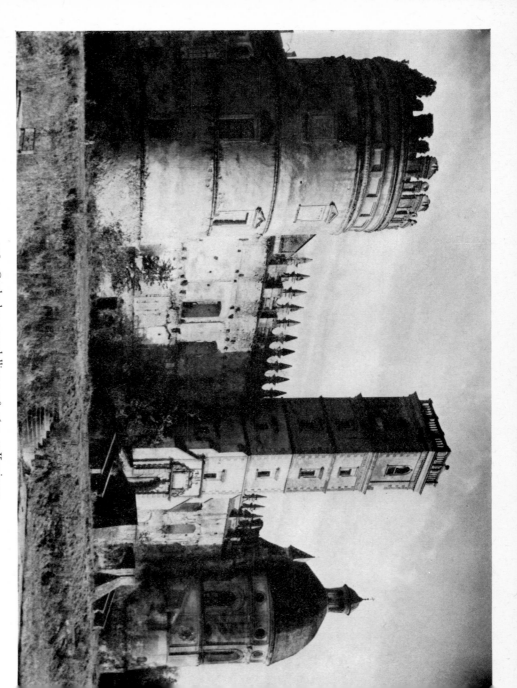

338 Castle, last remodelling 1598–1633, at Krasiczyn

340 Workshop of Santi Gucci: Tomb of the Branicki family,
1596. Niepołomice near Cracow, Parish Church

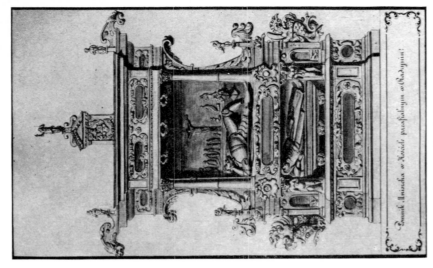

342 Tomb of Zofia and Mikołaj Mniszech. Radzyń.
After a nineteenth-century drawing. Warsaw,
University Library

341 Portal with dragon heads, arcade of the castle at Baranów

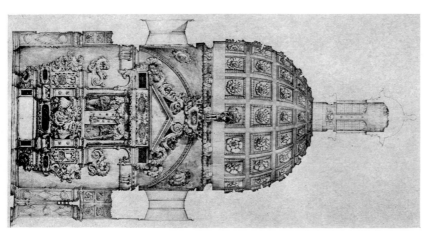

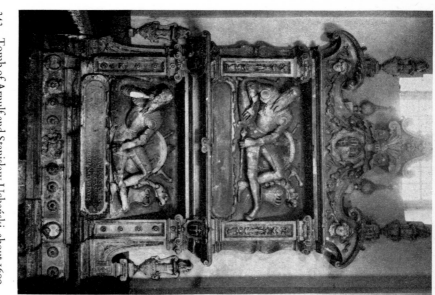

344–345 Workshop of Samuel Świątkowicz: Chapel of the Firlej family, 1593–1601. Doorway between the nave and the chapel, and modern drawing of the interior with the tomb of the Firlej family. Bejsce

343 Tomb of Arnulf and Stanislaw Uchański, about 1600. Uchanie, Parish Church

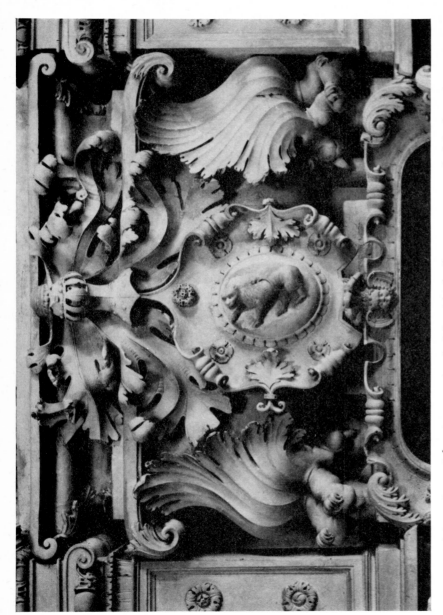

346 Workshop of Samuel Świątkowicz: Chapel of the Firlej family, 1593–1601. Detail of the decoration. Bejsce

347 Chełmno town hall parapet, 1567–70.

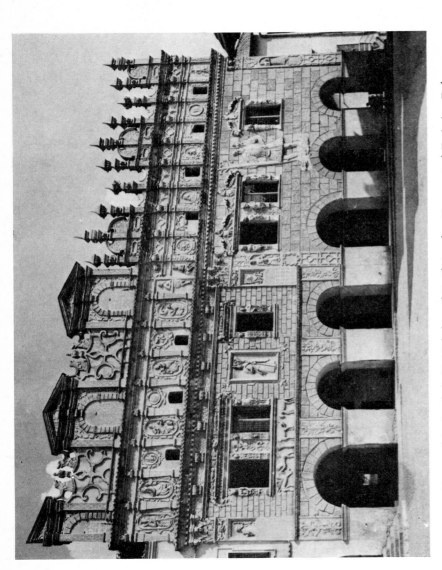

349 Houses of the Przybyla (St Nicholas and St Christopher Houses, 1615) Kazimierz Dolny

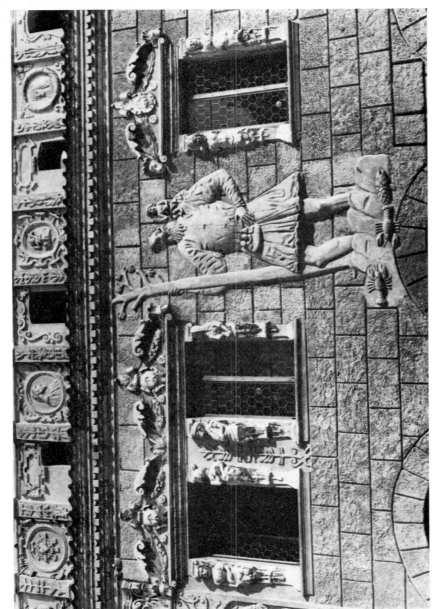

350 St Christopher relief. Kazimierz Dolny, Przybyla House

Bibliography

Actes Congrès Budapest, 1969 = *Evolution générale et développements régionaux en histoire de l'art. Actes du XXIIe Congrès International d'Histoire de l'Art, Budapest, 1969*, Budapest, 1972, I–III.

Ameisenowa, Z., 'Les principaux manuscrits à peintures de la Bibliothèque Jagellonienne', *Bulletin de la Société Française de Reproduction de Manuscrits à Peintures*, XVII, Paris, 1933–4.

Ameisenowa, Z., *Rękopisy i pierwodruki iluminowane Biblioteki Jagiellońskiej* (Manuscripts and illuminated incunabula of the Jagellonian Library), Wrocław–Cracow, 1958.

Ameisenowa, Z., *Kodeks Baltazara Behema*, Warsaw, 1961.

Ameisenowa, Z., *Cztery polskie rękopisy iluminowane z lat 1524–1528 w zbiorach obcych* (Four Polish illuminated manuscripts of 1524–8 abroad) (Zeszyty Naukowe Uniwersytetu Jagiellońskiego, CXIII, Prace z Historii Sztuki, 4), Cracow, 1967.

Angyal, A., *A reneszánsz és a barokk Kelet-Európában* (Renaissance and Baroque in eastern Europe), Budapest, 1961.

Angyal, A., 'Südosteuropäische Spätrenaissance', in Irmscher, ed., 1962, pp. 287–301.

Arte italiana in Cecoslovacchia, Boemia e Moravia, Prague, 1950 (Exhib. catalogue).

Baldass, P. v., R. Feuchtmüller, W. Mrazek, *Renaissance in Österreich*, Vienna, 1966.

Balogh, J., 'Andrea Scolari váradi püspök mecénási tevékenysége' (The patronage of Andrea Scolari, Bishop of Nagyvárad), *Archaeológiai Értesítő*, N.S., XL, 1923–6, pp. 173–88.

Balogh, J., 'Néhány adat Firenze és Magyarország kulturális kapcsolatainak történetéhez' (Contributions to the history of cultural relations between Florence and Hungary at the time of the Renaissance), *Archaeológiai Értesítő*, N.S., XL, 1923–6, pp. 189–209.

Balogh, J., *Contributi alla storia delle relazioni d'arte e di cultura fra Milano e l'Ungheria* (Trattati dell'Istituto di Storia dell'Arte della Reale Università Ungherese a Budapest, VIII), Budapest, 1928.

Balogh, J., 'Újabb adatok Firenze és Magyarország kulturális kapcsolatainak történetéhez' (New data for the history of cultural relations between Florence and Hungary), *Archaeológiai Értesítő*, N.S., XLIII, 1929, pp. 273–80.

Balogh, J., 'Uno sconosciuto scultore italiano presso il Re Mattia Corvino', *Rivista d'Arte*, XV, 1933, pp. 275–97.

Balogh, J., 'A renaissance építészet és szobrászat Erdélyben' (Renaissance architecture and sculpture in Transylvania), *Magyar Művészet*, X, 1934, pp. 124–58.

Balogh, J., 'I Monumenti del Rinascimento della chiesa parrocchiale di Pest', *Rivista d'Arte*, XX, 1938, pp. 60–77.

Balogh, J., 'Mátyás király ikonográfiája' (The iconography of King Matthias), in I. Lukinich, ed., 1940, pp. 435–548.

Balogh, J., *Az erdélyi renaissance* (Transylvanian Renaissance), I, Kolozsvár, 1943.

Balogh, J., 'La Madone d'André Báthory', *Bulletin du Musée Hongrois des Beaux-Arts*, I, 1947, pp. 8–14.

Balogh, J., 'Magister Albertus Pictor Florentinus', *Istituto Ungherese di Storia dell'Arte, Firenze, Annuario 1947*, Florence (1948), pp. 74–80.

Balogh, J., 'Die Ausgrabungen in Visegrád', *Österreichische Zeitschrift für Denkmalpflege*, IV, 1950, pp. 41–50.

Balogh, J., 'A budai királyi várpalota rekonstruálása a történeti források alapján' (Reconstruction of the Buda royal palace on the basis of historical sources), *Művészettörténeti Értesítő*, I, 1952, pp. 29–40.

Balogh, J., *A magyar renaissance építészet* (Hungarian Renaissance architecture), Budapest, 1953.

Balogh, J., 'A magyarországi négysarokbástyás várkastélyok' (Castles with four corner-towers in Hungary), *Művészettörténeti Értesítő*, II, 1954, pp. 247–52.

Balogh, J., 'Kora-renaissance' (The epoch of the Renaissance) and 'Késő-renaissance' (The Late Renaissance), in D. Dercsényi, ed., 1956, pp. 249–84 and 285–324.

Balogh, J., 'La Capella Bakócz di Esztergom', *Acta Historiae Artium*, III, 1956, pp. 1–197.

Balogh, J., 'Ercole Roberti a Buda', *Acta Historiae Artium*, VI, 1959, pp. 277–81.

Balogh, J., 'Joannes Duknovich de Tragurio', *Acta Historiae Artium*, VII, 1960, pp. 51–78.

Balogh, J., *A művészet Mátyás király udvarában* (Art at King Matthias's Court), I–II, Budapest, 1966.

Balogh, J., 'Wealthy Patrons of the Hungarian Renaissance', in *Mátyás magyar király*, I, Budapest, 1966.

Balogh, J., 'Die ungarischen Mäzene der Frührenaissance', *Jahrbuch des kunsthistorischen Institutes der Universität Graz*, V, 1970, pp. 23–32.

Balogh, J., 'Influssi veneziani nell'arte di Transilvania',

Studi di Storia dell'arte in onore di A. Morassi, Milan, 1971, pp. 188–96.

Balogh, J., 'I mecenati ungheresi del primo Rinascimento', *Acta Historiae Artium*, XIII, 1967, pp. 205–12.

Balogh, J., 'Mattia Corvino ed il primo Rinascimento Ungherese', in *Actes Congrès Budapest 1969*, Budapest, 1972, I, pp. 611–21.

Balšánek, A., *Štíty a motivy attikové v české renaissance* (Gables and parapet motifs in Czech Renaissance), Prague, 1902.

Banfi, F., 'Salve, Varadino felice . . .', *La Città di S. Ladislao nei rapporti italo-ungheresi, Corvina*, N.S. III, 1940, pp. 825–44.

Barušěk, A., in *Velké Losiny. Státní Zámek. Město a Okolí* (Velké Losiny. The state castle. The town and the surroundings), Prague, 1954.

Bascapé, G., *Le relazioni tra l'Italia e la Transilvania nel secolo XVI*, Rome, 1931.

Beltrami, L., 'Artisti italiani a Mosca al servizio di Ivan III', *Atti della Società Piemontese di archeologia e belle arti*, X, 1925, pp. 217–24.

Benesch, O., *The Art of the Renaissance in Northern Europe. Its Relation to the Contemporary Spiritual and Intellectual Movements*, Cambridge, Mass., 3rd ed., London, 1965.

Bérenger, J., 'Caractères originaux de l'humanisme hongrois', *Journal des Savants*, 1973, pp. 459–88.

Bergström, I., 'Medicina, Fons et Scrinium. A Study in Van Eyckean Symbolism and Its Influence in Italian Art', *Konsthistorisk Tidskrift*, XXVI, 1957, pp. 1–20.

Berkovits, I., *Corviniana. Iluminowane rękopisy Biblioteki Króla Macieja Korwina* (Corviniana. Illuminated manuscripts of the Library of the King Matthias Corvinus), Wrocław–Budapest, 1964.

Berkovits, I., *Illuminated Manuscripts in Hungary. XI–XVI Centuries*, New York, 1970.

Berti-Toesca, E., 'Arte italiana a Strigonia', *Dedalo*, XII(XI), 1932, pp. 933–60.

Berzeviczy, A., 'Rapporti storici fra Napoli e l'Ungheria nell'epoca degli Aragonesi (1442–1501)', *Atti della Accademia Pontaniana*, LVIII, 1928 (Naples), pp. 180–202.

Beth, I., 'Hans Dürer und der Silberaltar in der Jagellonenkapelle zu Krakau', *Jahrbuch der Preussischen Kunstsammlungen*, XXXI, 1910, pp. 79–98.

Bettenstädt, W., *Das Rathaus in Posen und seine Herstellung in den Jahren 1910–1913*, Posen, 1913.

Bettini, S., 'Alvise Lamberti da Montagnana', *Le Tre Venezie*, XVIII, 1944, Nos. 7–12, pp. 17–31.

Bettini, S., 'L'Architetto Alevis Novyj in Russia', *Bolletino del Centro di Studi di Architettura Andrea Palladio*, IV, 1964 (ed. 1965), II, pp. 159–80.

Białostocki, J., 'Historyzm' w sztuce polskiej XVI wieku' (Historicism in Polish art of the sixteenth century), in *Odrodzenie w Polsce* (Renaissance in Poland, collective work), II, I, Warsaw, 1956, pp. 387–9.

Białostocki, J., 'Mannerism and "Vernacular" in Polish Art', *Walter Friedländer zum 90. Geburtstag. Eine Festgabe seiner europäischen Schüler, Freunde und Verehrer*, Berlin, 1965, pp. 47–57.

Białostocki, J., 'Sea-Thiasos in Renaissance Sepulchral Art', in *Studies in French and Italian Art of Sir Anthony Blunt*, London, 1967, pp. 69–74.

Białostocki, J., 'Symbolika drzwi w sepulkralnej sztuce baroku' (The door-symbolism in the tomb art of the Baroque), in *Sarmatia Artistica. Księga Pamiątkowa ku czci Prof. Władysława Tomkiewicza* (Memorial book in honour of Prof. Władysław Tomkiewicz), Warsaw, 1968, pp. 107–19.

Białostocki, J., 'Kompozycja emblematyczna epitafiów śląskich XVI wieku' (Emblematic composition in Silesian epitaphs of the sixteenth century, in *Ze studiów nad sztuką XVI wieku na Śląsku i w krajach sąsiednich* (Studies in sixteenth-century art in Silesia and the neighbouring countries), Wrocław, 1968, pp. 77–93.

Białostocki, J., 'Two types of International Mannerism: Italian and Northern', *Umění*, XVIII, 1970, pp. 105–9.

Białostocki, J., 'Malerei', in G. Kauffmann, 1970, pp. 155–93 and pp. 202–8.

Białostocki, J., 'The Door of Death', *Jahrbuch der Hamburger Kunstsammlungen*, XVIII, 1973, pp. 7–32.

Bimler, K., *Das Piastenschloss zu Brieg*, Breslau, 1934.

Bimler, K., *Schlesische Burgen und Renaissanceschlösser*, Breslau, 1933.

Bimler, K., *Die schlesische Renaissanceplastik*, Breslau, 1934.

Bischoff, M., *Die Renaissance in Schlesien*, Leipzig, 1885.

Blažíček, O.J., 'Fontána v Bučovicích' (The Fountain at Bucovice), *Umění*, II, 1954, pp. 251–2.

Blunt, A., *Art and Architecture in France: 1500 to 1700* (Pelican History of Art), London, 1953.

Bocknak, A., 'Pomnik Kallimacha' (The Calli-machus Monument), *Studia Renesansowe*, I, 1956, pp. 124–37.

Bochnak, A., *Kaplica Zygmuntowska* (The Sigis-mund Chapel), no place (Cracow), 1953.

Bochnak, A., 'Problematyka krakowskiego renesansu' (Problems of the Renaissance in Cracow), in *Krakowskie Odrodzenie* (The Cracow Renaissance) (Acts of the Conference of the Society for History and Monuments of Cracow, 1953), J. Dąbrowski, ed., Cracow, 1954, pp. 106–24.

Bochnak, A., 'Mecenat Zygmunta Starego w zakresie rzemiosła artystycznego' (Sigismund the Old's Patronage in the field of decorative Arts), *Studia do Dziejów Wawelu*, II, 1960, pp. 131–288.

Bochnak, A., 'Canavesi a Padovano', in *Medievalia. W 50 rocznicę, pracy naukowej Jana Dąbrow-skiego* (Essays to celebrate the 50th anniversary of J. Dąbrowski's scholarly activity), Warsaw, 1960, pp. 415–24.

Bochnak, A. and Samek, J., *Katalog Zabytków Sztuki w Polsce* (Catalogue of art monuments in Poland), IV: *Miasto Kraków* (Cracow Town), II: *Kościoły i klasztory śródmieścia* (Downtown: Churches and Monasteries/Convents), I, Warsaw, 1971.

Bochnak, W., 'Brązowe płyty nagrobne Seweryna i Zofii Bonerów w kościele Mariackim w Krakowie' (Bronze tomb plaques of Seweryn and Zofia Boner in Our Lady's in Cracow), *Biuletyn Historii Sztuki*, XXXIV, 1972, pp. 279–94.

Bogdanowski, J., 'Ogrody włoskie pod Krakowem' (Italian gardens around Cracow), *Zeszyty Naukowe Politechniki Krakowskiej* (Scholarly Bulletins of the Cracow Polytechnical School), Special issue No. 1, 1966, pp. 59–121.

Bohdziewicz, P., 'O rozbudowie zamku królew-skiego w Warszawie w latach 1569–1572' (The enlargement of the Warsaw royal castle: 1569–72), Ro-zniki Humanistyczne, VI, 1957, No. 4, pp. 7–30.

Boloz Antoniewicz, J., 'Lament opatowski i jego twórca' (The Opatów Mourning and its creator), *Prace Komisji Historii Sztuki P.A.U.* (Studies of the Commission for Art History of the Cracow Academy of Learning), II, II, 1922, pp. 123–58.

Bonfini, A. de, *Rerum Hungaricarum Decades*, ediderunt J. Fógel, B. Iványi, L. Juhász, I–IV, Lipsiae, 1936-Budapest, 1941 (Bibl. Script. Medii Aevi, Rec. Aev.).

Boskovits, M., 'On the Trail of an Old Hungarian Master', *The New Hungarian Quarterly*, III, 1962, No. 6, pp. 96–109.

Boskovits, M., ed., *L'Art du Gothique et de la Renaissance (1300–1500). Bibliographie raisonnée des ouvrages publiés en Hongrie*, I–II, Budapest, 1965.

Botter, M., *La Villa Capodilista di Dario Varotari a Montecchia*, Treviso, 1967.

Breyer, A. and Masuch, H., 'Die Halbkreisaufsätze in der Weserrenaissance. Stilelemente des Baumeisters Jörg Unkair', *Mindener Heimats-blätter*, XXX, 1958, pp. 257–64.

Brunelli, B. and Callegari, A., *Ville del Brenta e degli Euganei*, Milan, 1931.

Budinis, C., *Gli artisti italiani in Ungheria*, no place (Rome), 1936.

Bunyitay, V., 'A menyői kereszktít és a renais-sance Szilágymegyében' (The baptismal font of Menyö and the Renaissance in the Szilágy district), *Századok. A Magyar Történelmi Társulat Közlönye* (Centuries, Bulletin of the Hungarian Historical Association), XX, 1886, pp. 886–95.

Burger, F., *Das florentinische Grabmal*, Strasburg, 1904.

Burnatowa, I., 'Ornament renesansowy w Kra-kowie' (Renaissance ornamentation in Cracow), *Studia Renesansowe*, IV, 1964, pp. 5–224.

Carnasecchi, C., 'La fonte del Verrocchio per Mattia Corvino', *Miscellanea d'arte*, I, 1903, p. 143.

Cercha, S. and Kopera, F., *Nadworny rzeźbiarz króla Zygmunta Starego Giovanni Cini ze Sieny i jego dzieła w Polsce* (The court sculptor to King Sigismund the Old, Giovanni Cini from Siena and his works in Poland), Cracow, no date (1917).

Chmarzyński, G., 'Sztuka Poznania w dobie Odrodzenia' (Art at Poznań in the time of the Renaissance), *Przegląd Zachodni*, IX, 1953, No. 11–12, pp. 627–43.

Chmiel, A., 'Wawel, II: Materiały archiwalne do budowy Zamku' (Wawel II: Archive records concerning the construction of the castle), *Teka Grona Konserwatorów Galicji Zachodniej*, V, 1913 (Publication of the Conservators of Western Galicia, the whole issue).

Chyczewski, J., *Kolegiata pułtuska na tle budownictwa mazowieckiego XV i XVI wieku* (The Pułtusk Collegiate Church seen against the background of architecture in Masovia in the fifteenth and

sixteenth century), (Prace z Historii Sztuki Towarzystwa Naukowego Warszawskiego, 1) (Studies in art history of the Warsaw Learned Society), Warsaw, 1936.

Chytil, K., *Umění v Praze za Rudolfa II* (Art in Prague in Rudolf II's time), Prague, 1904.

Chytil, K., 'Maestri luganesi in Boemia nel secolo XVI', *L'Italia e l'arte straniera, Atti del X Congresso Internazionale di Storia dell'Arte*, Rome, 1922, pp. 330–5.

Chytil, K., 'Mistři luganisti v Čechách v XVI století' (Masters from Lugano in Bohemia in the sixteenth century), *Ročenka Kruhu pro Pěstování Dějin Umění za Rok 1924* (Yearbook of the circle for study of art history for 1924), Prague, 1925, pp. 32–66.

Chytil, K. 'K literature o renaissančích detailes vladislavské části hradu pražského' (On literature concerning the Renaissance details of the part of the Prague castle built under King Vladislav), *Památky archeologické*, XXXV, 1926–7, p. 244.

Ciolek, G., 'Zamek w Baranowie – System krużganków' (The Baranów Castle – the system of the courtyard arcade) *Biuletyn Historii Sztuki i Kultury*, VI, 1938, p. 221.

Csabai, S., *Az erdélyi renaissance-művészet* (The Art of the Renaissance in Transylvania), Budapest, 1934

Csabai, S., 'Europäische und ungarische Renaissance', *Ungarische Jahrbücher*, XVI, 1937, pp. 268–74.

Csánki, D., 'La corte di Mattia Corvino', *Corvina*, I, 1921, pp. 25–47.

Csányi, C., 'Italienische Einflüsse auf die ungarische Kunst', *L'Italia e l'arte straniera, Atti del X Congresso Internazionale di Storia dell'Arte in Roma*, Rome, 1922, pp. 270–5.

Csapodi, C., 'Wann wurde die Bibliothek des Königs Matthias Corvin vernichtet?' *Gutenberg Jahrbuch*, 1971, pp. 384–90.

Csapodi, C., *The Corvinian Library, History and Stock*, Budapest, 1973 (= Studia Humanitas, I).

Csapodi, C. and Csapodi-Gárdonyi, K., *Bibliotheca Corviniana: The Library of King Matthias Corvinus of Hungary*, New York, 1970.

Csapodi-Gárdonyi, K., 'Bericht über neuere Forschungen auf dem Gebiet der Bibliotheca Corvina', in Irmscher, ed., 1962, II, pp. 9–13.

C. Csorba, 'Adatár a 10–17. századi alföldi várakról, várkastélyokról és erődiményekről, (Castles and fortifications in the great Hungarian lowland from the tenth to the

seventeenth century), *Debreceni Déri Múzeum Évkönyve*, 1972, pp. 177–236.

Cytowska, M., 'L'influence d'Erasme en Pologne au XVIe siècle', in Irmscher, ed., 1962, II, pp. 192–6.

Dayczak Domanasiewicz, M., 'Renesansowy dwór biskupów krakowskich na Prądniku Białym. Zagadnienie wczesnego oddziaływania wzorów Serliowsko-Palladiańskich na architekturę polską połowy 16 w.' (The Renaissance manor of the Cracow bishops at Prądnik Biały. The problem of early impact of Serlian-Palladian models on the Polish architecture of the mid-sixteenth century), *Sprawozdania z posiedzeń Oddziału P.A.N., Kraków* (Proceedings of the Cracow section of the Polish Academy of Sciences and Letters), XII, 1968, pp. 194–7.

Dąbrowski, J., 'Związki początków i rozwoju Odrodzenia w Krakowie z Odrodzeniem na Węgrzech' (Connections of the origins and development of the Renaissance in Cracow with the Renaissance in Hungary), in *Krakowskie Odrodzenie* (The Renaissance in Cracow) (Proceedings of the conference of the Society for the History and Monuments of Cracow, 1953) J. Dąbrowski, ed., Cracow, 1954, pp. 138–57.

Dąbrowski, J., 'Les relations de Cracovie et son Université avec la Hongrie à l'époque de l'Humanisme', in *La Renaissance et la Reformation en Pologne et en Hongrie*, Budapest, 1963 (Studia Historica Academiae Scientiarum Hungaricae, LIII), pp. 451–66.

Delogu, G., 'Arte italiana in Ungheria', *Emporium*, LXXXIII (year XLII), 1936, pp. 171–86.

Depowski, J., *Die Sigismundskapelle (Jagellonische Kapelle) in Krakau*, Freiburg, 1918.

Dercsényi, D., *Visegrád Műemlékei* (The monuments of Visegrad), Budapest, 1951.

Dercsényi, D., ed., *A magyarországi műveszet a honfoglalástól a XIX. század*ig (Hungarian art from the occupation of the territory to the nineteenth century), in L. Fülep, ed., *A magyarországi művészet története* (History of art in Hungary), I, Budapest, 1956.

Dercsényi, D., *Magyarország műemléki topográfiája*, V: *Pest megye műemlékei* (Hungarian monumental topography, V: The monuments of Pest), II, Budapest, 1958.

Dercsényi, D. and Gerő, L., *A sárospataki vár* (The Sárospatak castle), Budapest, 1957.

Dettloff, S., 'Humanizm a przedświt sztuki renesansowej w Polsce' (Humanism and the dawn of Renaissance art in Poland), *Księga Pamiątkowa ku uczczeniu Stanisława Dobrzyckiego* (Memorial volume to honour Stanisław Dobrzycki), Poznań, 1928, pp. 46–50.

Dettloff, S., *U źródeł sztuki Wita Stosza* (At the sources of Veit Stoss's art), Warsaw, 1935.

Dettloff, S., 'Wielkopolskie bronzy Vischerowskie' (The Vischer bronze plaques in Wielkopolska), *Arkady*, III, 1937, pp. 5–11.

Dettloff, S., 'O dwóch krakowskich nagrobkach bronzowych' (Two Cracow bronze tombs), *Arkady*, III, 1938, pp. 113–22.

Dettloff, S., 'Zur Jorg Huber-Frage', *Dawna Sztuka*, I, 1938, pp. 293–304.

Dettloff, S., *Wit Stosz*, I–II, Wrocław, 1961.

Divald, K., *A sárospataki vár* (The Sárospatak castle), Budapest, 1902.

Divald, K., 'Renaissance architecture and its popular variations', in *Old Hungarian Art*, London, 1931, pp. 169–94.

Divéky, A., 'Magyarország szerepe a Lengyel Renaissanceban' (Hungary's role in the Renaissance in Poland), *Archeológiai Értesítő*, N.S., XXX, 1910, pp. 1–11.

Divéky, A., 'Zsigmond lengyel herceg számadáskönyvei' (The account books of the Polish prince Sigismund), Budapest, 1914.

Divéky, A., 'Królewicz Zygmunt na dworze Władysława II, króla węgierskiego' (The prince Sigismund at the court of Władysław II, king of Hungary), in *Medievalia, w 50 rocznicę pracy naukowej Jana Dąbrowskiego* (Medievalia, essays to honour the 50th anniversary of Jan Dąbrowski's scholarly work), Warsaw, 1960, pp. 355–74.

Dmochowski, Z., *The Architecture of Poland: An Historical Survey*, London, 1956.

Dobrowolski, T., 'Zamek na Wawelu – dzieło architektury polskiej' (The Wawel castle as a work of Polish Architecture), *Biuletyn Historii Sztuki*, XV, 1953, No. 3/4, pp. 3–24 (also in *Studia Renesansowe*, I, 1956, pp. 140–80).

Dobrowolski, T., *Sztuka Krakowa* (The art of Cracow), 4th ed., Cracow, 1971.

Dobrowolski, T. and Tatarkiewicz, W., ed., *Sztuka nowożytna* (*Historia Sztuki Polskiej*, II) (Modern art; history of Polish art, II), Cracow, 1962, 2nd ed., Cracow, 1965.

Dobrzeniecki, T., *Tryptyk z Pławna* (The Pławno Triptych), no place (Warsaw), 1954.

Dolczewski, Z., 'Geneza i rozwój renesansowego nagrobka z figurą stojącą w Wielkopolsce' (Origins and development of the Renaissance tomb with standing figure in Wielkopolska), in *Studia nad Renesansem w Wielkopolsce* (Studies in the Renaissance in Wielkopolska), T. Rutkowski, ed. (Poznańskie Towarzystwo Przyjaciół Nauk, Wydział Historii i Nauk Społecznych, Prace Komisji Historii Sztuki, VIII, 3) (Poznań Learned Society, section of history and social sciences, Studies of the commission of Art History, VIII, 3), Poznań, 1970, pp. 131–46.

Drecka, W., *Kulmbach*, Warsaw, 1957.

Durand, G., 'Les Lannoy, Folleville et l'art italien dans le nord de la France', *Bulletin Monumental*, LXX, 1906, pp. 329–404.

Dutkiewicz, J., *Grobowce rodziny Tarnowskich w kościele katedralnym w Tarnowie* (Tombs of the Tarnowski family in the Tarnów cathedral) (Prace Towarzystwa Przyjaciół Nauk w Tarnowie, I) (Studies of the Tarnów Learned Society, I), Tarnów, 1932.

Dutkiewicz, J. E., 'Le sculpteur vénitien Gian Maria Padovano, dit il Mosca, et son activité en Pologne', *Venezia e l'Europa. Atti del XVIII Congresso Internazionale di Storia dell'Arte*, Venice, 1955, Venice, 1956, pp. 273–5.

Dvořáková, V. and Mahálková, H., 'Malovaná průčelí české pozdní gotiky a renesance' (The painted façade of the Czech Late Gothic and Renaissance), *Zprávy památkové péče*, XIV, 1954, pp. 33–73.

Eckhardtówna, J., 'Nagrobek Piotra Tomickiego w katedrze na Wawelu i jego twórca' (The tomb of Piotr Tomicki in the Wawel cathedral and its author), *Sprawozdania Poznańskiego Towarzystwa Przyjaciół Nauk* (Proceedings of the Poznań Learned Society), 1937, No. 3(30), pp. 130–8.

Eckhardtówna, J., 'Pomnik grobowy Batorego. Problem środowiska i fundatora' (The Tomb of Batory. Problem of artistic milieu and of the founder), *Biuletyn Historii Sztuki*, XVII, 1955, pp. 140–8.

Edgár, E., 'Budín a letohrádek Belvedér na Hradě pražském' (Buda and the Villa Belvedere on the Castle Hill in Prague), *Časopis Turistů*, LVI, 1944, pp. 50–1.

Edgár, E., 'Zámek ve Frankštejnu – dílo českého královského stavitele' (The Frankštejn Castle – a work of a Czech Royal Architect), *Slezský sborník* (Acta Silesiaca), LII (12), 1954, pp. 551–3.

(published by Slezský studijní ústav, Opava).

Ehrenburg, H., 'Firenczei János magyar és lengyel müvei' (Giovanni da Firenze and his works in Hungary and Poland), *Archeologiai Értesítő*, N.S., XIII, 1893, pp. 250–7.

Elekes, L., *Mátyás és kora* (Matthias and his time), Budapest, 1956.

Entz, G., 'A boroszlói városháza Mátyás arcképei' (Effigies of Matthias in Wrocław town hall), *Müvészettörténeti Értesítő*, IX, 1960, pp. 191–6.

Entz, G., 'Wizerunki Macieja Korwina w ratuszu wrocławskim' (Effigies of Matthias Corvinus in the town hall at Wrocław), *Kwartalnik Architektury i Urbanistyki*, VI, 1961, pp. 203–16.

Entz, G., 'Nouveaux résultats des recherches poursuivies en Hongrie sur le gothique tardif et la Renaissance', in *La Renaissance et la Réformation en Pologne et en Hongrie* (Studia Historica Academiae Scientiarum Hungaricae, LIII), Budapest, 1963, pp. 467–91.

Entz, G., 'Baukunst in Ungarn um 1500', *Acta Historiae Artium*, XIII, 1967, pp. 81–6.

Éri, I., 'Reneszánsz dombormű töredékek a nagyvázsonyi Kinizsivárból' (Fragment of the Renaissance-relief from the Castle Kinizsi at Nagyvázsony), *Müvészettörténeti Értesítő*, VII, 1958, pp. 124–33.

Ernst, N., 'Palats khana v Baktchisarayou y arkhitekht vyelikogo knyazhya Ivana III – Friasin Alevis Novyj' (The Palace of the Khan at Baktchisaray and the architect of the Grand Duke Ivan III – Friasin Alevis Novyj), *Zapiski Tavritcheskogo Obshtchestva Istorii, Archeologii y Ethnografii* (Proceedings of the Tauris Society for History, Archaeology and Ethnography) (Simferopol), II, 1928, pp. 1–16.

Estreicher, K., 'Miniatury Kodeksu Bema oraz ich treść obyczajowa' (The Bem-Codex miniatures and their importance for the study of manners and customs of the artisans), *Rocznik Krakowski*, XXIV, 1933, pp. 199–240.

Estreicher, K., Review of W. Husarski, 1936, *Dawna Sztuka*, I, 1938, pp. 78–81.

Estreicher, K., 'Grobowiec Władysława Jagielly' (The tomb of Władysław Jagiełło), *Rocznik Krakowski*, XXXIII, 1953, pp. 1–45.

Estreicher, K., *Collegium Maius. Dzieje gmachu* (Collegium Maius. The history of the building), Cracow, 1968 (Zeszyty Naukowe Uniwersytetu Jagiellońskiego, CLXX; Prace z Historii Szuki, No 6) (Scholarly Publications of the Jagiellonian University, CLXX; Studies in the History of Art, No. 6).

Estreicher, K., *The Collegium Maius of the Jagellonian University in Cracow, History, customs, collections*, Warsaw, 1973.

Estreicher, K. and Pagaczewski, J., 'Czy Jan Maria Padovano był w Rzymie? (Did Giovanni Maria Padovano visit Rome?), *Rocznik Krakowski*, XXVII, 1937, pp. 139–65.

Falke, J., von, *Schloss Stern*, Vienna, 1879.

Fehr, G., *Benedikt Ried. Ein deutscher Baumeister zwischen Gotik und Renaissance in Böhmen*, Munich, 1961.

Feuer-Tóth, R., 'Le rôle de la Dalmatie dans l'expansion de la Renaissance florentine en Hongrie', *Actes Congrès Budapest, 1969*, Budapest, 1972, I, pp. 623–30.

Feuer-Tóth, R., 'A budai "Schola": Mátyás Király és Chimenti Camicia reneszánsz ideálváros-negyed terve' (The 'Schola' at Buda. King Matthias and Ch. Camicia's project of a part of an ideal town), *Építés-Építészettu-domány*, V, 1973, pp. 373–85.

Filipović, V., 'Kroatische Humanisten des 15. und 16. Jahrhunderts', *Südostforschungen*, XVII, 1958, pp. 31–45.

Fiocco, G., 'Alvise Lamberti da Montagnana', *Bollettino del Museo Civico di Padova*, XLIV, 1956, pp. 83–8.

Fischinger, A., 'Przebudowa Kaplicy Mariackiej w katedrze wawelskiej na mauzoleum króla Stefana Batorego' (The transformation of the Lady Chapel in the Wawel cathedral into the mausoleum of the King Stefan Batory), *Studia do Dziejów Wawelu*, I, 1955, pp. 349–66.

Fischinger, A., 'Kaplica Myszkowskich w Krakowie' (The Myszkowski Chapel in Cracow), *Rocznik Krakowski*, XXXVII, 1956, pp. 83–113.

Fischinger, A., 'Ze studiów nad rzeźbą nagrobkową kaplicy Zygmuntowskiej' (Studies in the tomb sculpture of the Sigismund Chapel), *Sprawozdania z posiedzeń Komisji Oddziału P.A.N. w Krakowie* (Proceedings of the Cracow Section of the Polish Academy of Sciences and Letters), VIII, 1964 (II) pp. 496–8.

Fischinger, A., *Santi Gucci, Architekt i rzeźbiarz królewski XVI wieku* (S.G., sixteenth-century royal architect and sculptor), Cracow, 1969.

Fischinger, A., 'Ze studiów nad twórczością Bartłomieja Berecciego i jego warsztatem. Nagrobki Szydłowieckich i Tarnowskich

(Studies in Bartolommeo Berrecci's art. Tombs of the Szydłowiecki and Tarnowski), *Sprawozdania z Posiedzeń Komisii Naukowych P.A.N. Oddział Krakowski* (Proceedings of the Cracow section of the Polish Academy of Science and Letters), xvi, 1, 1972, pp. 154–6. [Summary only].

Fischinger, A., same title, *Folia Historiae Artium*, X, 1974, pp. 117–34.

Fisković, C., 'Ivan Duknović Dalmatà', *Acta Historiae Artium*, xiii, 1967, pp. 265–70.

Förster, O., *Bramante*, Vienna–Munich, 1956.

Foerster, R., 'Heinrich und Seyfried Rybisch und die Kunst in Schlesien', *Schlesiens Vorzeit*, N.F., iv, 1907, pp. 88–112.

Forbáth, A., 'A pécsi székesegyház Szathmáry-oltára' (The Szathmáry Altar in the Pécs cathedral), *Archeológiai Értesítő*, n.s. xxxviii, 1918–19, pp. 42–56.

Forssmann, E., *Säule und Ornament*, Stockholm, 1955.

Fraknói, G., Fógel, G., Gulyás, P., Hoffmann, E., *Bibliotheca Corvina. La Biblioteca di Mattia Corvino re d'Ungheria*, Budapest, 1927.

Fraknói, V., *Vitéz János esztergomi érsek élete* (The life of János Vitéz, archbishop of Esztergom), Budapest, 1879.

Fraknói, V., 'Mátyás király arcképe Boroszlóban' (The portrait of King Matthias at Wrocław), *Archeológiai Értesítő*, n.s. xi, 1891, pp. 14–17.

Franz, H. G., 'Der Schlossbau der deutschen "Sonderrenaissance" in Mähren', in his *Die deutsche Barockbaukunst Mährens*, Munich, 1943, pp. 9–12.

Frazik, J. T., 'Przemiany przestrzenne i stylistyczne Zamku w Krasiczynie' (Transformations in space composition and style of the Krasiczyn castle), *Sprawozdania z Posiedzeń Komisji Oddziału P.A.N. w Krakowie* (Proceedings of the Cracow section of the Polish Academy of Sciences and Letters), xii, 1968, pp. 187–9.

Frazik, J. T., *Zamek w Krasiczynie* (The Krasiczyn castle), Cracow, 1968 (Zeszyty naukowe Politechniki Krakowskiej, Architektura, No. 22) (Scholarly publications of the Cracow Polytechnical School, Architecture, No. 22).

Frazik, J. T., 'Z badań nad najstarszymi dziejami Zamku w Krasiczynie' (Research on the earliest history of Krasiczyn Castle), *Biuletyn Historii Sztuki*, xxxi, 1969, pp. 249–54.

Frejková, O., *Palladianismus v české renesanci* (Palladianism in Czech Renaissance), Prague 1941.

Frejková, O., *Česká renesance na pražském hradě*

(Czech Renaissance on the Castle Hill in Prague), Prague, 1941 (Poklady národního umění, Nr 37).

Gabriel, A. L., *The Mediaeval Universities of Pécs and Pozsony; Commemoration of the 500th and 600th anniversary of their foundation, 1367–1467–1967*, Frankfurt/Main, 1969.

Garády, S., 'Mátyás király Buda-nyéki kastélya' (King Matthias's Castle at Buda-Nyék), *Tanulmányok Budapest múltjából* (Study of Budapest History), i, 1932, pp. 99–111.

Garády, S., 'Mátyás király vadászkastélya a Hidegkúti-úton' (The recently discovered hunting castle of King Matthias at Hidegkúti street), *Archeológiai Értesítő*, xlvi, 1932–3, pp. 137–43.

Garády, S., *Mátyás király budanyéki vadászkastélya* (The hunting castle of King Matthias at Buda-Nyék), Budapest, 1941.

Garbacik, T., *Kallimach jako dyplomata i polityk* (Callimachus as a diplomat and a politician), Cracow, 1948 (Rozprawy Wydziału Historyczno–Filologicznego P.A.U., Seria ii, xlvi, Nr 4) (Dissertations of the Historical-Philological Section of the Polish Academy of Learning).

Gąsiorowski, E., 'Rynek i ratusz chełmiński' (The main square and the town hall of Chełmno), *Kwartalnik Architektury i Urbanistyki*, x, 1965, pp. 3–28.

Genthon, A., 'Der Kalvarienberg aus dem Schatz der Kathedrale von Esztergom', *Alte und moderne Kunst*, vii, 1962, No. 56/57, pp. 47–9.

Gerevich, L., 'Zamok Budy' (The castle of Buda; in Russian), *Acta Historiae Artium*, i, 1954, pp. 15–70.

Gerevich, L., 'Prager Einflüsse auf die Bildhauerkunst der Ofner Burg', *Acta Historiae Artium*, ii, 1955, pp. 51–61.

Gerevich, L., 'Gótika és proto-renaissance' and 'Késő-gótika Magyarországon' (Gothic and Proto-Renaissance; and: Late Gothic in Hungary), in D. Dercsényi, ed., 1956, pp. 175–214 and 215–44.

Gerevich, L., 'Joannes Fiorentinus und die Pannonische Renaissance', *Acta Historiae Artium*, vi, 1959, pp. 309–39.

Gerevich, L., 'Le maître des reliefs en marbre du roi Matthias et de sa femme Béatrice', *Bulletin du Musée Hongrois des Beaux-Arts*, No. 27, 1965, pp. 15–32.

Gerevich, L., 'Réflexions sur le château de Buda à

l'époque du Roi Matthias', *Acta Historiae Artium*, XIII, 1967, pp. 123–32.

Gerevich, L., *The Art of Buda and Pest in the Middle Ages*, Budapest, 1971.

Gerevich, T., 'Ippolito d'Este, arcivescovo di Strigonia', *Corvina*, I, 1921, pp. 49ff.

Gerevich, T., 'A régi magyar művészet európai helyzete' (The European position of the early art of Hungary), *Minerva*, III, 1924, pp. 98–122.

Gerevich, T., 'Związki sztuki węgierskiej z Polską' (Links between Hungarian and Polish art), in K. Huszár, ed., *Polska i Węgry* (Poland and Hungary), Budapest–Warsaw, 1936, pp. 123–6.

Gerevich, T., 'L'arte ungherese della Transilvania', in *Transilvania. A Cura della Società Storica Ungherese*, Budapest, 1940, pp. 151–82; and the same text in *Corvina*, N.S. III, 1940, pp. 513–90.

Gerevich, T., 'Il Mecenatismo di Mattia Corvino', *Corvina*, N.S. V, 1942, pp. 115–30.

Gerő, L., *Magyarországi várépítészet* (Architecture of fortifications in Hungary), Budapest, 1955.

Gerő, L., 'Włoskie fortyfikacje bastionowe na Węgrzech' (Italian bastion fortifications in Hungary), *Kwartalnik Architektury i Urbanistyki*, IV, 1959, pp. 23–42.

Gerő, L., *Magyar várak* (Hungarian castles), Budapest, 1968.

Goetel-Kopff, M., 'Mecenat kulturalny Jana Konarskiego (1447–1528)' (Cultural patronage of Jan Konarski), *Rozprawy i Sprawozdania Muzeum Narodowego w Krakowie* (Studies and Reports of the National Museum in Cracow), VIII, 1964, pp. 7–196.

Goldschmidt, A., 'Die Bedeutung der Formentspaltung in der Kunstentwicklung', in *Independence, Convergence and Borrowing in Institutions, Thought and Art* (Harvard Tercentenary Publication), Cambridge, Mass., 1937, pp. 167–77.

Goleníshtchev Kutusov, I. N., *Italianskoye vosrozhdenye y slavyanskye literatury*, Moscow, 1958; Polish: *Odrodzenie włoskie i literatury słowiańskie wieku XV i XVI* (Italian Renaissance and the Slavic Literatures of the fifteenth and sixteenth centuries), Warsaw, 1970.

Gostyński, T., 'Przypuszczalny prototyp wawelskiego stropu z głowami' (A probable prototype of the Wawel ceiling with heads), *Biuletyn Historii Sztuki*, XII, 1950, pp. 316–21.

Gostyński, T. and Guerquin, B., 'Zamek renesansowy w Baranowie' (The Renaissance castle at Baranów), *Biuletyn Historii Sztuki*, XV, 1953 (No. 3/4), pp. 97–104.

Guerquin, B., *Zamki śląskie* (The Silesian castles), Warsaw, 1957.

Guerquin, B., *Zamki w Polsce*, Warsaw, 1974.

Gukovskij, M., 'Il Rinascimento italiano e la Russia', in V. Branca, ed., *Rinascimento Europeo e Rinascimento Veneziano*, Venice, 1967, pp. 121–36.

Guldan, E., 'Werke und Wanderwege der Maestri Comacini 1400–1520', *Das Münster*, X, 1957, pp. 371–4.

Guldan, E., 'Ausstrahlungen der Comasken-Kunst in Europa', *Österreichische Zeitschrift für Kunst und Denkmalpflege*, XII, 1958, pp. 9–13.

Guldan, E., 'Die Tätigkeit der Maestri Comacini in Italien und in Europa', *Arte Lombarda*, V, 1960, pp. 27–46.

Guldan, E., 'Die Aufnahme italienischer Bau- und Dekorationsformen in Deutschland zu Beginn der Neuzeit', in *Arte e Artisti dei Laghi Lombardi*, E. Arslan, ed., I, Como, 1959, pp. 381–91.

Güntherová-Mayerová, A., 'Renesančne umenie na Slovensku' (Renaissance art in Slovakia), *Pamiatky a Múzea*, IV, 1955, pp. 97–114.

Habela, J. and Stankiewicz, J., 'Relacje saskogdańskie w architekturze Odrodzenia' (Saxon-Danzig relations in the architecture of the Renaissance), in *Komunikaty na Sesję Naukową poświęconą dziełom sztuki Pomorza* (Papers to be presented at the conference devoted to the art of Pomorze), Stowarzyszenie Historyków Sztuki, Oddział w Toruniu (Association of Art Historians, branch in Toruń), Toruń, 1966, pp. 84–7.

Hahr, A., *Die Architektenfamilie Pahr, eine für die Renaissanceknust Schlesiens, Mecklenburgs und Schwedens bedeutende Künstlerfamilie*, Strasburg, 1908.

Hahr, A., *Studier i nordisk renässanskonst*, I: *Studier i Vasa-renässansen och dess fortsättningar*; *Studier i skånsk renässans* (Skrifter utgifna af K. Humanistiska Vetenskapssamfundet i Uppsala, 15, 1), Uppsala-Leipzig, 1913.

Hahr, A., *Studier i nordisk renässanskonst, II: Östeuropeiska stildrag i nordisk renässansarkitektur* (Skrifter, as above, 18, 2), Uppsala-Leipzig, 1915.

Hahr, A., *Nordeuropeisk renässansarchitektur* (Bonniers allmänna Konsthistoria), Stockholm, 1927.

Hahr, A., *Drottning Katarina Jagellonica och Vasarenässansen. Studier i Vasatidens Konst och Svensk-polsk-italieniska förbindelser* (Skrifter as above, 34, 1) Uppsala-Leipzig, 1940.

Hajduch, J., *Slovenské Hrady* (Slovak Castles), Martin, 1972.

Halówna, M. and Senkowski, J., 'Materialy archiwalne do budowy zamku warszawskiego' Archive records for the history of the construction of the Warsaw castle', *Teki architwalne*, II, 1954, pp. 192–401.

Hanšová, F., *Zámek v Litomyšli* (The castle at Litomyšl), Prague, 1963.

Hartt, F., Corti, G., Kennedy, Cl., *The Chapel of the Cardinal of Portugal (1434–1459) at San Miniato in Florence*, Philadelphia, 1964.

Heckscher, W. S., 'The Anadyomene in the Mediaeval Tradition (Pelagia-Cleopatra-Aphrodite). A Prelude to Botticelli's "Birth of Venus"', *Nederlandsch Kunsthistorisch Jaarboek*, VII, 1956, pp. 1–38.

Hedicke, R., *Cornelis Floris und die Florisdekoration*, Berlin, 1913.

Héjj, M., *Visegrád történeti emlékei* (Historical Monuments at Visegrád), Budapest, 1954.

Héjj, M., *Der königliche Palast in Visegrád*, Budapest, 1970.

Hejna, A., *Opočno. Státní Zámek, Město a Okolí* (Opočno. State castle, town and surroundings), Prague, 1953.

Hentschel, W., *Sächsische Renaissancebildhauer in Nordwestböhmen*, Most, 1932.

Herbst, S., 'Uwagi nad renesansowym rozplanowaniem Głowowa' (Remarks on the Renaissance Planning of Głowów), *Biuletyn Historii Sztuki*, XVI, 1954, pp. 11–14.

Herbst, S., *Zamość*, Warsaw, 1954.

Herbst, S., 'Polska kultura mieszczańska XVI/XVII wieku' (Polish culture of burghers in the sixteenth and seventeenth century), *Studia Renesansowe*, I, 1956, pp. 9–24.

Herbst, S. and Zachwatowicz, J., *Twierdza Zamość* (Zamość Fortress), Warsaw, 1936.

Hevesy, A. de, 'Les miniaturistes du roi Matthias Corvin', *Revue de l'art chrétien*, LXI, 1911, pp. 109–20.

Hevesy, A. de, *La Bibliothèque du roi Matthias Corvin*, Paris, 1923.

Hilbert, K., 'Hudební kruchta v chrámu sv. Víta na Hradě pražkém' (Organ loft in St Vitus Church on the Castle Hill in Prague), *Časopis Společnosti Přatel Starožitnosti* (Periodical of the Society of Antiquarians), XVII, 1909, pp. 1–17.

Hildebrand, A., *Sächsische Renaissanceportale und die Bedeutung der halleschen Renaissance für Sachsen*, Halle, 1914.

Hilmera, J., *Jindřichův Hradec. Městská Památková Reservace a Státní Zámek* (J. H. Monumental town reservation and the state castle), Prague, 1957.

Hitchcock, H. R., 'The Beginnings of the Renaissance in Germany: 1505–1515', *Architectura*, 1971 (No. 2), pp. 123–47; 1972 (No. 1), pp. 3–16.

Hlobil, I., 'Zur Renaissance in Tovačov während der Aera Ctibors Tovačovsky von Cimburk', *Umění*, XXII, 1974, pp. 509–19.

Hofman, J., *Staré umění na Slovensku* (Early art in Slovakia), Prague, 1930.

Holl, J., 'Jelentés a nyéki kastélyépületek területén 1956-ban végzett hitelesitő ásatásról' (Report about the excavations to prove the authenticity, done in the area of the castle buildings in Nyek in 1956), *Budapest Régiségei. A Budapesti Történeti Múzeum Évkönyve* (Antiquities of Budapest. Yearbook of the Budapest Historical Museum), XIX, 1959, pp. 273–86.

Holotík, L. and Vantuch, A., ed., *Humanizmus a renesancia na Slovensku v 15.–16. storočí* (Humanism and Renaissance in Slovakia in the fifteenth and sixteenth century), Bratislava, 1967 (Published by Slovenska Akadémia Vied, Historický Ústav).

Hornung, Z., 'Mauzoleum króla Zygmunta I w katedrze krakowskiej' (Mausoleum of King Sigismund I in the Cracow cathedral), *Rozprawy Komisji Historii Kultury i Sztuki Towarzystwa Naukowego Warszawskiego* (Papers of the commission for the history of culture and art of the Warsaw Learned Society), I, 1949, pp. 69–147.

Hornung, Z. 'Działalność rze biarska Jana Ciniego ze Sieny w świetle nowych badań' (Jan Cini's activity as a sculptor in the light of new research), *Sprawozdania Wrocławskiego Towarzystwa Naukowego* (Proceedings of the Wrocław Learned Society), VIII, 1953, pp. 20–6.

Hornung, Z., 'Czy Jan Maria zwany "il Mosca"

albo Padovano był klasycystą?' (Was Jan Maria, called 'il Mosca' or Padovano a Classicist?), in *Księga ku czci Władysława Podlachy* (Studies to honour Władysław Podlacha), Wrocław, 1957, pp. 119–28.

Hornung, Z., 'Kilka uwag o pierwszym renesansowym mistrzu włoskim w Polsce' (Some remarks on the first Italian Renaissance Master in Poland), *Prace Wydziału Filologiczno-Filozoficznego, Towarzystwo Naukowe w Toruniu* (Publications of the Philological-Philosophical section of the Toruń Learned Society), VIII, I (*Teka Historii Sztuki*, I) (Art Historical Collection, I), 1959, pp. 57–84.

Hornung, Z., 'W sprawie datowania posągu Zygmunta I w kaplicy ostatnich Jagiellonów na Wawelu' (About the dating of the statue of Sigismund I in the chapel of the last Jagellons at the Wawel), same publication as above, pp. 85–102.

Hornung, Z., 'Gdańska szkoła rzeźbiarska na przełomie XVI i XVII wieku' (The Gdańsk school of sculpture at the turn of the sixteenth and seventeenth centuries), published as above, pp. 103–32.

Hornung, Z., 'Rodowód artystyczny twórczości rzeźbiarskiej Santi Gucciego' (Artistic genealogy of Santi Gucci's sculpture), *Biuletyn Historii Sztuki*, XXIV, 1962, pp. 227–30.

Horvat, A., 'Über das Eindringen der italienischen Renaissance aus der pannonischen Region nach Nordkroatien', *Actes Congrès Budapest, 1969*, Budapest, 1972, I, 631–4.

Horváth, E., 'Siena ed il primo Rinascimento ungherese', *Corvina*, V (vol. X), 1925, pp. 49–72.

Horváth, E., *Il rinascimento in Ungheria*, Rome, 1939.

Horváth, H., 'A mátyáskori magyar művészet' (Hungarian Art of the Mathias Time), in: I. Lukinich, ed., 1940, pp. 123–207.

Horváth, H., 'König Mathias und die Kunst', *Ungarische Jahrbücher*, XX, 1940, pp. 190–230.

Hořejši, J., 'Tvář pozdně středověkých historismů. In margine Birnbaumovy teze o románské renesanci' (The image of the late mediaeval historicisms. On the margin of Birnbaum's theses about the Romanesque revival), *Umění*, XVII, 1969, pp. 109–130.

Hořejši, J., *Vladislavský sál Pražského hradu* (The Vladislav Hall of the Prague castle), Prague, 1973.

Hořejši, J., 'L'aspect historisant – facteur déter-

minant de l'art des alentours de 1500 en Bohême', *Actes Congrès Budapest*, II, 1972, pp. 591–4.

Hořejši, J. and Vacková, J., 'An der Wende des Zeitalters. Hofkunst um 1500 in Böhmen', *Alte und Moderne Kunst*, XIII, 1968, No. 97, pp. 2–12.

Hořejši, J. and Vacková, J., 'Jagellonec na českém trůně' (The Jagellon prince on the Czech throne), *Umění*, XIX, 1971, p. 431.

Hořejši, J. and Vacková, J., 'Některé aspekty jagellonského dvorského umění' (Some aspects of the court art of the Jagiellons), *Umění*, XXI, 1973, pp. 496–511.

Hülsen, Ch. and Egger, H., *Die römischen Skizzenbücher von Marten van Heemskerck im Königlichen Kupferstichkabinett zu Berlin*, Berlin, 1916.

Husarski, W., *Attyka polska i jej wpływ na kraje sąsiednie* (The Polish parapet and its influence on neighbouring countries), Warsaw, 1936.

Husarski, W., *Kamienice renesansowe w Kazimierzu Dolnym* (Renaissance houses in Kazimierz Dolny), Lublin, 1950.

Husarski, W., *Kazimierz Dolny*, Warsaw, 1953.

Huszti, J., 'Tendenze platonizzanti nella corte di Mattia Corvino', *Giornale critico della filosofia italiana*, 1930, pp. 1–37, 135–62, 220–35, 272–87.

Hylík, V., *Banská Bystrica*, Martin, 1957.

Irmscher, J., ed., *Renaissance und Humanismus in Mittel- und Osteuropa. Eine Sammlung von Materialien* (Deutsche Akademie der Wissenschaften zu Berlin. Schriften der Sektion für Altertumswissenschaft, 32), I–II, Berlin, 1962.

Iwanoyko, E., *Gdański okres Hansa Vredemana de Vries. Studium na temat cyklu malarskiego z ratusza gdańskiego* (The Gdańsk period of Hans Vredeman de Vries. A study on the cycle of paintings from the Gdańsk town hall), Poznań, 1963 (Uniwersytet im. A. Mickiewicza w Poznaniu. Prace Wydziału Filozoficzno-Historycznego. Sekcja Historii Sztuki, Nr 1) (Mickiewicz University in Poznań. Studies of the department of philosophy and history. Art History Series, 1).

Izakovičová, M., Križanová, E. and Fiala, A., *Slovanské Hrady a kaštiele* (Slovak castles), Bratislava, 1969.

Jakimowicz, T., *Ratusz poznański. Muzeum Historii Miasta. Przewodnik* (Poznań town hall.

Museum of the history of the town. A guidebook, (Poznań, 1967).

Jakimowicz, T., 'Architektura świecka w Wielkopolsce w latach około 1540 do około 1630' (Secular architecture in Wielkopolska from about 1540 to about 1630), in T. Rudkowski, ed., 1970, pp. 9–38.

Jakimowicz, T., '"Turris Pyothrkoviensis" – pałac króla Zygmunta I' (Turris Pyothrkoviensis – the palace of King Sigismund I), *Kwartalnik Architektury i Urbanistyki*, XVII, 1972, pp. 21–38.

Jakimowicz, T. and Linette, E., 'Architektura' [of the Renaissance in Wielkopolska], in J. Topolski, ed., *Dzieje Wielkopolski* (History of Wielkopolska), I, Poznań, 1969, pp. 615–38.

Janák, P., 'Obnova sgrafitt na Míčovně' (The restoration of the sgraffiti at the Ball Court), *Umění*, I, 1953, pp. 215–25.

Jindra, V., 'Il rinascimento in Cecoslovacchia', *Palladio*, N.S., VII, 1957, pp. 26–9.

Jindra, B., 'K renesančńimu stavitelství na severovýchodní Moravě' (Contribution to the Renaissance architecture in north-eastern Moravia), *Časopis Slezského Musea*, XV, 1966, pp. 132–3.

Jobert, A., 'Érasme et la Pologne', *Cahiers d'Histoire*, VI, 1961, I, pp. 5–20.

Jůzová-Škrobalová, A., 'Zámecký portál v Tovačově a jeho místo v rančerenesančńí moravské architektuře' (The portal of Tovačov Castle and its place in the Early Renaissance architecture in Moravia), *Umění a svět. Uměleckohistorický Sborník Studie krajského musea v Gottwaldově, Řada společenských věd. Dějiny umění* (Art and world. Art historical publication of the studies of the district museum in Gottwaldov, Series of Social Sciences, Art History), I, 1956 (1957), pp. 22–9.

Kalinowski, L., 'Treści artystyczne i ideowe Kaplicy Zygmuntowskiej' (Artistic and ideological content of the Sigismund Chapel), *Studia do Dziejów Wawelu*, II, 1960, pp. 1–117.

Kalinowski, L., 'Motywy antyczne w dekoracji Kaplicy Zygmuntowskiej' (Classical motifs in the decoration of the Sigismund Chapel), *Sprawozdania z Posiedzeń Komisji Naukowych Polskiej Akademii Nauk, Oddział w Krakowie*, (Proceedings of the scholarly commissions of the Cracow section of the Polish Academy of Sciences and Letters), XVI, 1, 1972, pp. 152–4.

Kampis, A., *The History of Art in Hungary*, London and Wellingborough, 1966.

Kampis, A., *La sculpture hongroise ancienne*, Paris, 1948.

Kantorowicz, E. H., 'The Sovereignty of the Artist. A Note on Legal Maxims and Renaissance Theory of Art', in Meiss, M., ed., *De Artibus Opuscula XL. Essays in Honor of Erwin Panofsky*, New York, 1961, pp. 267–79.

Kardos, T., 'Mátyás udvara és a krakkói platonisták' (The Court of Matthias and the Cracow Platonists), *Apollo* (Budapest), 1934, pp. 10–16.

Kardos, T., 'Mátyás király és a humanizmus' (King Matthias and humanism), in Lukinich, L., ed., 1940, pp. 9–106.

Kardos, T., 'Mattia Corvino, Re umanista', *La Rinascita*, III, 1940, pp. 803–41, and IV, 1941, pp. 69–83.

Kardos, T., *A magyarországi humanizmus kora* (Hungary in the period of humanism), Budapest, 1955.

Katona, S., *Historia critica regnum Hungariae*, IX, Budae, 1793.

Kauffmann, G., *Die Kunst des XVI. Jahrhunderts* (Propyläen Kunstgeschichte, VIII), Berlin, 1970.

Kauffmann, H., 'Die Renaissance in Bürger- und Fürstenstädten', *Kunstchronik*, VII, 1954, pp. 126–8.

Kębłowski, J., 'Wendel Roskopf. Z zagadnień związków renesansu czeskiego i śląskiego' (W.R. About the links between the Renaissance in Bohemia and in Silesia), *Biuletyn Historii Sztuki*, XVIII, 1956, pp. 451–3.

Kębłowski, J., 'Marmurowe płyty nagrobne Stanisława Sauera i Henryka Rybischa we Wrocławiu' (Marble tomb slabs of Stanisław Sauer and Henryk Rybisch in Wrocław), *Biuletyn Historii Sztuki*, XXI, 1959, pp. 234–6.

Kębłowski, J., 'Marmurowe płyty nagrobne St. Sauera i H. Rybischa we Wrocławiu. Ze studiów nad renesansową rzeźbą na Śląsku' (Marble tomb slabs of S. Sauer and H. Rybisch in Wrocław. Studies in the Renaissance sculpture in Silesia), *Zeszyty Naukowe Uniwersytetu im. A. Mickiewicza, Historia Sztuki, 2* (Scholarly publications of Mickiewicz University, Art History, 2), Poznań, 1960, pp. 3–74.

Kębłowski, J., 'Ze studiów nad renesansową rzeźbą, Śląska. Andrzej Walter I. – Zagadnienie osoby i działalności rzeźbiarskiej' (Studies in Silesian Renaissance sculpture. A. Walter I. His person and activity as a sculptor), *Prace Komisji Historii Sztuki Wrocławskiego Towarzystwa Naukowego*

(Dissertations in art history of the Wrocław Learned Society), II, 1960, pp. 127–72.

Kębłowski, J., 'Renesansowy nagrobek biskupa Jakuba von Salza w Nysie' (The Renaissance tomb of the bishop Jakub von Salza in Nysa [Neisse]), *Zeszyty Naukowe Uniwersytetu im. Adama Mickiewicza. Historia Sztuki*, 3 (Scholarly publications of the Mickiewicz University, Art History, 3), Poznań, 1961, pp. 77–122.

Kębłowski, J., *Rzeźba dekoracyjna w architekturze śląskiej w I połowie XVI wieku* (Decorative sculpture in Silesian architecture in the first half of the sixteenth century), Poznań, 1966.

Kębłowski, J., *Renesansowa rzeźba na Śląsku: 1500–1560* (Renaissance sculpture in Silesia: 1500–1560), Poznań, 1967 (Poznańskie Towarzystwo Przyjaciół Nauk, Wydział Historii i Nauk Społecznych, Prace Komisji Historii Sztuki, VII, 1) (Poznań Learned Society. Department of history and social sciences. Studies of the commission for art history, VII, 1).

Kieszkowski, J., *Kanclerz Krzysztof Szydłowiecki. Z dziejów kultury i sztuki Zygmuntowskich czasów* (The chancellor Krzysztof Szydłowiecki. A study in culture and art of the Sigismund times), Poznań, 1912.

Kieszkowski, J., 'Kościół w Uchaniach i jego zabytki', in his *Artyści obcy w służbie polskiej* (The Church at Uchanie and its monuments, in: Foreign Artists working for Polish Patrons), Lwów, 1922, pp. 61–89.

Kieszkowski, W., 'Dzieje budowy zamku w Niepołomicach za panowania Zygmunta Augusta (1550–1571)' (History of the construction of the Niepołomice castle under Sigismund Augustus: 1550–1571), *Sprawozdania Towarzystwa Naukowego Warszawskiego, Wydział II* (Proceedings of the Warsaw Learned Society, Section II), XXVIII, 1935, pp. 1–28.

Kieszkowski, W., 'Zamek królewski w Łobzowie' (The royal castle at Łobzów), *Biuletyn Historii Sztuki i Kultury*, IV, 1935–6, pp. 6–25.

Kieszkowski, W., 'Prymas Jan Łaski i początki renesansu w Polsce' (The primate Jan Łaski and the Origins of the Renaissance in Poland), *Arkady*, II, 1936, pp. 551–5.

Kieszkowski, W., 'Dolny Zamek wileński' (The lower castle at Wilno), *Arkady*, III, 1937, pp. 506–12.

Kieszkowski, W., 'Lapidarium renesansowe w Arkadii. Ze studiów nad sztuką Jana Michałowicza z Urzędowa' (Renaissance lapidarium in Arcadia. Studies on the art of Jan Michałowicz of Urzędów), *Biuletyn Historii Sztuki*, XII, 1950, pp. 31–104.

Klaniczay, T., 'Problem renesansu w literaturze i kulturze węgierskiej' (The problem of the Renaissance in Hungarian literature and culture), in *Odrodzenie i Reformacja w Polsce* (Renaissance and Reformation in Poland), VI, 1961, pp. 175–200.

Knox, B., *Bohemia and Moravia. An Architectural Companion*, London, 1962.

Knox, B., *The Architecture of Poland*, London, 1971.

Kołakowska, M., 'Renesansowe nagrobki dziecięce w Polsce XVI i pierwszej połowy XVII w (Renaissance tombs of children in Poland in the sixteenth and first half of the seventeenth century), *Studia Renesansowe*, I, 1956, pp. 231–55.

Komáromy, J. (in the general report: 'Archäologische Forschungen im Jahre 1959'), *Archaeológiai Értesítő*, LXXXVII, 1960, p. 244 (Publication of the part of the Diósgyőr Madonna).

Komornicki, S. S., 'Franciszek Florentczyk i pałac wawelski' (Francesco Fiorentino and the Wawel Palace), *Przegląd Historii Sztuki*, I, 1929, No. 3, pp. 57–69.

Komornicki, S. S., 'Kaplica Zygmuntowska w katedrze na Wawelu: 1517–1533' (The Sigismund Chapel in the Wawel cathedral: 1517–1533), *Rocznik Krakowski*, XXIII, 1931, pp. 47–120, and an offprint (dated 1932).

Komornicki, S. S., 'Kultura artystyczna w Polsce czasów Odrodzenia' (Artistic culture in Poland in the Renaissance period), in *Kultura Staropolska*, Cracow, 1932, pp. 533–605.

Kopera, F., 'Grobowiec króla Jana Olbrachta i pierwsze ślady stylu Odrodzenia na zamku wawelskim' (The tomb of King Jan Olbracht and the first traces of the Renaissance style at the Wawel castle), *Przegląd Polski*, CXVIII, 1895, pp. 1–36.

Kopera, F., 'Jan Maria Padovano', *Prace Komisji Historii Sztuki P.A.U.* (Studies of the commission for the history of art of the Polish Academy of Learning in Cracow), VI, 1938, pp. 219–61.

Kotrba, V., 'Die Nachgotische Baukunst Böhmens zur Zeit Rudolf II', *Umění*, XVIII, 1970, pp. 298–330.

Kotula, F., 'Głowów, renesansowe miasteczko'

(Glowów, the little town of the Renaissance), *Biuletyn Historii Sztuki*, xvi, 1954, pp. 3–10.

Kovačovičová, B. and Cidlinská, A., 'Levoča a její výtvarné pamiatky' (Levoča and its monuments), *Pamiatky a Múzea*, v, 1956, pp. 102–15.

Kovačovičová, B. and Šášky, L., 'Banská Bystrica', *Pamiatky a Múzea*, iv, 1955, pp. 50–71.

Kovács, E., 'Uniwersytet krakowski a reformacja na Węgrzech' (Cracow University and the Reformation in Hungary), in *Medievalia. W 50 rocznicę pracy naukowej Jana Dąbrowskiego* (Medievalia. To honour the 50th anniversary of Jan Dąbrowski's scholarly activity), Warsaw, 1960, pp. 393–414.

Kowalczyk, J., 'Kościół pobernardyński w Lublinie i jego stanowisko w renesansowej architekturze Lubelszczyzny' (The old church of St Bernard friars in Lublin and its place in the Renaissance architecture of the Lublin area), *Kwartalnik Architektury i Urbanistyki*, ii, 1957, pp. 127–44.

Kowalczyk, J., 'O wzajemnych relacjach planu Zamościa i kolegiaty Zamojskiej' (Reciprocal relations between the plan of Zamość and that of the Collegiate church in that town), *Biuletyn Historii Sztuki*, xxiv, 1962, pp. 432–8.

Kowalczyk, J., 'Turobińsko-zamojski murator Jan Wolff oraz jego dzieła na Lubelszczyźnie' (Jan Wolff, stonemason in Turobin and Zamość and his works in Lublin area), *Biuletyn Historii Sztuki*, xxiv, 1962, pp. 123–7.

Kowalczyk, J., 'Morando e Zamoyski', in *Italia, Venezia e Polonia tra umanesimo e rinascimento*, M. Brahmer ed., Wrocław–Warsaw–Cracow, 1967, pp. 335–51.

Kowalczyk, J., 'Inspiracje Serlia i wątki antyczne w fasadzie poznańskiego ratusza' (Serlian inspirations and Classical motifs in the Poznań town hall façade), *Biuletyn Historii Sztuki*, xxx, 1968, pp. 401–4.

Kowalczyk, J., *Kolegiata w Zamościu* (The Collegiate Church in Zamość), Warsaw, 1968 (Studia i Materiały do teorii i historii architektury i urbanistyki, vi) (Studies and materials for the theory and history of architecture and urbanism, vi).

Kowalczyk, J., 'Polskie portrety "all'antica" w plastyce renesansowej' (Polish 'all'antica' portraits in Renaissance visual arts), in *Treści Dzieła Sztuki. Materiały Sesji Stowarzyszenia Historyków Sztuki*, Gdańsk, 1966 (The Con-

tents of Art Work. Proceedings of the conference of the Association of Art Historians, Gdańsk, 1966), Warsaw, 1969, pp. 121–36.

Kowalczyk, J., 'Fasada ratusza poznańskiego. Recepcja form z traktatu Serlia i antyczny program' (Poznań Town Hall Façade. Borrowings from Serlio and the Classical programme), *Rocznik Historii Sztuki*, viii, 1970, pp. 141–73.

Kozakiewicz, S., 'L'attività degli architetti e lapicidi comaschi e luganesi in Polonia nel periodo del Rinascimento fino al 1580', in *Arte e Artisti dei Laghi Lombardi*, i, Como, 1959, pp. 393–421.

Kozakiewicz, S., 'Początek działalności Komasków, Tessyńczyków i Gryzończyków w Polsce. Okres Renesansu (1520–1580)' (Beginnings of the activity of artists coming from Como, Tessin and Graubünden in Poland. Period of the Renaissance: 1520–1580), *Biuletyn Historii Sztuki*, xxi, 1959, pp. 3–29.

Kozakiewicz, S., 'Gli influssi italiani nell'architettura polacca prima della corrente palladiana', *Bollettino del Centro Internazionale di Studi sull'Architettura Andrea Palladio*, ii, 1960, pp. 42–5.

Kozakiewicz, S. and Zlat, M., 'L'attico in Polonia nel periodo del Rinascimento e le sue relazioni genetiche con l'arte Veneta', in *Venezia e l'Europa, Atti del XVIII Congresso Internazionale di Storia dell'Arte*, Venezia, 1955, Venice, 1956, pp. 275–7.

Kozakiewiczowa, H, 'Nagrobek Tomasza Sobockiego w Sobocie' (Tomb of Tomasz Sobocki at Sobota), *Biuletyn Historii Sztuki*, xiv, No. 4, 1952, pp. 175–9.

Kozakiewiczowa, H., 'Renesansowe nagrobki piętrowe w Polsce' (Renaissance double-decker tombs in Poland), *Biuletyn Historii Sztuki*, xvii, 1955, pp. 3–47.

Kozakiewiczowa, H., 'Nagrobki Kryskich w Drobinie' (The Kryski tombs at Drobin), *Biuletyn Historii Sztuki*, xviii, 1956, pp. 2–23.

Kozakiewiczowa, H., 'Spółka architektoniczno-rzeźbiarska Bernardina de Gianotis i Jan Cini' (Architectural and sculptural firm of Bernardino de Gianotis and Jan Cini), *Biuletyn Historii Sztuki*, xxi, 1959, pp. 151–74.

Kozakiewiczowa, H., 'Mecenat Jana Łaskiego. Z zagadnień sztuki renesansu w Polsce' (Jan Łaski's patronage. Problems of Renaissance art in Poland), *Biuletyn Historii Sztuki*, xxiii, 1961, pp. 3–17.

Kozakiewiczowa, H., 'Z badań nad Bartolomiejem Bereccim' (Bartolommeo Berecci Studies), *Biuletyn Historii Sztuki*, XXIII, 1961, pp. 311–27.

Kozakiewiczowa, H., 'Kim jest nieznana dama z herbu Ciołek?' (Who is the unknown lady with the Ciołek coat of arms?), *Biuletyn Historii Sztuki*, XXV, 1963, pp. 141–3.

Kozakiewiczowa, H., 'Bartolommeo Berecci', *Dizionario Biografico degli Italiani*, IX, Rome, 1967, pp. 393–6.

Kozakiewiczowa, H., *Relazioni artistiche tra Roma e Cracovia nella prima metà del '500*, Wrocław–Warsaw–Cracow, 1972.

Kozakiewiczowie, H. and S., 'Polskie nagrobki renesansowe: Stan, problemy i postulaty badań' (Polish Renaissance tombs: State of research, problems and scholarly needs), *Biuletyn Historii Sztuki*, XIV, 1952, No. 4, pp. 62–132 and XV, 1953, No. 1, pp. 3–57.

Kozakiewiczowie, H. and S., 'Rozwój historyczny badań nad sztuką polskiego Odrodzenia' (Development of research in Polish Renaissance art), in *Odrodzenie w Polsce. Materiały Sesji Naukowej P.A.N.* (Renaissance in Poland. Proceedings of the conference organized by the Polish Academy of Sciences and Letters), V, no place, 1958, pp. 204–313.

Kozłowska-Tomczyk, E., *Jan Michałowicz z Urzędowa*, Warsaw, 1967.

Krajčdvičova, K., 'Nové Zámky vo svetle ikonografických pramenov 16. a 17. storočia' (N.Z. in the light of iconographic sources of the sixteenth and seventeenth century), *Zborník slovackého národního Mūzea v Bratislave* (*Historia*), LXVIII, 1974, pp. 203–47.

Kramarczyk, S., 'Renesansowa budowa zamku piastowskiego w Brzegu i jej tło historyczne' (The Renaissance construction of the Piast castle at Brzeg and its historical background), *Biuletyn Historii Sztuki*, XXIV, 1963, pp. 323–43.

Kráśa, J., 'Renesanční nastěnná výzdoba kaple svatováclavské v chrámu sv. Víta v Praze' (The Renaissance wall paintings in the St Wenceslas Chapel in St Vitus Church in Prague), *Umění*, VI, 1958, pp. 31–72.

Kráśa, J., *Svatováclavská Kaple* (The St Wenceslas Chapel), Prague, 1971.

Krasnowolski, B., 'Architektura loggii małopolskich w latach 1500–1650' (Loggias in Małopolska in the time 1500–1650), *Biuletyn Historii Sztuki*, XXXI, 1969, pp. 434–7.

Krause, H. J., 'Das erste Auftreten italienischer Renaissance-Motive in der Architektur Mitteldeutschlands', *Acta Historiae Artium*, XIII, 1967, pp. 99–114.

Krčálová, J., 'Zámek v Brandýse nad Labem' (The castle at Brandýs on the Laba), *Umění*, II, 1954, pp. 136–52.

Krčálová, J., 'Několik poznámek ke knize Evy Šamánkové Architektura české renesance' (Some remarks on the book by E. S., The architecture of the Czech Renaissance), *Umění*, X, 1962, pp. 74–89.

Krčálová, J., 'Il palladianesimo in Cecoslovacchia e l'influenza del Veneto sull'architettura ceca', *Bollettino del Centro Internazionale di Studi sull'Architettura Andrea Palladio*, VI, 2, 1964 (ed. 1965), pp. 89–110.

Krčálová, J., 'Pietro Ferrabosco und sein Schaffen in Königreich Böhmen', *Ostbairische Grenzmarken*, XI, 1969, pp. 183–96.

Krčálová, J., 'Italští mistři malé strany na počátku 17 století' (Italian masters working on the Malá Strana in Prague at the beginning of the seventeenth century), *Umění*, XVIII, 1970, pp. 545–78.

Krčálová, J., 'Palác pánů z Rožmberka' (The palace of the Lords of Rožmberk), *Umění*, XVIII, 1970, pp. 469–83.

Krčálová, J., 'Kruh v architektuře českého manýrismu' (The circle in Czech Manneristic architecture), *Umění*, XX, 1972, pp. 1–25.

Krčálová, J., 'Kostel sv. Petra a Pavla v Kralovicích a Bonifac Wolmut' (The St Peter and St Paul Church at Kralovice and Boniface Wolmut), *Umění*, XX, 1972, pp. 297–315.

Krčálová, J., *Centrální stavby české renesance* (The centrally planned structures in the Czech Renaissance), Prague, 1974.

Křivka, J., 'O stavbě litomyšlského zámku' (Construction of the Litomyšl castle), in *Sborník příspěvků k dějinám Litomyšle a okolí* (Collection of contributions to the history of Litomyšl and its surroundings), Pardubice, 1959, pp. 107–22.

Križanová, E., 'Prešov', *Pamiatky a Múzea*, V, 1956, pp. 150–9.

Križanová, E., 'Mesto Bardejov' (The town Bardejov), *Pamiatky a Múzea*, V, 1956, pp. 6–11.

Kronthal, A., 'Sebastiano Serlio und das Rathaus in Posen', *Historische Monatsblätter für die Provinz Posen*, XIV, 1913, pp. 169–75.

Kropáček, J., 'On the penetration of the Renaissance into Central Europe in 1490–1510 (with special emphasis on the position of Prague)',

Actes Congrès Budapest, 1969, Budapest, 1972, I, pp. 639–44.

Kropáček, J., 'Triumfální motivy v počátcích renesančního umění v Záalpí' (The Triumph motifs at the beginning of the art of the Renaissance north of the Alps), *Umění*, xx, 1972, pp. 268–76.

Kruft, H.-W., 'Genuesische Skulpturen der Renaissance in Frankreich', *Actes Congrès Budapest, 1969*, Budapest, 1972, I, pp. 697–704.

Kruszyński, T., 'Jerzy Pencz z Norymbergi jako twórca malowideł tryptyku w Kaplicy Zygmuntowskiej' (Georg Pencz from Nürnberg as painter of the triptych in the Sigismund Chapel), *Biuletyn Historii Sztuki i Kultury*, II, 1933–4, pp. 179–216.

Krzyżanowski, L., 'Gdańskie nagrobki Kosów i Bahrów' (The tombs of the Kos and Bahr families at Gdańsk), *Biuletyn Historii Sztuki*, XXX, 1968, pp. 445–62.

Krzyżanowski, L., 'Sztuka gdańska a pojęcie manieryzmu północnego' (The art of Gdańsk and the concept of northern Mannerism), *Biuletyn Historii Sztuki*, XXX, 1968, p. 243.

Kubiček, A., 'Rožmberský palác na pražském hradě' (The Rožmberk Palace at the Prague Castle Hill), *Umění*, I, 1953, pp. 308–18.

Kubler, G., *The Shape of Time. Remarks on the History of Things*, New Haven and London, 1962.

Kudělka, Z., 'K otázce manýristické architektury na Moravě' (Problem of Mannerist architecture in Moravia), *Sborník Prací Filosofické Fakulty Brněnské University*, VII (Rada Umĕnovĕná/F./, Nr 2) (Journal of studies of the philosophical department of the University of Brno, VII: Art historical series/F./, No. 2), Brno, 1958, pp. 88–98.

Kuhn, I, *Renesančné portály na Slovensku* (Renaissance portals in Slovakia), Bratislava, 1954.

Kukuljević Sakcinski, I., *Leben Südslavischer Künstler*, Agram, 1868.

Kumaniecki, K., *Twórczość poetycka Filipa Kallimacha* (Filippo Callimacho's poetical works), Warsaw, 1953.

Kurzątkowska, A., 'Mauzoleum Firlejów w Bejscach, wybitne dzieło "manieryzmu pińczowskiego"' (The Firlej Mausoleum at Bejsce: an outstanding work of the Pinczów Mannerism), *Biuletyn Historii Sztuki*, XXX, 1968, pp. 120–4.

Russia ed i rapporti artistici italorussi nel tardo Quattrocento', *Arte e Artisti dei Laghi Lombardi*, I, Como, 1959, pp. 423–40.

Lechner, J., 'Tanulmányok a lengyelországi és felsőmagyarországi renaissance építésről' (Studies in Renaissance architecture in Poland and northern Hungary), *A Magyar Mérnök- és Építész Egylet Közlönye* (Bulletin of the Hungarian Association of builders and architects), XLVII, 1913, pp. 397–415, 421–33, 441–55, and an offprint, here quoted (51 pages).

Lechner, J., 'A pártázatos reneszánsz építés eredetéről' (The Architecture of the Renaissance Parapets), *A Magyar Mérnök- és Építész Egylet Közlönye* (as above), XLIX, 1915, pp. 189–205, and an offprint under a title: A pártázatos építés Magyarország határai körül (The architecture of parapets in the countries close to Hungary).

Lechner, J., 'Renaissance építési emlékek Szamosújvárott' (Monuments of Renaissance architecture: the Castle Szamosújvár [Gherla]), *Építő Mővészet*, 1916, and the offprint, Budapest, 1917, here used.

Lejsková-Matyášová, M., 'K tematice sgrafitové výzdoby domu u minuty v Praze' (On the subject-matter of sgrafiti at the Minuta House in Prague), *Umění*, XVII, 1969, pp. 157–67.

Lejsková-Matyášová, M., 'Zámek v Kostelci nad Černými Lesy ve svĕtle urbáře z roku 1677' (The castle at Kostelec nad Černými Lesy in the light of a document of 1677), *Umění*, IV, 1956, pp. 322–37.

Lejsková-Matyášová, M., 'K ikonologii figurálních štukű Hvĕzdy' (On the iconology of the stuccoes with figural representations in the Hvĕzda Castle), *Umění*, XI, 1963, pp. 209–12.

Leopold, A., 'Vitéz János esztergomi dolgozószo-bája' (The study of János Vitéz at Esztergom), *Szépmővészet*, IV, 1944, pp. 115–19.

Lepiarczyk, J., 'Znaczenie Krakowa dla sztuki renesansu w Polsce' (Importance of Cracow for the art of the Renaissance in Poland), in *Krakowskie Odrodzenie*, J. Dąbrowski, ed. (The Renaissance in Cracow. Proceedings of the conference organized by the Society for the history and monuments of Cracow, Cracow, 1953), Cracow, 1954, pp. 125–37.

Lepszy, L., 'Pomnik Kallimacha' (The Callimachus Monument), *Rocznik Krakowski*, X, 1926, pp. 134–63.

Lewalski, K. F., 'Sigismund I of Poland: Renaissance

Lasarev V., 'Le opere di Pietro Antonio Solari in

King and Patron', *Studies in the Renaissance*, XIV, 1967, pp. 49–72.

Lewicka, M., *Bernard Morando*, Warsaw, 1952.

Lewicka, M., 'Mecenat artystyczny Jana Zamoyskiego' (Art patronage of Jan Zamoyski), *Studia Renesansowe*, II, 1957, pp. 303–36.

Lewicka, M., 'Bernardo Morando', *Saggi e Memorie di Storia dell'Arte*, II, Venice, 1959, pp. 143–55.

Lewicka, M., 'Problematyka badań architektury renesansowej na Mazowszu' (Research problems in the Renaissance architecture in Masovia), *Biuletyn Historii Sztuki*, XXV, 1963, pp. 130–40.

Libal, D., 'Sviluppo storico delle città in Cecoslovacchia', *Casabella*, XXXI, 1967, No. 313, pp. 22–35.

Libal, D., *Alte Städte in der Tschechoslowakei*, Prague, 1971.

Lo Gatto, E., *Gli artisti italiani in Russia*, I, Rome, 1934 (Opera del Genio italiano all'estero).

Lorentz, S., 'Nagrobek Zygmunta I w mauzoleum wawelskim' (The tomb of Sigismund I in the Wawel mausoleum), *Biuletyn Historii Sztuki*, XV, 1953, No. 3/4, pp. 25–33.

Lukinich, I., ed., *Mátyás király emlékkönyv. Születésének ötszázéves fordulójára* (Memorial book devoted to King Matthias on the 500th anniversary of his birth), Budapest, 1940, I–II.

Lundberg, E., *Herremannens bostad. Studier över nordisk och allmänt västerländsk bostadsplanläggning*, Stockholm, 1935.

Lundwall, S., 'The Knights with the Crossed Legs', *Formae. Journal of Art History and Criticism* (*Tidskrift för konstvetenskap*), XXXVI, 1960, pp. 94–102.

Lux, K., *A budai várpalota Mátyás király korában*, Budapest, 1920. Also a short English version: *The Royal Palace and Fortress in Buda under King Matthias*, Budapest, 1921, and an Italian one: *La Reggia di Buda nell'epoca di Mattia Corvino*, Budapest, 1922.

Łempicki, S., *Renesans i humanizm w Polsce. Materiały do studiów* (Renaissance and humanism in Poland. Materials for further study [A collection of Essays]), no place [Cracow] 1952.

Łomnicki, J., 'Rezydencja Piastów Śląskich w Brzegu' (The residence of Silesian Piasts in Brzeg), *Biuletyn Historii Sztuki*, XVII, No. 3, 1955, pp. 371–2.

Łoziński, J. Z., 'Renesansowy dwór obronny w Pabianicach i jego budowniczy Wawrzyniec Lorek' (The Renaissance fortified manor at Pabianice and its architect W. L.), *Biuletyn Historii Sztuki*, XVII, No. 1, 1955, pp. 99–125.

Łoziński, J. Z., 'Cztery centralne kaplice kopułowe z początku XVII wieku' (Four centrally planned chapels with domes, built at the beginning of the seventeenth century), *Biuletyn Historii Sztuki*, XXX, 1968, pp. 300–34.

Łoziński, J. Z., 'Miechowskie Sepulchrum Domini' (The Miechów Sepulchrum Domini), *Biuletyn Historii Sztuki*, XXXI, 1969, pp. 151–65.

Łoziński, J. Z., 'Program pułtuskiej kaplicy biskupa Noskowskiego' (The programme of the Pułtusk Chapel of Bishop Noskowski), *Biuletyn Historii Sztuki*, XXXII, 1970, pp. 271–89.

Łoziński, J. Z., 'Die zentralen Grabkapellen in Polen', *Actes Congrès Budapest, 1969*, Budapest, 1972, I, pp. 667–76.

Łoziński, J. Z., *Grobowe kaplice kopułowe w Polsce, 1520–1620* (Centralized domed sepulchral chapels in Poland: 1520–1620), Warsaw, 1973.

Łoziński, W., *Sztuka lwowska w XVI i XVII wieku* (Art at Lwów in the sixteenth and seventeenth century), Lwów, 1898.

Łuszczkiewicz, W., 'Z wycieczki do Zawichostu i Sandomierza' (An excursion to Zawichost and Sandomierz), *Sprawozdania Komisji Historii Sztuki P.A.U.* (Reports of the art historical commission of the Cracow Academy of Learning), V, 1896, pp. iv–vi.

Łuszczkiewicz, W., *Sukiennice krakowskie* (The Cracow Cloth Hall), Cracow, 1899.

Maisel, W., 'Budowle Jana Baptysty Quadro w świetle poznańskich materiałów archiwalnych' (Buildings by J. B. Quadro in the light of Poznań archive sources), *Biuletyn Historii Sztuki*, XV, 1953, pp. 105–12.

Maisel, W., 'Giovanni Battista Quadro e le sue opere in Polonia', *Palladio*, XV, 1965, pp. 111–28.

Majewski, A., *Zamek w Baranowie* (The Castle at Baranów), Warsaw, 1969.

Majewski, K. and Wzorek, J., 'Twórcy tzw. renesansu lubelskiego w świetle nowych badań' (Creators of the so-called Lublin Renaissance in the light of recent research), *Biuletyn Historii Sztuki*, XXXI, 1969, pp. 127–31.

Mańkowski, T., 'Pochodzenie osiadłych w Polsce budowniczych włoskich' (The provenance of Italian architects residing in Poland), in *Księga*

Pamiątkowa ku czci Leona Pinińskiego (Memorial book to honour Leon Piniński), Lwów, 1936, II, pp. 133–46.

Mańkowski, T., 'Od renesansu włoskiego do północnego. Ustęp z dziejów rzeźby w Polsce' (From the Italian to Northern Renaissance. A chapter from the history of sculpture in Poland), *Biuletyn Historii Sztuki*, X, 1948, pp. 257–84.

Mańkowski, T., 'Głowy wawelskie' (The Wawel Heads), *Biuletyn Historii Sztuki*, XII, 1950, pp. 5–30.

Mańkowski, T., *Dzieje wnętrz wawelskich* (The history of Wawel interiors), Warsaw, 1957.

Mariacher, G., *Il Sansovino*, [Verona], 1962.

Marlier, G., *La Renaissance Flamande. Pierre Coecke van Alost*, Brussels, 1966.

Marrou, H. I., ΜΟΥCΙΚΟC ΑΝΗΡ. *Mousikos Anér: étude sur les scènes de la vie intellectuelle figurant sur les monuments funéraires romains*, Grenoble, 1938 (reprint: Rome, 1964 with a new postscript).

Matějček, A. and Tříska, K., *Jindřichův Hradec, Zámek a město* (J.H., The castle and the town), Prague, 1944 (also 1947).

Matejkova, E., 'K nově odkrytým malbam v kutnohorském Hradku' (On the recently discovered wall paintings in the castle of Kutná Hora), *Zprávy Památkové Péče*, XX, 1960, pp. 233–6.

Maurin Białostocka, J., 'W sprawie wpływów włoskich w płycie Kallimacha' (On the presumed Italian influences in the Callimachus slab), *Biuletyn Historii Sztuki*, XIX, 1957, pp. 178–82.

Meinert, H. G., *Das Auftreten der Renaissance in Breslau*, Breslau, 1935 (Thesis).

Meller, P., 'La fontana di Mattia Corvino a Visegrád', *Istituto Ungherese di Storia dell'Arte, Firenze, Annuario 1947*, Florence, 1948, pp. 47–73.

Meller, P., 'Physiognomical Theory in Renaissance heroic Portraits', *Studies in Western Art*, II: *The Renaissance and Mannerism* (Acts of the twentieth International Congress of the History of Art), Princeton, N.J., 1963, pp. 53–69.

Meller, S., *Peter Vischer der ältere und seine Werkstatt*, Leipzig, 1925.

Meller, S., 'Diva Beatrix', *Zeitschrift für Kunstwissenschaft*, IX, 1955, pp. 73–80.

Mellini, D., *Vita di Filippo Scolari volgarmente chiamato Pippo Spano*, Florence, 1570.

Mencl, V., *Elf Jahrhunderte tschechischer Architektur*, Prague, 1957.

Mencl, V., 'Vztahy východného Slovenska ke gotike sliezsko-poľskej vetvy' (Relations of eastern Slovakia to Silesian-Polish Gothic), in *Zo starších vytvarných dejín Slovenska* (On the earlier art history in Slovakia), Bratislava, 1965, pp. 25–50.

Mencl, V., *Praha*, Prague, 1969.

Mencl, V., (conceived and written by) and Vasilak, E. (air photographs), *Města, hrady a zámky* (Towns, castles and palaces), no place [Prague], 1970.

Menclová, D., 'Přehled vývije renesanční architektury na Slovensku' (Review of the development of Renaissance architecture in Slovakia), *Bratislava*, 1939, No. 1–2, p. 50.

Menclová, D., 'Kaštiel' v Betlanovciach' (The Betlanovce castle), *Pamiatky a Múzea*, II, 1953, pp. 67–75.

Menclová, D., 'Középeurópai XIV. és XV. századi szabályos alaprajzú várpaloták' (The castles with regular plans in Central Europe in the fourteenth and fifteenth century), *Művészettörténeti Értesítő*, VII, 1958, pp. 81–103.

Menclová, D., *České hrady* (Czech Castles), II, Prague, 1972.

Menclová, D. and Lejsková-Matyášová, M., *Bučovice, státní zámek, město a okolí* (Bučovice: the state castle, the town and the surroundings), Prague, 1954.

Menclová, D. and Stěch, V. V., *Červený Kameň*, Bratislava, 1954.

Mihalik, A., *I maestri orafi Pietro e Niccolò Gallicus di Siena*, in *Ungheria*, Siena, 1928.

Mihulka, A., 'Královský letohrádek na hradě pražském' (The royal summer villa at the Prague Castle Hill), *Ročenka Krulu pro Pěstování Dějin Umění za rok 1934* (Yearbook of the circle for study of art history, for the year 1934), Prague, 1935.

Mihulka, A., *Královský Letohrádek zvaný Belvedere na Hradě Pražském* (The royal summer villa called Belvedere on the Prague Castle Hill), Prague, 1939.

Miłobędzki, J. A., 'Ze studiów nad urbanistyką Zamościa' (Studies on Zamość Urbanism), *Biuletyn Historii Sztuki*, XV, No. 3/4, 1953, pp. 68–87.

Miłobędzki, J. A., 'Zamek w Mokrsku Górnym i niektóre problemy małopolskiej architektury XV i XVI wieku' (The castle of Mokrsko Górne and some problems of the architecture

in Małopolska in the fifteenth and sixteenth century', *Biuletyn Historii Sztuki*, XXI, 1959, pp. 46–51.

Miłobędzki, J. A., 'L'influence de l'Europe Centrale et de l'Italie sur l'Architecture de la Pologne méridionale (1430–1530)', *Acta Historiae Artium*, XIII, 1967, pp. 69–80.

Miłobędzki, J. A., *Zarys Dziejów Architektury w Polsce* (Outline of the history of architecture in Poland), 2nd ed., Warsaw, 1968.

Miłobędzki, J. A., 'Architektura i społeczeństwo' (Architecture and society), in A. Wyczański, ed., *Polska w Dobie Odrodzenia. Państwo, Społeczeństwo, Kultura* (Poland at the time of the Renaissance: state, society, culture), Warsaw, 1970, pp. 224–65.

Miłobędzki, J. A., 'Tradycja lokalna i renesans w architekturze Małopolski początku wieku XVI' (Local tradition and the Renaissance in the architecture of Małopolska at the beginning of the sixteenth century), in *Architectura perennis*, Warsaw, 1971 (Studia i materiały do teorii i historii architektury i urbanistyki, IX) (Studies and materials for the theory and history of architecture and urbanism, IX), pp. 107–9.

Miodońska, B., 'Renesansowe portrety biskupów krakowskich w klasztorze franciszkanów w Krakowie' (Renaissance portraits of the Cracow bishops in the cloister of the church of Franciscan friars in Cracow), *Rocznik Krakowski*, XXXV, 1961, pp. 3–38.

Miodońska, B., 'Korona zamknięta w przekazach ikonograficznych z czasów Zygmunta I' (The closed crown in iconography of Sigismund I's time), *Biuletyn Historii Sztuki*, XXXII, 1970, pp. 3–18.

Misiąg Bocheńska, A., *Głowy wawelskie* (Wawel heads), no place, 1953.

Misiąg Bocheńska, A., 'O głowach wawelskich i przypuszczalnych ich twórcach' (The Wawel heads and their presumed authors), *Studia do Dziejów Wawelu*, I, 1955, pp. 139–92.

Möller, L. *Der Wrangel-Schrank und die verwandten süddeutschen Intarsienmöbel des 16. Jahrhunderts*, Berlin, 1956.

Mojzer, M., 'Dürer és MS Mester' (Dürer and the Master MS), *Művészet*, VI, 1965, pp. 19–21.

Mojzer, M., 'Die Fahnen des Meisters MS', *Acta Historiae Artium*, XII, 1966, pp. 93–112.

Mojzer, M., 'Le huitième tableau de chevalet du Maître MS', *Bulletin du Musée Hongrois des Beaux-Arts*, No. 29, 1966, pp. 69–82.

Mojzer, M., 'Schongauer és MS Mester' (Schongauer and the Master MS), *Művészet*, VIII, 1967, No. 5, pp. 4–6.

Mols, W., 'Problem renesansu na półwyspie bałkańskim i w Europie wschodniej', (The Renaissance problem in the Balkan Peninsula and in eastern Europe), *Biuletyn Historii Sztuki*, XIV, 1952, pp. 133–51.

Mols, W. and Piwocki, K., 'Udział sztuki polskiej w Renesansie europejskim' (The share of the Polish Renaissance in the European Renaissance), in *Odrodzenie w Polsce* (Renaissance in Poland). Materiały Sesji Naukowej P.A.N. (Proceedings of the scholarly conference organized by the Polish Academy of Sciences and Letters), v, no place, 1958, pp. 159–77.

Mols, R., 'Branda di Castiglione, Ier', in A. Baudrillart (continued by A. De Meyer and E. van Cauwenbergh), *Dictionnaire d'Histoire et de Géographie Ecclésiastiques*, XI, Paris, 1949, sp. 1434–1444.

Morávek, J., 'Královské mauzoleum v chrámu sv.Víta a jeho dokončení v letech 1565–1590' (The Royal Mausoleum in St Vitus Church and its completion in the years 1565–1590), *Umění*, VI, 1959, pp. 52–4.

Morávek, J., 'Ke vzniku Hvězdy' (On the origins of Hvězda), *Umění*, II, 1954, pp. 199–211.

Morávek, J. and Wirth, Z., *Pražský Hrad v Renesanci a baroku 1490–1790* (The castle of Prague in the Renaissance and Baroque: 1490–1790), Prague, 1947.

Morelowski, M., 'Początki italianizującego renesansu na Śląsku' (Beginnings of Italianizing Renaissance in Silesia), *Rocznik Historii Sztuki*, II, 1961, pp. 31–86.

Mossakowski, S., 'La non più esistente decorazione astrologica del Castello reale di Cracovia', in *Magia, Astrologia e Religione nel Rinascimento, Convegno polacco-italiano 1972*, Wrocław, 1974, pp. 91–8.

Muczkowski, J. and Zdanowski, J., 'Hans Süss z Kulmbachu', *Rocznik Krakowski*, XXI, 1927, pp. 1–84.

Müller, P., 'Die "welschen Gewels". Ein Stielement der deutschen Renaissance-Architektur', *Mindener Heimatblätter*, XXXIII, 1961, pp. 121–39.

Müntz, E., 'La propagande de la renaissance en Orient pendant le XVe siècle (La Hongrie)', *Gazette des Beaux-Arts*, III/XII, 1894, pp. 353–70, III/XIII, 1895, pp. 105–22.

Myskovszky, V., *Bártfa középkori műemlékei*

(Mediaeval monuments of Bardejov[Bártfa]), Budapest, 1879–80, I–II (Monumenta Hungariae Archaeologica).

Nágy Margit, B., *Reneszánsz és barokk Erdélyben. Művészettörténeti Tanulmányok* (Renaissance and Baroque in Transylvania), Bucharest, 1970.

Narębski, S., *Kaplica renesansowa we Włocławku i jej związki z kaplicą Firlejowską w Bejscach* (The Renaissance chapel in Włocławek and its relations to the Firlej chapel at Bejsce), Bydgoszcz, 1961.

Némethy, L., 'Renaissance-emlékek a Budapestbelvárosi plébánia-templomban' (Renaissance monuments in the parish church of the central town in Budapest), *Archeológiai Értestő*, x, 1890, pp. 246–57.

Novak, V., 'The Slavonic-Latin Symbiosis in Dalmatia during the Middle Ages', *Slavonic and East-European Review*, xxxii, 1953, pp. 1–28.

Oettinger, K., *Die Bildhauer Maximilians am Innsbrucker Kaisergrabnal*, Nürnberg, 1966.

Olahus, N., *Hungaria-Athila*, C. Eperjesy and L. Juhász ed., Budapest, 1938.

Oprescu, G., 'Die Renaissance im Zuge der Kunstentwicklung der rumänischen Lander', in J. Irmscher, ed., 1962, pp. 322–7.

von der Osten, G. and Vey, H., *Painting and Sculpture in Germany and the Netherlands: 1500 to 1600*, Baltimore, Md, 1969 (Pelican History of Art).

Paatz, W. and E., *Die Kirchen von Florenz*, III, Frankfurt/Main, 1952.

Pagaczewski, J., 'Jan Michałowicz z Urzędowa', *Rocznik Krakowski*, xxxviii, 1937, pp. 3–79.

Panofsky, E., *Tomb Sculpture*, no place [New York], 1964.

Panofsky, E., 'Conrad Celtes and Kunz von der Rosen: Two problems in portrait identification', *Art Bulletin*, xxiv, 1942, pp. 39–54.

Panofsky, E., *Albrecht Dürer*, 2nd ed., Princeton, N.J., 1945.

Paszkiewicz, M., 'Głowy na renesansowych stropach i sklepieniach' (Heads on Renaissance ceilings and vaultings), *Biuletyn Historii Sztuki*, xxxv, 1973, pp. 219–30.

Passavant, G., *Verrocchio, sculture, pitture e disegni. Tutta l'opera*, Venice-London, 1969.

Pavel, J., *Pardubice. Státní Zámek a městská reservace památkové správy* (Pardubice. State castle and the town reservation), Prague, 1953.

Pawiński, A., *Młode lata Zygmunta Starego* (Early years of Sigismund the Old), Cracow, 1893.

Pešina, J., 'Malířská výzdoba Smíškovské kaple v kostele sv. Brabory v Kutné Hoře' (Painted decoration of the Smíšek Chapel in the St Barbara Church at Kutná Hora), *Umění*, xII, 1939, pp. 253–66.

Pešina, J., 'Der Anteil Böhmens an der Entwicklung des Stillebens in der Malerei des Spätmittelalters', *Festschrift K. M. Swoboda*, Vienna-Wiesbaden, 1959, pp. 223–36.

Pešina, J., 'Nový pokus o revizi dějin českého malířství' 15. století' (A new attempt to revise the history of fifteenth-century Czech painting), *Umění*, vIII, 1960, pp. 109–34.

Pešina, J., 'Böhmische Malerei um 1500 und Italien', in *Studi di Storia dell'Arte in Onore di Antonio Morassi*, Venice, 1971, pp. 97–105.

Pešina, J., 'Die Tafelmalerei am Jagellonenhof in Prag: 1471–1526', *Acta Historiae Artium*, xIx, 1973, pp. 207–30; xx, 1974, pp. 37–80.

Petranu, C., 'Die Renaissancekunst Siebenbürgens', *Südostdeutsche Forschungen*, 1939.

Pevsner, N., 'The Architecture of Mannerism', *The Mint*, I, 1946, pp. 116–37.

Pijaczewska, L., 'Wpływy polskie w monumentalnej rzeźbie nagrobkowej Śląska w dobie renesansu' (Polish influences on tomb sculpture in Silesia in the time of the Renaissance), *Sprawozdania Wrocławskiego Towarzystwa Naukowego* (Proceedings of the Wroclaw Learned Society), vIII, 1953, pp. 45–51.

Piwocki, K., 'Zagadnienie rodzimej twórczości w badaniach nad polskim renesansem' (Problem of vernacular art in research on the Polish Renaissance), *Biuletyn Historii Sztuki*, xIv, 1952, No. 4, pp. 40–61.

Piwocki, K., the same article reprinted in the same author's *Sztuka żywa* (A living art), Wrocław-Warsaw-Cracow, 1970, pp. 217–35.

Plicka, K., *Spiš*, Martin, 1972.

Poggio Bracciolini, Jacopo di, 'Vita di Messer Filippo Scolari' and the other Scolari biographies, reprinted in *Archivio Storico Italiano*, Iv, 1843, pp. 119–234 (Poggio: pp. 163–84).

Pollak, O., 'Studien zur Geschichte der Architektur Prags: 1520–1600', *Jahrbuch der Kunstsammlungen des allerhöchsten Kaiserhauses*, xxix, 1910/ 11, pp. 85–170.

Prijatelj, K., *Ivan Duknović*, Zagreb, 1957.

Prijatelj, K., 'Profilo di Giovanni Dalmata', *Arte Antica e Moderna*, vII, 1959, pp. 283–97.

Prijatelj, K., 'Uz nove radove Jolane Balogh o Ivanu Duknoviću' (A new work on Ivan Duknović by Jolan Balogh), *Peristil*, IV, 1961, pp. 137–9.

Prźaka, J., 'Nieznana rzeźba z warsztatu Berecciego w Grodzisku' (An unknown sculpture from Berecci's workshop at Grodzisk), *Studia do Dziejów Wawelu*, III, 1968, pp. 455–61.

Przybyszewski, B., 'Pochodzenie Bartłomieja Berecciego' (The genealogy of Bartolommeo Berecci), *Sprawozdania z Posiedzeń P.A.U.* (Proceedings of the Polish Academy of Learning in Cracow), XLIX, 1949, pp. 472–4.

Przybyszewski, B., 'Stanisław Samostrzelnik', *Biuletyn Historii Sztuki*, XIII, 1951, pp. 47–87.

Przybyszewski, B., 'Muratorzy i kamieniarze zajęci przy budowie zamku królewskiego na Wawelu (1502–1536)' (Stonecutters and stone-masons working on the construction of the royal castle at the Wawel: 1502–1536), *Biuletyn Historii Sztuki*, XVII, No. 1, 1955, pp. 149–61.

Ptaśnik, J., 'Rodzina Turzonów w Polsce i jej stosunki z Fuggerami' (Turzo family in Poland and its relations with the Fuggers), *Kwartalnik Historyczny*, XVII, 1903, pp. 170–1.

Ptaśnik, J., 'Bonerowie' (The Boners), *Rocznik Krakowski*, VII, 1905, pp. 1–134.

Ptaśnik, J., *Kultura włoska wieków średnich w Polsce* (Italian medieval culture in Poland), Cracow, 1922 (2nd ed. 1959).

Ptaśnik, J., review of E. Reinhart, J. Turzo von Bethlemsfalva. Bürger und Konsul von Krakau in Goslar, 1478–1496, *Rocznik Krakowski*, XXII, 1929, pp. 154–61.

Puppi, L., 'La "città ideale" nella cultura architettonica del rinascimento centro-europeo', *Attes Congrès Budapest*, 1969, Budapest, 1972, 1, pp. 649–58.

Radocsay, D., *Les primitifs de Hongrie*, Budapest, 1964.

Radocsay, D., *A középkori Magyarország táblaképei* (Medieval panel painting in Hungary), Budapest, 1955.

Radocsay, D., '450 Jahre des Meisters MS', *Acta Historiae Artium*, IV, 1957, pp. 201–30.

Rewski, Z., Discussion of the article by H. Kozakiewiczowa, *Biuletyn Historii Sztuki*, XXIV, 1962, pp. 216–20.

Rewski, Z., 'Konieczność poznania dawnej sztuki Szwajcarii' (Necessity to learn the old art of Switzerland), *Biuletyn Historii Sztuki*, X, 1948, p. 40–55.

Rhodes, A., *Art Treasures of Eastern Europe*, London, 1972.

Richter, D., 'Hans Dürers Cebes-Fries auf der Burg in Krakau', *Die Burg*, V, 1944, pp. 27–33.

Rogalanka, A., 'Źródła do zagadnienia malarskiej dekoracji fasad ratusza poznańskiego w epoce renesansu' (Sources for the painted façade decoration of the Poznań town hall in the Renaissance), *Biuletyn Historii Sztuki*, XVI, 1954, pp. 278–9.

Rogalanka, A., Discussion of the paper by J. Kowalczyk about the Poznań town hall, *Biuletyn Historii Sztuki*, XXX, 1968, p. 128.

Ross, J., 'Z dziejów związków artystycznych polsko-czeskich i polsko-słowackich w epoce Odrodzenia' (Studies in the artistic relations between Poland and Bohemia and Poland and Slovakia in the Renaissance), *Biuletyn Historii Sztuki*, XV, 1953, No. 3/4, pp. 88–96.

Ross, J., 'Więzi artystyczne zachodniej Słowiańszczyzny w latach 1500–1650' (Artistic links among western Slavic countries between 1500 and 1650), *Studia Renesansowe*, III, 1963, pp. 521–65.

Ross, J., 'Związki Słowaczyzny i Małopolski w dziedzinie rzeźby nagrobkowej z okresu renesansu i manieryzmu' (Connections between Slovakia and Małopolska as concerns tomb sculpture of the Renaissance and Mannerism), *Folia Historiae Artium*, V, 1968, pp. 131–47.

Ross, J., 'Bardiów a początki renesansu w architekturze Muszyny i Nowego Sącza' (Bardejov and the beginnings of the Renaissance in the architecture of Muszyna and Nowy Sącz), *Rocznik Sądecki*, XIII, 1972, pp. 421–8.

Roth, V., *Geschichte der deutschen Plastik in Siebenbürgen*, Strasburg, 1906.

Roth, V., ed., *Die deutsche Kunst in Siebenbürgen*, Berlin-Hermannstadt (Sibiu), 1934.

Rottermund, A., 'Nowe przekazy ikonograficzne do kaplicy Potockich (dawniej Padniewskiego) w katedrze na Wawelu' (New iconographic evidence concerning the Potocki Chapel (originally Padniewski Chapel) in the Wawel cathedral), *Biuletyn Historii Sztuki*, XXXII, 1970, pp. 199–201.

Rożek, M., 'Źródła do fundacji i budowy królewskiej kaplicy Wazów przy katedrze na Wawelu' (Sources for the foundation and construction of the Vasa chapel at the Wawel

Cathedral), *Biuletyn Historii Sztuki*, XXXV, 1973, pp. 3–9, with supplements in the same periodical: XXXVI, 1974, pp. 393–6.

Rudkowski, T., ed, *Studia nad renesansem w Wielkopolsce* (Studies in the Renaissance in Wielkopolska), Poznań, 1970 (Poznańskie Towarzystwo Przyjaciół Nauk, Prace Komisji Historii Sztuki, VIII, No. 3) (Poznań Learned Society, studies of the art historical commission, VIII, No. 3).

Rupprich, H., ed., *Der Briefwechsel des Conrad Celtis*, Munich, 1934 (Veröffentlichungen der Kommission zur Erforschung der Geschichte der Reformation und Gegenreformation: Humanistenbriefe, III).

Ruszczyńska, T., Sławska, A., and others, *Powiat Gnieźnieński* (Gniezno County), Warsaw, 1963 (Katalog Zabytków Sztuki w Polsce, J. Z. Łoziński ed., V: Województwo Poznańskie, No. 3) (Catalogue of art monuments in Poland, V: District of Poznań, No. 3).

Rutkowski, H., 'Zamek w Piotrkowie' (The Piotrków castle), *Kwartalnik Architektury i Urbanistyki*, III, 1958, pp. 155–76.

Salm, Ch., 'Malerei und Plastik der Spätgotik', in K. M. Swoboda, ed., *Gotik in Böhmen*, Munich, 1969, pp. 361–98.

Samek, B., 'Renesanční radnice v Moravské Třebové' (Renaissance town hall in Moravská Třebová), *Zprávy Památkové Péče*, XVII, 1957, pp. 174–80.

Schaffran, E., 'König Matthias Corvinus und die italienische Renaissance', *Pantheon*, XII, 1933, pp. 252–3.

Schaffran, E., 'Mattia Corvino re dell'Ungheria ed i suoi rapporti col Rinascimento italiano', *Rivista d'Arte*, XIV, 1932, pp. 445–61; XV, 1933, pp. 191–201.

Schaffran, E., 'Ungarn im 15. Jahrhundert und die italienische Frührenaissance', *Archiv für Kulturgeschichte*, XXXV, 1953, pp. 52–84.

Schönherr, D., 'Erzherzog Ferdinand als Architekt', *Repertorium für Kunstwissenschaft*, I, 1876, pp. 28–44.

Sebestyén, Gh. and Sebestyén, V., *Architectura renașterii in Transilvania* (The Renaissance architecture in Transylvania), Bucharest, 1963.

Severová, F., 'K problematike monogramistu M.S.' (Contribution to the problems of the Master MS), *Ars*, II, 1968, pp. 160–6.

Seymour, Ch., Jr., *Sculpture in Italy: 1400 to 1500*, Baltimore, Md, 1966 (The Pelican History of Art).

Seymour, Ch., Jr., *The Sculpture of Verrocchio*, London, 1971.

Schepper, C. de, *Missions diplomatiques de Corneille Duplicius de Schepper* par le Baron de Saint-Genois et G. A. Yssel de Schepper (Mémoires de l'Académie Royale de Belgique, Brussels, XXX, 1857).

Shervinskij, S., 'Venetsyanizmy moskovskogo arkhangelskogo Sobora' (The Venetian elements in the Moscow Archangel Church), in *Zbornik krushka iskustvennogo moskovskogo Mercurio* (Publication of the Moscow art historical group Mercurio), I, 1917, pp. 191–204.

Simon, K., 'Die Vischerschen Grabplatten in Krakau', *Repertorium für Kunstwissenschaft*, XXIX, 1906, pp. 19–26.

Simon, K., 'Zwei Vischersche Grabplatten in der Provinz Posen', *Kunstwissenschaftliche Beiträge August Schmarsow gewidmet*, Leipzig, 1907, pp. 163–9.

Sinding Larsen, S., 'Some functional and iconographic aspects of the centralized church in the Italian Renaissance', *Institutum Romanum Norvegiae, Acta ad Archaeologiam et Artium Historiam Pertinentia*, II, 1965, pp. 221–6.

Sinko, K., *Santi Gucci Fiorentino i jego szkoła* (Santi Gucci Fiorentino and his school), Cracow, 1933.

Sinko, K., 'Hieronim Canavesi', *Rocznik Krakowski*, XXVI, 1936, pp. 129–76.

Sinko-Popielowa, K., 'Hans Dürer i Cebes Wawelski' (Hans Dürer and the Cebes representation at the Wawel), *Biuletyn Historii Sztuki i Kultury*, V, 1937, pp. 141–63.

Sinko-Popielowa, K., 'Kościół w Niepołomicach' (The Niepołomice church), *Rocznik Krakowski*, XXX, 1938, pp. 85–90.

Sinko-Popielowa, K., Review of J. Pagaczewski, 1937, in *Dawna Sztuka*, I, 1938, pp. 83–8.

Sinko-Popielowa, K., 'Ze studiów nad Padovanem' (Padovano Studies), *Biuletyn Historii Sztuki i Kultury*, VII, 1939, pp. 109–28.

Sinko-Popielowa, K., 'Zaginiony nagrobek św. Jacka w Krakowie' (The lost tomb of St Hyacinthus in Cracow), *Prace Komisji Historii Sztuki P.A.U.* (Studies of the commission for the history of art of the Polish Academy of Learning in Cracow), IX, 1948, pp. 65–86.

Skubiszewski, P., *Rzeźba nagrobna Wita Stwosza* (The tomb sculpture of Veit Stoss), Warsaw, 1957.

Skubiszewski, P., 'Osteuropäische Plastik' in J. Białostocki, 1972, pp. 267–70 and 285–91.

Skuratowicz, J., 'Renesansowe kaplice grobowe z XVI i pierwszej połowy XVII w. w Wielkopolsce' (The Renaissance sepulchral chapels of the sixteenth and the first half of the seventeenth century in Wielkopolska), in T. Rudkowski, ed., 1970, pp. 51–70.

Słownik Artystów Polskich i w Polsce Pracujących (Lexicon of Polish artists and those who worked in Poland), J. Maurin Białostocka and others, ed., 1, Wrocław, 1971.

Smacka, J., 'Jan Turzo humanista i mecenas kultury renesansowej' (Jan Turzo, humanist and patron of Renaissance culture), *Roczniki Sztuki Śląskiej*, II, 1963, pp. 77–91.

Smetánka, Z., 'Základy uhersko-česko-polské skupiny pozdněgotických kachlů' (The basis of the Hungarian-Polish-Czech group of Late Gothic oven-tiles), *Památky Archeologické*, III, 1961, pp. 593–8.

Smrhá, K., *Vlast stavitelé v nejjižnější části Čech v době renesanční* (Italian architects in the most southern part of Bohemia in the time of the Renaissance), Prague, 1938.

Smrhá, K., 'Budějovická brána v Českém Krumlově' (The Budějovice Gate in Český Krumlov), *Umění*, IV, 1956, pp. 82–3.

Sokolowski, M., 'Ścibor ze Sciborzyc i Pippo Spano' (Š.z.Š. and P.S.), *Sprawozdania Komisji Historii Sztuki P.A.U.* (Records of the commission for art history of the Polish Academy of Learning in Cracow), VIII, 1912, pp. LXIX–LXXXV.

Sokolowski, M., 'Stosunek Andrzeja Krzyckiego do sztuki' (Andrzej Krzycki's attitude towards art), *Sprawozdania Komisji Historii Sztuki P.A.U.* (Records of the commission for art history of the Polish Academy of Learning in Cracow), VI, 1900, pp. 42–9.

Solmi, A., 'Il rinascimento italiano e l'Ungheria', *Corvina*, VIII, vol. XV–XVI, 1928, pp. 73–85.

Somogyi, A., *Die Schatzkammer von Esztergom (Gran)*, Budapest, 1967.

Sosnowski, O., 'System krużganków wawelskich' (The system of the Wawel arcades), *Biuletyn Historii Sztuki i Kultury*, III, 1935, pp. 69–71.

Stadler, F., *Hans von Kulmbach*, Vienna, 1936.

Stafski, H., 'Die Vischer-Werkstatt und ihre Probleme', *Zeitschrift für Kunstgeschichte*, XXI, 1958, pp. 1–26.

Stange, A., *Deutsche Malerei der Gotik*, IX: *Franken, Böhmen und Türingen-Sachsen in der Zeit von 1400 bis 1500*, Munich-Berlin, 1958.

Starzewska, M., *Oleśnica (Oels)*, Wrocław-Warsaw-Cracow, 1963.

Stefan, O., 'K počátkům klasicismu v renesanční architektuře Čech' (Origins of Classicism in Czech architecture of the Renaissance), *Sborník Prací Filosofické Fakulty Brněnské University* (Papers of the philosophical department of Brno University), X, 1961 (Řada Uměnovědná /F/) (Art Historical Series /F/), No. 5, pp. 237–55.

Stefan, O., 'K dějezpytkm otázkám naší renesančnš architektury' (Historical problems of our Renaissance architecture), *Umění*, XII, 1964, pp. 428–32.

Stein, M., 'The Iconography of the Marble Gallery Frederiksborg Palace', *Journal of the Warburg and Courtauld Institutes*, XXXV, 1972, pp. 284–93.

Stein, M., 'Mars og Venus. En bryllupsallegori fra den danske renaissance', *Kulturminder*, 1973, pp. 7–23.

Steinborn, B., *Złotoryja, Chojnów, Świerzawa. Zabytki sztuki regionu* (Goldberg, Haynau, Schönau, monuments of the region), Wrocław, 1959.

Steinborn, B., 'Malowane epitafium mieszczańskie na Śląsku: 1520–1620' (Painted upper middle-class epitaphs in Silesia: 1520–1620), *Roczniki Sztuki Śląskiej*, IV, 1967, pp. 7–125.

Sterling, Ch., *Still life painting from Antiquity to the present time*, New York – Paris, 1959.

Stolot, F., 'Testament Tomasza Nikla. Przyczynek do dziejów pińczowskich warsztatów budowlanych i kamieniarsko-rzeźbiarskich na przełomie wieków XVI i XVII' (T. Nikel's last will. Contribution to the history of Pińczów building and stonecutting workshops at the turn of the sixteenth and seventeenth century), *Biuletyn Historii Sztuki*, XXXII, 1970, pp. 227–44.

Strieder, P., entries on Hans Kulmbach in *Meister um Albrecht Dürer*, Nuremberg, 1961 (Catalogue of the Exhibition), pp. 97–138.

Svoboda, J. and Procházka, V., 'Mičovna' (Ball Court), *Památková Péče* (Care of Monuments), 1975, No. 1, pp. 18–44.

Szablowski, J., 'Ze studiów nad związkami artystycznymi polsko-czeskimi w epoce Renesansu i Renesansem Zachodnio-Słowiańskim' (Studies on the artistic links between Poland and Bohemia in the Renaissance and of Poland with the western Slavonic Renaissance), *Prace Komisji Historii Sztuki P.A.U.*

(Papers of the art historical commission of the Polish Academy of Learning in Cracow), IX, 1948, pp. 27–64.

Szablowski, J., ed., *Katalog Zabytków Sztuki w Polsce*, I (District of Cracow), Warsaw, 1953.

Szablowski, J., 'Domniemana rola Sabbionety w sztuce polskiej okresu manieryzmu' (Presumed role of the Sabbioneta in the Polish art of Mannerism), *Zeszyty Naukowe Uniwersytetu Jagiellońskiego*, No. 45; *Prace z Historii Sztuki*, No. 1 (Scholarly publications of the Jagellonian University, studies in the history of art, No. 1), Cracow, 1962, pp. 105–34.

Szablowski, J., 'Architektura renesansowa i manierystyczna w Polsce', in T. Dobrowolski and W. Tatarkiewicz, ed., 2nd ed., 1965, pp. 43–152; also a separate offprint, Cracow 1965 (pp. 5–124), here quoted.

Szablowski, J., ed., *Katalog Zabytków Sztuki w Polsce*, IV: *Kraków*, I: *Wawel*, Warsaw, 1965.

Szablowski, J., 'O pierwotnym wyglądzie kaplicy grobowej Filipa Padniewskiego w katedrze wawelskiej. Ze studiów nad twórczością Jana Michałowicza z Urzędowa' (Original appearance of the sepulchral chapel of Filip Padniewski in the Cracow cathedral. Jan Michałowicz of Urzędów Studies), *Sprawozdania z Posiedzeń Odziału P.A.N. w Krakowie* (Proceedings of the Cracow section of the Polish Academy of Sciences and Letters), 1966, Part I, pp. 173–4.

Szablowski, J., 'Jeszcze kilka słów o Michałowiczowskim wyposażeniu wnętrza mauzoleum Filippa Padniewskiego na Wawelu' (Again on the decoration of F. Padniewski's mausoleum at Wawel by Michałowicz), *Sprawozdania z Posiedzeń Odziału P.A.N., w Krakowie* (Proceedings of the scholarly commissions of the Polish Academy of Sciences and Letters, Section in Cracow), XV, 1972, II, pp. 139–41.

Szablowski, J., ed., *The Flemish Tapestries at Wawel Castle in Cracow. Treasures of King Sigismund Augustus Jagiello*, Antwerp, 1972.

Szabó, G., *Corvinus Manuscripts in the United States. A Bibliography*, New York, 1960.

Szafer, T. P., 'W sprawie badań nad urbanistyką Spisza' (Concerning research on Spiš urbanism), *Kwartalnik Architektury i Urbanistyki*, I, 1956, pp. 277–82.

Szmodis-Eszláry, E., 'Zur Frage der Verbreitung der Renaissance–Wandmalerei auf dem Gebiet des mittelalterlichen Ungarns', *Actes Congrès Budapest, 1969*, Budapest, 1972, I, p. 635–8.

Świszczowski, S., 'Rekonstrukcja nagrobka św.

Jacka' (Reconstruction of the St Hyacinthus tomb), *Prace Komisji Historii Sztuki P.A.U.* (Studies of the commission for the history of art of the Polish Academy of Learning in Cracow), IX, 1948, pp. 86–7.

Świszczowski, S., 'Sukiennice na rynku krakowskim w epoce Gotyku i Renesansu' (Cloth Hall on the Cracow Market Square in the time of Gothic and Renaissance), *Biuletyn Historii Sztuki i Kultury*, X, 1948, pp. 285–309.

Świszczowski, S., 'Problemy XVI-wiecznych Sukiennic' (Problems of the Cracow Cloth Hall in the sixteenth century), *Biuletyn Historii Sztuki*, XVII, 1955, pp. 470–2.

Świszczowski, S., 'Ołtarz Renesansowy z Kaplicy św. Trójcy na Wawelu. Problem rekonstrukcji i autorstwa' (The Renaissance altar from the Trinity Chapel at the Wawel. Problems of reconstruction and of authorship), *Studia do Dziejów Wawelu*, I, 1955, pp. 113–37.

Šamánková, E., 'Palác Benedikta Rejta na Blatné' (B. Ried's Blatná castle), *Zprávy památkové péče*, VIII, 1948, p. 111–14.

Šamánková, E., 'Rejtův Frankenstein' (Ried's Frankenstein[Ząbkowice]), *Zprávy památkové péče*, XIII, 1953, pp. 126–8.

Šamánková, E., *Architektura české renesance* (Architecture of the Czech Renaissance), Prague, 1961.

Šamánková, E., 'Über die Anfänge der tschechischen Renaissance–Architektur', *Acta Historiae Artium*, XIII, 1967, pp. 115–22.

Šourek, K., ed., *Kunst in der Slowakei*, Prague, 1939.

Takács, M. H., 'A páčini kastély' (The castle at Páčin), *Műveszettörténti Értesítő*, I, 1954, pp. 123–30.

Takács, M. H., *Magyarországi udvarháazak és kastélyok (XVI–XVII szászad)* (Sixteenth and seventeenth-century manors and castles in Hungary), Budapest, 1970.

Tatarkiewicz, W., 'O pewnej grupie kościołów polskich z początku XVII wieku' (A certain group of Polish churches built at the beginning of the seventeenth century), *Sztuki Piękne*, II, 1926, pp. 241–53.

Tatarkiewicz, W., 'Typ lubelski i typ kaliski w architekturze kościelnej XVII wieku' (The Lublin – and the Kalisz-type in seventeenth-century church architecture', *Prace Komisji Historii Sztuki P.A.U.* (Studies of the art historical commission of the Polish Academy of Learning in Cracow), VII, 1937–8, pp. 23–60.

Tatarkiewicz, W., 'Nagrobki z figurami klęczą-cymi' (Tombs with kneeling figures), *Studia Renesansowe*, I, 1956, pp. 274–328.

Tatarkiewicz, W., 'Bernado Morando réalisateur de la ville idéale', in *Venezia e l'Europa, Atti del XVIII Congresso Internazionale di Storia dell'Arte, Venezia, 1955*, Venice, 1956, pp. 297–9.

Tatarkiewicz, W., 'Sprecyzowanie pojęcia udziału Renesansu polskiego w sztuce europejskiej i jego odrębności' (Precise definition of the share of the Polish Renaissance in European art and of its specificity), in *Odrodzenie w Polsce, Materiały Sesji Naukowej P.A.N.* (Renaissance in Poland. Proceedings of the scholarly conference organized by the Polish Academy of Sciences and Letters), v, no place, 1958, pp. 179–82.

Tomkiewicz, W., '"Lament Opatowski". Próba interpretacji treści' (The 'Opatów Mourning'. An attempt to interpret its content), *Biuletyn Historii Sztuki*, XXII, 1960, pp. 351–64.

Tomkiewicz, W., 'Relations artistiques polono-hongroises à la fin du 15e et au début du 16e siècle', in *La Renaissance et la Réformation en Pologne et en Hongrie* (Studia Historica Acade-miae Scientiarum Hungaricae, LIII), Budapest, 1963, pp. 493–500.

Tomkowicz, S., 'Wawel, I: Zabudowania Wawelu i ich dzieje' (Wawel, I: The buildings at the Wawel and their history), *Teka Grona Konserwatorów Galicji Zachodniej* (A publica-tion of the group of conservators of western Galicia), IV, 1908.

Trajdos, E., 'Portal południowy katedry w Tar-nowie' (The southern portal of the Tarnów cathedral), *Biuletyn Historii Sztuki*, XXII, 1960, pp. 179–84.

Trajdos, E., 'Z ikonologii polskiej sztuki gotyckiej, Portal południowy katedry w Tarnowie' (Iconology of Polish Gothic Art: The southern portal of the Tarnów cathedral), *Studia Żródłoznawcze*, VI, 1961, pp. 121–7.

Truhlář, J., *Humanismus a Humanisté v Čechách za Krále Vladislava II* (Humanism and the Humanists in Bohemia at the time of King Vladislav II), Prague, 1894.

Trybowski, I. and Zagórowski, O., 'Retabulum renesansowe z katedry krakowskiej' (The Renaissance altar from the Cracow cathedral), *Studia do Dziejów Wawelu*, II, 1961, pp. 450–4.

Trybowski, I. and Zagórowski, O., 'Renesansowy ołtarz św. Doroty z katedry na Wawelu' (The Renaissance altar of St Dorothy from the Cracow cathedral), *Studia Renesansowe*, III, 1963, pp. 203–46.

Trzebiński, W., 'Polskie renesansowe założenia urbanistyczne – stan i problematyka badań' (Polish Renaissance urbanistic projects: prob-lems and state of research), *Kwartalnik Architektury i Urbanistyki*, III, 1958, pp. 313–27.

(Tubero, L.) Ludovici Tuberonis Dalmatae Abbatis, *Commentariorum de rebus suo tempore gestis libri XI (1490–1522)*, J. G. Schwandtner ed., Vindobonae, 1746 (Scriptores Rerum Hungari-carum Veteres ac Genuini, II).

Ulewicz, T., 'O związkach kulturalnych i litera-ckich polsko-czeskich w dobie humanizmu i renesansu' (Literary and cultural links between Poland and Bohemia in the time of humanism and Renaissance) *Sprawozdania z Posiedzeń P.A.N., Oddział w Krakowie* (Proceedings of the Cracow branch of the Polish Academy of Sciences and Letters), XII, 1968, pp. 67–8.

Ullmann, Ernst, 'Zur Rezeption der Renaissance in Sachsen und den gesellschaftlichen Grund-lagen der deutschen Frührenaissance', *Actes Congrès Budapest, 1969*, Budapest, 1972, I, p. 659–66.

Unnerbäck, E., *Welsche Giebel. Ein italienisches Renaissance Motiv und seine Verbreitung in Mittel– und Nordeuropa*, Stockholm, 1971.

Urbach, Z. S., 'Die Heimsuchung Mariä, ein Tafelbild des Meisters Ms', *Acta Historiae Artium*, X, 1964, p. 299–320.

Vacková, J., 'K ideové koncepci renesančních náštěnných maleb ve svatováclavské kapli' (Ideological conception of wall paintings of the Renaissance in St Wenceslas Chapel), *Umění*, XVI, 1968, pp. 163–73.

Vacková, J., 'K malbam ve smíškovské kapli' (About the wall paintings in the Smíšek Chapel), *Umění*, XIX, 1971, pp. 254–78.

Vacková, J., 'Reflets de l'italianisme dans la peinture en Bohême vers 1500', *Actes Congrès Budapest, 1969*, Budapest, 1972, I, pp. 645–8.

Valeri, D., 'Una Padova minore in terra di Polonia', in *Relazioni tra Padova e la Polonia*, Padua, 1964, pp. 89–92.

Vanková-Frejková, O., *Zámek Nelahozeves* (Castle N.), Prague, 1941.

Vătăşianu, V., *Istoria Artei Feudale în Tările romíne* (History of feudal art in the Rumanian State),

I (Arta in perioada de dezvoltare a feudalismului) (Art in the period of the development of feudalism), Bucharest, 1959.

Vătăşianu, V., 'Arta în Transilvania de la mijlocul secolului al XV-lea pînă la sfîrşitul secolului al XVI-lea' (Art in Transylvania from the mid 15th to the end of the 16th century), in G. Oprescu, ed., *Istoria Artelor Plastice în România*, Bucharest, 1968, I, pp. 403–27.

Vayer, L., 'Vom Faunus Ficarius bis zu Matthias Corvinus. Beitrag zur Ikonologie des osteuropäischen Humanismus', *Acta Historiae Artium*, XIII, 1967, pp. 191–6.

Venturi, A., *Storia dell'Arte italiana*, XI, I, Milan, 1935.

Vlassiuk, A., 'Novye issledovanya po arkhitekturie Arkhanghelskogo Sobora na Moskovskom Kremle' (New research in the architecture of the Archangel Church on the Moscow Kremlin), *Arkhitecturnoye Nassledye* (Architectural Heritage), II, 1952, pp. 105–32.

Voit, P., 'I codici modenesi di Ippolito d'Este e le costruzioni edili a Esztergom', *Acta Historiae Artium*, V, 1958, pp 283–315.

Voit, P., 'Reneszánsz építészetünk sajátos fejlődese' (The specific development of our architecture at the time of the Renaissance), *Építés- és Közlekedéstudományi Közlemények* (Architectural Bulletin), IV, 1960, pp. 353–77.

Voit, P., 'Una bottega in via dei Servi', *Acta Historiae Artium*, VII, 1961, pp. 187–228.

Voit, P., 'Les stalles de Nyírbátor', *Müvészet*, X, No. 9, 1969, pp. 40–41.

Voit, P. and Holl, I., 'Hunyadi Mátyás budavári majolikagyártó mühelye' (The majolica workshop of Matthias Corvinus in the Buda castle), *Budapest Régiségei. A Budapesti Történeti Múzeum Évkönyve* (Antiquities of Budapest. Yearbook of the Budapest Historical Museum), XVII, 1956, pp. 73–138.

Wagner, J., 'Renesanční kostely v severovýchodních Čechach' (Renaissance churches in northeastern Bohemia), *Zprávy pamatkové péče*, XIII, 1953, pp. 239–45.

Wagner, V., *Vývin výtvarného umenia na Slovensku* (History of art in Slovakia), Bratislava, 1948.

Wagner, V., 'Umenie neskorej gotiky a ranej renesancie' (Late Gothic and Renaissance art), *Pamiatky a múzea*, III, 1954, pp. 146–59.

Wagner-Rieger, R., 'Die Renaissance-Architektur in Österreich, Boehmen und Ungarn in ihrem Verhältnis zu Italien bis zur Mitte des 16.

Jahrhunderts', in *Arte e Artisti dei Laghi Lombardi*, I, Como, 1959, pp. 457–81.

Warschauer, A., 'Der Posener Stadtbaumeister Johann Baptista Quadro. Ein Künstlerleben aus der Renaissancezeit', *Zeitschrift der historischen Gesellschaft für die Provinz Posen*, XXVIII, 1913, pp. 151–211.

Wiliński, S., 'Il rinascimento di Wawel', *Acta Historiae Artium*, XIII, 1967, pp. 133–6.

Wiliński, S., 'Nad renesansem Wawelskim' (Thinking on the Wawel Renaissance), *Rocznik Historii Sztuki*, VII, 1969, pp. 384–5.

Wiliński, S., 'Zygmunt Stary jako Salomon. Z listów Erazma z Rotterdamu' (Sigismund the Old as Salomon. From Erasmus's Letters), *Biuletyn Historii Sztuki*, XXXII, 1970, pp. 38–47.

Wiliński, S., 'Ślepe okna termalne w Kaplicy Zygmuntowskiej' (Blind termal windows in the Sigismund Chapel), in *Granice Sztuki* (Limits of art: A book of essays in honour of Ksawery Piwocki), Warsaw, 1972, pp. 66–80.

Winkler, F., 'Notiz zu Jörg Pencz', *Jahrbuch der Preussischen Kunstsammlungen*, LVII, 1936, p. 253.

Winkler, F., 'Die Holzschnitte des Hans Suess von Kulmbach', *Jahrbuch der Preussischen Kunstsammlungen*, LXII, 1941, pp. 1–30.

Winkler, F., *Der Krakauer Behaim-Kodex*, Berlin, 1941.

Winkler, F., *Hans von Kulmbach. Leben und Werke eines fränkischen Künstlers der Dürerzeit*, Kulmbach, 1959 (Die Plassenburg. Schriften zur Heimatforschung und Kulturpflege in Oberfranken, 14).

Wirth, Z., 'Die Böhmische Renaissance', *Historia* (Académie Tchécoslovaque des Sciences, Section Historique), III, 1961, pp. 87–107.

Wirth, Z., 'Architektura renesanční, in *Architektura v českém národním dědictvi* (Architecture in the Czech national tradition), Prague, 1961.

Wittkower, R., *Architectural principles in the age of humanism* (especially the Chapter: The centrally planned church and the Renaissance', pp. 1–28), London, 1949 (several ed.).

Wojciechowski, J., 'Zamek Batorego w Grodnie' (The Batory castle at Grodno), *Biuletyn Historii Sztuki i Kultury*, VI, 1938, pp. 229–70.

Zabytki Sztuki w Polsce. Inwentarz topograficzny, IV: *Powiat Piotrkowski, Województwo Łódzkie* (Art monuments in Poland. A topographical inventory, IV: Piotrków county, district of Łódz), Praca zbiorowa (Collective work), Warsaw, 1950.

Zachwatowicz, J., *Architektura polska*, 3rd ed. (Polish architecture), Warsaw, 1966.

Zahorska, S., 'O pierwszych śladach Odrodzenia w Polsce' (first traces of the Renaissance in Poland), *Prace Komisji Historii Sztuki P.A.U.* (Studies of the art historical commission of the Polish Academy of Learning in Cracow), II, 1922, pp. 101-22.

Zarębska, T., 'O związkach urbanistyki węgierskiej i polskiej w drugiej połowie XVI w.' (Links between Hungarian and Polish urbanism in the second half of the sixteenth century), *Kwartalnik Architektury i Urbanistyki, Teoria i Historia*, IX, 1964, pp. 259-82.

Zdziarska, R., 'Nagrobek ks. Mazowieckich w katedrze warszawskiej' (Tomb of the Masovia dukes in the Warsaw cathedral), *Biuletyn Historii Sztuki*, XIV, 1952, No. 4, pp. 180-5.

Zimmer, J., '*Josephus Heintzius – architectus cum antiquis comparandus*. Příspěvek k poznání rudolfínské architektury mezi lety 1590-1612' (Contribution to the study of Rudolfinian architecture in the time 1590 to 1612), *Umění*, XVII, 1969, pp. 217-46.

Zin, W. and Grabski, W., 'Wyniki badań nad renesansowym Zamościem' (Recent research on the Zamość of the Renaissance), *Sprawozdania z posiedzeń Oddziału krakowskiego P.A.N.* (Proceedings of the Cracow branch of the Polish Academy of Sciences and Letters), XI, 1967, part 1, pp. 554-7.

Zin, W. and Grabski, W., 'Wyniki badań nad renesansowym dworem biskupim na Prądniku Białym' (Results of an investigation of the Renaissance bishop's manor at Prądnik Biały), *Sprawozdania z posiedzeń Oddziału krakowskiego P.A.N.* (Proceedings of the Cracow branch of the Polish Academy of Sciences and Letters), XI, 1967, pp. 848-50.

Zin, W. and Grabski, W., 'Gmach Akademii Zamojskiej w świetle ostatnich badań' (The building of the Zamość Academy according to the latest investigations), *Sprawozdania z posiedzeń Oddziału krakowskiego P.A.N.* (Proceedings of the Cracow branch of the Polish Academy of Sciences and Letters), XII, 1968, pp. 677-82.

Zlat, M., 'Attyka renesansowa na Śląsku' (The Renaissance parapet in Silesia), *Biuletyn Historii Sztuki*, XVII, 1955, pp. 48-79.

Zlat, M., 'Uwagi dyskusyjne do pracy J. Rossa "Związki artystyczne polsko-czeskie i polsko-słowackie w epoce Odrodzenia"' (Critical remarks on J. Ross's paper [Ross, 1953]), *Biuletyn Historii Sztuki*, XVIII, 1956, pp. 449-51.

Zlat, M., *Brzeg*, Wrocław, 1960.

Zlat, M., 'Brama zamkowa w Brzegu' (The Castle Gate at Brzeg [Brieg]), *Biuletyn Historii Sztuki*, XXIV, 1962, pp. 264-322.

Zlat, M., 'Zamek w Krasiczynie' (The Krasiczyn castle), *Studia Renesansowe*, III, 1963, pp. 5-143.

Zlat, M., 'Sztuki śląskiej drogi od gotyku' (How Silesian art went away from the Gothic), in *Późny gotyk. Studia nad sztuką przełomu średniowiecza i czasów nowych. Materiały Sesji Stowarzyszenia Historyków Sztuki* (Late Gothic. Papers concerning the art at the turning point between the Middle Ages and modern times. Papers presented at the conference organized by the Polish Association of art historians), Wrocław, 1962, Warsaw, 1965, pp. 141-226.

Zlat, M., 'Sztuka renesansu i manieryzmu: 1500-1650' (The Art of the Renaissance and Mannerism: 1500-1650), in: T. Broniewski and M. Zlat, *Sztuka Wrocławia* (The Art of Wrocław [Breslau]), Wrocław-Warsaw-Cracow, 1967, p. 183-256.

Zlat, M., 'Śląska rzeźba nagrobkowa XVI wieku wobec włoskiego renesansu' (Sixteenth-century Silesian tomb sculpture and its relation to the Italian Renaissance), in *Ze studiów nad sztuką XVI wieku na Śląsku i w krajach sąsiednich* (Studies in sixteenth-century art in Silesia and in neighbouring countries. Proceedings of a Conference organized by Muzeum Śląskie, Wrocław), Wrocław, 1968, pp. 17-42.

Zlat, M., 'Leżące figury zmarłych w polskich nagrobkach XVI w.' (Recumbent figures of the deceased in sixteenth-century Polish tombs), in *Treści dzieła sztuki. Materiały Sesji Stowarzyszenia Historyków Sztuki, Gdańsk, 1966* (Content of the work of art. Papers presented at the conference organized by the Polish Association of Art Historians, Gdańsk, 1966), Warsaw, 1969, pp. 99-120.

Zlat, M., review of J. Kębłowski, 1966, and J. Kębłowski, 1967, in *Roczniki Sztuki Śląskiej*, VIII, 1971, pp. 125-31.

Zlinsky-Sternegg, M., *Renaissance Inlay in Old Hungary*, no place (Budapest) 1966.

Zo starších výtvarných dejín Slovenska (Essays in honour of V. Wagner), Bratislava, 1965.

Żarnecki, J., 'Renaissance Sculpture in Poland: Padovano and Michałowicz', *Burlington Magazine*, LXXXVI, 1945, pp. 10-16.

Index

Aachen, Hans von, 83
Aelst, Pieter Coecke van, 13, Fig. 27
Alba Julia, see Gyulafehérvár
Alberti, Leon Battista, 7, 13–14, 16, 33
Alexander, Grand Duke of Lithuania, 10
Allio, Domenico dell', 79
Altichiero circle, miniature of Petrarch, 47, Fig. 135
Amberg, Georg von, 26
Amedeo, 29
Ameisenowa, Zofia, 59
Ammanati, Bartolommeo, 51, 80, 81, Fig. 170
Ammanatini, Manetto, 4, 5
Angevin dynasty, 4, 5
Antoni of Wrocław, Master, 24, Fig. 71; 25
Aostalli, Gian Maria, 77
Aostalli, Giovanni Battista and Ulrico, 77, 78, 85, Figs 297, 325–7
Aragon, Beatrix of, 7–8, Fig. 6
Attavanti, Attavante degli, 7, Fig. 5
Augsburg, Fugger Chapel, 2
Avostalis, see Aostalli

Baier, Melchior, 60, Fig. 212
Bakhchisaray, Demir Khapu Palace, Fig. 2
Bakócz, Tamas, Cardinal, 29, 31, 33, 45
Balassagyarmat, Páloc Museum, Fig. 130
Baldigara, Ottavio, 71, Fig. 271
Balin, Jacopo, Fig. 330
Balogh, Jolán, 8, 13, 14, 15, 32
Banská Bystrica, 69
Banská Štiavnica, 60
Baranów, 67, Figs 336–7; 86, 87, Fig. 341
Barbona, Pietro di, 81, Fig. 310
Bardejov, 23; market square, town hall and St Giles's Church, 61–2, Figs 216–21
Bartolo, Nanni di (Rosso), 53
Báthory Madonna, 9, Fig. 15
Báthory family, 62
Bautzen, effigy of Matthias Corvinus, 7
Behem, Baltazar, 59
Bejsce, Firlej Chapel, 87, Figs 344–6
Bendel, G., Fig. 328; 102 (note 65)
Benedikt, Master, 23, Fig. 65
Benesch, Otto, 2
Bergamo, Colleoni Chapel, 29
Bernburg, 68
Berrecci, Bartolommeo, 19–20, 35–7, 39, 40, 42, 43, 44, 49, 52, 53, 54, 57, 84; Frontispiece, Plate III, Figs VII, VIII, 101–12, 114, 118, 120, 121, 145, 149, 174, 180–2, 187, 195
'Beschlagwerk', 82
Betlanovce, castle, 68, Fig. 252
Biały, Jan, 50, Figs 159, 160
Biseno, Leonardo Gardo da, 78, Fig. 294
Blocke, Abraham van den, 83, Figs 312, 318
Blocke, Willem van den, 81, 83, Figs 311, 317; 101 (note 48)
Blocke family, 82, 83
Bocheńska, Dr Anna M., 24, 25

Bodzentyn, altar from Wawel cathedral, 61, Fig. 214
Boner, Jan, 39, 40, 60
Boner, Seweryn, 39, 40
Boner, family, 59
Bonfini, Antonio, 7, 8, 13, 91 (note 48)
Bosch, Hieronymus, 59
Boskovice, castle, 68
Boston Museum of Fine Arts, 42, Fig. 116
Botticelli, Sandro, 42, 47, 53, Fig. 179
Bourdelle, Emile-Antoine, 28
Boy family, 82
Bracciolini, Poggio, 6
Bramante, 20, 75
Bratislava (Pozsony), Academia Istropolitana, 6
Bregno, Andrea, 54, Fig. 183
Brescia: Jonah and his gourds, 54, Fig. 186
Breslau, see Wrocław
Brok, 86
Brunelleschi, 28, 29
Brzeg, castle, 26, 27, Figs 80–1; 83–5, 87
Brzeżany, synagogue, 67
Brzeziny, tomb of Stanisław Lasocki, 50; tomb of Urszula Leżeńska, 55, Fig. 189
Bucharest, baptismal font from Menyö, 45–6, Fig. 129; tomb of Sofia Pathócsy, 50, Fig. 155
Bückeburg, 68

Bučovice, castle, 78, Figs 298–9; 101 (note 23); fountain, 83, Fig. 321
Buda, 4, 5, 7, 15, 17, 62, 74; tombs in Dominican church, 45, Fig. 125; tomb of Bernardo Monelli, 45, Fig. 126; Corvinus's castle, 9, 13–14, 33, Figs 26–33, 35, 37
Budapest: Castle Museum, 8, Figs 6–7; 29–33, 35, 37, 45, Fig. 126; 46, Figs 131–2
Museum of Fine Arts, 9
National Museum, 8, Figs 10, 15; 62, Figs 221, 223–5
Budapest, Pannonian tomb stelae, 46, Figs 131–2
Buonaccorsi, Filippo (called Callimachus), 9, 42, 47, Fig. 133; 48, Fig. 137
Buondelmonte, Giovanni da, 5
Buontalenti, 80
Burgkmair, Hans, 47
Bylica, Marcin, 6

Callimachus, see Buonaccorsi, F.
Calvani, Ottaviano Gucci de', 95 (note 19)
Camicia, Chimenti, 7, 13
Canavesi, Hieronim, 51, 57, Figs 164, 167, 197
Caradoso (Foppa, Cristoforo), 7, 8
Carpentarius, Nicolaus, 62
Castiglione, Bishop Branda, 5
Castiglione, Nicolo, 20
Cattaneo, Pietro di Giacomo, 72, Fig. 272
Cellini, Baccio, 13
Celtes, Conrad, 47, 95 (note 19)
Český Krumlov, Town Hall, 68, Fig. 250
Česmicki, Ivan, see Pannonius
Charles V, Emperor, 73–4
Chełmno, Town Hall, 87, Figs 347–8
Chojnów, 27, Fig. 86
Cini, Giovanni, 49, Figs 145, 150–1
Ciriaco of Ancona, 6
Coducci, Mauro, 94 (note 16)

Colantonio, 47
Colijn, Alexander, 50, Fig. 154
Cologne, 70
Colombe, Michel, 2
cosmaschi, 12
Cometta, Antonio, 85, 102 (note 65), Fig. 329
Corvinus, Matthias, 4, 6, 7–8, 13, 14, 15, 47, 59, 60, 62, 74; his Gothic Calvary, 8, Fig. 8, and throne drapery, Fig. 10
Cracow: 4, 5, 6, 10, 13, 60; Zator Altar, 61, Fig. 213; Cloth Hall, 66–7, Figs 239–43
Church of Our Lady, 23, Fig. 68; bronze slabs of S. Boner and his wife, 51, Figs 161–2; Montelupi and Cellari tombs, 51, Figs 165, 168; Assumption of St Catherine by H. v. Kulmbach, 60, Fig. 210
Dominican Friars Church: Myszkowski family chapel, 51, Fig. 166; 81, Figs 307–8, 95 (note 50); tomb of Galeazzo Guicciardini, 51; tomb of St Hyacinthus, Fig. 160
Church of St Giles: remains of the tomb of St Hyacinthus, 50, Fig. 159
Jagellonian Library: Orlik tomb, 51, Fig. 167; Master of the Behem Codex, 59, Plate II, Figs 206–7
University: 6, 12, Fig. 22
Wawel Castle: 11, 18–25, 26, 49, Figs II, III; Figs 52, 55–8, 60–1, 63–4, 69–73, 76–9
Wawel Cathedral: tomb of Jan Olbracht, 10–11, Fig. 16; 18, 49
Wawel Cathedral: Sigismund Chapel: Frontispiece, 35–44, Plate III, Figs VII, VIII, IX; Figs 101–6; iconography and symbolism, 39–43, Figs 107–14, 118, 120; its impact, 43–4, Figs 121–3; 49, Fig. 124; tomb of Sigismund I, 52, Figs 174, 180; 57, Figs 200, 202; effigy of Sigismund II, 57, Figs 200–2; altarpiece, 60, Figs 211–12; 74
Wawel Cathedral: Chapel of Piotr Tomicki, 33–4, 43, Fig. 121; Vasa Chapel, 43–44, Figs 123–4; tomb of Władysław Jagiełło, 49, Figs 145–8; epitaph of Filippo Buonaccorsi (called Callimachus), 47, 48, Fig. 133; tomb of Jan Konarski, 49, Fig. 149; tomb of Fryderyk Jagellon, 50, Figs 156, 158; plaque of Piotr Kmita, 51, Fig. 163; tomb of Piotr Tomicki, 53–4, Figs 181–2; tomb of Piotr Boratyński, 54, Fig. 185; tomb of Andrzej Zebrzydowski, 55, Figs 188, 190–1; tomb and chapel of Filip Padniewski, 55, Figs 192–4; 95 (note 47); tomb of Stefan Batory, 57–8, Figs 203–5; 80, 86; tomb of Anna Jagellonica, 57–8, Fig. 204; stalls in Lady Chapel, 86, Fig. 335
Wawel State Art Collections, 18, Fig. 53; 61, Fig. 213
Csatka, tomb of Nikolaus Szentléleki, 45
Ctibor of Cimburk, Lord, 64
Czchów, tomb of Kasper Wielogłowski, 51, Fig. 164

d'Andrea, Salvi, 33
Danzig, *see* Gdańsk
Darmstadt Library, Fig. 135
Dębno, Castle of Jakub Dębiński, Fig. 21
Dalmata, Giovanni (Duknović, Ivan), 5, 7, 8, 9, 14, 17
Debrecen, Museum, 62
Decius, Jost Ludwik, 75, Figs 277–8
della Porta, Antonio, 10
Demir Khapu, Iron Gate of Bakhchisaray palace, 3
Diósgyör Castle in Miskolc, 'Diósgyör Madonna', 9, Fig. 12
Dominici, Paolo, 81, Fig. 310
Donatello, 56
Dřevokostice, castle, 78
Drobin, Kryski tomb, 51, Fig. 169; 86
Ducerceau, Jacques Androuet, 77, Fig. XVII
Duknović, Ivan, *see* Dalmata
Dürer, Albrecht, 12, Fig. 25; 50
Dürer, Hans, 24, 60, Figs 70, 71
Erasmus, 40
d'Este, Ippolito, 8
Estreicher, Karol, 60
Esztergom, 4, 7, 45, 46, 74; Gothic Calvary, 8, Fig. 8; Apostolic Cross, 8, Fig. 9; frescoes, 8, Fig. 11
Chapel of Cardinal Bakocz, 10, Fig. 20; 11, 17, 18, 29–33, 35, 61, Figs IV, V
Cathedral, 29, 30
Museum, Christ falling under the Cross by Master M.S., 60, Fig. 209, Plate IV

Faconi, Giovanni Maria, 85, Fig. 329
Felsöelefánt, tomb slab of Gergely Forgách, 46
Ferdinand, Archduke, 73, 79, Fig. XVIII
Ferrabosco, Pietro, 77, 78, Figs 298–9
Ferrucci, Andrea, 32, 61, Fig. 95
Fieravanti, Aristotele, 3, 7
Fiesole, Badia, 20; marble retable, 32
Filarete, Antonio Averlino, 7, Fig. 4
Filelfo, Francesco, 6
Fiorentino, Santi Gucci, *see* Gucci
Fiorentinus, Albertus, 8
Fiorentinus, Joannes, 2, 18, 34, 45, 46, Figs 125–9
Florence: S. Maria del Carmine, Soderini tomb, 11, Fig. 18
S. Pancrazio, Cappella Rucellai, 13–14, Fig. 34; 33
Palazzo Medici, 14
San Lorenzo, 28
S. Lorenzo, Medici chapel, 29, 51
S. Spirito, 32, 33, Fig. 98
S. Maria Maddalena dei Pazzi, 33
Cathedral, 38
SS. Trinita, 41, 52
Palazzo Pitti, 81
Florentinus, Franciscus, 10, 11, 18, 19, 20, Figs 16, 52, 53, 55
Floris, Cornelis, 81, 82, Fig. 316; 102 (note 48)
Flötner, Peter, 60, Figs 161–2, 212
Folleville, Lannoy tomb, 10, Fig. 17
Fontana, Albin, Fig. 333
Foppa, Cristoforo, *see* Caradosso
Fora, Gerardo and Monte del, Plate I
Forssman, Erik, 83
Fra Giovanni, 14
Francia, Francesco, Fig. 9
Frankenstein, Jan, 66
Frederick II, Duke of Legnica and Brzeg, 26, 27, Fig. 82
Frederick III, Duke of Legnica and Brzeg, 27, Fig. 86
Frederik II of Prussia, 26
Friasin, Marco, 3, Fig. 1

Fričovce, castle, 68, Fig. 253
Frydman, church tower, 68, Fig. 255
Fugger family, 59

gable parapet, 65, Figs 232–3, 236–8
Gabri, Pietro, 78, Figs 298–9
Gaggini, Pace, 10, Fig. 17
Gamrat, Bishop Piotr, 53
Garda, Leonardo, 78
Gargioli, Giovanni, 16
Gausske, Britius, 7
Gdańsk: Trinity church, 65, Fig. 234; 68
 High Gate, 81–2, Fig. 311
 Artus Court, 82, Fig. 320
 Arsenal, 83, Figs 313–15
 Golden Gate, 83, Fig. 312
 Bahr monument, 83, Fig. 318; 101 (note 48)
George II, Duke of Legnica and Brzeg, 26, Fig. 85
Gerevich, László, 13, 18, 45, 46
Gerlach, Stephen, 91 (note 6)
Ghirey, Khan Mengli, 3
Ghirlandaio, 47
Gianottis, Bernardino Zanobi de, 49, Figs 150–1
Giovanni, Fra, 14
Głowa, Krzysztof, 71
Głowów, 71
Gniezno Cathedral, Laski chapel, 33–4, Fig. VI; 45;
 tomb slabs, 46, Figs 127–8
Goldschmidt, Adolf, 85
Goujon, Jean, 2
Graz, the Landhaus, 79
Gregory, of Késmárk, 62, Fig. 222
Griespach, Florian, 77, 83, 101 (note 23)
Grodziec, castle, 64
Grzegorz of Sanok, 2, 6
Guarini, Guarino, 6
Gucci, Santi, Frontispiece, 2, 51, 57, 58, 66, 84, 86,
 87, 88, Figs 165–6, 158–9, 201, 203–5, 243, 305–
 8, 335, 340
Gunter, Lorenz, 69, Fig. 263
Güstrow, castle, 27
Győr, town plan, 71, Fig. 270
Gyulafehérvár (Alba Julia), chapel of János Lázói, 33,
 Figs 99, 100

Hahn, August, 1
Halle cathedral, 68, Fig. 260
Hedicke, Rudolf, 83
Heemskerck, Maerten van, 92
Hercules fountain, *see* Visegrád
Hillebrandt, Franz Anton, 29
Holy Sepulchre, Alberti's, 16
Horšovský Týn, castle, 85, Fig. 234; 101 (note 23)
Horst, Hendrik, 50
Hradec Králové, 67
Huber, Jörg, 10, Fig. 16
Humanists, Hungarian, 2
Husiatyn, 67
Hvězda Castle, *see* Prague

intarsia work, 62, 84, Fig. 323
Italus, Franciscus, *see* Florentinus
Ivan III, 3
Ivanovice, castle, 78

Jagellon, Sigismund, King, 9–10, 11, 18, 19, 25, 35,
 49, 59, 60; Fig. 208

Jagellon, Vladislav II, King, 4, 9, 15, 17, 60, 73
Jagellonian dynasty, 4, 43
Jagiełło, Władysław, 6, 49
Jan III Sobieski, 29
Janda, Joannes, 25
Jaroměř, 23, Fig. 67
Jaroszewicz, Jan, Fig. 334
Jindřichův Hradec, castle, 64, Fig. 231; 78, Fig. 296;
 85, Figs 328–9; 101 (note 23)
Jiřík of Olomouc, 64, 69
Joannes Fiorentinus, *see* Florentinus
Joos van Ghent, 28

Kačerov, castle, 77, Fig. XVI, Figs 288–9; 79, 101
 (note 23)
Kaliningrad, *see* Königsberg
Kalinowski, Lech, 37, 38, 39, 40, 41, 42
Kalisz, Franciscan Friars church, 86, Fig. 333
Kalocsa, 5
Kamienna Góra, castle, 64
Kazimierz IV, 4, 9
Kazimierz Dolny, parish church, 86, Fig. 330;
 Przybyła houses, 88, Figs 349–50; Celejowski
 House, 88, Fig. 351
Kežmarok, 62, Fig. 222, 68
Kmita, Piotr, bronze plaque of, 51
Kmita, Piotr, the younger, 51
Kochanowski, Jan, 2
Konarski, Bishop Jan, tomb of, 49, Fig. 149
Königsberg (Kaliningrad), Duke Albrecht's tomb by
 Cornelis Floris, 82, Fig. 316
Kościelec, tombs of Jan and Janusz Kościelecki, 56,
 Fig. 196
Kostelec nad Černými Lesy, castle, 77, 79, Fig. 292,
 86; 101 (note 23)
Kowalczyk, Jerzy, 70
Kralovice, epitaph of Florian Griespach, 83
Kramer, Hans, 81, Fig. 311
Krasiczyn, 67, Figs 338–9, 87
Krępachy, 68
Krzycki, Bishop Andrzej, 11
Książ Wielki, Mirow castle, 80–1, Figs 305–6
Kübler, George, 84
Kulmbach, Hans Süss von, 50, 60, Figs 157, 210
Kunstschränke, 84, Fig. 323
Kutná Hora, Smíšek chapel of St Barbara's church,
 28, 60, Figs 88–90

Labenwolf, Pankraz, 60, Fig. 212
Laetus, Pomponius, 47
Langinis, Christophorus, 62
Lannoy, Raoul de, tomb of, 10, Fig. 17
Laurana, 25
Lázói, János, 33
Legnica, castle gate, 26, Fig. 82; 27
Leonardo da Vinci, 37
Lessing, Gotthold Ephraim, 54
Levoča, 62, Fig. 222; 68, 69, Fig. 264
Lippert, József, 30
Lippi, Filippino, 8
Litoměřice, altarpiece, 28; town hall, 65, Fig. 236
Litomyšl, castle, 78, Fig. 297, 79; 85, Figs 325–7; 87;
 101 (note 23)
Lombard artists, 26–7
Lombardi school, Pietro, 94 (note 16)

London: British Museum, 60, Fig. 208
National Gallery, 53, Fig. 179
Victoria and Albert Museum, 32
Lorek, Wawrzyniec, 65, Fig. 238, Figs XII–XIII
Lorenzo the Magnificent, 8
Loschi, Antonio, 6
Louis I the Great, 5, 6
Louis II of Hungary and Bohemia, 73
Lübeck, town hall, 63
Lubiendu, Reinold, 91 (note 6)
Lublin, Cracow gatehouse, 70, Fig. 266; St Bernard
 Friars church, 86, Fig. 332
Lubomł, Synagogue, 67, Fig. 246
Lucchese, Giovanni, 79, Fig. 303
Ludvík of Hungary, King, 17
Lwów, Dr Anczowski's 'Black House', 67, Fig. 245;
 Valachian church, 81, Fig. 310
Łaski, Andrzej, 46
Łaski, Jan, 11, 33–4, Fig. 127, 35, 45
Łobzów, castle, 101 (note 32)

Maggi, Baldassare, 102 (note 65)
Maiano, Benedetto da, 7, 8, 51, 62
Malbork, 68
Manetti, Antonio Ciaccheri, 29
Mantegna, Andrea, 7
Marieschi, Bartolommeo de, 91 (note 14)
Markl, J., 24
Marone, F., (?), 62, Figs 223–5
Martini, Francesco di Giorgio, 71–2
Martinola, G. P., Fig. 328; 102 (note 65)
Master Alexius, 23, 61–2, Figs 217–20
Master Benedikt, 19, 23
Master, M. F., Fig. 138
Master 'M.S.', *see* Monogrammist M.S.
Master of the Behem Codex, Plate II, Figs 206–7
Master of the Litoměřice altarpiece, 28
Master of the Marble Madonnas, 15
Master of the Tiburtine Sibyl, 28
Matteo the Italian, 20
Medici Chapel, Michelangelo sculptures, 51
Meller, P., 15
Mensator, Joannes, 62, Fig. 220
Messina, Antonello da, 47
Michalowicz, Jan, 2, 55, 56, Figs 188–92; 95 (note 47)
Michelangelo, 29, 51, 69
Michelozzo, 14, 29
Miechowita, Maciej, 27
Milan, Portinari chapel in S. Eustorgio, 29
Milano, Ambrogio, 94 (note 16)
Miłobędzki, Adam, 11
Miskolc, *see* Diósgyör Castle
Mitrovic, Vaclav Vratizlav z, 91 (note 6)
Mohács, Battle of, 2, 17, 73
Monogrammist M.S., 69, Plate IV, Fig. 209
Montagnana, Alvise Lamberti da, (*see* Novyj), 3
Montecchia, Palazzo Emo Capodilista, 69, Fig. 262
Morando, Bernardo, 71–2, Fig. 275
Moravská Třeborá, 102 (note 23)
Moravský Krumlov, castle, 78, Fig. 294; 101 (note 23)

Mosca, Gian Maria, *see* Padovano
Moscow, cathedral of St Michael the Archangel, 3,
 Fig. 3; Faceted palace, 3, Fig. 1; Dormition
 Church, 3

Mozart, Anton, Fig. 322
Mucante, Paolo, 50
Munich, Bayerische Nationalbibliotek, 90
Munich, epitaph of Conrad Paumann, 47, Fig. 136,
 48
Münster, Landesmuseum, Fig. 223
Musi, Agostino, 27
Myszkowski, Bishop Piotr, 81

Nachod, castle, 101 (note 23)
Nagyvárad, 5
Náměšt' nad Oslavou, castle, 78, Figs 295, 301; 101
 (note 23)
Naples, Alfonso I's triumphal arch, 25, Fig. 74;
 Piccolomini chapel in S. Anna dei Lombardi,
 29, 38
Nelahozeves, castle, 77, Fig. XVII, Figs 290–1; 79,
 101 (note 23)
New York, Metropolitan Museum of Art, 47, Fig.
 134; 84, Fig. 332; Pierpont Morgan Library,
 Plate I
Niedzica, castle, 68, Fig. 254
Niepolomice, 79; Branicki tomb, 86, Fig. 340
Nograd, coats of arms of Bathory family, 46, Fig.
 130
Nové Zámky, town plan, 71, Fig. 271
Novyj, Alevis, 3, Figs 2, 3
Nyék, Corvinus's hunting lodge, 10, Fig. 19; 15, 18,
 Fig. 54; 74
Nyírbátor, stalls and inlaid panels, 62, Figs 223–5
Nysa, cathedral, tomb of Balthasar of Promnitz, 49,
 Fig. 143; monument to Bishop Jakub of Salza,
 50, Fig. 153

Oláh, Miklós, 14
Olbracht, Jan, 9; tomb of, *see* Cracow, Wawel
 Cathedral
Oleśnica, tomb of Jan Podiebrad by Jan Osley, 50,
 Fig. 152
Oliwa, Kos monument, 83, Fig. 317; 101 (note 48)
Olomouc, 7
Omichius, Franciscus, 91 (note 6)
Opatów, tomb of Krzysztof Szydłowiecki, 50, Fig.
 150; 52, Figs 171–3
Opbergen, Anthonis van, 82, Figs 313–15
Opočno, castle, 78, Fig. 293; 101 (note 23)
Osley, Jan, 50, Fig. 152

Pabianice, parapets, 65–6, Fig. 238, Figs XII, XIII
Paczków, 64, Fig. 230
Padovano, Gian Maria Mosca il, 53–7, 66, 67, 69, 84,
 Figs 181–2, 187, 198–9, 241, 244
Padua, tomb of Benavides by Ammanati, 51, Fig.
 170; Palazzo della Ragione, 74
Palladio, 38, 75
Palmanova, 61
Pambio, Juan Maria del, 79, Fig. 303
Panicale, Masolino da, 5
Pannonia, 46
Pannonius, Janus (Česmički, Ivan), 2, 6
Panofsky, Erwin, 45, 46, 47, 51, 52, 54, 101 (note 23)
Pardubice, castle, 23, Fig. 66; market square, 64,
 Fig. 227; the Green Gatehouse, Fig. 228; 69, 78
Paris, Louvre, 52

Parr (Parrio), Jacopo and Francesco; Parr family, 26–7
Pavel, Master, 65
Pécs cathedral, 6, 8; marble tabernacle, 9, Fig. 13; 18
Pencz, Georg, 60, Fig. 211
Pernštejn, Vilem, 64
Pešina, Jaroslav, 28
Pest, marble tabernacles in parish church, 9, Fig. 14
Petrus Pictor, 62
Piast dynasty, 26
Piccolomini, Enea Silvio, 6
Pienza, Piccolomini Palace, 20
Pieskowa Skała, castle, 79, Fig. 300
Pilon, Germain, 2
Pińczow workshops, 87
Piombo, Sebastiano del, 83
Piotrków, castle, 23, Figs 62, 65
Płock cathedral 11
Plzeň, town hall, 68, Fig. 249; 69
Poggio a Cajano, 81
Polish parapet, 63, Fig. XI
Pollak, O., 74
Pollaiuolo brothers, 8, 52
Porta, Antonio della, 10, Fig. 17
Poznań cathedral: Górka family tomb, 57, Fig. 197; tomb of Adam Konarski, 57
Poznań, town hall, 69, Fig. 265; 70, Figs 267–9
Pozsony, see Bratislava
Prachatice, 68
Prague: 4, 5, 6, 15, 17
Belvedere Villa, 5, 74, Figs 279–82; 75
Vladislav Hall, 15–16, 17, Figs 42–7
Riders' Staircase, 16, 17, Figs 48–9
Hradčany Castle, 17, Figs 50–1; 23
St George's Church, 17, Fig. 51a
Cathedral, Chapel of St Václav, 28
St Vitus's Cathedral, Bansburg tomb, 50, Fig. 154
Týn school, Fig. 233
Lobkovic-Švarcenberg Palace, 65, Fig. 235; 68, 85
Rožmberk Palace, 65, Fig. 237; 85
Royal Ball Court, 75, Figs 283–4
Organ Loft, St Vitus's Cathedral, 75, 76, Fig. 285, Fig. XV
Parliament Hall, 75, 76–7, Fig. 286
Hvězda Palace, 79–80, Figs 303–4, Figs XVIII, XIX
Prato, S. Maria delle Carceri, 28
Přerov, the upper town, 64
Prešov, parapets, 62, 68, Figs 246–7
Pułtusk, Collegiate Church, 86, Fig. 331

Quadro, Giovanni Battista, 69, 70, Figs 265, 267–9

Ráckeve, tomb of Nikolaus, 45
Radzyń, Mniszech tomb, 87, Fig. 342
Raphael, 92, Galatea, 42
Reepham, tomb of Sir Roger de Kerdeston, 54, Fig. 184
Regiomontanus, 6
Riccio, Andrea, delle Torre tomb reliefs, 52
Ried, Benedict, 15–16, 17, 23, 64, 73, 74, Figs 42–51a, 229
Rollwerk' cartouche, 82
Romano, Gian Cristoforo, 8, Figs 6, 7
Rome: Bramante's Cortile di San Damaso, 20, Fig. 59

Borghese Gallery, Venus Anadyomene, 42, Fig. 119
Villa Farnesina, Raphael's Galatea, 42, Fig. 117
National Museum, 42, Fig. 115
S. Maria in Aracoeli, tomb of Cardinal dei Vincenzi, 52, Fig. 175, 53, 55
St Peter's: Pollaiuolo's tomb of Innocent VIII, 52
S. Maria del Popolo, effigies, 52, 53, Fig. 177
S. Marcello al Corso, tomb of Cardinal of Santangelo, 53, Fig. 178
S. Clemente, tomb of Cardinal Venerio, 54, Fig. 183
Belvedere of Innocent VIII, 99 (note 47)
Rosice, castle, 78, 101 (note 23)
Roskilde, 82
Rossellino, Antonio, 29
Rosso, see Bartolo, Nanni di
Rovezzano, Benedetto da, 11, Fig. 18; 94 (note 16)
Rudolph II, 87
Russia, 3–4
Rustinimicus, 95 (note 19)
Rybisch, Heinrich, 48

Sabbioneta, Gonzaga effigies, 81
Šamánková, Eva, 69
Samostrzelnik, Stanisław: Sigismund I's Book of Hours, Fig. 208; 98 (note 5)
Sandomierz, 67
Sangallo, Giuliano da, 28, 32, 33, Fig. 98
San Gimignano, tomb of S. Bartholo, 51
Sanmicheli, 82
Sansovino, Andrea, 49, 52, 53, 55, Figs 175, 177
Sansovino, Jacopo, 53, Fig. 178
Sárospatak, castle, 79, Fig. 302
Schedel, Hartman, World Chronicle, 27, Fig. 26
Schnitzer, Hans, 25
Schweiger, Salomon, 91 (note 6)
Sciacca, Palazzo lo Sterpinto, 99 (note 47)
Scolari, Andrea, 5
Scolari, Filippo (see Spano), 5
Serlio, 70, 74, 75, 82
Seymour, Charles, 8
Sforza, Queen Bona, 24, 25, 53
Siena, stalls of Monte Oliveto monastery, 62
Sigismund I of Poland (see also Jagellon, Sigismund), 9–10, 11, 18, 19, 25, 35, 49, 59, 60; Fig. 208; and Solomon, 39–40
Sigismund II August, 38
Sigismund of Luxemburg, 4, 5
Silesian parapet, 63, Fig. 226
Sinko, Krystyna, 50
Slavonice, gable parapet, Fig. 232
Smiřicky, Jaroslav ze Smiřic, 77
Smíšek, Michael, 28
Sobieski, Jan III, 29
Sommerfeld, 95 (note 19)
Solari, Pietro Antonio, 3; Fig. 1
Soncino, 99 (note 47)
Spalato, see Split
Spano, Pippo (see Scolari, Filippo), 5
Speckle, 71
Speyman, Hans, 83
Spiš, 68
Spittal an der Drau, Porzia castle, 79
Split, Temple of Jupiter, 25, Fig. 75

Spranger, Bartholomaeus, 83
'Stabwerk', 82
Stange, A., 28
Staszów, Tencyński chapel, 81, Fig. 309
Statio, Giovanni de, *see* Vlach, Hans
statues accoudées, 52ff.
Stein, Passauer Hof, 68, Fig. 261
Stella, Paolo della, 74, 75, 84, Figs 279-80, 282
Sterbebild woodcut, 47
Stoss, Veit, 10, 47, Figs 133, 137
Strol, Hans, 27
Stuba, Dionizy, 24, Fig. 69
Stüler, Friedrich August, 81
Stuttgart, 70
Sucha, 79
Sušice, town hall, 68, Fig. 251
Svatý Jur, altar of St George, 61, Fig. 215
Sviňa, 68
Szathmáry, George, 9, 18
Székesfehérvár, 8
Szydłowice, 67
Szydłowiecki, Krzysztof, 11, 98 (note 5)
Świątkowicz, Samuel, Figs 122, 344-6

Tacca, Pietro, 83, Fig. 321
Tarnów, cathedral, Fig. 24; tomb of Barbara Tar-
nowska, 12, Fig. 23; Tarnowski tombs, 54, 55,
Fig. 187; 56; Fig. 195; 57, Figs 198-9
Tarnów, town hall, 67, Fig. 244
Tarnowski, Jan, 12, 54
Tarnowski, Jan Krzysztof, 57
Tauerbach, Sebastian, 25, Figs 72, 76-9
Tchélébi, Evlia, 32
Tedaldi, Lattanzio, 95 (note 19)
Telč, 68
Tenczyński family, 81
Thiene, Villa Porto Colleoni, Fig. 258; 99 (note 47)
Thuróczi, János, 47
Tirol, Hans, 77, 79, Fig. 303
Tomicki, Piotr, 43
Torgau, Hartenfels Castle, 2
Toruń, 82
Tovačov, the Nové Město, 64
Traversari, Ambrogio, 6
Tubero, Ludovicus, 91 (note 10)
Turzo, Jan, 11, 49
Turzo, family, 25

Uchanie, vault decoration, 86, Fig. 334; Uchanski
tomb, 87, Fig. 343
Uherský Ostroh, castle, 78

Vác cathedral, coats of arms on tomb slabs, 46
Vacková, Jarmila, 28
van Aelst, Peter Coecke, 13
van Eyck, Jan, 47
van Ghent, Joos, 28
Varotari, Dario, 69
Vasa dynasty, 43
Vasari, Giorgio, 8, 13, 62
Velius, Caspar Ursini, 13
Velké Losiny, castle, 78, Fig. 101 (note 23)
Venice, Giambattista of, Fig. 331

Venice, Scuola di San Marco, 68, Fig. 259
Vergerio, Pier Paolo, 6
Verona, S. Fermo Maggiore, Brenzoni monument,
53, Fig. 176; Santa Maria in Organo, stalls, 62;
Sanmicheli's gates, 82
Verona, Giovanni da, 62
Verrocchio, 7, 8
Veselí nad Lužnicí, town hall, 68, Fig. 248
Veszprém, 5, 8
Vicenza, Palladio's basilica, 74
Vienna, St Stephen's, epitaph of Cuspinianus, 47, 48;
Schweizerhof, 77, Fig. 287; Stallburg, 79;
Nationalbibliothek, 79, Fig. XVIII; 80
Vischer workshop, 2, 47, 50; bronze plaques and
slabs, 51, Figs 156, 158, 161-3
Visegrád, 4, 7, 14, 15; Corvinus's castle, 14, Figs 36-
8; Hercules Fountain, 14, 15, Figs 39-41
Vitéz, János, 2, 6, 7, 8
Vlach, Hans (Giovanni de Statio), 68, Fig. 249
Vladislav, King, 4, 9, 15, 17, 60, 73
Vries, Jan Vredeman de, 82, Fig. 320
Vries, Adriaen de, 83

Wallbaum, Matthias, Fig. 322
Walter I, Andreas, 27, 48, 49
Warsaw, cathedral, tombs of Dukes of Masovia, 50,
Fig. 151
Warsaw, Baryczka family house, 67; University
Library, Figs 65, 342
Washington, National Gallery of Art, 8
Wawel, Castle and Cathedral, *see* Cracow
Webster, John, 52
Widman, Georg, 102 (note 65)
Wilno, tomb of Witold Gasztold, 49-50
Winkler, Friedrich, 59
Wiśnicz, 79
Witten, Hans, 60
Władysław, King, 6
Włocławek cathedral, 43, 45, Fig. 122; 95 (note 47);
tomb slabs, 46
Wohlmut, Bonifaz, 74-7, 79, 84, Figs 279-80, 283-6,
Figs XV, XIX
Wola Justowska (near Cracow), villa of Jost Ludwik
Decius, 75, Figs 277-8
Wolff, Jan, 86, Fig. 334
Wrocław: tombs of Stanislaus Sauer and Heinrich
Rybisch, 48, Figs 138-41
tomb of Jan V. Turzo, 49, Figs 142, 144
Golden Crown House, 63, 64, Fig. 226
oriel on town hall, 69, Fig. 263
Museum Narodowe, Nunhart epitaph, 83, Fig.
319

Ząbkowice, castle, 64, Fig. 229
Zagórze Śląskie, Fig. 247
Zagreb, 62
Zamość, town plan, 71-2, Figs 273-4; Collegiate
Church, 72, Fig. 275; main square, Fig. 276
Zamoyski, Jan, 71-2
Zarębska, Teresa, 71
Zator, altar, Fig. 213
Zlat, Mieczysław, 68
Żółkiew, 67
Żywiec, 79